STYLES OF SERIOUSNESS

STYLES OF SERIOUSNESS

Steven Connor

Stanford University Press
Stanford, California

Stanford University Press
Stanford, California

Printed and bound by CPI Group (UK) Ltd, Croydon, CR0 4YY

Cataloging-in-Publication Data available upon request.
Library of Congress Control Number: 2022058937
ISBN: 9781503636453 (cloth), 9781503636866 (paper), 9781503636873 (ebook)

Cover designer: David Drummond
Cover photograph: iStock

Contents

Contents

1 Seriously, Though

This book may be thought of as a long and ramiculated brood on the difficulty, and perhaps the impossibility, of being completely serious or, so to speak, really, seriously serious. In it, I will try to fill out my intuition that being serious is affected by the same internal shimmer that affects words like *act* or *perform*. Acting means both doing something for real and pretending to do it, just as performing a duty means both really doing it and putting on a performance, just as *agency* is a word employed to mean both acting for yourself and getting someone to act on your behalf. One can similarly never be sure about seriousness, one's own or anyone else's.

Do we live in an age of seriousness? Or just in an age of "seriousness"? The evidence of the titles of books from the last half century in UK academic libraries might seem to suggest a growing hunger to be serious, or at least to buy books that promise the "taking seriously" of different topics. Remarkably, given the existence in English since 1655 of the phrase *to take seriously*, the single example of a title having the form *Taking . . . Seriously* before 1975 is William Loftus Hare's *Taking Politics Seriously* (1913). Yet, in the forty-five years since then, there has been a multicolored flood tide of book titles employing the phrase. These books promise treatments of how to take seriously, among many other things, African cartoons, animals, appearance, the Bible, boys, children, cinema, comedy, complexity, complainants of torture, concepts, conspiracy theories, culture, the Curry-Howard correspondence, cycling, Darwin, democracy, detective stories, diversity, domestic violence, Dutch art, duties, economics, embodiment, employment discrimination,

equal opportunities, ethics, evil, experience, eyeglasses, ex nihilo, faith, George W. Bush, glasnost, God, hallucination, harm, identity, ideology, innovation in the public sector, input derivatives, Jesus, journalism, juvenile justice, language, laughter, leisure, life, life and death, medical law, metaphysics, migration, money, morality, ourselves, philanthropy, philosophy, popular music, public universities, qualitative research, racism, religion, rights, rites, sex, science, the sixties, socialism, solipsism, sustainable cities, swords and sorcery, teaching, things, television, trade policy, transparency, the unconscious, utilitarianism, victims, women, and wrongs. Some of the topics that one is encouraged to think might be taken seriously make a certain kind of sense, given the likelihood that they might otherwise be thought unworthy of serious attention—soaps, sport, *South Park*, Sudoku. But there is something a little comical in the idea that one might need argument or urging to take death, life imprisonment, oppression, suffering, type 2 diabetes, or New Zealand seriously.

Predictably enough, since among the things we mean by seriousness is "not being funny," these titles include John Moreall's *Taking Laughter Seriously* and Jerry Palmer's *Taking Humor Seriously*. There has been much that calls itself philosophy of laughter, but hardly any serious attention has been paid to its logical inverse, the laughter in and of philosophy. We take it for granted that thinking is a serious matter. *Wit* used to mean both comic contrivance and intelligence or understanding in general, though these two usages have steadily drifted apart since the seventeenth century. To say that somebody looked thoughtful would make it hard to imagine them smiling or laughing while doing so. Why not? Reasoning about comedy has rarely suspected that there could be anything substantially or systematically comic about the exercise of reason, a lapse of attention that might itself be regarded as a little droll.

As I go along, I hope to provide persuasive reasons for thinking of comedy not merely as part of the rhetorical texture of thought, as apology for or antidote to its austere demands, but rather as essential to its conduct and constitution. Ultimately, I will propose, comedy is a vehicle for the negotiation of our emotional ambivalence not just about the large kinds of things to which philosophy pays attention—time, matter, free will, the body, language, nature, and so forth—but also about the act of thinking that we like to think makes us human and enables us to know ourselves as such. This can explain why laughter is so much part of our constitution as human beings, since reflection

on our own powers of thinking is so universal, going far beyond the relatively specialized pursuits of philosophers. I want to build the case that, whatever else it might be, laughter is a communal and community-forming commentary on thinking, one that promises at once to enlarge the dominion of thought and immunize against some of its atrocities. It is not possible to think seriously about comedy without having to think about our thinking; and it is not possible to think seriously about thinking without stumbling on, and into, comedy.

The aim I set out with in writing this work was to develop arguments of this kind for taking laughter seriously. It would not be the first time that anyone has done this, and there are signs that many more writers in recent years have been drawn to such an ambition. But taking the laughter in serious matters like thought and reason seriously began, slowly but more and more irresistibly, to open up for me another kind of question, which this book will make it its principal business to try to respond to, namely the question of what seriousness might be. This is a question that must be answered in part phenomenologically, since seriousness must always mean seriousness for us—or, if we do not necessarily want to claim that being serious is uniquely human— for the kind of beings, if any there be, for whom seriousness is a serious matter. What does it mean to be serious? What work is performed by seriousness? What needs does it meet, and what rewards and gratifications does it offer? How many forms of seriousness are there? In a way, the challenge I set myself was to see whether it might be possible to take seriousness seriously in any way that was not merely tautological.

There seem to me to be two ways of asking the kind of "what is" question exemplified in "What is seriousness?" which might be characterized as the two principal ways of conducting what we recognize as serious kinds of enquiry. Rather conveniently, these two options can be illustrated by the approaches that have been taken to laughter, and allied notions such as comedy, humor, wit, and fun. The illustrations are convenient just because the apparently contradictory nature of such an enterprise seems to isolate what is going on in the act of taking seriously in a way that is not quite so conspicuous in taking serious things seriously.

The first and by far the most common way of taking laughter seriously (taking laughter temporarily as a summarizing synecdoche for the whole spectrum of appearances of the comic) is to try to find some unifying feature in it, some essential thing that laughter is, or some compulsory and recurrent

function that all instances of laughter may be held to perform. So success-ful have writers on laughter phenomena been in this ambition that they have actually narrowed the range of options drastically; indeed, on the view I will be getting behind here, such accounts of laughter have been successful pre-cisely because such narrowing is a recurrent part of what being serious is typically taken to mean or entail. As a result, commentators on laughter and comedy struggle to avoid falling back into one of the well-established theories of the comic, of which there seem to be no more than three. They are the relief theory, the incongruity theory, and the superiority theory. The relief theory proposes that we laugh in order to reduce or discharge some kind of tension, cognitive or emotional, and, when it comes down to it, this being the kind of thing we expect to happen when things are taken seriously, almost always both. The incongruity theory proposes that we laugh at things that do not seem logical, rational, or properly aligned with the categories through which we see the world. Laughter in this view might be a sort of inverted, immu-nizing disgust. The link between laughter and disgust may be suggested by the fact that the formula "matter out of place" to characterize the disgusting or the unclean is oddly irreversible: all disgust may be caused by matter out of place, but matter out of place does not always create disgust, and when it doesn't, it will most commonly create amusement in place of revulsion. The superiority theory (the least in favor among theorists who want to argue that laughter performs serious and therefore valuable work) is that we laugh at something we regard as defective or inferior: in Thomas Hobbes's (2008, 54) crisp and quotable formula, laughter is "nothing else but a sudden glory aris-ing from sudden conception of eminency in ourselves, by comparison with the infirmities of others." I have long thought that there are really only two and a half explanations in this list, since what laughter affords relief from (or to) seems ultimately to be kinds of complexity or incongruity that without the catharsis of laughter might be intolerable. In fact, a determined be-all and end-aller might well want to claim that Hobbes's principle swallows both of the other goldfish in the bowl, since in discharging complexity one achieves a gratifying triumph over the difficulty it seems to propose, or at least the con-ception of that easeful eminency.

All of these theories depend on the assumption that laughter needs to be explained and that explaining will not mean, as the word seems to promise it might, an unrolling or spreading out but rather a reduction of laughter to the fulfillment or expression of some other necessity, both essential to the laughter

yet also extrinsic to it, and thus simpler and more primary than it. It is explanation by canceling down, or the *"nothing-buttery"* that Peter Medawar (1961, 100) sees as "always part of the minor symptomatology of the bogus."

But what if laughter were not only not susceptible of such explanation by recourse to radicality but also in no need of it? What if laughter were neither the concealment nor displaced expression of any kind of something else? What if we laugh because we enjoy laughing, and enjoy laughing just because we enjoy enjoying ourselves, and in rather a lot of different ways? We enjoy laughing by evolutionary chance, because we have stumbled on it as a way of getting and prolonging pleasure. Other animals mostly have not (yet), but they are working on it (dogs especially), and it may only be a matter of time. Rather than wondering what occasions laughter, we might then be able to see laughter as the desire for enjoyment in search of occasions. This obviously conceals a reduction of its own, in the version of the pleasure principle on which it may seem to rely, but this can probably not be helped. However, we can be helped out of it to a large degree by the suggestion that the nature of pleasure is not of a fixed and necessary kind, meaning that pleasure may be partly characterized by the desire to diversify, yea, even to perversify, its forms. One of the things we seem to take pleasure in (needless to say, please, not the only, essential, or always necessary thing) is our capacity to take pleasure in many different sorts of things. Laughter seems materially to assist this process at times: giggling schoolgirls and bantering schoolboys enjoy getting into a condition in which nothing is safe from being made ridiculous. The contagiousness of laughter may be an indication that it is laughing that we find fun, rather than the response to certain kinds of essentially funny thing.

For some reason, the second view of laughter, as what Americans still often, and admirably, call "a bunch of stuff," seems to strike us as less serious than the first. A little later, I will suggest some of the ways in which seriousness comes to be associated with contraction of possibilities, rather than unfolding of them. There is a clue here, I think, to the kind of work performed by the action of taking something seriously, as opposed to finding it ridiculous. Seriousness is selective attention, in what must seem like a tautology, since surely all attention is selective attention, for everyone but God. The impulse or exhortation to pay attention to a field or assemblage of different things—a landscape, say, or the history of a neighborhood—would irresistibly constitute it as a bounded object, picked out from a more indeterminate background. And yet, if this is a recurrent feature of the kind of things we take to

be serious, or the seriousness of our taking, this need not, I think, imply that seriousness is itself just this one kind of thing. Indeed, the view given license in this book will have to be that seriousness in fact promises us the same kind of unfolding or enlargement of the family resemblances, along with prodigal progeny and distant cousins, of a given topic as laughter, in an anthological rather than unearthing procedure.

This will explain why this book is composed of the chapters, or more strictly the kind of chapters, it is. Rather than circling around seriousness or seeking to penetrate to its depths, I aim to espalier what seem to me to be some of its principal modalities, idioms, and implications, without necessarily suggesting that they are expressions of some more ultimate principle: importance, intent, solemnity, sincerity, urgency, regret, warning, ordeal.

I just said that animals are at a very early stage in the development of the capacity to laugh. Part of the purpose of this book is to show that humans are correspondingly capable of a quality of seriousness that it is hard to imagine in animals. Animals are certainly capable of differing degrees of the kind of concentrated attentiveness that is often associated with seriousness in humans. One need only think of the sudden switch in a domestic cat from indolent lolling to alert watching at a mouse hole. But it does not seem likely, at least to me, that there could be any conscious relation in the animal to the idea or experience of its own seriousness. Human beings, by contrast, are capable of being serious about their own seriousness and perhaps are not even able to help it. This is for the unexpected reason that humans are much more versatile than most animals at not being completely serious and, in J. L. Austin's phrase, of "not exactly doing things"—so compulsively versatile, in fact, that actually or really doing things, or being sure that one is, can pose significant difficulties. Many in the ancient world followed Aristotle's apparently seriously held view that wandering thoughts during the work of begetting were to blame for birth deformities. Such inattention to the integrity of one's offspring is the mainspring and principle of (defective) action in Sterne's *Tristram Shandy*.

This goes beyond something like, for example, being intently aware during some operation requiring intent awareness—performing brain surgery, or opening the batting for Middlesex—of the need to remain in a condition of high and vigilant alertness. It extends into all the many ways in which seriousness may be invested with value, in the process described by Freud as *Besetzung* and rendered by his English translator James Strachey as *cathexis*.

I will be concerned in this book not so much with serious action as with the more or less serious ways in which the idea of such serious action is regarded, or the ways in which seriousness is, and sometimes is not, held to matter, and to be a matter of concern.

Concern is taken to be a serious matter, in keeping with its origin (like *discern*) in Latin *cernere*, to sift, or separate; a *cernicle*, from medieval Latin *cerniculum*, is a sieve. So when people employ the word *discern* to do the work of the word *distinguish*, they are righter in their way of being wrong than they seem to know. *Certainty* is from *certus*, the past participle of *cernere*, hence that which has been sorted, sifted, or discriminated. In legal language, the process known as *cerning* or *cerniture* means the formal declaration, hence the establishment or certification, by an heir of acceptance of an inheritance. An alternative form of this legal term, *cretion*, from Latin *cretio*, is secreted in English *discrete* (and *discreet*), *concrete*, *secrete*, and *accrete*. *Concern* has felt the caress in English of *concentration* and *concentric*, but in fact its principal meaning, from *con-* + *cernere*, is not to sift or separate but to mix or mingle together—to *decern* rather than *discern*, as it were. To pay the kind of full and undivided attention that translations of Heidegger sometimes describe as "concernful," excluding premature exclusions, is in fact not to rush to make the critical distinctions that aim at or lead to certainty, but to permit attention to the internal concerts and contentions of concepts: to take in the way in which *cernere* can give rise both to *certainty* and *excrement*. This may mean that the kind of abstraction thought to be characteristic of seriousness may, to be properly serious, need to be open to the distractions that seriousness risks making itself look silly by sifting out.

This is why in this book, I abstain from trying to define any zero degree of seriousness, but rather content myself with assembling some of its characteristic modulations. In concerning myself with what I call the styles of seriousness, I mean to intimate that one cannot simply be serious by subtraction, by stopping being other, more distracted, more compounded kinds of thing, as might be implied by an expression like "Seriously, though" or "Come on, be serious," but must find and follow particular ways of being serious. The reason for this is the essential seriousness of questions of style themselves, for creatures apparently deprived of the capacity ever simply to be, in any final degree of distillation, but having always to seek some manner of being, some idiom or other of existence. This is indicated neatly in the question sometimes addressed to young humans, "What are you going to be?" and the kinds of answer it is apt

to produce, which are really anticipations to the answer that one hopes to be able at some future date to give to the question "What do you do?" Appropriate answers to such a question seem usually to require a noun preceded by an indefinite article: "a plumber like my father before me" or "a baseball player" or "a nurse." Just occasionally the definite article may appear—"the head of the Civil Service, like my mother before me," "the terror of the earth"—but always in such a case implying the following of some pattern or occupation of some category. One's occupation names not only what you occupy yourself with but the category of being that you occupy, or will have occupied. To be able to see what one will be is to see what one's being will have amounted to, or the recognized form it will take, meaning the mode of being it will enact, on some model or other, even if it establishes the model. For a model is a mode, and one must exist one's existence or, even without having exerted oneself in that way, must without fail end up having had a certain kind of existence, or having existed in a certain way. Even if one's answer to "What are you going to be?" is something twinkly and Wildean, like "incomparable" or "indecisive" or "what the fates decree" or "a disappointment to my family" or "that from a long way off looks like flies," the answer will have to accede to the proposition contained in the question that one's being will have to settle into some substantive how or what, something other than just something-or-other, either through one's own decision or through acquiescence to what something hidden from us chose, assuming those two to be genuinely distinguishable (or even discernible).

Humor and funniness are often thought about in terms of their implied contrast with seriousness. The contrast often has to be implied since it is assumed that seriousness is familiar and well understood, as the unmarked or ordinary condition of things from which comedy, irony, frivolity, and so forth constitute a reprieve. One of the things that will become clear through the course of this book is that my first ambition of taking laughter seriously will be obliquely brought home in the gradual sedimenting of the axiom that nothing can be really serious that does not admit of an intestine murmur of absurdity. Yet one of the intriguing things about seriousness is that it is a conjunction of several contraries. It is the opposite of gaiety and merriment. It is the opposite of pretense and make-believe. It is the opposite of unimportance. And it is the opposite of harmlessness and safety, as in a serious illness or serious crisis. All these ways of not being things are ways of being serious, but the seriousness may be of a different kind in each case.

Circumstances are certainly imaginable in which gaiety, make-believe, and unimportance are conjoined—a Punch and Judy show at a children's party, for instance—but they need not be and usually perhaps are not. Pretense is often amusing, but not invariably so. Saying what you seriously mean does not necessarily mean saying it seriously or gravely ("What a glorious morning!" "You are a sight for sore eyes!"). But if there is no one kind of thing that seriousness is, it seems to be an important part of its understanding that it should mark the modification, suspension, or reversal of ordinary or unmarked states of affairs. Laughter breaks out in ordinary conditions; seriousness breaks in on them. We think of levity and gaiety as holidays from or suspensions of the serious business of work. But it is important to grasp the fact that seriousness is also the episode or intermission from the many forms of nonseriousness—including pretense, imposture, performance—forming the ground bass of much of our shared experience. We might think merely of how often we feel impelled to say "seriously, though" or "joking apart," setting aside the facetiousness or semidistraction that constitutes the usual condition of things.

We are exhorted to seriousness more often than to lightness or diversion (even "lighten up" is a serious injunction), since it is assumed that we know how to divert ourselves without the necessity for any form of self-discipline, whereas we need schooling to become serious. Perhaps how to be serious is one of the most important lessons imparted by formal education. This is because seriousness seems to require arduous effort, the effort required to pull oneself together after a fit of the giggles, or to refocus one's attention or intentions, or to avert some threat. In fact, children both are and are not capable of seriousness. The play of a child is often not playful at all, but absorbed in the way in which work is supposed to be for an adult. But we should call such play serious only by resemblance, precisely because seriousness is schooled, as the putting away of childish things. In order to be serious, you need to be able to be something else, which you are also able to put on hold. You cannot, that is, be spontaneously serious, which means that your seriousness must always be in quotation marks, and anxious to live up to its reputation.

There are two broad semantic fields in which the word *serious* tends to be deployed. The first is the field of what Foucault (2010, 32) calls "veridiction," the means employed in the telling of truth. To be serious means to mean what we say. Serious utterance is utterance that means to be taken as veridical—that is, truth telling—and therefore, as we say, to be "taken seriously." To be serious about something means to mean it, in the sense not just of intending

it ("What do you mean by that?") but also of being intent on it. This kind of seriousness therefore applies primarily to speaking persons, or to persons whose actions seem to embody intentions in an unmistakable manner ("She really *meant* that kick").

This seems to be a derivation from Latin *serere*, the primary meaning of which is to sow, or plant seeds in a row. In their etymological account of the word, Alfred Ernout and Alfred Meillet (2001) speculate that the conjunction of sowing and planting in *serere* "is evidence of a period in which sowing was not done broadcast but by pressing seeds one by one into the ground" (618). Indeed, *serious* was used in English up to the end of the fifteenth century to mean serial, or singly in sequence. *Serere* acquired the signification of binding, continuity, or joining together, in words like *assert, desert, exert, insert,* and *dissertation*. The horticultural Varro speculated attractively in his *On the Latin Language* on the links between speech and the sowing of seed:

> Our word *disserit* is used in a figurative meaning as well as in relation to the fields: for as the kitchen-gardener *disserit* "distributes" the things of each kind upon his garden plots, so he who does the like in speaking is *disertus* "skilful." *Sermo* "conversation," I think, is from *series* "succession" . . . for *sermo* "conversation" cannot be where one man is alone, but where his speech is joined with another's. (Varro 1951, 1.231–33)

The second semantic field of the serious concerns feeling rather than meaning, and signifies the disposition or demeanor associated with veridiction or serious intent. Seriousness, as a manner or deportment, is a means by which we may mean to be taken to mean what we say. To be serious means to be grave, solemn, or earnest, with a strong implication of sadness or melancholy, this association probably given extra force in English because of the conjuncture of Latin *gravis* (heavy, burdened), from which *gravity* and *grief* derive, and Old English *grafan*, from pre-Germanic **ghrābh-*, to dig, which lies behind the words *grave* and *groove*. It seems that there is no direct connection with Greek γράφειν, to write, *engraving* deriving more directly from the Germanic idea of digging. Mercutio's valedictory joke, feeble, but forgivable in the circumstances, "Ask for me tomorrow and you shall find me a grave man" (Shakespeare 2011, 1024), is in a long tradition of jokes on what it means to be grave. By transference, serious illnesses or circumstances are ones that usually provoke concern or anxiety. This kind of seriousness suggests severity, with which *serius* has been associated—for example, in words such as *persevere* and

asseverate, to assert seriously. All these associations seem to assume or assert that being serious is a more or less painful or exacting business. They amount to the tendentious theory that truth, as opposed to life, is essentially difficult, dangerous, and demanding: *hard*. But why is a precious thing like mercy not regarded as serious, along with all the many other holiday virtues that fall mercifully short of inviolability, or not until they are strained into the unforgiving severity of a principle? What is light-minded about entertaining mercy mercifully in thought?

The existence of a word like *diversion*, when used in the sense of some amusement or entertainment, might suggest that straight-and-narrow seriousness is the unmarked or base condition from which we occasionally, if also repeatedly, feel the impulse to take our leave. Even *sport* is a shortening of *disport*, which signifies a departing or deporting from some other more basic condition. Departing from seriousness means relaxing or relinquishing the effort required to be self-consistent. Ralph Waldo Emerson is among those who have assumed that human beings introduce nonseriousness into a nature that is fundamentally "in earnest" and incapable of the kind of temporizing or double-dealing characteristic of jesting:

> The restraining grace of common-sense is the mark of all the valid minds, — of Æsop, Aristotle, Alfred, Luther, Shakspeare, Cervantes, Franklin, Napoleon. The common-sense which does not meddle with the absolute, but takes things at their word, — things as they appear, — believes in the existence of matter, not because we can touch it or conceive of it, but because it agrees with ourselves, and the universe does not jest with us, but is in earnest, is the house of health and life. In spite of all the joys of poets and the joys of saints, the most imaginative and abstracted person never makes with impunity the least mistake in this particular,—never tries to kindle his oven with water, nor carries a torch into a powder-mill, nor seizes his wild charger by the tail. We should not pardon the blunder in another, nor endure it in ourselves. (Emerson 1875, 9)

In his essay "The Comic," Emerson (1875) turns his attention away from the carefully selected minority of "valid minds" to fill out what might seem like an alternative perspective, that "a taste for fun is all but universal in our species, which is the only joker in nature. The rocks, the plants, the beasts, the birds, neither do anything ridiculous nor betray a perception of anything absurd done in their presence" (127). This taste for fun shows mankind to be

the exception proving the rule of Reason in nature, which must be regarded as soberly incapable of laughter or practical jokes, because it "meddles never with degrees or fractions; and it is in comparing fractions with essential integers or wholes that laughter begins" (127). Emerson lifts this hint of an identification between the comic and the fractional into a definition:

> The essence of all jokes, of all comedy, seems to be an honest or well-intended halfness; a non-performance of what is pretended to be informed, at the same time as one is giving large pledges of performance. The balking of the intellect, the frustrated expectation, the break of continuity in the intellect, is comedy; and it announces itself physically in the pleasant spasms we call laughter. (Emerson 1875, 139–40)

The examples that Emerson (1875) goes on to give all in fact depend on the confrontation of the wholeness of Reason, which, like the nature with which it is alloyed, "does not joke" (141), with different kinds of "halfness or imperfection." Joking is against glumbucket nature in that it introduces discontinuity into it: "The whole of nature is agreeable to the whole of thought, or to the Reason; but separate any part of nature, and attempt to look at it as a whole by itself, and the feeling of the ridiculous begins" (140).

But the idea that halfness—or, as it might alternatively be seen, the capacity to stand apart from things or from ourselves—belongs to the capacity for comedy is reversible, since it is possible to see seriousness as depending on just this capacity to be in two places at once, in our given, distracted condition and in the condition of intensified seriousness that we may hopefully imagine for ourselves, as Harry G. Frankfurt affirms:

> Blind, rollicking spontaneity is not exactly the hallmark of our species. We put considerable effort into trying to get clear about what we are really like, trying to figure out what we are actually up to, and trying to decide whether anything can be done about this. The strong likelihood is that no other animal worries about such matters. Indeed, we humans seem to be the only things around that are even capable of taking themselves seriously. . . . Taking ourselves seriously means that we are not prepared to accept ourselves just as we come. (Frankfurt 2006, 1–2)

Seriousness, it seems, involves something of the same "honest or well-intended halfness" as joking. In both cases, the spur seems to be the experience of the passage of time, or rather the capacity to represent it to ourselves, in memory

in one direction, and the projection of future states in the other. In both cases, "Time breaks the threaded dances / And the diver's brilliant bow" (Auden 1991, 134), joining what is and what is not, and making possible the relation of negation that cannot easily be thought to exist in nature, but is everything in the ill-assorted second nature of human representations. But in fact Emerson's conviction that nature does not jest or go in for mistiness or half measures is surely an illusion. It is perhaps the opposite of the illusion, which has become almost proverbial among avant-garde artists, that art, or more usually artists, should open unto us the precious truth of process, accident, and the haphazard, as a relief from an administered human world characterized by wearisome, safety-first predictability. Against the assumption that the high degree of orderliness and predictability characteristic of the human world reflects the fundamental orderliness of nature, thermodynamics and then information theory have powerfully suggested the opposite, that order may have a fundamentally statistical character and is not only itself rare in nature but identical with rarity itself. In the cosmic sea of contingency and nonrepetition, it is conformity to *nomos* that is the anomaly, which is precisely what makes that conformity interesting and valuable to entities such as we, concerned to keep themselves entire, in the state of being rather than becoming, and therefore in the Yeatsian sense "out of nature" (Yeats 1951, 218). Barely ten years after Emerson, Nietzsche saw at work in the coherence and predictability of systems of knowledge the principle of the self-preserving will to power:

> In order for a given species to preserve itself—to grow in power—it must capture in its conception of reality enough of what is uniform and predictable that a scheme of its behaviour can be constructed on that basis . . . a species grasps so much of reality *in order to master it, in order to take it into service.* (Nietzsche 2017, 287)

In fact, the tendency for human beings to pay attention only to the kind of regularities that conduce to our fancied or desiderated intactness, cognitive and otherwise, means that humanity may in fact belong, not with the wholeness and entity of Reason, but with the condition of halfness or partiality, which for Emerson (1875) is the trigger of the ridiculous. The prophet and the philosopher do not "bring the standard, the ideal whole, exposing all actual defect" (141), but rather suggest the halfness or amputation of every candidate wholeness.

To be serious is in fact to concentrate, that peculiar kind of retentive sub-traction, to draw our energies and inclinations inward, resisting their apparently natural tendency to diffract and disport themselves. The seriousness of subtraction suggests contraction of possibility. Because the longer-term tendency of things seems to be to fall apart or miscegenate rather than spontaneously to self-organize, at least not into the forms of arrangement that strike entities like us as tidy, if only because there are so many more ways for things to become disorderly than to become orderly, seriousness must be a local supervention, a concentrating, negentropic pressure brought to bear on things, rather than any way of going with the Heraclitean flow.

This is presumably the reason that seriousness is often identified with the most serious act of keeping things in line we know, the business of staying alive as an organized being rather than subsiding into the slushily stochastic state of matter going about its own business that we might otherwise be and will assuredly become. *Tidy* derives from *time* (Old English *tíd*), but is tidally untimely. Seriousness has sometimes been identified with the matter of life and death that survival may sometimes seem to be—for example, in the characterization of seriousness advanced by Alexander Düttmann:

> What is seriousness? It may seem rather simple to answer this question. Something turns into a serious matter when self-preservation is at stake. Each time I must worry about survival, about persevering in my condition or being, each time I must worry about how to continue living under circumstances that appear more and more precarious, each time that something or someone I care for is threatened by grave illness, destruction, extinction, demise, or death, I must feel seriously concerned. (Düttmann 2014)

It is easy to go along with this characterization while demurring from the suggestion that it is universally applicable. The definition is weakened by what seems to give it its strength: the definition of seriousness by reference to the most serious kind of concern to which it may be applied. It may well be that "something turns into a serious matter when self-preservation is at stake," but this does not honestly earn the inverse principle, that seriousness must always, even ultimately or essentially, concern self-preservation, or indeed that any other kinds of ultimate issue must be at stake. It may incidentally be wise to be leery of the artificial raising of the stakes that is often going on when the phrase "at stake" is deployed. The stake in operation in the metaphor was probably just a stick on which the subject of a wager might be placed, but the

inflationary pressure in the metaphor of being "at stake" has come to suggest the kinds of extreme or ultimate concern for which one ought to be willing to "go to the stake." Düttmann's definition does not allow, for example, for the common act of "taking something seriously," which would seem to suggest at least a focusing of intent or attention on a particular matter, in a particular way, that would come some way short of a matter of life and death. For we are serious about many different kinds of things—about the necessity of ventilation, or how to make a garden bee-friendly, or how to help children understand things—and in many different ways, without ever needing to approach to incandescent or apocalyptic forms of anxiety about preserving my being or the sickness unto death of those in my circle of care. These are all ways of caring seriously that do not seem to come close to or have anything necessarily in common with the last-ditch definition of seriousness identified by Düttmann, which strives to rule out all but the most serious forms of seriousness. Taking seriousness this seriously leads Düttmann to claim that seriousness of an ultimate kind must always be a choice forced on us by some higher, more irresistible necessity, a matter about which there could be no question of taking it in any other way but "seriously":

> I hit the bedrock of reality and witness, in a flash, how my freedom of thought and action is significantly diminished, if not reduced to a minimum, the minimum of an exclusive focus. Seriousness, in this sense, is an attitude imposed upon me, a way of relating to the world, to others and to myself, that is borne out of the necessity of dealing with necessity, of relating to that which leaves very little space and time, very little leeway for a possible relation. Seriousness results from a subtraction, a selection, an exclusion. It is a concentration, a concentrated form of attentiveness that I barely choose because, in truth, the choice is inflicted upon me, or because any distraction could prove deadly. (Düttmann 2014)

Everything in this passage passes muster until the two words "in truth," though they are the blossoming of the rot incipient in the phrase "bedrock of reality." For "in truth" the idea that seriousness is imposed on me as a necessity is part of the phenomenology of seriousness, and indeed very often part of what we impose on ourselves, or pretend to be subjected to, rather than anything like a necessary or actual condition. We will encounter a little later the oxymoronic name that Jean-Paul Sartre coins for this principle of the choice of having no choice, the principle that, in Düttmann's formulation, "Where

there is seriousness, there is destiny" (Düttman 2014). "Destiny"? Ultimacy has here become ultimism, a condition becoming a comportment, that feverishly embraces the absence of any possibility of demur. People are never more parochially self-pleasuring than when magicking up mystically ineffable necessities of this kind. I would wish to allow the possibility of wondering about the idea that seriousness is so serious that it would have to come from some ineffable elsewhere. This ultimist view of seriousness leads to the claim that

> seriousness is about form as the last resort against the chaos of a breakdown. Never is form so pure, never does content depend so much on form as when seriousness arises from a threat posed to self-preservation. Seriousness is the outlook of form, the coolness of making distinctions and feeling and knowing the weight of things. (Düttmann 2014)

This claim, that seriousness induces form, at first rather baffling, becomes more understandable if one takes the word *form* in the informational sense as redundancy or repeatability—anything of which one, or any kind of entity capable of such an apprehension, might say, "Ah, that again." One must seemingly be serious about preserving one's own form, as something continuously distinct and recognizable, which seems to mean (the "seems" is quietly searing) that one feels the pressure to be serious about preserving the purity or absoluteness of the form of one's seriousness. "This is why seriousness must regularly guard itself, and the self, against the wrong form of seriousness, against a distorting, erosive and self-eroding form" (Düttmann 2014). Düttmann cannot be blamed for not knowing, or for having forgotten, that the phrase *the wrong form of* has a giggly quiver to British ears used to autumn excuses for delayed trains, which are attributed regularly to "the wrong kind of leaves" on the line. Nevertheless, the particular kind of coercion articulated here, of a concern with the quality of one's own concern, does seem phenomenologically in the right region, even if its "must" must be a thimble of mist. We do indeed worry at times of stress about whether we are dedicating to our concerns the right kinds of headaches and worry, though the right kind ought really to be the one calculated to evaporate rather than consecrate our worry. We care for and care about our cares. Our caring for and about the things that give us care is itself in our care (Connor 2019b, 174–203).

Essentially, then, this book is concerned with a complex condition of feeling—concerned, that is, not with what is serious but with what it means to

take things seriously. So the book does not aim to provide a full and reasoned roster of things that we should take seriously, what Samuel Beckett (1977, 125) sardonically calls "life, death and other tuppenny aches," but rather to convene a number of what seem to be prominent accents, occasions, or idioms of seriousness. Even were I minded to offer a guarantee that they form an exhaustive list, or are even the most prominent of ways of being serious, it would be reckless of me to do so.

The book revolves, in ragged and irregular kinds of orbit, around the central principle that the feeling of seriousness is the most powerful and most powerfully organizing of feelings, while also being the most poignantly indeterminate. Caring for our cares means that we want to be serious about things, especially about seriousness itself. And yet there is no qualia of seriousness, nothing that *it is like*, to feel the seriousness of something. By this I mean, as one always must when making this kind of proposition, something like the antic opposite. Because there is nothing that it is like to feel serious (nothing that seriousness unmistakably and immemorially is), we are forced to depend on things that seriousness is like (things that seem to us to have a convincing resemblance to seriousness)—that is, on semblances, stand-ins, enactments, makeshifts, supposings, *proxime accessits*. Seriousness is the puppet-play demanded by the deepest passion—unless it is the impassioning of that puppetry.

2 Intent

Few human activities are as serious, or at least aim to take themselves as seriously, as the exercise of formalized thinking, and in particular the kind of exercise of formalized thinking known as philosophy. The work of philosophy and, more particularly, the idea of the work of philosophy, is without doubt to be understood as the most highly specialized version of the long, self-admiring, and self-securing narcissism involved in the Freudian principle of omnipotence of thoughts, which has operated in different ways in all human times and places (Connor 2019a, 100–110), and expresses itself also in the magical practices of medicine and religion, always tightly intertwined. Philosophy aims at accomplishing serious thinking not just because it addresses itself to matters that are reputed to be weighty (personal existence, truth, religious belief, causality, morality, mortality) but also because it aims to take them seriously—that is, to pay sincere, unswerving, and honest attention to them, taking precautions to avoid fallacy, hypocrisy, idleness, self-interest, self-deception, and other impediments to serious reflection. All of these might expose one to the charge of pretentiousness, a word that was once used of forms of worldly ostentation, but in the twentieth century came to be reserved for the peculiar kind of pretense of seriousness characteristic of philosophy without substance or serious intent. In an essay that attempts to argue that serious philosophy need not be solemn, Susan Haack (2016) is able to bring forward arguments for comedy only as a kind of nutritional supplement to the earnest pursuit of truth. Humor helps to establish friendly communications

with your audience: "The right kind of 'buffoonery' can serve *both* to refresh the mind, *and* to keep your intellectual feet on the ground," and "the habit of laughing wryly at yourself when you realize you're in danger of succumbing to self-importance, to overreaching, to taking yourself too seriously" (406) can help keep the philosopher sober and honest. In the very way that she argues for humor, her essay demonstrates clearly that she does not feel it can have any serious philosophical purpose. There is nothing to object to in this argument, once one has noticed that it does not seem to have its heart in what it tries to be taken to say. Perhaps laughter is just a useful lenitive, one that helps soften and civilize what might otherwise become an inhuman or purely calculative crunching of arguments. But the question of philosophical seriousness is in fact much more substantial than a stylistic question of whether it accessorizes with a buttonhole or a twinkle in its eye; or, rather, let us earnestly declare, the particular way of being serious that philosophy represents is substantially if usually obscurely in question in its practice. Philosophy is one of the weightiest of the ways in which human beings try to take themselves seriously.

Or at least, most philosophers seem to take it for granted that, whatever it is and does, philosophy should itself be taken seriously. Philosophy, especially in the European forms deriving from classical Greece, in their strong association with Christian forms of religion, has tended to ally and elevate itself to this kind of austere seriousness. Philosophers are serious about the seriousness of their calling, even if they rarely pay much attention in public—that is, formal, philosophical attention—to the nature of seriousness. So seriousness is therefore everywhere and nowhere in philosophy: everywhere implied, aspired to, admired, and depended on, everywhere regulating and animating the exercise of philosophy, and yet rarely in focus as the object of philosophical concern.

Seriousness, for example, lies at the heart of the philosophy of mind proposed by Hegel, for whom all human history may therefore be said to be the struggle to achieve seriousness, in the sense of a kind of absolute coincidence with itself. Seriousness is always a struggle for Hegel, for the necessity of struggle is a large part of what it means to be serious. Philosophy, in particular, as both an explication and an exemplification of the historical struggle of mind, must always be an overcoming of impediment, and especially the impediment formed by taken-for-granted assumptions:

Just as much as in the procedure of ratiocination, the study of philosophy finds obstruction, too, in the unreasoning conceit that builds itself on well-

established truths, which the possessor considers he has no need to return upon and reconsider, but rather takes to be fundamental, and thinks he can by means thereof propound as well as decide and pass sentence. In this regard, it is especially needful to make once again a serious business of philosophy. (Hegel 1949, 124–25)

At the beginning of *The Phenomenology of Mind*, Hegel argues that even divinity needs the seriousness of the "labour of the negative," to escape from an inert, emptily onanistic condition of playing with itself:

The life of God and divine intelligence, then, can, if we like, be spoken of as love disporting with itself; but this idea falls into edification, and even sinks into insipidity, if it lacks the seriousness, the suffering, the patience, and the labour of the negative. *Per se* the divine life is no doubt undisturbed identity and oneness with itself, which finds no serious obstacle in otherness and estrangement, and none in the surmounting of this estrangement. But this "per se" is abstract generality, where we abstract from its real nature, which consists in its being objective, to itself, conscious of itself on its own account (*für sich zu sein*); and where consequently we neglect altogether the self-movement which is the formal character of its activity. (Hegel 1949, 81)

The close of *The Phenomenology of Mind* makes clear the importance of seriousness, in the sense of an ongoing active antagonism to any final self-gathering of spirit:

Self-conscious spirit, passing away from abstract, formless essence and going into itself—or, in other words, having raised its immediacy to the level of Self—makes its simple unity assume the character of a manifold of self-existing entities, and is the religion of spiritual sense-perception. Here spirit breaks up into an innumerable plurality of weaker and stronger, richer and poorer spirits. This Pantheism, which, to begin with, consists in the quiescent subsistence of these spiritual atoms, passes into a process of active internal hostility. The innocence, which characterizes the flower and plant religions, and which is merely the selfless idea of Self, gives way to the seriousness of struggling warring life, to the guilt of animal religions; the quiescence and impotence of contemplative individuality pass into the destructive activity of separate self-existence. (Hegel 1949, 702)

One of the few places in which Hegel's philosophy, otherwise so avariciously encyclopedic in the range of its concerns, lingers on the question of

seriousness is in his remarks on the function of sports and games in the classical world. The most important thing about the athletic and aesthetic displays of games held in Elis and other places, their "inner nature" as Hegel (1884) styles them, is that they are "opposed to serious business, to dependence and need. This wrestling, running, contending, was no serious affair; bespoke no obligation of defence, no necessity of combat" (252). Neediness and necessity are what define seriousness for Hegel: "Serious occupation is labour that has reference to some want," he tells us (252). Straight away, and without pausing to give a reason or allowing us to enquire whether fancying a kick-about counts as wanting, Hegel moves from the indefiniteness of "some want" to absolute life-or-death necessity: "I or Nature must succumb; if the one is to continue, the other must fall" (252). We might think this a very strange way of defining necessity, when there are so many other conditional or contingent forms of necessity to choose from—"If I am not to be hungry, I must find something to eat"; "If I am to be able to relieve my weariness, I must find a safe place to sleep"; "I must run to the top of the hill to escape the flood, or leveling mighty wind," and so on. But this raising of the stakes has a serious purpose, or at least a rhetorical utility. For, anticipating Bill Shankly's famous remark that football is not a matter of life and death (because it's more important than that), it allows Hegel to argue that

> in contrast with this kind of seriousness, however, Sport presents the higher seriousness [*höhere Ernst*]; for in it Nature is wrought into Spirit, and although in these contests the subject has not advanced to the highest grade of serious thought, yet in this exercise of his physical powers, man shews his Freedom, viz. that he has transformed his body to an organ of Spirit. (Hegel 1884, 252)

The necessity for seriousness prevails even in philosophers who proclaim the primacy of laughter or the absurdity of philosophical reflection, since in doing so they nevertheless aim to be taken seriously—as philosophers, at least. And few philosophers have proclaimed the value of laughter as loudly and emphatically as Nietzsche, who sets it against the timorous conformity of ordinary kinds of moral seriousness. The arch-laugher in Nietzsche is the prophetic character Zarathustra:

> Truly, Zarathustra comes into all sepulchres like a thousand peals of children's laughter, laughing at those night-watchmen and grave-watchmen, and whoever else rattles gloomy keys. . . . You will terrify and overthrow them

with your laughter . . . Henceforth laughter of children will always issue from
coffins. (Nietzsche 1969, 158)

Nietzsche's laughter is the manic cackle of the master criminal in melo-
drama—the forced laughter of the ham actor that is mirthless because it is
so full throated. Simulators of laughter should know that it can only come
convincingly from the inanition of air, when you are using the last of the air
left in your lungs. Fill your lungs with air, as inexperienced actors are wont
to do, thinking of the demands in store, and the laughter emitted will be in
a strange way hollow or void, and so merely operatic. You cannot sing laugh-
ter, because laughter strangles singing. Laughter can only come from the one
it almost overcomes. The triumphant conditions in which Nietzsche evokes
laughter and its conquering effects make it clear that it has nothing at all to do
with the helplessness of laughter, the kind of helplessness to which Nietzsche
is as stiffly, grandiosely allergic as an Edwardian gentleman. Although laugh-
ter barks and guffaws through *Thus Spoke Zarathustra*, the forcing presence
of exclamation marks is an infallible sign that it is not really laughter, but
Laughter. If this were a play script, one could be sure that the laughter would
be rendered with a villainous "Hah! Hah! Hah!"

In the chapter titled "The Vision and the Riddle," Zarathustra tells of the
shepherd he encounters with a snake biting the back of his throat. Struggling
in vain to pull the snake away, Zarathustra finally urges him to bite away the
snake's head. After the shepherd succeeds in doing so and spitting the head
out, he is

> No longer a shepherd, no longer a man—a transformed being, surrounded
> with light, laughing! Never yet on earth had any man laughed as he laughed!
>
> O my brothers, I heard a laughter that was no human laughter—and
> now a thirst consumes me, a longing that is never stilled.
>
> My longing for this laughter consumes me: oh how do I endure still to live!
> And how could I endure to die now! (Nietzsche 1969, 180)

Zarathustra leadenly poses to us the question of the meaning of this rid-
dle: "*Who* is the shepherd into whose mouth the snake thus crawled? *Who*
is the man into whose throat all that is heaviest, blackest, will this crawl?"
(Nietzsche 1969, 180). It really does not help to refer us to "Siegfried's slay-
ing of the *Schlangenwurm*" in Wagner, as Paul S. Loeb (2010, 158) solemnly
proposes. For, as with many riddles posed in faux-vatic texts like this, the
answer is wearisomely obvious from the beginning, partly because it has been

paraded so many times already, for example in the section titled "Of Reading and Writing":

> And when I beheld my devil, I found him serious, thorough, profound, solemn: it was the Spirit of Gravity—through him all things are ruined.
>
> One does not kill by anger but by laughter. Come, let us kill the Spirit of Gravity! (Nietzsche 1969, 68)

Nietzsche's Spirit of Gravity—*Geist der Schwere*—the repeated evocation of which is as ponderous as what it means to evoke, seems to recur in the work of Jean-Paul Sartre, whose *Being and Nothingness* seems to be written against what he calls the "spirit of seriousness," "l'esprit de sérieux" (1943, 674; 1984, 580). Somewhat unexpectedly, the opposite of seriousness for Sartre is not frivolity or joy but rather "anguish," defined as "the reflective apprehension of freedom by itself" (1984, 39), such that "I apprehend myself at once as totally free and as not being able to derive the meaning of the world except as coming from myself" (40). The spirit of seriousness accords reality to the world rather than to the self arising in it, and therefore at a weird angle to it: "The serious attitude involves starting from the world and attributing more reality to the world than to oneself; at the very least the serious man confers reality on himself to the degree to which he belongs to the world" (580). For Sartre, seriousness assumes not only the priority of the things of the world but also that values are themselves in fact already existing things in the world, "transcendent givens independent of human subjectivity" (626). This is why, surprisingly enough, for Sartre, seriousness is materialist, and all materialists, most especially revolutionary Marxists, are subject to the spirit of seriousness. In *Being and Nothingness*, the subjection to the world, in which the principle of the material has become one of Sartre's transcendents, is an attitude that paradoxically aligns Marxists with the worldly powers they seek to overthrow:

> It is not by chance that materialism is serious; it is not by chance that it is found at all times and places as the favorite doctrine of the revolutionary. This is because revolutionaries are serious. They come to know themselves first in terms of the world which oppresses them, and they wish to change this world. In this one respect they are in agreement with their ancient adversaries, the possessors, who also come to know themselves and appreciate themselves in terms of their position in the world. Thus all serious thought is thickened by the world; it coagulates; it is a dismissal of human reality in favor of the world. (Sartre 1984, 580)

Oddly enough, one might easily be able to invert the values usually accorded to seriousness and play. Seriousness may allow itself the appearance of gravity and moral solemnity, but it does so precisely as a kind of make-believe, which allows for evasion of the sense of anguish attaching to the freedom in which nothing absolutely has to be, and so nothing absolutely and irrevocably is. Sartre's name for this pretense is "bad faith," taking oneself to be a thing, rather than the "nothing" that is an achingly irreducible freedom from thingliness:

> We are already on the moral plane but concurrently on that of bad faith, for it is an ethics which is ashamed of itself and does not dare speak its name. It has obscured all its goals in order to free itself from anguish. Man pursues being blindly by hiding from himself the free project which is this pursuit. He makes himself such that he is waited for by all the tasks placed along his way. Objects are mute demands, and he is nothing in himself but the passive obedience to these demands. (Sartre 1984, 626)

This is why the earnestness of Marxism can be seen as a self-soothing evasion, even as Sartre seems to borrow from the Marxist theory of reification, the freezing of processes into immutable and disconnected objects, the very terms of his criticism:

> The serious man at bottom is hiding from himself the consciousness of his freedom; he is in bad faith and his bad faith aims at presenting himself to his own eyes as a consequence; everything is a consequence for him, and there is never any beginning. That is why he is so concerned with the consequences of his acts. Marx proposed the original dogma of the serious when he asserted the priority of object over subject. Man is serious when he takes himself for an object. (Sartre 1984, 580)

To devote more than a quarter of a million words to the philosophical undoing of seriousness seems at the very least to flirt with oxymoron. Although Walter Redfern (2008, 139) suggests that "even Sartre himself did not know how serious he was in rejecting seriousness," Sartre (1983) was quite capable of acknowledging, as it seems, in all seriousness, that the systematic war on seriousness was the motive principle of his life: "If there is some unity in my life, it is that I have never wanted to live seriously. I have been able to play at comedy, to know pathos and anxiety and joy. But I have never, ever known seriousness. The whole of my life has been a game, sometimes long, and wearisome, sometimes in bad taste—but a game" (380, my translation).

Pretense

Performative utterances may, much more often than one might suspect, be doubly performative, in that they both perform an action, of promising, insulting, admiring, and so on, and perform their performance of it, emphasizing the fact of the action of performing. One does things, therefore, not only with words but also with verbal doings. One can perhaps posit a similar duality in pretending. One must wonder whether one can pretend something without in some sense having to keep up the pretense that one is pretending. Most actions of pretending aim at being mistakable for the action that is being pretended, and most pretenders discover that a good way of achieving this mistakability is to allow for or engineer the mistaking in oneself. But this surrender of self-consciousness to absorption must be framed or limited by a kind of ongoing reservation—which need not in any sense be kept "in mind" but only somewhere and somehow "in reserve"—about that absorption, which must therefore be revocable. The difference seems to be between pretending to oneself and pretending to others, even though pretending to oneself (pretending that you are not pretending) is a helpful and perhaps needful auxiliary to pretending to others. Such is the condition of what Emerson (1875, 139) calls "honest or well-intended halfness." Saying to yourself or intimating to others that you are "only pretending" is indeed a pretense, for it can never reliably be the case that one is "only" pretending, in the sense that there is nothing there but the pretense, the whole pretense, and nothing but the pretense. Children are quick to learn this "just kidding" defense.

But the opposite (I hope it is the opposite) must also often be the case. Just as one must often have to pretend that one is only pretending, so one must have to accept the wager of the seriousness and steadiness of intent of one's act of pretending. To say you are only pretending is to say that you are really pretending, through and through, and as it were in all seriousness. But just because of the mixed kind of thing it is, it is hard to pretend seriously or, so to speak, conscientiously, without intermission, let, or hindrance. An actor is protected from prosecution for the criminal acts he may appear to commit on stage by the principle that he is pretending to do what he is doing. What the actor may mean to do will have little to do with the matter. If a fight scene has been preceded by a dressing-room altercation which means that every jab or stab is in fact lethally and completely meant, meaning that the actor is no longer really serious about his pretending, it will still qualify as a pretended action as long as it is taken to be the consensually suppositious entity known

as "Hamlet" and not Henry Irving giving the thrust. He is not really committing actionable bodily harm, as long as circumstances qualify him to say he is only pretending (and so really pretending), rather than, as must sometimes be the case—and, yes, must always in part be the case—in reality pretending to pretend.

This is not just true for professional actors (delicious phrase—how does one profess to be an actor? and yet it happens all the time). Because pretending is something one does, there will always have to be something serious about it, even if being serious about one's pretending is subject to the same necessity as many other kinds of action, of being hard simply and unconditionally to "do," meaning that one must to some degree fake it until you can make it. Oscar Wilde's (1980) Algernon explains that it is only amusing to "Bunbury" (to pretend to be visiting a sick relative called Bunbury) if one takes it seriously, which means being inconsistent about it. Being consistently serious would be pure frivolity: "One must be serious about something, if one wants to have any amusement in life. I happen to be serious about Bunburying. What on earth you are serious about I haven't got the remotest idea. About everything, I should fancy. You have such an absolutely trivial nature" (119).

Sartre gives another example of the seriousness of pretense in his evocation of the mannered behavior of a waiter:

> Let us consider this waiter in the cafe. His movement is quick and forward, a little too precise, a little too rapid. He comes toward the patrons with a step a little too quick. He bends forward a little too eagerly; his voice, his eyes express an interest a little too solicitous for the order of the customer. Finally there he returns, trying to imitate in his walk the inflexible stiffness of some kind of automaton while carrying his tray with a recklessness of a tight-rope-walker by putting it in a perpetually unstable, perpetually broken equilibrium which he perpetually reestablishes by a light movement of the arm and hand. (Sartre 1984, 59)

The waiter is behaving in this way because he wishes to fulfill our wish, or wishes to seem to, that he perform the function of a waiter, which means not just grudging, surly compliance with the duty of bringing the drinks and counting out the change, but that he add the stylistic flourishes that pay us the compliment of displaying the extra effort that has been put into the playing of his role—that he has not just served us our drinks but also served up the signs of "service." Sartre (1984) intends us to take this as an example of what he

means by bad faith, the deliberate and self-deceiving limitation of a person's essential freedom, in fulfillment of the principle that "there are indeed many precautions to imprison a man in what he is, as if we lived in perpetual fear that he might escape from it, that he might break away and suddenly elude his condition" (59).

But there is something more in Sartre's description, which makes the attribution of bad faith—a free being inauthentically confining himself in an unfree role—uncertain. For there is an undeniable kind of seriousness in the waiter's masquerade:

> All his behaviour seems to us a game. He applies himself to chaining his movements as if they were mechanisms, the one regulating the other; his gestures and even his voice seem to be mechanisms; he gives himself the quickness and pitiless rapidity of things. He is playing, he is amusing himself. But what is he playing? We need not watch long before we can explain it: he is playing at *being* a waiter in a café. (Sartre 1984, 59)

Like Algernon in his earnest Bunburying, the waiter is serious in the game he plays of being a waiter. Sartre does not leave us, or even perhaps himself, easily able to decide whether the waiter is exercising his freedom in the performance of his role or denying it, yet perhaps freely denying it. We will not be able to leave alone for long the complex question of whether playing at being serious is itself to be taken seriously.

Sincerity

Sincerity is a distinctive idiom of really meaning something that can be distinguished from simply being serious about it. Lionel Trilling (1972, 6) writes that "a historical account of sincerity must take into its purview not only the birth and ascendancy of the concept but also its eventual decline, the sharp diminution of the authority it once exercised." In fact, though, it might be said that sincerity has actually sharpened its force, in that the range of things that can be done and more particularly said sincerely has been reduced so markedly that it has brought sincerity to a particular, but also rather peculiar, intensity of focus. Trilling observes that, from its first appearance in English in the early sixteenth century, the word *sincere* "referred primarily not to persons but to things" (12). This meant that wine could be described as sincere, in the sense of being pure, and a translation could be described as sincere in the

sense of being faithful. Most common of all, perhaps, was the reference to religious faith or doctrine as sincere when it was sound, correct, or unmixed with error. It would be easy to read many sixteenth-century sermons as celebrating or calling for honesty with their use of the word *sincerely*, when the concern is probably primarily with coherence or orthodoxy. This certainly seems to be the leading sense of the word sincere in the dedication of the Dominican preacher William Peryn's 1546 sermons to Edmund Bonner, the Catholic-leaning bishop of London, sermons that Peryn hopes will find

> not onely acceptacyon and place, wyth the catholyke people, but also, no smal ornament and dignite of so godly and catholyke a patrone, whome they maye, and do ryght well perceaue, to fauour tenderly the syncere catholyke faythe & pure worde of God, detestinge heresyes. (Peryn 1546, n.p.)

The protestation with which the dedication ends, that the book "procedeth (vndoubtedly) of a single and a sincere mynd" (Peryn 1546, n.p.), may also lay the emphasis on doctrinal singularity rather than lack of dissimulation. Dryden (2000) can still, a century later, use the word sincere to mean whole or intact when referring to the body of Cygnus, uninjured by Achilles's spear: "Th' inviolable Body stood sincere" (410).

As Trilling (1972) again explains, it was during the course of the sixteenth century, as questions of performance and dissimulation came to be strong preoccupations, that sincerity came to mean pure not in the sense of unmixed but in the sense of honestly meant, without dissimulation or imposture (13). By 1640, it seems that sincerity had become much more a matter of honesty than of orthodoxy. It was a particularly potent word among Puritans, one of whom, Nicholas Lockyer, Cromwell's chaplain, devoted a whole book to it. In it he explains that

> the proper subject of divine joy, is the *righteous man*, as the Psalmist frequently notes: And this man is made the subject of Divine joy in my Text, *For [our] reioycing, &c.* that is, we which are sincere: hypocrits have nothing to doe with divine joy; Their joy is suiteable to their spirits, deceit-ful. (Lockyer 1640, 5)

And yet Lockyer's many examples of sincerity also often imply integrity and fidelity—purity of action as well as honest belief. Indeed, Lockyer (1640, 11) distinguishes what he calls "moral" from "theological" or godly sincerity, the latter a phrase taken from 2 Corinthians 1:12. "A morall sincere man," Lockyer

explains, "is but an out-side holy man, but observes it not;, and therefore (I think) called by some, a close hypocrit" (13). It might seem as though the way is being prepared for some inner virtue to be opposed to this "out-side" holiness. In fact, though, it turns out that godly sincerity, though belonging to the "heart of man," emanates from a divine outside:

> But this is not that *sincerity of God*, which my Text speaks of. godly sincerity is a *speciall worke of God upon the soule, &c.* This *Genus*, the Apostle confirmes in my text, calling sincerity εἰλικρινείᾳ Θεῦ, *the sincerity of God.* That is, that sincerity, which is after a speciall manner wrought of God, in the heart of man. So likewise else-where the Apostle solemnely praies for sincerity, in the behalfe of the *Philippians;* which plainly shewes, that sincerity is not *Quid proveniens a natura,* a thing growing naturally in man. (Lockyer 1640, 13)

So this kind of godly sincerity still seems to mean faith or even grace rather than truth-to-oneself: "Sincerity is such a speciall worke of God upon the soule, that it makes a man so constant in his endeavours to do the Will of God, that no opposition can make him to cease this labour" (Lockyer 1640, 19). It certainly seems to be the case nowadays that sincerity is not only something that is reserved for human subjects but something we resist transferring even metaphorically. We might say that the rain was falling remorselessly, savagely, gently, delicately, or kindly, but it would be a kind of madness to say that it was raining sincerely.

Saying I am serious can be taken not just to mean that I mean what I say but also that I am what is called sincere in saying it. Sincerity is not identical with seriousness, since it has to do with a certain kind of feeling that I might be thought to have as a complement to things that I may say, do, or be thought to mean. But there are only certain kinds of feeling that can constitute sincerity. One can feel sincere affection (yours sincerely), sincere regret, sincere concern, sincere gratitude, and sincere devotion. One can promise, believe, affirm, argue, compliment, and congratulate sincerely, in the sense that one does them seriously, or genuinely. But there are many things that one can do seriously or genuinely that one cannot do sincerely, or that at least our contemporary usage does not easily allow us to say we can. One cannot, it seems, feel sincere rage or sincere fear, or reprimand, condemn, or curse sincerely. If I shout "Stop thief!" or "Damn your eyes!" I may be deadly serious, but I hardly know what it would mean to call such ejaculations sincere. It is not a problem with ejaculation as such: the "Oh I

say" damply breathed in appreciation of a deftly executed backspin lob can perfectly easily impress us as sincere.

One should perhaps say that one cannot do these things *any more*, since sincerity has in fact reduced the range of its application quite dramatically, from truthfulness, purity, and honesty in general to truthfulness in respect only of certain kinds of (mostly positive) social feeling and action. We know what these feelings are, or at least we know what kinds of feelings it feels right to describe as sincere, better than we know what holds them together. We might say that there is something like a language game of sincerity, one that we know how to play without knowing that, or how, we know it, because we know without having to work it out when an articulation breaks the rules.

I can make a sincere effort but not a sincere mess (though I can make a mess of something while sincerely trying to make a success of it). I can sincerely try to succeed, but, strangely, cannot sincerely succeed. It is not that sincerity is impossible, exactly; it is that our patterns of linguistic usage do not allow us to apply the notion of sincerity to such actions: I could not succeed insincerely either. I can urge or warn or dissuade sincerely, but I cannot weary or cease or desist or abandon something sincerely. I can believe and recant seriously, but there is something skew-whiff about being sincerely indifferent. I can have sincere hope but not sincere despair. I can thank you sincerely, but though I may be able to ignore or disappoint you deliberately, I cannot do either of these sincerely in any way that does not sound strange. I can say "I honestly think," but "I sincerely think" is peculiar. Most suggestive of all, yet most perplexing too, I can deliberately take my own life, and be judged to be or have been quite serious about doing so, but some mysterious system of interdiction prevents me, it seems, from being able to commit suicide sincerely.

The oddity of "I sincerely think" is redeemable, like many other examples, with the dodge "Sincerely, I think that . . .," but really it is a dodge because the sincerity has been transferred from the thinking to the articulation of the thought. I can assure you sincerely, but I cannot accuse you sincerely. To be sure, I can bring an accusation on grounds that I sincerely believe, but then it is the believing that is sincere. Accusation as such, as an action in the world, bringing to bear a formal process, say, is not susceptible of sincerity, any more than catching a train or paying for a sandwich. However, I might well say or write, "He was exonerated, but she continued sincerely to accuse him in her mind." These examples might suggest to us that sincerity is nowadays reserved

for actions of affirmation, about which one might or might not be thought to be sincere. One would have to extend this principle, though, to actions that imply or amount to affirmations; otherwise what are we to do with a specimen such as "gazing at her in silent yet sincere admiration"?

I think these considerations may be working us toward a definition of sincerity, or more honestly a working principle for the delimitation of its ordinary use, as arising from an affirmation or an *action amounting to an affirmation*, which I honestly believe to be true, or may honestly be believed to believe to be true. This would account for the difference noted earlier between the orthodox "sincerely trying to succeed," and the nonconformist "sincerely succeeding." I can be imagined as honestly representing my efforts to myself as fully intended, but because there is no need for me to represent the fact of success to myself and agree that it indeed qualifies as a success, sincerity does not come into it. It would come into it, though, as soon as my belief or representation about it became a factor: thus "I sincerely believe I won that game in spirit," but not "I sincerely won the semifinal in straight sets." The introduction of the adverb *sincerely* always seems to introduce this self-reference, and therefore some reference to the implied act of referring. The difference between "I really hate you" and "I sincerely hate you" would lie in this wrinkle of reflexivity: "really hating" applies to the action directly and sufficiently; "sincerely hating" implies "Pray regard me as really meaning it when I say 'I hate you.'"

But what decides which actions in fact imply, involve, or amount to affirmations in this way—if there is anything like a decisive principle in this matter? Obviously, there are some actions that by their nature seem incompatible with honesty, really meaning something, or doing something deliberately. So it makes a kind of sense on this principle that one cannot pretend or idle sincerely. I can dream sincerely only if I dream in the sense of consciously aspire to: "She dreams sincerely of being president," but not "Last night I dreamt sincerely that I went to Mandalay."

If this account of sincerity is allowed some sway, it will let us think of sincerity as limited (as currently limited, let us emphasize again) to cases that involve a judgment, stated or implied, about my belief in something, and more poignantly, my belief in the honesty of that judgment. "I believe you to be a cheat" need not necessarily involve the certifying self-relation required for (or at least suggested by) sincerity; "I sincerely believe you to be a cheat" articulates the belief backed up by the belief in the honesty of the belief (or some

statement of it). Being sincere is undoubtedly a member of the near-universal class of linguistic performatives, and is subject to the somewhat dizzying self-referentiality that may be a feature of all performatives: to perform the action of affirming the honesty of my belief is simultaneously to affirm my belief in that honesty.

This makes for difficulties in discussions of the feeling of sincerity, imparted not to others but to myself or, as Beckett puts it, "in my soul I suppose, where the acoustics are so bad" (1973, 113). Daniel Gregory (2018), for example, has recently suggested that "the phenomenology of making an assertion in inner speech varies depending on whether the assertion is sincere or insincere, that is, on whether or not the assertion expresses a proposition that the individual making it believes" (225–26). I think this certainly does identify a very important quality in inner speech and is persuasive that "there is something it is like to make a sincere assertion in inner speech" (226). It would assuredly be quite a surprise if there were not. But if one asks the qualia-talk of the "something it is like" in this case to show its hand, one would surely have to say that it would be just what-it-is-like, in the sense now of what it resembles, or is "*just* like," to make the assertion of sincerity necessary to making a sincere assertion, whether or not it actually is sincere. What a sincere assertion *is like* is to be so like a sincere assertion as makes no difference, or none that can be made out. Of a sincere assertion, or the sincere witness to a feeling I may have, I can only ever say for sure that it feels sincere, or seems to. But then that is all I generally need to say, since the feeling of sincerity is what the assertion of sincere feeling must attest to.

The apparently exotic or specialized phenomenon of the sincere inner voice may in fact be essential to our contemporary understanding of sincerity—or the understanding implied by our contemporary usage, at any rate. Sincerity is about this kind of inner voice, or the innerness of voice more generally, since to be sincere only to someone else must be complemented by sincerity-to-self: to say "I sincerely think" is to say that I could sincerely say *to myself*, assuming the acoustics to be reliable, that I think it. And yet it is also clear that sincerity is a thoroughly outside-in phenomenon. Sincerity is not a feeling or a judgment, though it exists in order precisely to seem to come authentically from me and nowhere else, underwriting the proposal that I personally mean the things I say and feel the things I say I do. Sincerity, we have seen, is an intricately coded form of assertion that operates within a complex and changing network of permissibility and possibility. The faux-etymology

of *sincerity—sine cera*, or without wax, that is, without artificial or external supplementation—is evidence of what we want to believe about what everyone must always have believed about sincerity, namely that it is spontaneously self-announcing and self-validating, not patched out with any kind of substitute or supplement. The etymythological idea of being without waxy artifice may have generated rare usages like William Hamilton's 1760 reference to "The pleasing look sincere of art" (244), in which the look is sincere not in being meant but in being free of the admixture of artifice. But the authenticating machinery of sincerity makes it clear that what it is like to be sincere is carefully composed of the highly specific forms of the "what-it-is-like" of sincerity. One cannot be sincere without at least implicitly or *in potentia* affirming it, which is to say without the adjunct of the affirmation that must introduce the very possibility of the dissimulation—for to affirm must always be to admit this possibility—that might introduce the possibility of doubt into the matter.

Pretension

The seriousness of philosophy is a mixture of the different kinds of seriousness, but perhaps the familiarity of the charge of pretentiousness leveled at "pseudophilosophy" may suggest that the kind of seriousness that matters may consist of arguing seriously rather than struggling against difficulties or dealing with matters of great moment. One should argue seriously, or "for real"—that is, sincerely, sustainedly, and systematically. This is true even of philosophy that may employ irony or comic witticism. Philosophy still has the popular reputation of tussling with what is called the "meaning of things," or even the "meaning of life." The implication of this usage of the word is that existence, human and otherwise, is to be regarded as a sort of allegory that both veils and dimly intimates some purpose or proposition. This understanding of the meaning of meaning suggests the need for unraveling or interpretation of what is taken to be a sort of riddle. But there is another meaning of meaning, namely that the universe and all that is in it is intentional, in the sense of deliberate, implying that it is *for* something. The difference between the two meanings of meaning is (1) that employed in the sentence "in French, *plein* means full" and (2) that employed in the sentence "When you said 'Je suis plein,' did you mean to say 'I am full' (rather than 'I am pregnant')?" In the first case, meaning is imagined as being immanent to the object of one's reference, such that, like the verb *to be*, one cannot without absurdity think

of it as the performing of any kind of act. So to say that *plein* means "full" is really just a statement about something about it, rather than anything that one could imagine it doing (or declining to do). But as soon as one uses the word *mean* in the second sense of "intend," one must assume an intender doing the intending. One can imagine the idea of a divinity, or other uncaused cause, being a back-formation from this understanding of the word *meaning* as deliberate intention.

The two meanings of meaning, as intent and signification, are what in an essay of 1892 Gottlob Frege (1980) distinguished as sense (*Sinn*) and reference (*Bedeutung*) (56–78). Reference refers to what your words mean, and sense refers to what you mean to say by them. Asking "What do you mean by that?" is almost always an enquiry as to sense rather than reference. Seriousness usually relates only to sense rather than reference, as in "What do you mean by bursting in here making a scene?" The two meanings of meaning, as signifying and meaning to say (French unhelpfully conflates the two in *vouloir dire*, which, despite its anthropomorphic suggestion, in fact means the former rather than the latter) are in play throughout philosophical writing, even though its principal preoccupation will often seem to be much more with questions of reference rather than sense. This means that some strange, if also rather delightful, things can begin to happen when philosophers set out to deal with the matter of seriousness itself.

The question of this kind of meaning is one with which J. L. Austin has a particular and insistent, if oblique, preoccupation. It will be abundantly clear to a reader of any of his pellucid essays how concerned Austin is with the requirement to use speech that is not only clear but also, as far as is possible, plain and familiar. In his essay "A Plea for Excuses," Austin (1979, 181–82) offers what sounds like an Orwellian manifesto for linguistic hygiene: "words are our tools, and, as a minimum, we should use clean tools: we should know what we mean and what we do not, and we must forearm ourselves against the traps that language sets us." Austin is known as a practitioner of "ordinary language" philosophy, by which is usually meant the study of ordinary language conducted in it, both surprisingly novel ideas in the second half of the twentieth century. Unconvinced by the seriousness-stoking pretensions of specialist or technical vocabulary, Austin prefers to describe this procedure as "examining *what we should say when*, and so why and what we should mean by it" (181). The workings of this phrase are almost too exquisite to want to prise apart, but its pleasure, for me, has something to do with the way the

carefully policed, calm-paced ordinariness of those interrogative *whats* and *whys* and *whens* actually starts to turn into a dizzy, dyslexic piece of jingle that hints at Humpty Dumpty or *Finnegans Wake*. One does not know quite what to do with the amusement imparted by its mazy motion, which has something of the effect of the flamingo being used by Alice as a croquet mallet that curls around to fix its wielder with its gaze. Is it just a little gift of nursery-rhyme singsong to the reader, or is its approach to silliness a poke at the eye of philosophical persnicketiness? A paragraph or so later, Austin offers us a more respectably technical account of the kind of philosophy he is attempting: "I think it might be better to use, for this way of doing philosophy, some less misleading name than those given above—for example, 'linguistic phenomenology,' only that is rather a mouthful" (182). It is indeed, but the Graeco-Latin tongue-twister has the same chewiness as the Germanic sequence of when, why, and what served up a little earlier.

Austin begins "A Plea for Excuses" in something of the same spirit of prodigally improvised precaution:

> The subject of this paper, *Excuses*, is one not to be treated, but only to be introduced, within such limits. It is, or might be, the name of a whole branch, even a ramiculated branch, of philosophy, or at least of one fashion of philosophy. (Austin 1979, 175)

Here, Austin plays the game, characteristic of Beckett in his prods and pokes at philosophical discourse, of seeming to whittle away with qualifications— "it is, or might be"; "philosophy, or at least one fashion of philosophy"—the branch on which he is pretending to perch. At the same time, he seems casually to hold out the prospect of a hugely, even vaingloriously ambitious program, for "a whole branch, even a ramiculated branch" of philosophy. "A whole branch" is beautifully poised: "a whole field" or "a whole discipline" would be usual and unexceptionable, but a branch is usually what branches away from wholeness, and so a part of a larger whole. This is especially the case if it is that singular kind of branch that may be called "ramiculated." This word is perhaps not likely to cause much puzzlement, except among those inclined momentarily to wonder if ramiculation might be a special kind of ramification. It certainly has an air of greater precision, given that *ramifying* and *ramification* have come to have rather rambling connotations, as of an unofficial rose. *Ramiculated*, by contrast, may suggest a particular way of ramifying, even indeed a special branch of the field of ramifications in

general. This may be because of the echo in it of the words *particular* and *articulated* (the latter meaning consisting of joints and branches). However, a reader picky enough to check with the *OED* will find that it provides no evidence of "ramiculate" or "ramiculated" in written English. *Ramify* sprouts as early as 1425, in a translation of Guy de Chauliac's *Grande Chirurgie*, to refer to the branching of arteries, here clearly signaling its derivation from Latin *ramus*, a branch, and *ramificare*, to put forth branches. It would however take a century and a half for *ramify* to pluck up the courage to appear again in print.

One of the interesting ramifications of the word ramify is the fact that it turns from a transitive usage, the earliest examples signifying the act of dividing something into branches, into an intransitive verb, in which ramification is what something spontaneously does, on its own account, and also, in a sense, to itself, rather than being subject to it, thus becoming the spontaneous habit of the rose rather than the project of the gardener. In the process it begins to acquire the slightly suspect sense of proliferating beyond control. Another rendering from de Chauliac from the mid-sixteenth century offers "they ramyfye in to two partyes" as a rendering of the reflexive "elles se ramifient en deux parties." By 1757, the intransitive use had attained its majority, allowing for an observation, again translating a French reflexive, that "Many of our Philosophers . . . *discover Truths which divide and subdivide, and ramify almost to Infinity*" (d'Argens 1757, 137).

Austin might have brought off the word ramiculated by honest accident, assuming reasonably enough that, where you can ramify, you surely ought to be able to ramiculate as well, without this being taken to be unreasonable linguistic vagrancy. I would like to think it more likely that he had encountered the word *ramificate*, used occasionally both transitively and intransitively and with a slightly comic sense of brambly overelaboration, or, somewhat more likely perhaps for a classicist, *ramicle*, appearing in 1846 as an Anglicization of Latin *ramiculus* and French *ramicle*, a little branch, or twiglet. In any case, ramiculated, along with ramify itself, must both be regarded as nice examples of autology, or the capacity of a word to refer to itself, since the *-fy, -ficare* suffix is such a familiar way of creating a verb as an offshoot of a noun. One may think of ramiculated, perhaps, as a runcible kind of word, where *runcible* might be taken to mean encouraging recognition of its own quality of vaguely evoking some precise quality or other. Ramiculation should certainly by now have earned its place in the *OED*, for it has been used by a number

of other authors, none of them, however, predating Austin's inaugural use in the lecture he gave to the Aristotelian Society in 1956 in Bedford Square, and some of them perhaps self-consciously acknowledging their pedigree in Austin's usage. The work of lexical ramiculation in which I have myself engaged here might be regarded as self-indulgent; though, if so, the indulgence seems, if only semiseriously, to be extended by Austin (1979) himself, who goes on to remark, of the philosophical methods he is recommending to the society, "Much, of course, of the amusement, and of the instruction, comes in drawing the coverts of the microglot, in hounding down the minutiae, and to this I can do no more here than incite you" (175). "Invite you" would have been more civil and invited less attention to itself; "incite you" seems oddly inflammatory. With "microglot," of which the *OED* similarly furnishes no evidence, we are of course on our own, if still with the world all before us.

The stately caper that Austin (1979) almost allows himself in the self-excusing opening of "A Plea for Excuses" becomes a full-fledged frolic at times in the essay "Pretending." As part of the effort "to bring out more of the full features of the situation when we are pretending, which is moderately complicated" (259–60), Austin invokes etymology, weaving a circle with the kind of circumstantial ceremony typical of invocation: "And first for that goddess fair and free (fairly fair, fraily free), divinest Etymology" (260). In order to help the promotion of Etymology to goddess status, Austin conflates it with Euphrosyne, who is summoned at the beginning of Milton's "L'Allegro," in order to diffuse the Cimmerian clouds of melancholy:

> But com thou Goddes fair and free,
> In Heav'n ycleap'd *Euphrosyne*,
> And by men, heart-easing Mirth,
> Whom lovely *Venus* at a birth
> With two sister Graces more
> To Ivy-crowned *Bacchus* bore. (Milton 2012, 28)

"Fair and free" is a common poetic epithet, but the "goddess fair and free" seems to make Milton the most likely object of the allusion. Euphrosyne is a poetical version of εὔφρων, *euphrone*, literally "of sound mind," and therefore cheerful, gracious, kindly, reasonable. Euphrosyne, said to be the daughter of Venus and Bacchus, was one of the three Graces. She was also known as *Euthymia*, εὐθυμία, cheerfulness, which is a recurrent term in the fragments of Democritus, the "laughing philosopher" (Kahn 1985, 24). Euthymia is also

now a clinical name for a temperate condition not subject to the extreme fluc-
tuations of mood (Fava and Bech 2016), odd though it may seem that such an
obviously nonclinical condition should need a clinical name. The tetrameter
couplet of "(fairly fair, frailly free) divinest Etymology" seems at once to exalt
etymology and warn against its exaltation through the balancing, euthymic
caveats, which suggest the evidence that etymology may only be fair within
reason, and may not be as free (of what—error? presumption?) as all that. The
minor outbreak of "heart-easing Mirth" in Austin's own sober sentences sug-
gested by the skipping rhythm gently discredits in advance the solemn preten-
sions of etymological analysis. Austin explicates the literal meaning of *prae-
tendere* with the help of an example from Ovid:

> *Prae-tendere* in Latin never strays far from the literal meaning of holding or
> stretching one thing in front of another in order to protect or conceal or dis-
> guise it: even in such a figurative use as that in Ovid's "praetendens culpa
> splendida verba tuae," the words are still a façade to hide the crime. (Austin
> 1979, 260)

Austin need only to have consulted Lewis and Short's Latin dictionary to sup-
ply himself with the example from Ovid (1929) he gives, which is from the
beginning of the *Remedia Amoris*. The poet is here advising the lover seeking
to cure himself of his amorous affliction by long travel overseas to resist the
pull of homesickness: "you will wish to return; but it will not be your home
and country, but the love of your mistress that calls you back, cloaking your
weakness in grand words [*praetendens culpa splendida verba tuae*]" (194–95).
Ovid's *culpa* seems to be used in the sense of fault or failing rather than crime,
though Austin's (1979) word fits with some of his own fanciful examples of
criminal simulation in "Pretending," the unspecified "miscreants" who pre-
tend to be sawing a tree, the hopeful burglar pretending to be cleaning win-
dows (259, 263). Austin has a weakness for the stimulus that etymology can
provide, and I should know. In a talk about the question of culpability titled
"Three Ways of Spilling Ink," Austin offers brief characterizations of what he
calls the "trailing etymologies" of three ways of doing things seriously, on the
grounds that "no word ever achieves entire forgetfulness of its origins":

> The metaphor in "deliberate" is one from "weighing" or "weighing up," that
> in "intend" (one which keeps breaking through in many cognate words) is
> from bending or straining toward (compare "intent on mischief" and "bent

on mischief"). In "purpose," the idea is that of setting something up before oneself. (Austin 1979, 283)

Pretending is obviously one of these cognate words, as indicated by an expression like *holding out that*, for dubiously maintaining something. Another, more extended recourse to etymology occurs in "A Plea for Excuses," the third paper in which Austin (1979) concerns himself with what, in the closing words of "Pretending," he calls ways of *"not exactly doing things"* (271). In a section headed *"Trailing clouds of etymology"* (201), Austin outlines the utility of etymology for identifying the root conceptions of certain words:

> A word never—well, hardly ever—shakes off its etymology and its formation. In spite of all changes in and extensions of and additions to its meanings, and indeed rather pervading and governing these, there will still persist the old idea. In an *accident* something befalls: by *mistake* you take the wrong one: in *error* you stray: when you act *deliberately* you act after weighing it up (*not* after thinking out ways and means). It is worth asking ourselves whether we know the etymology of "result" or of "spontaneously," and worth remembering that "unwillingly" and "involuntarily" come from very different sources. (Austin 1979, 201–2)

Etymology is sometimes used to identify what are claimed as root or core conceptions, which are thought to express something like the primary, because primal, intention in or behind a word. Austin's (1979) view is rather that these survivals are often obnubilating inconveniences especially when a simple physical model of action, such as pushing or straining or weighing, may have been "extended to cases that have by now too tenuous a relation to the model case, that it is a source of confusion and superstition" (203). A reader primed by Austin's explanation of the spun-out but residual influence of word beginnings may wonder if they are meant to register the link between "extended" and "tenuous" in that sentence, both of them offshoots of the arboreally extended family of words from Latin *tendere* and Greek τείνειν (to stretch or strain), and ultimately having to do with the serial connections through time that seem to be necessary to serious matters. The intention that may seen to be sedimented in a word, and to continue to operate by extension in later uses of that word, can come to be a pretense, pretext, or pretension, even, it may seem, a sort of "façade to hide the crime" (260). The different words we have for being serious or doing things seriously seem not to be serious, in the old,

not entirely obsolete sense of lined up in a row or forming a continuous series. "Pretending" offers many examples of a controlled slippage from seriousness that make us wonder whether or not they are meant to be taken seriously—that is, as hints that to be fully serious one might need discreetly to step aside from being deadly serious. Being serious, for Austin, means not expecting to find complete and connected series, and being willing to tolerate, even to take serious account of, the breaks in transmission that constitute language and the concepts it allows us to deploy.

The end of Austin's (1979) "Pretending" instances a rather different disposition toward seriousness and importance, in the characteristic piece of deflected conclusiveness or, possibly, deflective conclusion it offers: "What, finally, is the importance of all this about pretending? I will answer this shortly, although I am not sure importance is important: truth is" (271). Austin here adroitly balances expansion and retraction, introduced in the antithesis "although I am not sure importance is important: truth is." This has the air of a rather conventional little deceit, in which importance is first deflated, only instantly to be replaced by something that sounds even grander, and calculated to produce sage nodding of heads: "well, yes, of course truth is more important than mere crowd-pleasing grandeur." In fact, though, the word *truth* itself has a false bottom for Austin, who begins his essay "Truth" with the recommendation that, rather than concerning themselves with the nature of truth as such, "philosophers should take something more nearly their own size to strain at" (117)—"straining" at plucking the string of words like *extension* and *pretension*—and occupy themselves more locally and pragmatically with "the use, or certain uses, of the word 'true.'" Given the questions of magnitude in play here, we may feel encouraged to enjoy and congratulate ourselves on recognizing the echo of Jesus's rail against the interpreters of law in Matthew 23:23–24:

> [23] Woe unto you, scribes and Pharisees, hypocrites! for ye pay tithe of mint and anise and cummin, and have omitted the weightier matters of the law, judgment, mercy, and faith: these ought ye to have done, and not to leave the other undone. [24] Ye blind guides, which strain at a gnat, and swallow a camel. (Matthew 23:23–24)

In truth, a great number of Austin's remarks on philosophy, mostly in the form of spiky asides from the philosophy he is actually doing ("actually" in the French sense of what he is in the process of doing rather than what he is

in fact or in truth doing), might be described as a politely diminished form of the denunciation "Woe unto you, scribes and Pharisees!" "Strain at" was improved into "strain out" in most versions after the King James, but the optical suggestion of laborious squinnying does some nice comical work in Austin, as does the suggestion that the gullibility about camel-sized abstractions in fact reduces to the scale of the gnat the needle-threading philosopher who should pick on something his own (inconsiderable) size. One might wish for warrant also for the even more attenuated allusion to the philosophical Gnat in Lewis Carroll's (1998) *Through the Looking Glass*, whose minute reflections on names and their answerability are rendered in tiny typography, even though the Gnat suddenly becomes "a *very* large Gnat: 'about the size of a chicken,' Alice thought" (149).

Austin (1979) signs off the paragraph with a characteristically muted *mot*. "*In vino*, possibly, '*veritas*,' but in a sober symposium '*verum*' " (117). In Latin, *verum* is a nominalized adjective which refers to the local truth of various sorts of matter, or what may be the case about various particular kinds of things ("Life is short, short, brother / Ain't it the truth? / And there is no other / Ain't it the truth?"). Veritas refers to truthfulness, or "verity," as such, and in the abstract. Austin's (1962) tendency to treat truth as an episodic rather than exaltedly eternal kind of thing is evidenced in the opening words of *How to Do Things with Words*: "What I shall have to say here is neither difficult nor contentious; the only merit I should like to claim for it is that of being true, at least in parts" (1). Austin's phrasing gives a bow to the timid curate who responds to the observation of the Bishop with whom he is taking breakfast that his egg is off, "Oh yes, my Lord, really—er—some parts of it are very good." According to Garson O'Toole (2019), the joke first appeared in the comic magazine *Judy: The London Serio-Comic Journal* on 22 May 1895. The joke is supposed to be that whatever good parts there might be in a rotten egg will be vitiated by its rottenness, goodness in eggs being taken to be an all-or-nothing phenomenon: one can no more have an egg that is good in parts than one can be somewhat pregnant or fairly dead. Austin's little almost-joke, or almost-allusion to it, allows the audience to object that something that is only somewhat or sometimes true is not really true at all. And yet this kind of be-all and end-all assumption about truth is indeed precisely what Austin repeatedly sets about trying to tease out, and tease his audience out of. So one might say that for a moment, Austin is pretending to be serious about truth in order seriously to alert us to its pretenses.

In hinting at the importance of the topic of pretending, the last sentences of "Pretending" effect another deflationary amplification, reminding us of earlier ramiculations:

> In the first place, it does seem that philosophers, who are fond of evoking pretending, have exaggerated its scope and distorted its meaning. In the second place, in the long-term project of classifying and clarifying all possible ways and varieties of *not exactly doing things*, which has to be carried through if we are ever to understand properly what doing things is, the clarification of pretending, and the assignment to it of its proper place, within the family of related concepts, must find some place, if only a humble one. (Austin 1979, 271)

This opens up the prospect of an ambitious philosophical program extending far beyond what has just been undertaken, in an *occupatio* recognizable from many concluding paragraphs. I think Austin intends to allow us the suspicion that his Borgesian project of "classifying and clarifying all possible ways and varieties of *not exactly doing things*" is incapable of fulfillment, since there may always turn out to be more ways of not exactly doing things of which account will need to be taken, meaning that we may have to reconcile ourselves to never being able "to understand properly what doing things is." There is a rheumy-eyed White Knight melancholy in the idea that rather than using the knowledge of how to do things seriously, or properly, in the way that really belongs to them, to illuminate the bosky dimness of the almost or not quite, one might have to begin by ruling out all of the possible ways in which doing things might fail, misfire, or deliberately deceive, before one could be sure of a proper understanding of what one might be doing in one's way of doing things. We might reasonably feel entitled to find ourselves uncertain whether this prospective philosophical undertaking, or entertainment of such a philosophical prospect, is itself an example of properly doing something, or of not exactly doing it. Is Austin sketching a serious program of research, or is he (seriously) pretending to sketch it in order to suggest the smaller, and so greater, importance of more local kinds of undertaking?

The philosophical program with which Austin is most commonly associated is that of speech-act theory, as introduced by his *How to Do Things with Words* (1962), based on a series of lectures given at Harvard in 1955. The project of understanding what sort of doing is involved in language may be regarded as a sub-branch of the grand undertaking of deriving a proper understanding of what doing things is. Many readers will have noted the

fact that what Austin says in that book about performatives does not seem to tell the whole truth about what his own comic performances seem to be doing between the lines or in the wings of his arguments. The interchange that took place between Jacques Derrida and John Searle on the question of whether performatives can be restricted to what Austin described as "serious" uses of language, sets in play a series of questions about how seriously one must or even can take such a restriction. Muted as it is, Austin's comedy on this and other questions is hard to miss (though Derrida toils so hard at his own jokework that he nearly manages it). Jeffrey Nealon has focused attention on the destabilizing force of the joke in Austin, suggesting that it represents a kind of nervous philosophical embarrassment: "Even as Austin tries to keep the joke under control," Nealon (2017, 2) writes, "its logic remains central to his work." Failing to keep joking in its place, allowing himself nervous chuckles in lieu of the full disclosure about the trousers-down embarrassment that joking is supposed to cause him, means that the joke must be on Austin. Along with wearily sedimented and conventionally semidemented assumptions about what being a male Oxford philosopher "of a certain generation" must involve, Nealon (2017, 14) obediently reinstates the view of the Derrida-Searle debate as a clash of philosophical idioms, with plodding, sobersides analytical philosophy of the kind represented by Austin being hilariously outdanced by wily deconstruction. Nealon follows many other commentators in observing that "it's safe to say his commitment to capital-p Philosophy might explain Austin's uncomfortableness theorizing about comedy, or including jokes within his 'serious' discourse on ordinary speech" (15). Anyone who has wrung out from a reading of Austin's work the idea that he goes in for anything that might reasonably be called "capital-p Philosophy" must be presumed also to be capable of imagining that he played Widow Twanky at the Bradford Alhambra, was the leading scorer for Preston North End in the 1954–55 season, or directed Allied intelligence operations in the run-up to D-Day. Relying perhaps (and perilously) on the principle that there is nothing funnier than someone who does not realize the joke is on them, Nealon himself declares in a seriously-though manner that "As funny and self-deprecating as his lectures are, Austin can't, I think, bring himself to wonder outright whether 'the truth is a joke'" (15). In other words, Nealon thinks that Austin does not take jokes seriously enough to realize the importance of being earnest about them, in order to state final, encompassing, and "outright" things about the nature of

"the truth" (here surely the Veritas from which Austin politely turns away), presumably in the manner expected of the "capital-p Philosophy" to which Austin is said to be committed. Nealon's preference, as affirmed in his final sentence, is that we take the "comic performativity" of Derrida's way of dealing with his opponents as "a sharp provocation for the political future of thinking, an especially important weapon in these dark political times" (21). It is Derrida (1988) who writes, of those who claim to be able to make out clearly the difference that Austin makes out between doing things in words and not exactly doing them, "I do not take their seriousness very seriously" (107), but the sentence has a ring, if a muffled one, of Austin's own manner. Austin's "comic performativity," perhaps along with Derrida's more leaden version, seems to chide in advance the sottish solemnity of such sternness.

Play

Perhaps it is useful—by which I cannot, at this time of day or any other, mean much more than interesting, this being its principal form of usefulness to the kinds of being who go in for it—to think of philosophy as the play of seriousness, especially if we allow our minds to play over the range of meanings available in the word *play*. This is to say that philosophy can be a venue in which seriousness can be, for example, played with, played out, played for, and put into play. It may not be the only such venue, but the seriousness that is thought to be requisite to philosophy means that the matter of its seriousness may often be, if only implicitly, in play in it, and even interestingly in play, in the sense that we offer to make a game "interesting" by raising the stakes.

Here we may note a curious asymmetry between play and seriousness. One can certainly be serious about one's seriousness, and perhaps must always be to some degree for it to qualify as serious activity at all. But one cannot be playful about one's play, because then of course the play simply evaporates. This recalls the point made earlier in this chapter about the requirement to be serious in all acts of pretending. To play must always involve being serious about one's play, since absorption is the point of all play. There is no exterior compulsion to play, which, as Jean Baudrillard (2007) remarks, makes its rules (if it is a game with rules) or its processes implacable and inescapable. You can break a law, but you cannot transgress play, to which you give yourself freely, for if you refuse to give yourself to it—by cheating, for example, or by paying no attention to its requirements, in the manner of avant-garde artists—you

are not playing unseriously but simply no longer playing at all: "either you play or you don't play" (91).

And the most serious game of all is the game of being serious. To tell someone to be serious or to take something seriously is to enjoin or induce them to play the game of seriousness. There is, for a human, that *"being such that in its being, its being is in question in so far as this being implies a being other than itself"* (Sartre 1984, lxii), only the choice between merely playing at being serious, or seriously putting oneself in play, which is what putting in question means.

If I turn up to a ministerial briefing or an appeal tribunal in fancy dress, I might very well be thought not to be taking the occasion seriously. But this does not imply at all that I can expunge dressing up from proceedings altogether. For I must dress in some manner or other, complete undress of course being bound to be taken, in a world inhabited exclusively by beings who dress for the occasion, whatever it may be, as one of my wardrobe choices, even if a strongly contraindicated one. (Being strongly contraindicated is just the thing that makes nudity a wardrobe choice.) I will be expected to dress in some way which indicates that I have taken care with my dress, which under some circumstances can include the care I take not to give the impression of extravagance or fluttering self-display. I must mark the fact that I have adopted an appropriately unmarked mode of dress, dressing in some way that indicates that I have taken care not to exhibit too much the care I have taken, lest I be thought to be more concerned with the sartorial splash I might be making than with the pressing matters at hand. Fortunately, these judgments do not need to be made in a vacuum, since there are at any one time helpful conventions in play as to what kind of attire will do the job of marking my agreement not to mark myself out (high-buttoned blouse and business-like skirt, heels just high enough to avoid the slatternly suggestion of flats; suit and tie, preferably eschewing cummerbunds and medals). I had a colleague who would always arrive at formal academic proceedings in a crumpled T-shirt, jeans, and sandals, in what many took to be a performative assertion of the overriding importance of being focused exclusively on the matters in hand, and a puritan reproof to everyone else in the room who had allowed mere convention to shutter the inner light of academic conscience. But his locusts-and-wild-honey way of enacting the importance of being earnest fell as far short as every calculated spontaneism must, precisely because it became the signature of his *civilité sauvage*, meaning that it would have been more unnerving for

him to arrive wearing a college tie than a floaty negligée. What is more, for any other members of the committee to have taken his performative provocation seriously, or affected to, by adopting his desert-father chic, could only have been seen as an insulting travesty. Seriousness is inseparable for human beings from the signatory repertoires of seriousness, and every puritan subtraction of ceremony must have the capacity to become a counterceremonial ritual. It is for this reason that the one who believes that being serious means being wholly and exclusively serious, and therefore purifying existence of every kind of pretense or performance, is so often by that very action precipitated into pure pantomime. We will encounter this kind of ontological somersault in the intensifying logic of the zealot.

It may in fact be that certain kinds of play provide the necessary conditions for the development of the capacity for what we recognize as seriousness. These include most particularly the artificial absorption that most forms of play both enjoin and allow, along with the motivating sense of pleasure in the anticipation and awareness of that absorption. The absorptive quality of play is just what is serious about it and what encourages us to be serious about it. Indeed, could anyone who had never known what it was to play, to take on the para-existence or second life that playing institutes, ever be capable of that similarly abstractive process known as being serious? The seriousness of our play has a large part to play in teaching us to play at seriousness.

The stylistics of seriousness extend in all directions, encompassing not just dress but voice, gesture, and other modes of bodily comportment, and all the many language games, charted and uncharted, in which we are, all unsuspecting, versed. The concern of this book is with the many ways in which human beings play the game of seriousness, a game that extends, perhaps not right from the beginning of existence but from the beginning of social existence, all the way to its end. Perhaps every performance of seriousness is a kind of rehearsal of last rites, or recitable last words.

What has been called a "spirit of playful seriousness" (Ardley 1967, 227) is present in philosophy as early as Plato's (1926a) dialogs and, in particular, in a notable passage from the Laws. Early on in the daylong discussion among three old men on the island of Crete on how best to frame the laws for a new city, the unnamed Athenian stranger proposes that "each of us living creatures is an ingenious puppet of the gods, whether contrived by way of a toy [παίγνιον] of theirs or for some serious purpose [σπουδῇ]—for as to that we know nothing" (69). The essential feature of seriousness is allied throughout

their discussion with the question of who is doing the playing. Later on, in book 6, the Athenian returns to the question of how a plaything might come to take itself seriously. For, he maintains, the most serious thing a man, even or especially as the plaything of God, can do is to make God the object of his serious attentions:

> What I assert is this, —that a man ought to be in serious earnest about serious things [σπουδαῖον σπουδάζειν], and not about trifles; and that the object really worthy of all serious and blessed effort is God, while man is contrived, as we said above, to be a plaything of God, and the best part of him is really just that. (Plato 1926b, 53)

The Athenian rejects the common idea that serious things are done in order to bring about opportunities for nonserious pursuits—he instances the wars that bring peace, but we might ourselves similarly counterpose work and leisure: "They imagine that serious work [τὰς σπουδὰς] should be done for the sake of play [παιδιῶν]; for they think that it is for the sake of peace that the serious work of war needs to be well conducted" (Plato 1926b, 54). In fact, however, it is play that is paramount, for success in war depends on it:

> It is the life of peace that everyone should live as much and as well as he can. What then is the right way? We should live out our lives playing at certain pastimes—sacrificing, singing and dancing—so as to be able to win Heaven's favor and to repel our foes and vanquish them in fight. (Plato 1926b, 54)

But this idea of subservience in the condition of divine plaything seems to be in tension with the idea that humans have a responsibility to form themselves, and indeed, that seriousness essentially consists in this act of self-formation and self-realization:

> Just as a shipwright at the commencement of his building outlines the shape of his vessel by laying down her keel, so I appear to myself to be doing just the same—trying to frame, that is, the shapes of lives according to the modes of their souls, and thus literally laying down their keels, by rightly considering by what means and by what modes of living we shall best navigate our barque of life through this voyage of existence. (Plato 1926b, 53)

The Athenian ends up asserting the equivalence of the autonomy of the self-forming subject and the heteronomy of the puppet, as they rely on divine intimations regarding "the way they are to play and win their favor, and thus

mold their lives according to the shape of their nature, inasmuch as they are puppets for the most part, yet share occasionally in truth" (Plato 1926b, 54). Megillus is not convinced that this is a very dignified way of conceiving the life of man, and the Athenian seems to acknowledge that the whole passage has been a kind of diversion, which in fact represents rather a low opinion of humans:

> Marvel not, Megillus, but forgive me. For when I spoke thus, I had my mind set on God, and was feeling the emotion to which I gave utterance. Let us grant, however, if you wish, that the human race is not a mean thing, but worthy of serious attention [μὴ φαῦλον, εἴ σοι φίλον, σπουδῆς]. (Plato 1926b, 54)

It might seem as though having your mind set on God is a mark of seriousness, even if the consequence is to diminish the seriousness of the man who, even at his most pious and observant, will be nothing but a plaything. But it may be necessary to play at seriousness in the hope that the play may come to be taken seriously. The fact that the Athenian has to retract, or at least to apologize for, the passage in which he asserts the seriousness of human play at divine observance, or the observance of divine play, leaves it unclear whether humans are to be regarded as capable or not of the seriousness that demands and issues from the capacity to "mold their lives according to the shape of their nature."

This ambivalence regarding whether one should be serious or not about oneself, and whether seriousness involves realizing one's nature or setting one's self aside, not only runs through Greek conceptions of seriousness but is inherited in Christian notions of devotion to serious concerns. It is present in Leonard Cohen's words, in the *in articulo mortis* of his poem "Puppets," in which acknowledging the playfulness of appearance is both humiliation and Yeatsian grandeur:

> Puppet flower
> Puppet stem
> Puppet Time
> dismantles them
>
> Puppet me and
> puppet you
> Puppet German
> Puppet Jew ...

Puppet night
comes down to say
the epilogue to
puppet day (Cohen 2006, 160)

Responsibility

If philosophy is driven by the ambition to be able to mean what we say, it is a model for what is meant by "living meaningfully." To give meaning to a life may seem to imply two distinct kinds of things. The first is interpretable meaning or significance. A life with meaning in this sense is a life that may seem to have significance, may seem, that is, to be a life that is expressive or even exemplary of something. A life lived in the service of others need not be or, more to the point, need not have been meant in this sense. Indeed, such a notion of a meaningful life will very often be understood as a life lived in or at the service of some extrinsic principle, or as the fulfillment of some duty.

The other way of living a life meaningfully is actively to mean it or, as we say, give meaning to it. But what might it mean to strive to mean one's life? One may perfectly easily mean seriously to do certain things in, and even with, one's life; but what meaning can we attach to the idea of meaning one's life? Yet that conception does seem to be at work in the idea of the one who lives seriously. At the Mad Hatter's tea party, Alice is told by the March Hare, "You should say what you mean":

> "I do," Alice hastily replied; "at least—at least I mean what I say—that's the same thing, you know."
>
> "Not the same thing a bit!" said the Hatter. "You might just as well say that 'I see what I eat' is the same thing as 'I eat what I see'!" (Carroll 1998, 61)

The order of things, here meaning simply their sequence, rather than the disposition of things in general, defines different ideas of seriousness. To say what you mean is to have an idea of or plan for what you mean to say in advance of saying it. It implies that your meaning, in the sense of what you mean to say, is apparent to you in advance of the saying of it. Almost all of our discourse, and a very large part of our educational practice when it comes to language, implies this fuel-injection view of saying and meaning. Yet we never can mean *exactly* what we say, in the sense of knowing the exact words that we intend to utter, or the words that we will end up having uttered. If and when we do utter

a phrase precisely as we have planned to, we are likely to be falling into a for-mula, or speaking words by rote, in playing a part on the stage, for example, or following some prescribed performance, as in saying "I declare you man and wife."

J. L. Austin (1962) famously, and inflamingly, says that linguistic perfor-matives are required to be serious, by which he means "spoken 'seriously' and so as to be taken 'seriously'" (9). But, as an odd and unexpected consequence, the desire to be taken seriously that Austin requires of performatives also requires that they do not need to be meant seriously, in the sense that they can be regarded as "the outward and visible sign, for convenience or other record or for information, of an inward and spiritual act" (9). Austin gently mocks the assumption of "the fictitious inward acts" (10) that are supposed both to have preceded and to cleave closely to true or seriously meant utterances, in his rendering of what he calls "the classic expression of this idea" in the words of Hippolytus to his nurse, "ἡ γλῶσσ' ὀμώμοχ', ἡ δὲ φρὴν ἀνώμοτος," indi-cating that he is unable in the light of what he has just been told to keep the secret he has sworn to, which Austin renders as "i.e. 'my tongue swore to, but my heart (or mind or other backstage artiste) did not'" (9–10). So it is an odd consequence of the kind of seriousness characteristic of performatives that the question of whether they are meant seriously is itself, to borrow the words that Austin famously applies to poems, jokes, or soliloquies, "*in a peculiar way* hollow or void" (22). We are much more likely to give the sense, to our-selves and others, of saying what we mean, if we say it, as we say, "in our own words," which almost always implies something different from writing down what we mean, correcting it carefully, then reading it out. So meaning what you say implies not knowing until the moment of articulation exactly how you are going to say it. It implies a faith in the power of the *what*, if clearly and emphatically enough conceived, to exercise a necessary authenticating force over the *how*. At the same time, the way the *how* falls out, provided it yields compliantly to the wordless force of the unuttered but sovereign and solid-gold *what*, is what retrospectively secures that force.

One means what one says in a performative utterance not because one says what one means but because, in saying it, one means to be taken to have said what the words will have been taken seriously as meaning. One means what one, or any of the "offstage performers—the lights men, the stage manager, even the prompter" mischievously acknowledged by Austin (1962, 10) in a footnote will contrive to have made the utterance mean: that a couple has

been legally married, for example. If I give you a fiver or, convincingly cos-
tumed to issue criminal sentences, send you down for five years, it makes no
difference at all whether or not I "mean" it; what matters is whether the cir-
cumstances make it meaningful, which is to say, are taken seriously enough
to make it meaningful.

The seriousness here performed, and of its performance, is not so much
a commitment as a promise to permit: permit, that is, one's reader or inter-
locutor to take one to have meant what one said. One of the advantages of
the acquisition of theory of mind among children, otherwise hedged in by
so many thorny inconveniences, is the possibility of change of mind, real or
simulated. Children learn early, and it would appear universally, the sneaky
efficacy of the squealed "But I didn't *mean* to." But they must also, late or early,
learn the lesson of irrevocability, that to give one's word is to promise one's
willingness to be taken at it. In giving permission for one's words to stand for
what one meant, or even meant to happen, serious talk is therefore an act of
proleptic standing in or substitution, even a kind of prostitution, as truly one
of the oldest professions, the employment of the act of profession.

There are two formative conditions for the taking of responsibility
involved both in speaking and in acting seriously. One is the condition of
temporality, which exposes every action or word-action to unknowable con-
tingencies. This is why the ultimate seriousness for Nietzsche is to be able to
will, or be willing to settle for having willed, everything in one's life, even,
or especially, if one were fated to live it over and over again in unwilled
repetition. In a sense, this is an intensification of the Greek principle of
spoudaia, the opposite of which, according to Aristotle, is living at random,
surrendered to the operations of *tuché*, chance. Perhaps as a rejoinder to
the fact that nobody can be said unridiculously to mean to have been born,
human beings, or ones who feel the hunger to be more serious, aim to try to
make their lives, and so their deaths, and so by back-formation their births,
things meant. This need not mean that one commits oneself to serious or
truly worthwhile things, which seems to be how Aristotle distinguishes the
spoudaios, or serious man. All that may be necessary for modern serious-
ness is the treatment of the contingent as though it were necessity (it is) or,
in Larkin's (1988, 98) terms, the robing of "compulsions . . . as destinies."
Yeats seems to articulate such a Nietzschean will to seriousness even, and
very likely especially, in the face of the absurdity of eternal recurrence, in "A
Dialogue of the Self and Soul":

I am content to live it all again
And yet again, if it be life to pitch
Into the frog-spawn of a blind man's ditch,
A blind man battering blind men;
Or into that most fecund ditch of all,
The folly that man does. (Yeats 1951, 267)

An associated condition of seriousness, deriving from its necessary temporality, is that of accountability. The underlying notion here is that one's life is not merely something that one lives seriatim, as it were, taking what comes, making it up as one goes along, but rather something to be actively and deliberately lived, within an intricately economized temporality of expenditures, investments, redemptions, and returns. No more niggardly and anxious mode of accounting can be imagined than what is thought to be the nonactuarial mode of existence known as "living in the moment," which would have to mean being superhumanly vigilant in chocking every tendency to retrospection and future-directed speculation that might arise. For a serious life, one may be expected, and in fact may willingly agree, to undertake an ongoing audit of oneself, in order to be able at every point to be able to return accounts. Such a view of seriousness becomes explicit in some Christian economies of damnation and salvation, which engineer seriousness from the imaginary prospect of consequences in an afterlife. By projecting the "what" of the "So what?" seriousness can therefore continue to mean seriality, and derive from consequentiality. But this idea of having to live one's life as something for which one may be held, or may hold oneself, accountable is in fact implicit in many other ethical outlooks. Societies held together by codes of honor, for example, rather than religious doxa, similarly demand a process of ongoing adequation between one's actions and the self-ideal that one would wish to have lived up to or been thought to. The necessity of self-supervision in such codes of seriousness precipitates anguishing paradoxes of number. One can only be held to be serious if one attains and maintains unity of being and purpose, through the work of self-assaying deliberation that involves taking one's own measure and weighing oneself in the scale, even as one is the scale itself. But one can only perform that action by an act that continuously effects the internal self-division that the act of accounting is intended to overcome. This duality between oneself and one's self is signaled in the reverberation contained within the idea of responsibility, understood as an ongoing

interrogation and answering back to oneself. Sartre points to this near-comic self-division:

> If candor or sincerity is a universal value, it is evident that the maxim "one must be what one is" does not serve solely as a regulating principle for judgments and concepts by which I express what I am. It posits not merely an ideal of knowing but an ideal of *being*; it proposes for us an absolute equivalence of being with itself as a prototype of being. In this sense it is necessary that we *make* ourselves what we are. But what are we then if we have this constant obligation to make ourselves what we are, if our mode of being is having the obligation to be what we are? (Sartre 1984, 59)

This ongoing bookkeeping, whether it be through nightly prayer, regular consultation of conscience, the technology that tells us how many steps we have taken in a given day, or other operation of the remorse of conscience, is the rotation into a temporal horizontal axis of what Peter Sloterdijk (2013, 59) has called "the general constitution of beings under vertical tension." It is the willing of what will have been done in the future-perfect tense.

I have been considering a number of ways in which philosophers have reflected on what it means to live a meaningful life, as a heightened example, borrowing much from religious belief, of what it might mean to mean one's life. Many professional philosophers would probably nowadays regard this as rather a vulgar view of what philosophy is and does. Rather than attempting to assay what the most serious versions of what living meaningfully might be, I have sought in this chapter to characterize what is specific to what might be called the philosophical style of seriousness. That this is by no means restricted to philosophers, who have sometimes, we have seen, allowed themselves to enquire rather queasily into its exactions, is exactly what makes it a style, a way of doing things, and therefore, as a style, a way of not simply or exactly doing them.

3 Importance

The aim of this chapter is to reflect on the nature of importance as an important modality of the serious. Considerations of importance are ubiquitous in human reasoning and communication, but considerations of the nature of importance as such are harder to find. We weigh the many different kinds of importance of different kinds of things so energetically that it is surprising to find that importance is so invisible to itself. One can do the same thing with the phrase "the importance of," as one can, and I in fact did earlier on, with the phrase "taking X seriously," for it seems that there is nothing that somebody does not think it important enough to discuss the importance of. Dorothy Emmet's (1946, 234) remark that "the idea of Importance has received scanty treatment in philosophical literature, yet it is always turning up" is borne out by an hour or so spent with the philosophical database Philpapers, which readily rustles up articles on the importance of randomness (Yurchenko 2021), being rational (Lord 2018), being erroneous (Beisecker 1999), being human (Diamond 1991), us (Tuomela 1995), others (Kandiyali 2020), knowing Greek, philosophy, logical form, well-being, personal identity, riddles, the phoneme theory, being Islamic, the verb *to be*, having a plastic brain, and the ethical treatment of elephants. Such rhetoric is not at all outlandish for philosophers, or scholars in general. My point is that one can find reading about the importance of particular concepts with which to curl up (Sawyer 2018) very much more easily than anything about the concept of importance. Of course, it is positively encouraging for me, though I might pretend to sigh

at it, to find how niggardly search engines are in response to a query about the "nature of importance," assuming as they do that the enquirer can only mean "the importance of nature," which is rather like the assumption that I see what I eat is the same as I eat what I see.

The generalization of mass-mediated relations brings about something equivalent to the expansion of the realm of exchange value effected by the generalization of the money-form, with the move from heavy and cumbrous material forms of exchange (cowrie shells, gold bullion, undutiful daughters) to near-immaterial electronic forms mediating between the semiotic and the economic realms. When everything can be communication, and every feeling and meaning can be put swiftly on display and into circulation, dramatic slippages between seriousness and silliness can occur. The mediation of extremity and emergency I have called "crisis work" (Connor 2016) becomes a means to keep the value of crisis constant, as that which goes beyond mere signification, even as any and every crisis is assimilated into the routine and rapidly run-through rhetorics of extremity. The struggle between salience—what leaps out—and the anesthetic effect of signs, the effect of which is always to assert the homogeneity of the order that signs form with themselves, is figured in miniature in the fortunes of the word *significant*, a word that was used originally to mean expressive or indicative, but began by the early seventeenth century to mean important, substantial, or weighty, in a sense newly expressive of the desire to push signs beyond mere signification. The sense of some concealed or unexpressed significance lying in the word significance is borne out by the puzzlement of generations of English literature students, who can usually make a confident sally at an answer when asked what a passage of text might signify, but are thrown into mystified confusion when the question is followed by "Yes, but what is its *significance*?"

In this, the word significance follows the track marked out by the word *importance* itself, which originally emphasized that which was of "import," or the purport carried or conveyed in some sign or message. Indeed, the primary meaning of Latin *importare* was "to bring in," in the modern sense of importation of goods, and so physically to cause or occasion, rather than merely to imply or convey an idea. The oscillation between substantial import (of real significance) and insubstantial import (because merely a matter of signification) is suggested in the duality of the English *portentous*, which was used from the fifteenth century to mean ominous, embodying some serious threat or warning, or more generally extraordinary or

marvelous, as in the kind of signs known as portents, which portend, or literally bend toward.

But, as we will see again in chapter 7, such portendings have a way of developing their own autonomous intensity, or inward rather than outward tending. The word important, like its pressing twin, *urgent*, points us away from itself, to something to which we should pay our attention. It says, "Don't look at me; focus on that." But, as with the pointing finger, for the toddler who has not yet learned the indexical code and so does not realize its attention is being directed elsewhere, the attribution of importance has a way of attracting attention to itself, for its own qualities. The idea of importance has a way of becoming as important as what it portends. But the importance of such portents, as with everything else that forms part of the symbolic order, is in part that they become available to be reflected on and played with on their own account, provoking delay, digression, reflection, variation. In confirmation of Jacques Derrida's (1995, 34) surprisingly genial remark that language is "a machine for undoing urgency." what aims to press forward, away from, and out of the orders of representation becomes a kind of "abstitution," holding fire on what it aims at, and abating what it incites. It can also appropriate the very quality it names, claiming for itself the importance at which it gestures elsewhere. During the nineteenth century, the inflation and multiplication of such significations of import seem to have led to the word portentous being applied to things felt to be falsely or pretentiously portentous, and therefore exaggerated or pompous; indeed, the words pretentious and portentous seem often to be boomingly blurred together. A children's magazine of 1922 writes of a small parasitic insect used to control the citrus-fly in Florida that "[o]f microscopic size, the foe of the citrus-fly staggers under the portentous name of *Prospatella lahorensis*" (Zimmerman 1922, 993).

The allure of the idea of importance, along with the fact that concerning oneself with matters of importance appears to be a way of acquiring it for oneself, means that the pursuit of importance can easily become a trivial infatuation. The gloomily routine pressure to be thought important means that contemporary writing in academic and associated writing trades is rapidly running out of idioms in which to break free of solemnity, or the pantomime greasepaint of seriousness that has come everywhere to prevail. This is perhaps particularly the case in those disciplines that deal with representations of things and actions of representation, such as literature or visual studies, which have been beset from their beginnings by the sense that the study of mere

signs and signification needs to be made weightier and more concerned with serious, real-world matters. The discovery that it was possible to turn the study of poems, paintings, plays, stories, and even sonatas into political matters, by representing such things not as mere walking shadows or geegaws for idle moments but as matters of earnest import, enabled such disciplines to become the newly self-acknowledged legislators of the world, though they have had to wait for a world in which media relations have expanded to encompass the whole of social relations.

To believe or even allege, as I have excitedly and citably done (Connor 2019c), that it is more important for people such as academics to be interesting than to be important is very likely to mean that you are taken to be frivolous, pompously self-indulgent, and politically irresponsible. Indeed, it may be that you can only dare intimate that there might be limits to the importance of what you do as an academic from a position of institutional eminence such as the one that, like Bede's sparrow tarrying between storms, I temporarily occupied as I gave utterance to this sentiment. Only the important can jestingly proclaim the unimportance of what they do, or pretend they think that the people who deliver books for Amazon might be more important than the people who write them. The lowly and permanently petitionary postdoc, by contrast, must docilely act their part in the puppet-play of relevance, meaningfulness, and the search for what those who assay the importance of research in the UK call "impact," but might just as well, and much more accurately, be called "import."

The small number of studies that consider the nature of importance tend to neglect the relation between the importance of things and the importance assumed of or imparted to persons. It is the latter of which Harvey C. Mansfield (2007) speaks when observing the inattention within social studies to the factor that seems to drive so much of the discourse of identity, namely the "importance of importance," by which he means the sociological significance of the thymotic drive for recognition, or the need to be thought important, that seems to remain at least as powerful as the more obviously acquisitive desire for this person's art and that person's scope. People really do not seem to want to be rich or free or happy or powerful, as economists and political theorists variously say, except insofar as these things make them feel or seem important. The intensely social nature of humans means that they are also intensely rivalrous, and what is important in rivalry is usually, quite as much as the advantages and accomplishments of one's rival that one would like to

appropriate for oneself, one's envy of their importance. Indeed, Mansfield's phrase might do very well to alert us to the importance, for one's salary, job security, and status, of claiming or seeming to be taken up in one's work in affairs of sublime importance.

This is a ticklish matter for the humanities, or those forms of it focused on what used to be called "the arts," in particular because of the traditional association of music, painting, acting, and storytelling with amusement rather than importance. The notion of amusement itself has declined in force. It used to be closer to amazement than it is now, and was often spelled with a magico-mysterious z, to hint at its perilous allure (Connor 2014a, 179–82)—for example, in a 1678 sermon by Edward Young, which distinguished the voluptuary from the debauchee in the following (rather intelligent I think) terms:

> To indulge appetites and gratifie senses, to live soft and delicate according to the scheme of studied pleasure, is the businesse of the Voluptuous; but the Debauchee is not so choice: For his end is not so much to please, as to amuze; and his whole study is onely for a course of expedients how to darken the mind, and divert thought, and fence out reflexion. (Young 1678, 28)

It is plain that it is the voluptuary who is set on a life of mere amusement in modern terms, while the debauchee has a darker project of sinful self-extinction. A religious pamphlet a few years later complained of churchmen who criticized the king in order "to incense or amuse the People with Fears and Jealousies" (Care 1687, 6).

But scholars working in the arts would do well to retain their sense of the importance of amusement, rather than hurrying over it in favor of what seems to be, or at least can be made to count as, importance. In the case of literary criticism, my own area of sometime specialty and emolument, to forget the essential nonseriousness of literature—that is, writing for which there is abundant use but little necessity—by cranking it up into the high seriousness of philosophy, religion, or social theory, is to reduce the enterprise of making sense of the texts we think of as literary to a footling parlor game, which is no less capable of being deadly in its effects for that.

Not to succumb to the factitious temptations of importance is not the same as surrendering all claims to interest or significance. I think Paul Davies is right, in his response to Alexander Düttmann, to criticize

> the assumption that to treat literature or poetry seriously is to treat it *philosophically*, the assumption in other words that it is philosophy that bequeaths

the requisite seriousness to any investigation or undertaking into areas or phenomena otherwise considered non-serious or frivolous, nonessential or intrinsically under-determined. (Davies 2014)

A moment later, though, Davies (2014) offers us what looks like an immaculately worked example of this kind of disciplinary ante-upping, in his characterization of *Tristram Shandy* as a novel that "sets in motion a vertiginous play between the serious and the non-serious such that the reader can never identify a moment or a sentence where seriousness cannot be doubted and yet where even the most trivial and everyday exchanges and occurrences might serve as a candidate for a life changing significance." This is a good thing to hear about a novel for which my appetite for hearing good things is well-nigh insatiable. But in its solemn claim that *Tristram Shandy* can be read as a kind of philosophical argument about the unknowability of seriousness, it effects exactly the kind of promotion of literature into philosophy that Davies has just professed himself doubtful about. One might say instead or as well that there are other, perfectly reputable kinds of ways of being serious about what *Tristram Shandy* is and does than buffing up its metacritical credentials.

Perhaps, however, this points to a more general difficulty in making either play or seriousness the subject of serious consideration. For to do this is inevitably to wonder what the value of either play or seriousness might be, and wondering about the value of things always seems to inveigle one into seriousness. At its crudest, this seems to mean that one can only affirm the seriousness of play (against seriousness), by affirming its seriousness in such a way as to neutralize its playfulness. Seriousness therefore seems to be serenely, yet somewhat irritatingly, self-immunizing. There are many questions that, upon consideration, turn out to be pseudoquestions, questions that are not really questions at all, which one can at best only play at answering. But the question of their seriousness must always, it seems, be exempt from this disqualification, for it must always be allowed to be a serious question. If a philosopher, or anyone else for that matter, undertakes to argue that it is a trivial matter to speculate on, say, the ontology of unicorns or the nature of posthumous experience, then the work of demonstrating this triviality can always itself be taken seriously. To ask the question, "Is this a serious matter?" must itself start the slouch toward earnestness.

Aristotle (1898) points to a set of associations with seriousness that we might seem to have lost, when he defines tragedy as, in S. H. Butcher's translation, the "imitation of an action that is serious, complete, and of a certain

magnitude" (23). "Action that is serious" is a rendering of "πράξεως σπουδαία," which D. S. Margoliouth translates as "chapter of heroic life" (Aristotle 1911, 154) and W. Hamilton Fyfe translates as "action that is heroic" (Aristotle 1953, 24, 23). Spoudaia, σπουδαία, has also been translated as "elevated" by Stephen Halliwell (Aristotle 1995, 47), and elsewhere as simply "good." Aristotle counterposes the spoudaios to the *phaulos*, φαῦλος, cheap, easy, paltry, mean, that may be thought to be unserious not in the sense of being flighty but in the sense of being base, vulgar, or of little account. This distinction survives in usages like "serious music" as opposed to "popular music," still definable only as vaguely as Charles Reid's (1967, 237) "connotation of something important's being at stake in the sense of engagement or coming to grips, emotionally or intellectually."

In Plato's (2013) *Republic*, Socrates advises that the soul who has escaped the cave with its flickering shadows into the light of clear conceptions must return with the news to his fellow prisoners in the cave, "whether they are inferior or more worthy of serious attention [εἴτε φαυλότεραι εἴτε σπουδαιότεραι, *eite fauloterai eite spoudaioterai*]" (124–25). Throughout its uses in classical Greek writing, and especially in the work of Plato and Aristotle, seriousness moves across constantly from being an action or attitude to being a kind of person: "the good man [σπουδαίῳ] wishes for what is truly wished for, the bad man [φαύλῳ] for anything as it may happen [τυχόν, chance, randomness]" (Aristotle 1926, 142–43). The idea expressed here—that base or light-minded persons not only do not wish for things that are truly good but do not actually care whether what they wish for is good or bad, since they wish for whatever may randomly occur or pop into their minds—is tripe, of course, and tripe of an unusually magnificent order, not least because it contradicts the reasonable things Aristotle has just been saying about the striking relativity of what seems good to different people. The fact that different people wish for many different and even incompatible kinds of things does not in the least mean that they cannot be serious about the multifarious things they wish for—or does so only for an absolutist worldview that assumes that there can only be one kind of truth and one way of being good, accessible only to people who are serious about them.

The Aristotelian equation of the serious with the noble and exalted, along with the assumption that serious action must involve the highborn rather than the hoi polloi, is not one that we would nowadays find very congenial, or say we did in open court. But the equivalence is perhaps still exercising some

force in Matthew Arnold's (1921) judgment that Chaucer's work is lacking the quality of "high seriousness" that is necessary to great poetry, a judgment that has done little harm to Chaucer's reputation but has helped the somewhat antique notion of high seriousness itself to be taken seriously. The height or exaltedness of seriousness is one of the most important, or at least defining, of its assumed attributes and their associations. Arnold strives, though perhaps not all that hard, to keep the poetic quality of seriousness apart from the kind of spiritual nobility that he regards as necessary to poetry:

> Something is wanting, then, to the poetry of Chaucer, which poetry must have before it can be placed in the glorious class of the best. And there is no doubt what that something is. It is the σπουδαιότης, the high and excellent seriousness, which Aristotle assigns as one of the grand virtues of poetry. The substance of Chaucer's poetry, his view of things and his criticism of life, has largeness, freedom, shrewdness, benignity; but it has not this high serious-ness. Homer's criticism of life has it, Dante's has it, Shakespeare's has it. . . . A voice from the slums of Paris, fifty or sixty years after Chaucer, the voice of poor Villon out of his life of riot and crime, has it at its happy moments. . . . But its apparition in Villon, and in men like Villon, is fitful; the greatness of the great poets, the power of their criticism of life, is that their virtue is sus-tained. (Arnold 1921, 32–34)

The association of seriousness with worth persists, even if the worth now attaches less to the serious person than to the serious topic, for it remains the case that serious matters are ones we regard as worth taking seriously. The reason seriousness matters to us may be because seriousness concerns questions of worth and value—that is, thematizes mattering itself. We ascribe worth to the act and fact of ascribing worth. So to take something seriously is to assume that it will repay the trouble we may take in doing so.

Seriousness, as the assumption and ascription of worth to some object of concern, can become autonomous of that object. In such cases, the impor-tance one attaches to whatever one takes seriously can be transferred to one-self, as its bearer or instantiation. One's supposed seriousness may then come to provide the measure of one's social worth, making one a figure to be reck-oned with. So great and alluring can this transferred sense of seriousness be that the temptation to take shortcuts will become irresistible—for example, by pretending to the seriousness of the concern for which one might wish to be applauded and rewarded. Seriousness therefore remains allied with the will

to aristocratic distinction in spoudaios. It has, however, passed across from the traditional and more moth-eaten associations of aristocracy—breeding, wealth, renown as a warrior, a way with horses—to the modern forms of distinction and mediated renown (or, as its contemporary misspelling literalizes it, "reknown") that are their equivalent.

Importance seems to follow something like the same trajectory as seriousness, and for many of the same reasons, in the process tending to become steadily more abstract. Shakespeare (2011) often uses importance to imply an action performed by a particular person or assumed persons, of pressing, urging, requiring or demanding. Confessing to the plot against Malvolio at the end of *Twelfth Night*, Fabian says "Maria writ / The letter at Sir Toby's great importance" (1216). Importance in Shakespeare means the act of importuning, effected by some identifiable entity or personage. For us, importance is thought of almost always as a condition rather than an action, connected to its former usage perhaps by the idea that an important matter is something that represents a kind of claim on our respectful attentiveness, and an important person somebody taken up with such important matters, and therefore impressively subject to their importuning.

To be important is to be recognized and respected, as a mark of social standing and distinction, it being taken for granted that most people are unimportant in many respects. There would be no point or purchase in the pious proclamation that everyone is important unless it were widely assumed not to be true at all, or ever likely to be. This is why the thymotic drive for recognition of one's importance is so intensely competitive, in a way it would not need to be if importance did not depend so obviously on its scarcity. Importance is what one wants for oneself, and it is hard to know what a "self" could be in the absence of any sense of that self's importance to itself. And yet we have come to feel that "self-importance" is a kind of imposture and thus incompatible with genuine importance. This means that importance, thought to be so essential to autonomous selfhood, is in fact allonomous, or governed by the acknowledgment of others. The most important thing about being important is the fact that others think you are. Of course I can devote myself in my library, laboratory, or allotment to noiseless toil, the importance of which may not currently be recognized, but even the most obsessive recluse will likely look forward to the vindication of posterity, like the academic Louit in Samuel Beckett's (2009a) *Watt*, who accidentally mislays in a station waiting room a hundred-page manuscript "which, qua MS, could not be of the

smallest value to any person other than himself and, eventually, humanity" (148).

Although it seems likely that the sense of being important to at least one other person is important to the early development of infant humans, importance tends to require the imputed involvement of other humans collectively. So one needs and strives for the sense that others may recognize and be in accord with the assumed sense of one's importance to others still. To be taken to be important, one must be thought to be the kind of person people will take to be important. One may assume that at least some of the vehemence of the thymotic drive to be thought important, or, more commonly, the insult to one's honor of being slighted or thought unimportant, comes from the master's notorious resentment at having to be dependent on the slave's acknowledgment of their mastery. According to Hegel:

> The object in which the master has achieved his mastery has become, to the master, something entirely different from a self-sufficient consciousness. It is not a self-sufficient consciousness which is for him but above all a non-self-sufficient consciousness. His certainty is therefore not that *of being-for-itself* as the truth; instead, his truth is the inessential consciousness and the inessential doing of that inessential consciousness.
>
> The *truth* of the self-sufficient consciousness is thus the *servile consciousness*. (Hegel 2018, 114)

One strives for the impossible, truly sovereign kind of importance that would not require the sickly, lunar gleams of recognition from unimportant people, and is consequently enraged by the humiliating necessity of having to be measured by that recognition, perhaps because it is a constant, chafing reminder that the ones who confirm one's importance are therefore really the important ones, making one dependent on one's dependents.

So the allonomy of importance comes from the fact that one can only ever be important for, or in the view of, others. But there is a second feature of this allonomy. We have seen that the capacity to understand the importance of things is necessary to being important, in the same way that, for Aristotle, being a serious person requires taking things and, most particularly, the matter of one's own life, seriously. The simple injunction "Be serious" covers both cases: be serious about things, and thereby be a serious person; take things seriously in order to be yourself taken seriously. Importance has a similar orientation beyond or away from oneself. For important things have import, and

are often and usually important for, or in respect of, other things: vitamin D is important for health, as is avoiding prolonged exposure to sunlight. There is no importance in itself: like equipment, the importance of something is always accessory, and so points away from itself. To be important must always be to be important *as*—a key worker, an experimental poet—or important *for*, that is, as a requirement or desideratum for some effect to come about. So nothing that is important can be all-important, for it must take second place in importance to that for which it is important.

Can any useful sense therefore be made of Harvey Mansfield's striking notion of the "importance of importance"? It may at least let us into something that seems important about the way in which importance is thought of. We can start by acknowledging the straightforward acceptability of the point made by Jonathan Harrison, in the course of what is still one of the very few philosophical discussions of importance:

> Though "important" can be used by itself, it most naturally is used as an aux-illiary to a class word; though we can say the Battle of Hastings was important, the suggestion is that it was an important battle or an important event. Expressions such as "He is very important" are therefore, if I am right, incomplete. Sir Fred may be an important man, because he is prime minister, but not a very important prime minister, because he was in office for only six months, and all the important measures he introduced were defeated. (Harrison 1978, 223)

Harrison reinforces his argument by disposing of what might otherwise seem to be a logical contradiction, that to be thought important in and as oneself might entail that somebody is simultaneously important and unimportant. It must obviously be the case that such a person must be regarded as important only in some contingent rather than absolute respect:

> It goes almost without saying that "Sir Fred is an important man" cannot mean "Sir Fred is a man and Sir Fred is important," for then "Sir Fred is an important man, but an unimportant prime minister" would then entail that Sir Fred is both important and unimportant, which it does not. That "important" is auxiliary in this way is also shown by the fact that the class of important things (particulars) may be a very unimportant class. (Harrison 1978, 223)

This explanation has the advantage of rescuing from being nonsense many of the things we routinely say and very likely feel about importance, by allowing us

to recognize that to "be important" always contains some implication of being important for some reason or in some respect. Harry G. Frankfurt (1998) comes at the question of importance from a more reflexive viewpoint, by considering a slightly more complex form of auxiliary importance, in the things that are important *to us*. For Frankfurt, importance belongs to a domain of enquiry that is separate both from epistemology, the study of what we should believe, and from ethics, the study of how we should behave. Asking what importance is means reflecting on *"what to care about"* (80) and why we care about what we do.

Early in Frankfurt's enquiry, we encounter what will remain a largely intractable circularity. The things that are important to us are so because we care about them; but if it is asked why we care about them, the answer must involve some kind of registration of their importance to us:

> How is it possible, then, for anything to be genuinely unimportant? It can only be because the difference such a thing makes is itself of no importance. Thus it is evidently essential to include, in the analysis of the concept of importance, a proviso to the effect that nothing is important unless the difference it makes is an important one. Whether a useful account of the concept can be developed without running into this circularity is unclear. (Frankfurt 1998, 82)

An important concomitant of this circularity is that importance brings about and in fact depends on a strangely ambivalent kind of agency. On the one hand, the things we care about are important to us not just in a momentary or merely adventitious way, but as things that are at the center of the care we have for ourselves. The way we care about things is an indication of our care for our own caring. Our care for things need not be lifelong, but it must be more or less enduring, and so in a sense must contribute to the way in which we conceive our lives as an ongoing totality. This is the serious and formative kind of serious self-concern that characterizes the Aristotelian spoudaios:

> The moments in the life of a person who cares about something, however, are not merely linked inherently by formal relations of sequentiality. The person necessarily binds them together, and in the nature of the case also construes them as being bound together, in richer ways. This both entails and is entailed by his own continuing concern with what he does with himself and with what goes on in his life. (Frankfurt 1998, 83–84)

There must be some active assent to the things about which we care: we can indeed be careless about things that are nevertheless important to us (health,

for example), but for them to be objects of care, we have ourselves to accord them importance for us. We may cultivate such concerns, but things that are important to us nevertheless do not feel as though they are freely chosen, as though picked out from a catalog or an identity parade of candidate importances. This means that the person who cares about something important to them may be subject "to a familiar but nonetheless somewhat obscure kind of necessity, in virtue of which his caring is not altogether under his own control" (Frankfurt 1998, 86). Of such a person, we may curiously but still reasonably say that "it is not by his own voluntary act that his will is what it is" (88). The circularity of caring about the things that are important to us because we care about them derives in part from the fact that it involves this "volitional necessity," as Frankfurt terms it (86), the one who is both subject to and the subject of it being "simultaneously both active and passive with respect to the same force" (88).

Frankfurt (1998) distinguishes the field of ethics, which "focuses on the problem of ordering our relations with *other people*" from the study of care, which involves the self-relation of "deciding what to do with *ourselves*" (80). Since his concern is mostly with the latter, he does not concern himself with the interpersonal relations of Mansfield's "importance of importance," in the concern with being thought important oneself. But his argument is not without implications for understanding this concern. The desire for importance blends ethical relations and relations of self-care in that it is really a modification of our self-concern, to encompass the expression and effect of the importance to us of our importance to others. Indeed, it may well be that we commonly undertake some kind of assay of how our concern with what we care about may be regarded by others as a necessary part of every sort of concern for what we care for. In liberal and nonauthoritarian societies, where they still persist, it is taken to be a general principle of importance that people should have things that are important to them. The importance of importance may take an exaggerated form, both needy and demanding, when that act of internal assay moves from being an appraisal to being an injunction, or when the force exercised upon ourselves in relation to what is important to us is directed outward to become coercive on others. In such a case, what we wish is to occasion in others the volitional necessity, or involuntary subjection to their own willing, that caring about things involves. Being important to others is a colonization of their own autonomous and self-forming powers of self-subjection. Where the objects of my concern that are important to me render

me actively passive, my concern with my importance to others renders them in my eyes passively active.

We may perhaps say that the thymotic drive for recognition and respect is the drive to deflect auxiliary importance *for* into autonomous importance *as*—to reduce the relativity or instrumentality of importance in order to concentrate in oneself the reputation of some all-purpose or omnidirectional importance-in-general. The VIP, or Very Important Person, seems to have entered British English from military slang during the 1930s. In fact, the first *OED* citation of the phrase, from a scene in Compton MacKenzie's 1933 comic spy thriller *Water on the Brain*, explicates it not as Very Important Person, but "Very Important Personage" (111), the slightly puffy word *personage* hinting at the dummy condition of ascribed importance, since a personage is both an ideal kind of person and for that reason the idea or effigy of a person (in fact, a kind of impersonation). The more important you may be, the more your importance may come to be in embodying the autonomous idea of importance itself, separated from allonomous kinds of importance-for. A brigadier general or monarch is important in the sense that they exist in order to be regarded and treated as figures of importance. They may have certain ceremonial functions to perform—inspecting battalions, opening parliament—but the function of those ceremonies is not to do something that might otherwise fail to be done but to secure the sense of their ceremonial importance. So the most important thing that the VIP, or the MIP, the Most Important Person, does is to perform the kind of actions that testify to the ineffable importance of such acts.

The duality is exquisite here. Such persons come within an ace of the condition of embodying the desiderated importance in and of itself, that transfiguration of accessory importance into essential importance. And yet such ceremonial importance remains accessory through its very self-reference, subordinated as it is to its function of maintaining the importance of importance, or keeping alive the idea, which must mean other people's idea, along with the ideas they may have of the ideas of other people still, of importance in itself. No nondelusional sovereign has been able to keep from themselves for long the awareness of their crushing subordination to their own sovereignty (which is therefore, of course, not in the least their own).

It is important therefore that the idea of importance must always have something vague and unspecified in it. "Important" and "importance" are recurrent words for W. H. Auden, who makes them do some very characteristic

work. Indeed, one might say that the elusive importance of importance is the deflective theme of most of Auden's work, and his poetry is a laboratory in which the different measures and modalities of modern importance are put into the scale. In his "In Memory of W. B. Yeats," the word summons up the possibility that "A few thousand will think of this day / As one thinks of a day when one did something slightly unusual" amid "the importance and noise of tomorrow" (1991, 247). In "Dover," the port is perched "On the edge of a sky that makes England of minor importance" (149). Auden often poses historical importance against the unimportance of the habitual or unremarked, in order to suggest their unexpected interchangeability, most famously perhaps in "Musée des Beaux Arts," in which "the ploughman may / Have heard the splash, the forsaken cry, / But for him it was not an important failure" (179).

Auden (2002) was wary of claims for the importance of poetry, flatly insisting that it "makes nothing happen," and resisting the adoption of what he called "the Myth," which he characterized as "a set of values and ideas which are impersonal and so break the one-to-one relationship of poetry to experience by providing other standards of importance than the personally interesting" (156). In fact, though, inasmuch as Auden's poetry might be said to have as its recurring preoccupation the concern with importance, and in particular the importance of poetry, this may be said to be poetry's and his own animating Myth. Auden (1945) introduced the *Collected Works* he rather self-importantly issued at the age of thirty-eight with the dismissive remark that the bulk of any poet's collected works must consist of "pieces he has nothing against except their lack of importance" (vii). He described a way of testing whether a young man announcing that he wants to be a poet is likely to end up a good one:

> "Why do you want to write poetry?" If the young man answers, "I have important things I want to say," then he is not a poet. If he answers, "I like hanging around words listening to what they say," then maybe he is going to be a poet. (Auden 1996, 343–44)

For Auden it was only possible to conceive the importance of poetry if one acknowledged the wearisome vacuity of most of the claims made on its behalf, or on behalf of its putative practitioners. Reviewing an edition of Keats's letters in 1951, Auden (2008, 265) wrote that "dedicated artists are liable to suffer from two complaints, a humorless over-earnest attitude toward art, and a lack of ordinary social responsibility, a feeling that what they are doing is so important

that it is the duty of others to support them." Auden uses the word "important" in the ordinary sense quite frequently, often with a teasingly pompous refusal, when alluding to "important poets" in particular, to be more explicit as to the nature of the importance. But he is also sensitive to the fact that importance is a matter of import rather than matter. In a broadcast for the BBC in 1953 about *Huckleberry Finn* and *Oliver Twist*, he pointed out that

> in the States, money, which is thought of as something you extract in your battle with nature, represents a proof of your manhood. The important thing is not to have money, but to have made it. Once you have made it you can perfectly well give it all away. (Auden 2008, 381)

Auden ends a 1941 essay on dying words with a paragraph that balances the solemn settling of accounts with the arbitrary and off-center:

> I think often of ridiculous, crazy, incompetent old Lady Hester Stanhope whispering *"It's all been very interesting,"* and then dying far from home with her nose in the air. If when my time comes, I can show even half as much courage, the mortician may paint me all the colors of the rainbow, the columnists come out every morning with an entirely new explanation of the World Crisis, and the telephone bleed to death under the stairs, but I shall not care. (Auden 2002, 148)

In *The Dyer's Hand*, Auden states the alternatives that recur throughout his writing about poetry:

> The material with which the poet starts is a crowd of recollected historic occasions of feeling. Some of these may be called Outstanding, others Significant. An outstanding event is the sort one reads about in the newspapers or puts down in one's diary; a significant event is one which one may hardly notice at the time but which on reflection seems to hide some important secret. (Auden 2008, 551)

The temporally distributed nature of importance, suggesting that most important things are things of which the import is recognized only once it can do less good than it previously might, is observed in the note of the first, longer version of "At the Grave of Henry James" that

> the actual self
> Round whom time revolves so fast

Is so afraid of what its motions may do
That the actor is never there when his really important
Acts happen. (Auden 1945, 128)

Reflecting on "What griefs and convulsions startled Rome / Ecbatana, Babylon," Alonso, in *The Sea and the Mirror*, remarks, "How narrow the space, how slight the chance / For civil pattern and importance" (Auden 1991, 417). The Second Wise Man in *For the Time Being* similarly asks, "who knows if it is by design or pure inadvertence / That the Present destroys its inherited self-importance?" (369). In an address to the Indian Congress for Cultural Freedom in 1951, Auden (2008) articulated his suspicion of the earnestness of being important:

> Because what I make are verses which say something, it is my duty to see that as far as I know and so far as it goes, what they say is true and not false. How important the truth may be is not for me to say. Indeed if I once started thinking about importance I shall immediately start lying. (Auden 2008, 246)

Perhaps at the center of Auden's work is "The Fall of Rome," which replays the comic-solemn collision of accident and destiny in a series of vignettes imagining how the everyday ways in which our own end of days might evidence themselves: "Fantastic grow the evening gowns . . . the muscle-bound Marines / Mutiny for food and pay" (1991, 332, 333). Two forms of unhistoric act end the poem: the record of the futile protest of an insignificant clerk, and the approach of a new era of unwrittenness in the reclaiming of space by nature:

> Caesar's double-bed is warm
> As an unimportant clerk
> Writes *I DO NOT LIKE MY WORK*
> On a pink official form.
>
> Unendowed with wealth or pity,
> Little birds with scarlet legs,
> Sitting on their speckled eggs,
> Eye each flu-infected city.
>
> Altogether elsewhere, vast
> Herds of reindeer move across
> Miles and miles of golden moss,
> Silently and very fast. (Auden 1991, 333)

The interest of Auden's interest in importance is that he lived through and partly documented an era in which the affective grammar of importance may have changed its character. He inherited what would by the end of his life have begun to be a rather antique distinction between the spheres of the private and the public, the "individual" and "society," which were staples of English Literature examination questions for most of the twentieth century. In the poem "Numbers and Faces," those who love small numbers "go benignly potty," while those adherents of the general life, who embrace big numbers, "go horribly mad" (Auden 1991, 623). In his 1951 address, Auden makes the point that we must all in fact simultaneously inhabit the two worlds of "faces" and "numbers":

> There are two real worlds and we inhabit both of them. One, the natural material world, the physical world, the world of mass, of number, not of language. A world in which freedom is indeed consciousness of necessities, a world in which justice means equality before the law of physics, chemistry, physiology. And then there is the other world, the historical community of persons, the world of faces, the world of language where necessity is the consciousness of freedom and justice is the command to love my neighbour as myself, that is to say, as a unique, irreplaceable being. (Auden 2008, 248)

Though he continued throughout his life to consider the commuting between the realms of the general and the individual life, his tendency increasingly was to defend the latter. In 1951, however, he pointed to the consequences of mistaking one realm for the other:

> Unreality comes when either world is treated as if it were the other one. The ancient unreality was to treat the natural world as if it were a world of faces producing a magic polytheism. The new modern unreality, and even more dangerous, is the treatment of persons as if they belong to the world of numbers, as if they were only documents. And with that unreality, needless to say, back come the fetishists, the orgiasts. (Auden 2008, 248)

In the seventy years since those words were written, a mutation has taken place in "the world of numbers," as evidenced and perhaps even to a degree accomplished by the phenomenon of personal computing (a phrase which in itself seems to collapse together the worlds of face and number). In "the new form of totalitarianism" that consists of treating persons as though they were numbers, Auden saw "animism stood on its head," but what seems to be

happening in the world of personalized number is in fact a reversion to the "magic polytheism" of an animistic view of the world, only this time projected not through small numbers but through large numbers, indeed through the quantical quality of numerized magnitude, made thrummingly mythical.

Pierre Bourdieu marked out in his book *Distinction* the beginnings of a demotic generalization of aristocratic forms of refinement, finding in the practices associated with the "aesthetic" a social play-space, than which nevertheless nothing could be more serious and socially systematic, in which the act of distinguishing is itself marked out of and made socially distinctive:

> The antithesis between quantity and quality, substance and form, corresponds to the opposition—linked to different distances from necessity—between the taste of necessity, which favours the most "filling" and most economical foods, and the taste of liberty—or luxury—which shifts the emphasis to the manner (of presenting, serving, eating etc.) and tends to use stylized forms to deny function. (Bourdieu 1984, 6)

Seriousness here declares itself in the principle of the unimportance of importance. Bourdieu (1984) made sure that there would be no difficulty for his readers in making out his lesson, that "art and cultural consumption are predisposed, consciously and deliberately or not, to fulfil a social function of legitimating social differences" (7), making the act of aesthetic distinction nothing but a machinery for making social distinctions and, risibly enough, distinguishing between those who are equipped to make distinctions and those who are not. We can recognize here a repetition of the Aristotelian distinction between the serious man, who is capable of distinguishing what is serious from what is not, and the gullible clown, only moved from the sphere of morality to that of the choice and consumption of goods. The working classes oafishly choose consumption, while the aristocratic remnants consume choice, or rather choosiness. It is an elegant and, in its own way, aristocratic argument, paradox being a mode of discrimination raised to the higher power of comedy.

Bourdieu's (1984) conclusion in both senses turns on the distinction between raw quantity and cooked quality that has structured his entire investigation. This is replayed as the vulgarity of a Marxism that depends on the absolute givens of class position, and the theoretical refinement of the doctrine of the "relative autonomy of the logic of symbolic representations with respect to the material determinants of socio-economic condition" (483). We

must, he argues, get beyond a distinction between a purely quantitative kind of "social physics," which assigns classes by means of percentages, and the idealism of pure semiology, which seems to allow for the reality of self-representation. Bourdieu offers a reformulation of this stand-off between statistics and semiotics in terms of Marx's famous promise of a history made but not under conditions of its own making:

> Position in the classification struggle depends on position in the class structure; and social subjects—including intellectuals, who are not those best placed to grasp that which defines the limits of their thought of the social world, that is, the illusion of the absence of limits—are perhaps never less likely to transcend "the limits of their minds" than in the representation they have and give of their position, which defines those limits. (Bourdieu 1984, 484)

Importance is standing, eminence, or exalted status; importance has a vertical dimension. It is noble, in the sense that a gas like xenon (Greek ξένον, stranger) is described as noble—namely, that it does not consort or combine promiscuously with what is not itself, unlike the thoroughly ignoble oxygen, which will compound with anything. But this dimension is dynamic, linked not just with superiority but with the striving for uprightness that resists or overcomes the pull of gravity. This is the Shakespearian force of importunity in importance. But the most important feature of importance is spatial in a more expanded sense, for it connotes expansion itself. Uprightness is arboreal, aspiring to height and distinction; importance is gaseous, though also territorial, seeking volume and the occupation, not of actual space, but the space of others' regard and attention. The forms of ascetological self-training identified by Peter Sloterdijk (2013, 113) conduce to an ethics of the vertical; but the striving for importance or, what may be more important, the striving against unimportance, is in its essential features voluminous. The sense of importance derives from a primary apprehension of mass and matter. It strives, not against gravity, but against spatial paucity. The ethics of the vertical aim at transcendence; the importance of importance is simply cumulative, and so without finite aim.

This is why importance is so much more obviously quantitative, and subject to the desire for and satisfaction of measure. As one tracks the appearances in print of the word "importance" from the middle of the sixteenth century onward, it is notable how often it is accompanied by indications of

measure—in references to "great importance," "most importance," "light importance," "no importance," "no small importance," "lyke or less importance." Importance is great and weighty, but is conceived as a matter of greatness and weight themselves. Just as Richard Feynman's explanation of the conservation of energy in terms of a mother carefully accounting for the number of toy blocks scattered around the house by her toddler at the end of each day concludes that, when it comes to energy, the accounting is all, such that *"there are no blocks"* and "we have no knowledge of what energy *is*" (Feynman, Leighton, and Sands 1963, chap. 4, p. 2), so the material imagination of importance leads us to something like an abstract kind of physicality, which has quantitative variability but no variability of quality. Importance is just a kind of extensible *hyle*: indifferently qualityless esteem-stuff, the more the better, though it is unclear in what kind of warehouse it may be stockpiled.

This may further explain why the importance of importance seems so very well adapted to the paradoxically mensurative intensity characteristic of modern digital communications, which allow for, and can so rarely get beyond, the simple agglomeration of votes, views, likes, and followers. The idea of importance is well adapted to the power laws that govern the distribution of random events—for example, in the distribution of wealth, or the number of titles sold in the best-seller lists: in the Pareto distribution, a very small number of participants in an economy, whether of wealth or fame, tend to monopolize the top ten or so positions in the rank order, with a very long tail who get only nibbles and sniffs at the total resource available. It may also explain why importance is so competitive. If I aspire vertically, to saintliness, say, to athletic or artistic excellence, or some other form of distinction, my aim is to leave the world of the given behind, and so to put a distance between myself and the world, as well as my rivals in it. When I crave importance, I seek to colonize and engorge the world, closing up every interval and monopolizing the available esteem-space. Esteem is estimation, of uncertain etymology, though some still accept the odd suggestion that it is from *aes* + *tumo*, "I cut bronze" (de Vaan 2008, 28). It is scalar rather ascensive. The very fact that importance implies import means that it implies implication: it contains the idea of some capacity to be, as we say, rolled out, over a very large extent, which seems all the larger for being as yet implicit or unspecified. Accounts of importance seem to verify the intuition we have about important things, or the intimation we want them to give, of having relevance or interest on a larger rather than a smaller scale. "An event is important," Jonathan Harrison

(1978, 223) ventures, ". . . if it affects, for good or ill, a large number of people to a very great extent." Dorothy Emmet quotes approvingly, in support of her argument that important things are those that relate to large issues, G. H. Hardy's account of serious as opposed to trivial mathematical theorems: "We may say, roughly, that a mathematical idea is significant if it can be connected, in a natural and illuminating way, with a large complex of other mathematical ideas" (Hardy 1940, 29, quoted in Emmet 1946, 241, n. 1.).

One may measure the distinction between the principles of distinction and of importance in terms of their characteristic affects. Distinction distinguishes itself from the realm of feeling, in different forms of affective nicety, or suspensive judgment. It seems quite clear, by contrast, that importance has become compact with a peculiar kind of ravening anger. The thymotic drive to assert one's importance makes it clear that politics, in Harvey Mansfield's (2007) formulation, "is about what makes you angry," adding that "you can tell who is in charge of a society by noticing who is allowed to get angry and for what cause." Being able to be angry is a privilege rather than an affliction, though part of the privilege is to be entitled to represent your title as an affliction, something over which you have no choice, but rather a duty to blaze abroad and avenge. This kind of anger has to do, not with right and wrong, or with the innocently spontaneous desire for betterment, but with the feeling of *being* wronged, the superb and swelling sense of magnificence that comes with the brandishing of your dangerous right to be the subject of wrong. Most of the truly oppressed—animals, children, the starving, tortured, and sick unto death—have no recourse to such moral opportunity or importunity. In most parts of the animal world, being in the right is not what matters in circumstances of conflict so much as how lucky you feel with regard to the forthcoming fight. In human societies in which so much conflict is diffracted into symbolic terms, the anger of the aggrieved is a way for them to make their own luck, seizing their lack of opportunity with both hands, rather than having to take the risk of taking up arms. As the creakingly chivalric cast of the word suggests, *grievance* belongs to an affective economy of honor, dignity, and repute rather than of competitive desire and interest. It is focused much more on matters of insult and offense than on matters of inequality and disadvantage. This is not to say that deprivation and disadvantage are entirely irrelevant to the assertion of importance, but is rather to say that they are seen not as injustices in a rational-legal sense but as insults to the dignity of an individual or group.

This kind of assertion of importance has become unignorable in what is called the politics of identity. This is sometimes explained as a widespread return, in a world of anonymous and interchangeable experiences, of a sense of the importance of identity to people. We might just as well say that identity has become the vehicle for the affirmation of importance. What needs to be understood in this is the inseparability of the importance of identity from the development of strongly symbolic collectivity, which has turned the question of identity into one that can function in a psychopolitical economy of importance. When I was young, identity was spoken of almost exclusively as a psychological matter, to be come at, for example, through the thematics of phenomenology and existentialism and employing the language of some version or other of psychoanalysis, often of a Jungian flavor. Identity was not only personal and private; it was privative, and thus strongly marked by the need to feel apart from or unassimilated to larger wholes. Identity was formed, that is, through disidentification, of the vehement and scrupulously self-doubting kind characteristic of the adolescent, who, like the fierce hermits of the early Christian era, would resort to various kinds of wilderness or, failing that, simply forms of wildness, in the effort, as used indulgently to be said, to "find themselves." Those who emerged from the wilderness found the skeptical slicing and dicing of deconstruction, which did not until the 1980s have anything to do with politics, and the denunciations of the bourgeois subject highly congenial. Identity politics of our contemporary kind came into being, from the 1970s onward, as identity ceased to refer to the dark night of mystical-psychological intellectual agonies and became identified with the psychopolitics of identification, thereby becoming associative rather than privative, and allowing for militant forms of organized solidarity. As a result, identity now means the opposite—indistinguishability from others rather than identity with oneself—of what it meant fifty years ago. One no longer has to venture into the dark wood of self-discovery when one's identity can be found ready-made.

We may register, as a local perturbation of this system, a certain shuttling of prepositions. Up until the 1980s, I fancy, the usual preposition attached to acts of imaginary or imaginative identification would have been *with*: the first examples in English of the usage "identify with," meaning to model oneself on or feel oneself to be identical with and perhaps, more precisely, to feel the desire to be identical with, date from the early eighteenth century. During the twentieth century it became a common expression in literary-critical discussion; typically, readers of books would say they identified *with* Jane Eyre,

Heathcliff, David Copperfield. To identify *as* was almost always transitive—that is, it involved some active entity X identifying some object Y as Z, in the sense of establishing or confirming what it was: identifying somebody as the perpetrator of a crime in an identity parade; identifying a bright dot in the sky as the planet Venus. The first example given by the *OED* of *identify as*, meaning to assume and, increasingly, affirm oneself to be, is from 1975.

Sometime over the following decade, two new features were increasingly attached to this usage. One was the sharpening of *identifying as* into an action of assertion, actual or implicit, often in the sense of a bid or laying claim. Such an assertion is the action of X identifying Y as Z made reflexive, such that X identifies X as Y, Z, or A. "Identifying with" a character in a novel is usually a private and often not even a conscious matter, while "identifying as" will almost always involve some performative action, typically a formal declaration, such as "I identify as," in something of the same way that you can only really vow something, or be sure to be taken to have, by using some variation of the phrase "I vow that." It is true that nowadays identifying-as is increasingly being taken up into administrative or bureaucratic usage (for example, in university enrollment procedures), but it remains the fact that identifying-as involves some form of performative "hereby" function. Identifying-as often occurs in an announcement, sometimes even a kind of annunciation.

The second feature of identifying-as is that X identifies X, not with some person, ideal or otherwise, but with a group, type, or category of being. The difference between identifying oneself as working class (which might easily involve a certain surprised realization, of a well-I-never-I-suppose-I-must-be character) and identifying as working class lies in the fact of laying claim to a certain condition and asserting a right to insist on being so considered. It is perhaps the move from confession to profession, from having an intuition to making a bid. It is the move from self-recognition to self-promotion (from *pro* + *movere*, to cause to move, or move on behalf of). Identity is no longer an inside-out matter of how you might feel about yourself, but rather an outside-in matter of how you might seem to others (or how you feel about how you think you seem).

It is this assertiveness that makes identity a matter of such importance, that is to say, something about which, in Harvey Mansfield's terms, one has a mandate, and perhaps increasingly a sense of a duty, to be angry, and angry pride in that duty. Before 1970, the one thing one could be assured of was that one's identity could not without absurdity or bad faith be reduced to one's

social "role" or position: in the clinching final line to Neil Innes's 1968 song, "I'm the urban spaceman, babe, but here comes the twist. / I don't exist." After 1970, one could assume the right to be taken to be identical with one's role or position.

One of the striking features of this right is its growing quality of provocative overreach. On the one hand, identity is no more and no less than what you look like, or are taken to be. On the other, your inner conviction as to what you really are, despite appearances, is believed to be able to trump what others take you to be. So this kind of assertion derives much of its verifying force from the countermanded suspicion of imposture. In this kind of contingent destiny, identity is therefore both allowed to be "fluid" and required nevertheless to be metaphysically immutable. This is the daring *credo quia absurdum* ju-jitsu logic of Tertullian (2016), arguing against the reservations of Marcion regarding the unlikelihood of the incarnation: "Et mortuus est dei filius: prorsus credibile est quia ineptum est. et sepultus resurrexit: certum est, quia impossibile" (18): "The Son of God died: it is completely credible because it is crazy. He was buried and rose again: it is impossible so must be true" (my translation). Importance is usually kept at a dignified distance from absurdity, but not when questions of dignity are fundamentally in question.

It would be easy to think of externalized identity as a surrender of an ideal of personal identity to the alienation of abstract categories, or of face to number, in the terms borrowed by Auden from Rudolf Kassner's *Zahl und Gesicht* (1919). In fact, however, it has become perfectly clear over the last half century that the realm of number is not the bleakly inhuman scene imagined by Auden in "The Shield of Achilles":

> A plain without a feature, bare and brown,
> No blade of grass, no sign of neighborhood,
> Nothing to eat and nowhere to sit down,
> Yet, congregated on its blankness, stood
> An unintelligible multitude,
> A million eyes, a million boots in line,
> Without expression, waiting for a sign.
>
> Out of the air a voice without a face
> Proved by statistics that some cause was just
> In tones as dry and level as the place:
> No one was cheered and nothing was discussed;

Column by column in a cloud of dust
They marched away enduring a belief
Whose logic brought them, somewhere else, to grief.
(Auden 1991, 596–97)

For abstraction is no longer the opposite of life. The last half century has brought the passion of the abstract, and a domination by the fiercely intransigent libido of typology. It is as though the abstract categories distilled from the complexity of experience by sociological analysis were being greedily reintrojected as modes of the *Lebenswelt* itself. The terror of being absorbed by system, category, and mechanism has become the dread of failure to coincide with one's thoroughly exteriorized identity, and consuming rage at anyone who refuses to acknowledge the correlational absolutism in which the gentle intuition that there are many different kinds of people is pinched into shriveling conviction that there are only kinds of people.

This could only have been accomplished by a mediation of the realms traditionally distinguished by Ferdinand Tönnies in 1887, and elaborated by later sociologists, especially Max Weber, as Gemeinschaft and Gesellschaft, the first characterized by community relations based on feeling and tradition, the second consisting of abstract, impersonal associations based on contract and calculation. Introducing the two concepts, Tönnies wrote that

> all intimate, private and exclusive living together, so we discover, is understood as life in Gemeinschaft (community); Gesellschaft (society) is public life—it is the world itself. In Gemeinschaft with one's family, one lives from birth on, bound to it in weal and woe. One goes into Gesellschaft as into a strange country. (Tönnies 1963, 33–34)

One may leave aside the vexed question of whether these concepts really name states of being and forms of actual organization or rather perspectives on different styles or aspects of collective living. This question can be suspended because of the revelation that both kinds of arrangement depend in any case on relations of mediation, the means by which each form of society can produce and sustain an image or understanding of itself. The very conditions of Gesellschaft have produced a third, mediating realm, of mediation itself, as exemplified by the range of actions and apparatuses known casually but aptly as "social media." As has often been noted, at first in a kind of utopian register, social media overcome the distance between the global and the local, enabling one to have immediate relations with persons and processes that

would in earlier times have seemed far removed by physical and social distance, and therefore by the time taken for the passing of a message to and fro. The demand for data privacy only proves that privacy is now in fact no more, or less, than a state of exception within the world of data mediation, not a realm set apart by any qualitative difference that it might be possible to rescue or redeem. The idea that one could and should "take back control" of one's data (Véliz 2020), as though one had once had it, but had inadvertently given it away, makes it clear that we have passed into a state of existence in which one voluntarily accedes to the idea of privacy as self-management, or a modulation of the administered society in the direction of self-administration. A medieval peasant had no control over their data to take back. Privacy is the name for a remission or intermission: the suspension of transmission that transmits one's suspension like a carrier wave (Connor 2019b, 19–27).

It seems reasonable, even unexceptionable, to most that the preoccupation with identity arises naturally from the fact that identity is important to people—that, in Sartre's (1984) formulation, conscious being is "*a being such that in its being, its being is in question*" (xxxviii). The oddly indigestible fact, however, is that being is not like this really, not for most of the time. Indeed, the striking point about identity is precisely how banal, because universal, it is, since, as Sartre adds, "There is no being which is not the being of a certain mode of being" (xxxviii). Like the certainty of personal death that is shared with every other person who has ever been and ceased to be, the uniqueness of every human person is a universal and therefore trivial feature. The empty accident of my being unique, in so many respects and along so many measures, is exactly the thing that I have in common with everybody else, and so the least distinctive thing about me. Just as there is no necessity for me to have the particular kind of being (embodiment, history, aptitude) I have— though there is a necessity for me to have a particular kind of being—so there is no necessity for the question of my being to have any particular kind of importance.

Why then the importance attached to being? One may say that this is a mere survival of an instinct for survival itself, a vigorous preference for persistence in being over extinction, which seems to make it impossible to separate existence from care or concern—the principle that Martin Heidegger calls *Sorge*, or the mattering of being to us. Perhaps the importance of this sense of the importance of our life is just that it makes existing a matter that we must take seriously rather than a matter of indifference.

Importance does not arise spontaneously in each individual soul as something to be expressed or defended against degradation, but is rather an effect or, perhaps more precisely an infection, of the friction of striving. Maine de Biran (1841) derived the whole of the experience of personal identity from the feeling of effort, "a power of willing and of effort identified with personality itself" (205; my translation). "An effortless being would not suspect any existence, not even his own," writes Arthur Robinson (1914–15, 261), a compression of experience into will aptly named by Gaston Bachelard (1948) a "cogito of striving" (78; my translation). Biran derives psychology from a sort of primary physiology of resistance, but does not develop an analysis of the forms of resistance against and between resisting centers of being—that is to say, other subjects—seeing psychic striving as exercised against the mute insensate other of inert matter. But we may assume that in fact the primary sensation of will is brought into being in a social context of striving against other strivers. The importance of this is that it keeps the relation of striving alive by creating a kind of economy of striving. The importance of importance, the will to assert oneself over or against others, is that it keeps the idea of importance, or the need to strive for importance, alive in rivalry.

Importance has become identical with the generalized sense of import provided by ever denser forms and occasions of mediation. Mediation mediates nothing but the striving to open and occupy more attention space, drawn together and given tension by the quality of pure quantality that digital communication provides. One of our most tenacious assumptions is that communication is a necessity and an unarguable good, such that the answer to aggressive communication will always be taken to be more or better communication, with better communication never meaning reduction, like the tattoo that can be obliterated only by being overwritten. Communication creates a community of striving to be heard and to be recognized. We are unlikely any time soon to reach and, even less likely to act on, the conviction that less communication makes for more peace and more freedom.

The politics of identity helps to identify an essential principle of importance, whether it is the importance of things or of persons. For importance is always a straining, pressure, or bearing upon. Even in its inertly symbolic forms, such as the importance of a monarch or archbishop, there is the sense that important things urge, importune, or make demands. The importance of the idea of identity in forming and sustaining the sense of the important itself derives from the cogito of striving spoken of by Bachelard, and the intolerable

insipidity of the idea of identity made from what something hidden from us chose, the trifling universality of our merely accidental uniqueness. Hence the strange fervor attaching to the idea that one must in a sense actively and transitively be the being one is, making something, as we might once have said, of ourselves, performing the duty of being ourselves that we owe to ourselves, as a self-imparted and self-imported duty. Like the serious man, we give meaning to our lives by striving to have meant them, to have been in earnest about them, forging essence from existence. Identity becomes important because it seems best fitted to maintaining the importance of importance itself, the urging and impulsion to resist nonresistance, catching and singing the sun in flight.

This association of importance with striving, a striving for nothing less than being recognized as important, requires an antagonist, which it finds in the condition of nonrecognition itself. No rational or attentive being is capable of hiding for long from the observation that most of the social world and all of the natural world decline to offer their recognition of the atomic and accidental self. The striving for recognition makes that indifference its own by turning it into grievance, the sense that not being recognized is a wrong done to one, the one that is summoned to life by the irritant sense of the indifference of the many, that animates the striving itself. One harvests the possibility of importance therefore from the very sting of not being thought sufficiently important. The fact of my individual insignificance may be a provocation to strive for recognition, to make my name in the world, but it is only the most devotedly pathological kind of narcissist who can regard this as a wrong done to me in particular, provoking the duty in me to right that wrong, since most of those who ignore me do not do so actively and culpably but simply because they are ignorant of my existence.

But this unignorable fact that most ignorance is not nonrecognition helps define the utility of gathering the cogito of striving into aggregate forms. The development of ideas of collective identity, or indeed, what we must acknowledge as the collectivization of identity through identification practices and appetites, is based almost entirely around groups who may be said to have been the subject of wrongs, either through active persecution or through the passive persecution of exclusion from notice, or of having no account taken of them. This kind of collective identity allows for the establishment of cadres, guilds, and finally corporations of grievance. As Harvey Mansfield (2007) notes, such groups care more about rights than benefits, since the violation of

rights gives one the right to be angry, such that "the rich are not allowed to get angry unless their democratic rights are violated." The right to anger is much more fulfilling than any merely satisfied or guaranteed right, such as the right to vote, since anger is a means of ensuring one's right to be in the right. The baboon-like prickliness of the psychopolitics of offense, or perhaps more precisely the psychosocioendocrinology of generalized androgenic escalation, allows for the conversion of insult into exulting, its etymological variant, from *ex +salire*, to leap out, resiling from *in + salire*, to leap in or at.

The anti-economy that finds investment opportunity in disadvantage allows for accumulations of historic wrong equivalent to the assets and deposits that make up Peter Sloterdijk's (2010) freeze-dried "rage capital" (146) through the least laborious of affiliations, allowing for access to the kind of indemnity fund assumed by the feminist Olive Chancellor in Henry James's (2009) *The Bostonians*, who "considered men in general as so much in the debt of the opposite sex that any individual woman had an unlimited credit with them; she could not possibly overdraw the general feminine account" (132) The principle of identification not only establishes the cohesion of the disrespected group, giving it reason to strive against the wrong of nonrecognition, but imparts that cohesion to all members of other groups, in a world in which there are held only to be identifiable and identificatory kinds of people, and no singleton sets.

Since all such forms of identity-through-identification involve the loan or larceny of being, it is not surprising that they should be subject to piratical attempts at borrowing from those suffering disadvantage-envy, the accessory grievance of a lack of grievance against which tonically to strive. Thus members of putatively culpable categories may crave and even be urged to indulge the temporary ticket-of-leave of joining the struggle against their own culpability. Males are similarly sometimes allowed a conditional participation in the authenticating struggle of femaleness.

Yet the task of making identity, and indeed the construal of identity as a task rather than a condition, must always strive against heteronomy, the fact that we can only be important in ourselves in the ways in which others take us to be, and the misrecognition that consequently comes from recognition. The most that can be achieved is the guided accident of the task accepted by William Cowper, in the poem that ended up being titled "The Task":

> The history of the following production is briefly this. A lady, fond of blank verse, demanded a poem of that kind from the author, and gave him the SOFA

for a subject. He obeyed; and having much leisure, connected another subject with it; and pursuing the train of thought to which his situation and turn of mind led him, brought forth at length, instead of the trifle which he at first intended, a serious affair—a Volume. (Cowper 1995, 113)

All instances of the identificatory collectives of striving are subject to the dissolutions of time, and it is oblivion against which they strive most ferociously and desperately. Like the world bank of rage established through communism and still trading in local markets, the identificatory collectives of thymotic importance act as insurance against the forgetting of importance, which, it is feared, unless unchecked, will spread like an epidemic, silently and very fast.

4 Solemnity

Solemnity, like seriousness, of which it is both an accent and an apotheosis, is part of the process whereby human beings regulate their lives in time. At its heart is the question of persistence, of how to stay put and how to stay the same, under temporal conditions that make mutability unavoidable. Solemnity mediates between the continual and the continuous. Solemnity shares in the definitional ambivalence of seriousness, in that although seriousness is intended to create and maintain continuity or life in series, seriousness itself is intermittent and discontinuous, tending to occur in episodes and outbreaks. Seriousness is, we must say, serial, a matter of continual repetitions rather than continuous process. It is the assumption of this book that it is the impossibility in practice for humans to be continuously serious that makes seriousness a specialized and unusual phenomenon, leading to the need for serious matters to be stylized or set ceremonially apart. As Emile Durkheim (2008, 164) observes, "There is no people among whom the great solemnities of the cult are not more or less periodic." And yet solemnity, whether formalized as ritual action or intimating this kind of formality through the suggestion of ritualized repetition, as a generalized sort of *déjà vu* or *déjà voulu*, seems also to project a vision of existence as made continuous by intention. Solemnity and the production and deployment of it in the process known as solemnization are ways of showing that we mean our lives to have meaning, not in the sense of standing for something, but in the sense discussed in earlier chapters, of having been meant, as we say that something is "meant to be," in the sense

of destined, from Latin *de* + *stanare*, to bind, make, fast, or cause to stand. As a term in archery, *destinare* has the specialized sense of aiming at, in common with *intendere*. Both are verbal tensors, which give shape and purpose to time by bringing it under tension.

Solemnity is a mode of magical assent, which gives to the one who assents the sense that they have licensed or even determined that to which they give assent, transforming agreement into assertion and accident into act. Solemnity is a mood rather than an act of mind, but it conceals the possibility or fantasy of its own judicature and executive office. Like so many pleasurable or significant acts and attitudes of mind, it intimates and enjoys its magical omnipotence, precisely through the action of putting the action aside from itself and giving it the impersonality of destiny. To *destine*, along with the rarer *destinate*, formerly existed as a transitive verb, meaning to fix, determine, or devote. From the seventeenth century onward, its usage was increasingly restricted to sovereigns and others of similar authority, until by the nineteenth century the impersonal use had come to predominate, so that now things that are destined are not thought to be destined by any human agent but by the obscurely impersonal fact and force of destining known as destiny. However, the erosion of personal action in destiny or destining is recompensed by the sense of certainty assented to and asserted in the mental action of recognizing and succumbing to destiny, as what has been meant to be, whereby one may, as it were, destine destiny. This may be related to the tendency to believe in what is called "immanent justice"—that goodness spontaneously prospers and badness is self-punishing (Mercier 2020, 162–63). The idea and feeling of solemnity participate in these psychosocial periodicities whereby things are made, and made to remain, serious.

The origin of the word *solemn* is not completely certain, but it seems likely that it preserves some reference to an idea of wholeness, from Proto-Italic *solno-* and PIE *sol(h2)-no-*, whole. These are cognates with Old Irish *slán*, whole, sound, from which derives the common Irish toast *sláinte*, cheers or good health. It is tempting to see some connection with Latin *soleo*, to be used or accustomed to, given that solemnities are customary procedures, and *solemnis* has often been understood to mean *solet annus*, it is celebrated annually, though the link is itself phonological and customary rather than strictly etymological.

Solemnity has an external and an internal dimension. Since the late fourteenth century, *a solemnity* has been used as the name of a ceremony of

particular seriousness or importance. In the Catholic Church, a solemnity is the name for the most important ceremonial days, ranking above feasts and memorials and typically celebrating the essential mysteries of the church (Christmas, known officially as the Solemnity of the Nativity of Christ, being the principal one) or events in the life of Christ or the Virgin.

Solemn events or procedures occur in the world and exert their force on their participants, and usually have a collective character. But solemnity also names a mood or feeling, of a kind that might be expected to arise at or be appropriate to a solemn ceremony or festival. The interlocking of object and subject in solemnity is characteristic of matters of seriousness. A solemn occasion, or sometimes the location or action associated with it (a solemn mass, for example), is one that is to be treated with due solemnity, and so derives its character from the feelings and behavior associated with it. But the solemnity due to a solemnity derives its meaning and force in turn from the sense of what is required of a solemn occasion. The solemnity of occasions is confirmed by the solemn feelings they are designed to occasion. Far from being absurd, this interdependence of circumstance and sentiment probably has a large part to play in the constitution of solemnity—though we will see that the potential for absurdity remains.

Solemnity has had a part to play in recent sociology of religion that tends to emphasize emotional experience and ritual over articles of religious faith. For Douglas Ezzy (2016, 270), "Religion is often oriented to this world and encompasses a range of emotions and aesthetic experiences, including solemnity, beauty, pleasure, joy and suffering," even though he maintains that "religion incorporates much more than solemnity." It may be, however, that solemnity does not exactly belong in the list of religious feelings that Ezzy produces, since solemnity may be thought of, not so much as an emotional experience in itself as providing the special kind of framing, emphasis, or tonality that makes the experiences of pleasure, beauty, joy, and so on religious, or spiritual. Solemnity is what solemnizes joy, grief, rapture, and devotion.

It may be, as John Carroll suggests, that some element of the feeling of transcendence has a part to play in the work done by the idea of the solemn, as embodied in different kinds of defrocked religion:

> The religious has not been disenchanted out of existence in modernity—if religion is conceived of in William James' broad terms, as primal reality to be approached solemnly and with dignity, and linked with some feeling of transcendence beyond the normal human plane. (Carroll 2012, 221)

Transcendence, as the sense of what is larger than or unencompassable by human powers, especially human powers to conceive, has been characterized by Gregory Gorelik like this:

> The transcendent experience is marked by a subsumption of the individual self in an all-encompassing reality. The boundary between the self and the outside world is broken and a more expansive perspective diffuses throughout all aspects of one's experience. All the while, the self fizzles out and gets replaced by something greater than one's self. Such experiences are often accompanied by the revelation of some heretofore hidden, in-expressible truth communicated by a higher intelligence or all-pervading sentience. (Gorelik 2016, 287)

But an experience of transcendence that were merely the sense of something immeasurably bigger and more powerful than one's self might easily, and one would think naturally, be an experience of simple jitters or panic. As indicated by the phrase *transcendent experience*, an experience of transcendence does not simply involve a dissolution of the ego, for, if it did, there would be nothing left in place to have any experience of any kind—or, more strictly, to have had it, for "an experience" as opposed to experience in general is an episode that must have an onset and come to an end. It seems clearly to be the case that transcendence is an experience simultaneously of what goes beyond the self and of the self elasticated in imagination beyond its own customary limits. It seems unlikely that animals without the degree of self-consciousness necessary to identify themselves in this way with what seems to dissolve their identity—or, more precisely, the capacity to make an object of themselves in order to reach beyond it—could have any kind of transcendent experience.

The two-sided nature of this apprehension, of going beyond oneself in such a way as to abide with one's self, would seem to be operative in the feeling of solemnity. Indeed, the most important feature of solemnity, which distinguishes it from states characterized as mystical ecstasy or rapture, is the degree of its containment. One may say that solemnity is an experience of subjection of the self to some power that is nevertheless constrained or focused rather than diffusive or solvent. Unlike sublimity, which flirts with a kind of vertigo, solemnity holds the experience of transcendence steady. Sublimity excites and accelerates; solemnity slows and solidifies. In solemnity, one might say, there is an agitation into gravity.

This mixture of expansion and containment may account for the affective ambivalence of religious solemnities, which are often thought of as celebrations as well as grave or chastening memorials. Emile Durkheim (2008), who saw the origin of the religious impulse in experiences of the collective effervescence by means of which human society "has the capacity to set itself up as a god," (161) nevertheless saw these experiences as solemnities. In such ceremonies, one can let oneself go while also seeming approvably well behaved. There seems to be a feeling of moral compulsion involved in solemnity, as well as, reciprocally, the solemnity of what we may feel as moral pressures, as instanced perhaps in Kant's (1997) famous association, in the conclusion to his *Critique of Practical Reason*, of the two things that "fill the mind with ever new and increasing admiration and reverence, the more often and more steadily one reflects on them: *the starry heavens above me and the moral law within me*" (133). For Durkheim (2008), this feeling of moral force, or of a force that we process as the pressure of moral command, comes from the fact that, in such experiences, humans feel that "this moral *tonus* depends on an external cause; but we do not perceive where or what it is. And we tend to conceive of it in the form of a moral power that, while immanent in us, represents something other than ourselves" (159).

Kant (1997, 66; 1915, 100) remarks intriguingly of the respect we have for authoritative moral examples, that "so *little* is respect a feeling of *pleasure* that we give way to it only reluctantly," and that "even the moral law itself in its *solemn majesty [feierlichen Majestät]* is exposed to this striving to resist respect for it." And yet he instantly and somewhat unaccountably adds:

> *So little displeasure* is there in it that, once one has laid self-conceit aside and allowed practical influence to that respect, one can in turn never get enough of contemplating the majesty of this law [*man sich wiederum an der Herrlichkeit dieses Gesetzes nicht sattsehen kann*], and the soul believes itself elevated in proportion as it sees the holy elevated above itself and its frail nature. (Kant 1997, 67; 1915, 101)

It seems plain that the solemn majesty of the law is not what we contemplate but rather the effect of the particular mixture of pleasure and displeasure in our contemplation, with which we can never be sated.

For William James, solemnity names the special kind of seriousness that attaches to religious experiences. Indeed, James comes close to defining religion as solemnity itself:

> There must be something solemn, serious, and tender about any attitude which we denominate religious. If glad, it must not grin or snicker; if sad, it must not scream or curse. It is precisely as being *solemn* experiences that I wish to interest you in religious experiences. So I propose—arbitrarily again, if you please—to narrow our definition once more by saying that the word "divine," as employed therein, shall mean for us not merely the primal and enveloping and real, for that meaning if taken without restriction might well prove too broad. The divine shall mean for us only such a primal reality as the individual feels impelled to respond to solemnly and gravely, and neither by a curse nor a jest. (James 1985, 38)

For James, solemnity seems both itself to be unmistakable and to mark out as unmistakably religious the experiences it accompanies.

> At their extreme of development, there can never be any question as to what experiences are religious. The divinity of the object and the solemnity of the reaction are too well marked for doubt. Hesitation as to whether a state of mind is "religious," or "irreligious," or "moral," or "philosophical," is only likely to arise when the state of mind is weakly characterized, but in that case it will be hardly worthy of our study at all. (James 1985, 39)

So religion must involve solemnity, and solemnity is the test and best proof that an experience is religious. Yet what is solemnity? Once again, the suggestion seems to arise that solemnity is not a feeling so much as the intensifier of feeling in general:

> This sort of happiness in the absolute and everlasting is what we find nowhere but in religion. It is parted off from all mere animal happiness, all mere enjoyment of the present, by that element of solemnity of which I have already made so much account. Solemnity is a hard thing to define abstractly, but certain of its marks are patent enough. A solemn state of mind is never crude or simple—it seems to contain a certain measure of its own opposite in solution. A solemn joy preserves a sort of bitter in its sweetness; a solemn sorrow is one to which we intimately consent. (James 1985, 48)

James is not quite clear here. If solemnity is characterized by a mixed state, bitter and sweet, sad and acquiescing, it is not plain what the "its" might refer to in the statement that "a solemn state of mind . . . seems to contain a certain measure of its own opposite in solution." Solemnity is here mixed with its

opposite and yet consists of this mixture, making it unclear what the opposite of that mixture might be.

So solemnity would not mean simple seriousness; it would mean taking seriously the commixture of seriousness and frivolity, rather than light-mindedly trying to purify either of them. In thinking about religious solemnity, James (1985, 75) believes, "We shall have abundant reason for refusing to leave out either the sadness or the gladness, if we look at religion with the breadth of view which it demands. Stated in the completest possible terms, a man's religion involves both moods of contraction and moods of expansion of his being."

The affective mixture of positive and negative is certainly a feature of many poetic evocations of solemnity, and perhaps especially those aiming to evoke religious states. Milton's "At a Solemn Musick" takes the form of an exhortation to the powers of "voice and verse" (and therefore in some wise to itself), to match the condition of the work of divine praise continuously kept up by angels:

> And to our high-rais'd phantasie present,
> That undisturbed Song of pure concent,
> Ay sung before the saphire-colour'd throne
> To him that sits theron
> With Saintly shout, and solemn Jubily. (Milton 2012, 21)

Solemnity here does not seem allied to gravity, but rather to a kind of joyous triumph, a sober intoxication and a chaste libidinousness. Samuel Taylor Coleridge's (1912) "Religious Musings" evokes the state of calm felt by one rescued by faith from terror as "a soft solemn bliss," shielded by the glittering armor of faith, "thus transfigured with a dreadless awe, / A solemn hush of soul, meek he beholds / All things of terrible seeming" (1.112). The ambivalence remains in the evocation later in the poem of the experience of the delight of heaven floating down to earth:

> When in some hour of solemn jubilee
> The massy gates of Paradise are thrown
> Wide open, and forth come in fragments wild
> Sweet echoes of unearthly melodies. (Coleridge 1912, 1.122)

Solemn jubilee announces the commixture of continence and abandon repeated in "fragments wild / Sweet echoes."

Solemnity is seriousness, but it is not ordinary seriousness or merely seriousness. It is seriousness striving to be lifted above itself, a seriousness that takes itself seriously, the seriousness, perhaps, to which Larkin (1988) seems to allude in referring to "a hunger ... to be more serious" (98). It is seriousness set apart, intensified, purified, made exemplary, as the sign of itself, but yet in the process seriousness generalized, made more all-including. Solemnity is therefore seriousness in some strange way *solemnized*. Such seriousness seems in part to consist of a wish not to pretend or to delude oneself. For Ernest Renan, whom James (1985) quotes as an example of the "*je m'en fichisme* [that] recently has been invented to designate the systematic determination not to take anything in life too solemnly" (38), it is something like the dignity that comes from not having been duped by other sorts of factitious seriousness:

> If in effect the world be not a serious thing, it is the dogmatic people who will be the shallow ones, and the worldly minded whom the theologians now call frivolous will be those who are really wise. . . . Good-humor is a philosophic state of mind; it seems to say to Nature that we take her no more seriously than she takes us. (Renan 1892, 395, 396; translated and quoted in James 1985, 37)

James characterizes solemnity as a kind of feeling. This seems plausible enough, since feeling is certainly involved in solemnity, and it seems nearly intelligible to say we have a solemn feeling or, if this straight away sounds a shade unconvincing, that certain actions or events might convey or impart such a feeling. Usually, however, solemnity, unlike, say, joy or desperation, is said to be the thing we feel or sense—"the solemnity of the occasion was borne in upon me"—rather than the feeling itself. Solemnity is like gravity in being shared between a feeling and its object; the gravity of a situation will properly evoke grave feelings. In this respect it is more like a mood than an emotion, in the sense that we tend to attribute moods to places or occasions as well as the effect they may have on us. Francis Hutcheson relates this to the use of pathetic fallacy, or

> the Prosopopoeia, by which *every Affection* is made a *Person*; every *natural Event, Cause, Object*, is animated by *moral Epithets*. For we join the Contemplation of *moral Circumstances* and *Qualitys*, along with *natural Objects*, to increase their *Beauty* or *Deformity*; and we affect the *Hearer* in a more lively manner with the Affections describ'd, by representing them as *Persons*. Thus a shady Wood must have its *solemn venerable Genius*, and proper *rural Gods*. (Hutcheson 1738, 264)

The association between solemnity and pathetic fallacy does not cover all cases of solemnity; but we may perhaps agree that, even where there is no formal projection of personhood into a scene, there is a sort of imputation of the power to feel to the scene that provokes the feeling.

This duality or interior distance in the relation between solemnity and feeling may intimate to us that solemnity is a reflexive or, as I have called it, a metafeeling, a feeling we have about feeling, in feeling that it is the kind of thing we should feel (Connor 2013). This is not at all to say that the feeling of solemnity is just an idea about or attitude toward solemnity. Rather, it is something we actually feel about what we might expect to feel, or wish we might feel, or feel we should feel. The fact that this kind of exhortative solemnity is often a feature of collective experiences may explain some of the normative pressure to solemnity that is part of the feeling of it. The feeling we have of solemnity is both the apprehension that something solemn is occurring and a feeling that we may have toward that solemnity—a feeling of respect, perhaps, or reverence, or even perhaps awe.

Or perhaps it is no more than what Emily Dickinson (1975, 162) calls "a formal feeling," the feeling attached to the sense that something formal is occurring, where a formal occurrence is definable as a recurrence, or an event having the quality of an object as defined by A. N. Whitehead:

> The theory of objects is the theory of the comparison of events. Events are only comparable because they body forth permanences. We are comparing objects in events whenever we can say "There it is again." Objects are the elements in nature which can "be again." (Whitehead 1920, 144)

Thus solemn events or experiences are those that encourage solemn feelings about their solemnity, where that solemnity has, or more simply is, the *déjà vu* quality of being haunted by itself. The feeling of solemnity is also itself solemn in that the feeling called forth is intended in some sense as an answering consecration—that is, precisely, a solemnization—of the event or occasion. The solemness of a solemn feeling lies in part in its capacity to impart solemnity to that which provokes it. Far from depriving solemnity of its basis, this circularity is a large part of the feeling of solemnity, insofar as it also involves a certain solemnization of feeling itself, a feeling that this kind of "formal feeling," a feeling for the formality of things, and a feeling that is itself made into a form, has value and power. There is undoubtedly something magical about this, in the Freudian sense that it involves omnipotence of thought, or perhaps rather the thought of

the omnipotence of feelings, though this need not imply anything imaginary about it. The many forms of action in which we affirm our belief in the omnipotence of thought, in the face of all the unanswerable objections to the notion, are real and substantial enough. Omnipotence of thought is a deluded conviction, but the conviction is one of the realest things in human experience. Perhaps one solemnizes in something of the way in which one blesses, by the donation of a feeling that is felt to have the force of a wish and that lies somewhere between an action and a feeling. Indeed, solemnizing and blessing sometimes converge, as when one is invited to a wedding to bless a union.

The frailty of seriousness is one of the most surprising things about it. And, of all the styles of seriousness, solemnity is the one most vulnerable to the hairline fracture that lets in the light of lightness. A distinctive and somewhat unexpected feature of solemnity is that it is so often accessory to amusement, or directly tributary to laughter. Tobias Smollett (2009) refers in *Humphrey Clinker* to the absurdity of the self-important quack doctor after overhearing a remark on the smelliness of the river mud under the windows of the Pump Room in Bath: "Humming thrice, he assumed a most ridiculous solemnity of aspect, and entered into a learned investigation of the nature of stink" (17). Stink and solemnity are comically stitched together again in a later scene in which the aristocrat Frogmore makes terrified confession of his sins "under the pressure of a double evacuation," following application of a powerful purgative, so that the attending parson, "obliged to hold his nose while he poured forth spiritual consolation from his mouth" (303) has to speak "in a solemn, snuffling tone, that heightened the ridicule of the scene" (304). The aptness of solemnity to provoke comedy intimates the difference between being solemn and being serious. To be serious means to be intent on some matter, to have focused one's attention on it respectfully and without distraction. To be solemn is to be faux-serious, or serious in such a way as to reveal one's wish to seem serious. It is sometimes to be more serious about that seeming, and the wish for admiration and approval, than about the object of one's apparent attention. If there is always, as already suggested, something reflexive about the kind of seriousness involved in solemnity, a sense that one should take seriously one's seriousness, we might say that comical solemnity is unself-consciously reflexive, in letting on about its own absorption in the work of wishing to seem serious without recognizing it.

And yet there is another kind of solemnity that, although also characterized by an absence of self-consciousness, can prompt a less satirical and

more forgiving kind of laughter. Smollett used this conjuncture of absurdity and solemnity to characterize Cervantes's *Don Quixote*, in a note to his own translation:

> The Translator's aim, in this undertaking, was to maintain that ludicrous so-lemnity and self-importance by which the inimitable Cervantes has distin-guished the character of Don Quixote, without raising him to the insipid rank of a dry philosopher, or debasing him to the melancholy circumstances and unentertaining caprice of an ordinary madman; and to preserve the native humour of Sancho Panza, from degenerating into mere proverbial phlegm, or affected buffoonery. (Cervantes 1986, 19)

We must wonder why, if solemnity is the will to take things seriously, it lies so deliciously and dangerously close to hilarity. One of the best evocations I know of a hilarity prompted and fed by solemnity is the description in D. H. Lawrence's *The Rainbow* of Anna Brangwen's fit of the giggles as she hears her cousin Will Brangwen starting to sing alongside her in church:

> He stood up beside her to sing, and that pleased her. Then suddenly, at the very first word, his voice came strong and over-riding, filling the church. He was singing the tenor. Her soul opened in amazement. His voice filled the church! It rang out like a trumpet, and rang out again. She started to giggle over her hymn-book. But he went on, perfectly steady. Up and down rang his voice, go-ing its own way. She was helplessly shocked into laughter. Between moments of dead silence in herself she shook with laughter. On came the laughter, seized her and shook her till the tears were in her eyes. She was amazed, and rather enjoyed it. And still the hymn rolled on, and still she laughed. She bent over her hymn-book crimson with confusion, but still her sides shook with laughter. She pretended to cough, she pretended to have a crumb in her throat. Fred was gazing up at her with clear blue eyes. She was recovering herself. And then a slur in the strong, blind voice at her side brought it all on again, in a gust of mad laughter. (Lawrence 1998, 108–9)

The most important thing to note straight away in this description is that nei-ther Anna nor the reader seems to be given anything to laugh at, unless it is the very exaltation of Will Brangwen's voice, an exaltation that one might expect could have provided Lawrence with the occasion for one of his own high-toned, self-propelling, quasi-religious passages of spiritual uplift. There are small hints around which one might build an explanation of what Anna

might find funny: "Up and down rang his voice, going its own way" suggests that there may be the kind of relapse of the organic into the mechanical that Bergson thought might be the essential stimulation for laughter. But it seems as though it is solemnity itself that produces Anna's uncontrollable hilarity, a hilarity that puts her into such an ecstasy (weirdly, she is said both to be amazed by her laughing fit and to find it enjoyable) that it almost seems of a piece with what is provoking it.

Like all people who are unable to stop laughing under circumstances where they should be serious, Anna resorts to the impersonation of seriousness in order to regain her composure. The conjoined phrases "She pretended to cough, she pretended to have a crumb in her throat" suggest an inward turn to *erlebte Rede*, as though, prompted by the authorial "she pretended to cough," we were half overhearing her saying to herself self-directively, "I have a crumb in my throat; all I am doing here is coughing to try to dislodge it, as discreetly and respectfully as possible." It begins to work, though at the cost of increasing the tension to maintain appearances even more, such that it takes only the suggestion of "a slur in the strong blind voice at her side," a sort of parodic imitation of her own feigned cough perhaps, to trigger another wave of laughter.

Although absurdity is destructive of solemnity, it is constitutive of it as well, in the following unlikely seeming way: solemn circumstances can reasonably be described as circumstances that, were it not for their solemnity, could easily be regarded as ridiculous. It is perhaps of importance that many religious rituals alternate seriousness and irresponsible merriment. Solemnity gains in force from the very inhibition of laughter that it exacts. Indeed we might well go further and say that solemnity depends on the temptation it offers to laughter that gives it its need and opportunity for inhibition. And perhaps the regulated associations of solemnity and carnival in religious festival are a means of immunizing the former from the dissipating force of the latter.

Oaths

We have seen that solemnity does not mean purity or simplicity but rather the completeness of complexity. At the same time, and for this very reason, solemnity enjoins steadiness, sustaining, or continuity of being. This may be why people wishing it to be believed that they believe something seriously will

say that they *maintain* it, meaning that they mean to keep a grip on it, and possibly on themselves by means of it. But maintaining something, beyond the impulsive *maintenant*, in the kind of *sostenuto* or sustained intent that seriousness involves, that stylite posture of continuously meaning to mean something, is far more difficult than we commonly recognize. Steadiness of belief is so difficult that we have invented various machineries to corset us in conformity with our intentions and keep us faithful to them, whether or not we really and reliably feel inclined to take them seriously.

This is the reason that solemnity is one of the most important of the stylings of seriousness. The bond, promise, or plighting of troth, truth being simply that which keeps its promise or stays true to itself (as steady as the *tree* with which it has been suggested *true* may share an Indo-European base), is one of the most powerful of the ways of enforcing seriousness, along with its legal formalization in the contract. The action of contraction means drawing parties together in agreement, but also means pursing oneself into strict and persisting conformity with one's self, in a kind of action that eschews action. It is striking how many of the forms of solemnization that abound in different societies constitute this kind of contract or willed binding (McAleer 2019), undertaken often in a walled building that images the immurement it promises, whether it be in initiations, vows of fealty, marriages, or other occasions of oath taking. Perhaps this helps confirm James's intuition that religion must have something essentially solemn about it, for the ligature formed in "religion" often takes the form of the solemnizing vow or contract. An *earnest* therefore comes to be the name of a pledge or guarantee, which functions as the warrant of one's seriousness. An earnest is therefore the same as a surety, which does not, no matter how many students are sure of the contrary, mean the condition of certainty, or being sure, but rather a security, of which *surety* is in fact a contraction, the bond, pledge, or indemnity that helps to make you sure of someone's seriousness.

We may take the operations of the oath as distilling the liability to absurdity that is essential to solemnity. The oath represents the performance of solemnity by reference to the particular kind of usage involved in oath taking or the imparting of solemnity to vows—often, in fact, by invocation of the idea of solemnity itself, as in a locution such as "Do you solemnly swear you will tell the truth, the whole truth, and nothing but the truth?" One often makes such attestations through the mediation of other things—by all the saints, by God, on one's own honor, the life of one's firstborn and so on—all of

which seem to be offered as a kind of external guarantee of the truth of one's words. And yet, of course, as Giorgio Agamben has argued, the externality on which one principally relies in such cases is in fact one's own word, as evoked in one's words and absurdly inseparable from them. If someone says, "I give you my word," it would be very dim indeed of you to ask, "How?" because you are supposed to have just been a recipient of the gift and witness to its giving. As in prayer, of which swearing and vowing are very likely varieties, solemn declarations are declarations of and by the power of language for the human subject. The act that Agamben (2017, 344) calls "veridiction" is more than a matter of giving a true account of how things are or have been. It is a determination to verify—that is, to enforce the truth of certain things and, in the process, if there had ever been a time for such a word, *veridicate* the truthfulness of one's words. An oath is an answerable statement of one's fidelity to the project of making one's life faithful to one's words. Solemnization of intent through the ritual intensifications of language is also a solemnization of what Agamben calls "the sacrament of language" itself, and the fact that "uniquely among living things, man is not limited to acquiring language as one capacity among others that he is given but has made of it his specific potentiality; *he has, that is to say, put his very nature at stake in language*" (352–53).

Agamben here draws on the now largely forgotten work of the nineteenth-century German philologist Hermann Usener, and in particular his argument that the notion of divinity develops from local and unsystematic apprehensions of the sense of divinity that were suddenly and momentarily aroused by and affixed to nondivine objects in nature. Usener (1896) called these "momentary gods" [*Augenblicksgötter*] (280). Where Usener finds in language the evidence of these elementary flarings of religious apprehension, Agamben argues that what is divinized

> is the very event of the name; nomination itself, which isolates and renders recognizable a gesture, an act, a thing, creates a "special god," is a "momentary divinity [*Augenblicksgott*]. The *nomen* is immediately *numen* and the *numen* immediately *nomen*. . . . the god invoked in the oath is not properly the witness of the assertion or the imprecation: he represents, he *is*, the very event of language in which words and things are indissolubly linked. (Agamben 2017, 335)

The solemnity of a vow is in fact perfectly identical with its potentially vacuous recursivity. When you solemnly swear to tell the truth, in the bootstrapping

hereby of performative attesting, can you be relied on to be telling the truth at that exact moment and in that precise respect? Or do we just have to take your word for the fact that you are giving your word about your wish to be taken at your word and your reassurance that you can be? This is particularly at issue in the use of the particular word *solemnly*, which tends to occur at points where a general sense of seriousness is sharpened to the point of making some kind of promise or attestation. When one solemnly declares, promises, proclaims something or other, or, as is common, is urged or requested or required to make such a solemn declaration, one is saying that one is really saying what one seems to, and not, as may always be the case with any utterance, just saying it (for example, because someone has just asked you to, in all solemnity, or some). "I say to you now, I am not just saying this."

Solemn ceremonies depend not just on language but on deliberated actions, often taking the form of certain kinds of minor probative ordeals—fumbling with the ring, having to walk at a certain regulated pace, and so on. When he was Master of Birkbeck College, presiding over college graduation days at which I played the part of College Orator, Tim O'Shea was always on the lookout for bits of what he called "high-wire stuff," which could impart a certain kind of solemnizing tension to the occasion—undemanding requirements that had the capacity to go wrong, though never very seriously (the fact that they could never go very seriously wrong being a proof of the protective membrane of seriousness provided by the occasion itself). The most pulsating piece of business in these ceremonies involved candidates for doctoral degrees walking across the stage to kneel before a prayer stool in academic gown and cap in order to be ceremonially invested with their academic hood, this last being done by the Master in an extravagantly sweeping, toreador-like parabola. For this maneuver to come off, it was required for the candidate deferentially to remove their academic cap at the same time as they sank to their knees, to succeed in giving the effect of the neat descent of a nimbus, and avoid any awkward sort of shuffling, as of a tight polo neck, when the hood was slipped over their heads. The most ordinary and habitual kinds of action become very difficult when they are required to be done deliberately—that is, with the kind of deliberation that itself imparts the suspicion of imposture. (Signing one's name, or even saying one's name out loud, can seem very unnatural if one is required to repeat it for purposes of verification.) The feat of coordination required to remove one's academic cap simultaneously with sinking to one's knees, in some kind of dignified way that did not suggest

getting down to investigate a blocked sink—this a literal, because bodily, deliberation (Latin *de* + *librare*, to weigh or balance)—proved almost beyond the capacities of many of the doctoral candidates. But, of course, the minor kinds of botch to which this movement was heir were semiotically immunized by the solemnity of the occasion, meaning the shared, solemnizing consent of all involved in doing duty to its solemnity. This concordat somehow assimilated and neutralized the idiosyncrasies with which each candidate attempted to fulfill the ceremonial conditions, with a special kind of indulgence, like that extended to an infant performing their first solo in the nativity play, which itself confirmed and deepened the solemnity.

Other kinds of material accessories are often requisite for the performance of solemnity, and often accessories that require some sort of trouble to be taken with them. It is remarkable for instance how regularly solemnity depends on insecure headgear: crowns, bearskins, policemen's helmets. Having gone to such extraordinary lengths to transport, shape, and erect their colossal monumental statues, the inhabitants of Easter Island put themselves to the considerable extra trouble of forming cylindrical "hats," known as *pukao*, from volcanic rock, which were then placed in position on the heads of the statues. Some witnesses have construed them as baskets and others as piled hairstyles (Hixon et al. 2018, 149–50). The chief pilot of the *Santa Rosalia*, which visited Easter Island in 1770, observed that "the diameter of the crown is much greater than that of the head on which it rests, and its lower edge projects greatly beyond the forehead of the figure; a position which excites wonder that it does not fall" (Corney 1908, 94). That the headpiece should be both precipitous and unshiftably steady seems to be a large part of its point: a natty little pill-box affair would have been positively offensive to the dignity of the figure.

The tall hat is similarly the equivalent and sometimes the accompaniment of what Yeats calls "high talk," which articulates the principle that nothing can be truly exalted that does not have a teetering tendency:

> Because children demand Daddy-long-legs upon his timber toes,
> Because women in the upper storeys demand a face at the pane,
> That patching old heels they may shriek. (Yeats 1951, 331)

The tall hat, so indispensable to the appearance and performance of solemnity in so many places, tells us much of what we need to know about the balancing act required of solemnity. Traditionally, the judge in English courts wears

a black cap when passing a sentence of death, or more precisely it seems, in order to pass such a sentence. The cap in question is modeled on the Tudor biretta or *pileus quadratus*, a floppy version of the mortar board that is still known as an academic square and that became a standard constituent of the judge's costume by 1635, before wigs became a customary feature of court-room attire. It was not at first associated with the passing of death sentences in particular, as is indicated by the fact that it is still part of the panoply of the most solemn legal occasions. The crucial bit of fabulation, at some point during the nineteenth century, involved the perching of the cap on top of the wig that had replaced it (Woodcock 2003, 43–45). What makes the ceremony so absurd—as though this, the most serious and consequential sentence any human can have addressed to them, would fail in its effect were the cap to be plucked off by a freak draft, or flutter away following a judicial sneeze and have to be retrieved by a scrabbling usher—is precisely that it cannot be sol-emn without immunizing exposure to the risk of absurdity: laugh *this* off, if you dare. The only truly solemn moments in legal proceedings are those that would resemble *Alice in Wonderland* were they not solemn, their solemnity being secured by the counterpressure of the inhibition of their silliness.

The dignity of the tall hat therefore comes from accident held at bay, or kept, as we say, waiting to happen. Like the tightrope, it images the concen-tration of will and being into narrowness and exaltation (perhaps especially in the pointed hat that has run the gamut from wizard and magus to witch and dunce (Connor 2019a, 253), and a subjection of all the things that tempo-rally might happen into what for the time being must happen. To walk across a tightrope, or process up a nave wearing a weighty crown, is to give your merely adventitious being the meaning that comes from seeming to mean everything about your being. Nietzsche (1969, 43) affirmed that "Man is a rope, fastened between animal and Superman—a rope over an abyss." Every steadiness is a kind of solemnity, and the steadiness of solemnity is in fact suffused by the wobble that it turns into armature by calmly countermanding it. Solemnity is perhaps steadiness braced against—and therefore embraced by—the chastened panic of precipitate collapse into wildness and shrieking. In solemnity, I am mine own precipice (Marvell 1971, 22); I force myself to the brink that I make of myself by holding back from it. Solemnity is the gymnas-tics of the statue.

Veterans of young ladies' deportment classes, if any are still on the earth, know that the other principle of solemnizing danger is that it requires you

to move slowly. Slowness in human actions creates solemnity by seeming to measure out time, taking your time rather than being casually taken up in its passing. To move deliberately is to move as though deliberating each movement rather than simply making it, this being one of the reasons it proves so hard to perform simple and habitual actions in solemn circumstances. Solemnity aims to make the habitual laborious, by lifting unconscious habit into conscious ritual. In many cultures, women do not have such regular access to tiered solemnity as men, though high-piled headgear is common among them, perhaps more often as a sign and enactment of the achievement of continuous corporeal self-management rather than status. Solemn slowness is often described as stately, a word that suggests a movement that has the steadiness and durability of stasis, as though a statue walked. It is hard to imagine a fidgety or spasmodic ghost, ghosts traditionally being stately: at the beginning of *Hamlet*, Horatio describes how the figure of Hamlet's father appears before Marcello and Bernado "and with solemn march / Goes slow and stately by them" (Shakespeare 2011, 296).

The corporeal styling of solemnity is most widespread in military gait, especially in the surprisingly wide variations in marching styles. George Orwell used the Nazi goose step to focus the contrast between British and German styles of life:

> One rapid but fairly sure guide to the social atmosphere of a country is the parade-step of its army. A military parade is really a kind of ritual dance, something like a ballet, expressing a certain philosophy of life. The goose-step, for instance, is one of the most horrible sights in the world, far more terrifying than a dive-bomber. It is simply an affirmation of naked power; contained in it, quite consciously and intentionally, is the vision of a boot crashing down on a face. Its ugliness is part of its essence, for what it is saying is "Yes, I *am* ugly, and you daren't laugh at me," like the bully who makes faces at his victim. Why is the goose-step not used in England? There are, heaven knows, plenty of army officers who would be only too glad to introduce some such thing. It is not used because the people in the street would laugh. Beyond a certain point, military display is only possible in countries where the common people dare not laugh at the army. (Orwell 1968, 61–2)

Orwell's remarks about the goose step seem slightly unfocused. The goose step is indeed meant to convey menace, but, in its origins in the Prussian *Stechstritt*, or "stab step," it seems closer to the thrust of the bayonet than that

of the stamp, as employed, for example, in the ceremonial Maori *haka*, though Orwell (1954, 215) was fond enough of the "vision of a boot crashing down on a face" to incorporate it into the climax of *Nineteen Eighty-Four*. A version of the slow march, which stiffly delays the descent of the leg to the ground, is still employed in funeral ceremonies in countries outside the usual post-totalitarian sphere of influence of the goose step, and what it really resembles is the "ballet, expressing a certain philosophy of life" hinted at by Orwell. The difference between the agitated strut of the goose step and the disciplined descent of the stiffened leg in the slow march is the difference between threat and dignified mourning.

Similarly, the slowing of utterance is an important way in which it is turned from a spontaneous act into a kind of movement, thus corporealizing it. All words have to be pronounced, but speaking in such a way as to make one's pronunciation prominent is imperative in what are called pronouncements. This corporeal stylization is redoubled by the synchronization of speech with formal physical actions (one might see such actions as reinforcing the utterance with corporeal duet): placing your hand on a Bible or other holy book, for example, or performing some required gesture. Indeed, the very act of reading a text "out loud" has the function of corporealizing it, by making it a formal action, offering confirmation through conforming. This not only exposes the person performing this action to the possibility of error, accidental slurring, omission, or mispronunciation of words, for example, but also opens up the performance to the near certainty that it will not seem meant in any of the ways in which things that you say in the ordinary course of things are things you mean to say—saying you feel a bit peckish, saying no to an unappealing offer, saying that you think it must be close to eleven o'clock by now. The solemnization of the act and fact of speaking is a solemnization of the power of language to bind, through a process that mimes the binding of the speaker to their language. This kind of solemnization is at once a lifting of language into an ideal condition, able to exert magical control over contingency, and through that very act a denaturing of language. Solemn language comes into its own by ceasing to be what language is, which is to say nothing at all essentially or in particular, but just the open and evolving repertoire of different kinds and possibilities of light behaving.

Actions, occasions, and relations are solemnized through acts of language that solemnize language itself, through a solemn pretense (literally a reaching forth in advance) that it is something other than language, something with

a binding force that language can never have, precisely because words can never be fully identical with what they picture or pronounce, for if they could, words *would be no use at all.* "George Bailey, I'll love you till the day I die" may be taken as a convergence of what English used to distinguish with the verbs *will* and *shall*—that is, a future-tense predication of what will transpire in the future and a present-tense articulation of an intention with regard to that future. If the first could be guaranteed to be true, it would render vacuous the statement of one's resolution to force the statement to turn out to be true. (You do not promise to keep breathing in oxygen and breathing out carbon dioxide to the best of your ability.) But if the second statement has any force, it can only be because there must be some doubt about the first, in the very possibility of doubt against which the promise is meant to bear up. The comic structure of the solemn declaration, and perhaps of any such declaration, and of any kind of solemnity whatever, is of a piece with Steven Wright's "I intend to live forever. [*Crosses fingers*] So far, so good!"

The denaturing of language effected in solemnization must usually in fact supplement that act with some source of external reinforcement—the force typically imparted by a formula, which seems to have the force it does precisely because, unlike the act and fact of the words spoken by human mouths, it is fixed and immutable. So you can only conform by performing your conformity, which must open up the fissure between conforming and aping the mere form of conforming that is not to be closed by any available means. In solemnizing actions, one must always be said to be "going through the motions," in going through some kind of approved motion or other, in a way that not only is unnecessary in the ordinary course of things but actually casts doubt on the possibility that they are in fact meant.

This particular question comes to the fore in Quakerism, the famous sobriety of which, so often mocked, aspired to be more than a style, or rather, and of course impossibly, very much less than a style. Quakers took the question of seriousness so seriously that they were determined to tolerate no exceptions to what is enjoined in the Sermon on the Mount in Matthew 5:35–37:

> I say unto you, Swear not at all; neither by heaven; for it is God's throne: [35] Nor by the earth; for it is his footstool: neither by Jerusalem; for it is the city of the great King. [36] Neither shalt thou swear by thy head, because thou canst not make one hair white or black. [37] But let your communication be, Yea, yea; Nay, nay: for whatsoever is more than these cometh of evil.

The reasoning here is that appropriating some supplement to underwrite the truth of one's words implies that they are in the normal course of things not to be regarded as completely trustworthy. This is, like so much in religion, politics, law, and psychology, a principle of mediation. Just as one should be able to trust in the possibility of direct communication between the individual soul and its creator, unmediated by the worldly paraphernalia of saints, ceremonies, effigies, or metaphors, so one's communication in the world should dispense with the prosthetic apparatus of swearing and oath making. The logic here, impeccable in its way, was that solemnizing ceremonies that both implied and allowed something other than complete truthfulness and, as we might now say, transparency, in ordinary dealings, destroyed their basis in truth. Trusting absolutely in the power of the word, Quakers felt compelled to violent allergy to the procedural idolatry of the word enacted in solemnic spell making.

The centrality of such solemnizing procedures, which remain today more than symbolically in force in law, politics, and religion, made such a refusal a direct challenge to the worldly authorities who depended on acts of oath taking, acts of borrowed solemnity and solemnized borrowing, to enact the bonds of fidelity to the social order. In December 1678, Ambros Galloway, a Quaker who refused to testify on oath, found himself on the wrong side of the law, during the Old Bailey trial of one William Brayn for stealing a horse from him:

> One testifi'd his knowledge, that it was *Ambros Galloways* Horse; and another, that he bought it of the Prisoner. But *Ambros* himself, being a Quaker, would not, for Conscience-sake, as he said, swear, and so could give no testimony about his losing him. Upon which the Court directed the Jury to find the Prisoner Not guilty for want of Evidence, and committed the Quaker, as a concealer of Felony, for refusing an Oath to Witness for the King. (*An Exact Account of the Trials of the Several Persons Arraigned* 1678, 27)

The Quaker objection is indeed far reaching. If telling the truth depends not on an immanent will to truthfulness but on the performance of what are obviously and indubitably magical formulae, this was for Quakers a scandalous dishonoring of ordinary truthfulness. But of course, it opens up a much more corrosive perspective that would have to wait until 1873 to be more clearly articulated in Nietzsche's (2006) "On Truth and Lies in a Nonmoral Sense," that all truth-telling may in fact be nothing but a sort of Simon-says suasive

magic, or "a sum of human relations which have been enhanced, transposed, and embellished poetically and rhetorically, and which after long use seem firm, canonical, and obligatory to a people" (117). Indeed, Nietzsche derives truth itself from the desire to assert the importance of knowing, or rather of the knower's sense of the importance they derive from their knowing. It is the drastic reversibility of scale that makes for solemnity rather than convulsions, in the fact that, "in the out-of-the-way corner of that universe which is dispersed into numberless twinkling solar systems, there was a star upon which clever beasts invented knowing" (114). But the sense of omnipotence that knowing gives, the sense that to know the universe is to govern it, is the same as would be possessed by any such Aesopian fly on the coach wheel: "If we could communicate with the gnat, we would learn that he likewise flies through the air with the same solemnity, that he feels the flying centre of the universe within himself" (114). But, as Nietzsche promises: "When it is all over with the human intellect, nothing will have happened." ("Wenn es wieder mit ihm vorbei ist, wird sich nichts begeben haben.") (2006, 114; 1922, 75).

This seems to make it clear why telling the truth is not felt to be enough without the extra injection of force that we call solemnity. Solemnity is not in fact a confirmatory adjunct to truth, for things that are the case are trivially and inconsequentially true, whether or not we affirm them to be. Truthfulness, knowing and asserting that things that are the case are indeed so, is itself the means of achieving solemnity—that is, the sense of the importance of the fact that one knows, and the feeling that it gives of being in charge of or giving consent to the way things are. All such solemnity is, for Nietzsche (2006, 123; 1922, 91), "playing with seriousness [ein Spielen mit dem Ernste]." In fact, Nietzsche characterizes this sense of importance not as mastery or pride but as pathos: the possessor of knowledge "nimmt ihn so pathetisch" ("takes it so solemnly"), just like the putatively putating gnat to whom the possessor of knowledge is compared, as "auch sie mit diesem Pathos durch die Luft schwimmt" ("he likewise flies through the air with the same solemnity") (1922, 75; 2006, 114). Pathos names effectively the suppressed pain and sadness of the sense of solemnity, and the brewing of solemnity out of this throb. Pathos still conjoins sadness and madness, naming things that are both painful and painfully ridiculous.

Of course, there remains a sense in which the joke might be on Nietzsche or, as seems increasingly to be the case in his writing, in him. For Nietzsche himself is subject to the same desire for triumph, or having the last epistemic

word on knowing, by asserting the ultimate truth of the triviality of human perspectives on the scale of the universe. But if what Nietzsche says about the triviality of human perspectives is really true, no such absolute perspective or scalar baselines will be available, except through precisely the same kind of omnipotence fantasy as he is here skewering so scornfully. If there is no *haut* from which this *de haut en bas* utterance might emanate, there is equally no obvious *bas* either, and so no reason to regard the affirmations either of proto-zoon or higher primate as ultimately unimportant. In certain understandings at least of the nature of divinity, for example J.B.S. Haldane's inference from the evidence of nature that God must have an inordinate fondness (or in other accounts a "special preference") for beetles (Gould 1995, 378–82), the sense of scale would be entirely absent in a Creator as traditionally conceived, whom we would have to imagine delighting as much in the splitting of an embryo as the conflagration of a supernova. Indeed, it would be perfectly possible to say that the affirmation of forms of local importance in the face of the vastness of everything that renders them of so little account is precisely what gives them their dignity and solemnity. There seems no way to negotiate a way out of this twinning of nobility and negligibility—not even through the feeling of pathos that conjures grandeur out of the idea of littleness crazy-heroically defying its own condition.

Nowhere is the truth, and the ceremonial means to maintain and establish the sense of it, more impregnated with solemnity than in the workings of the law, which both depends on and demands much in the way of oath taking. Oaths are the means by which law insinuates itself into speaking persons and thereby dissimulates itself, by giving those subjected to law the momentary sense that they are the subjects of it. Power asserts itself routinely through the requirement to make free and honest attestations, whether in being inau-gurated as the president of the United States, getting married, or solemnly undertaking "not to bring into the Library or kindle therein any fire or flame" when becoming a reader of the Bodleian Library. Oaths involve obedience and subjection, and the mood of solemnity seems strongly related to this particu-lar aspect of performative paradox, whereby one establishes one's moral large-ness not through assertion but precisely through one's capacity to chasten or abase oneself. Only the most eminent, it seems, are capable of self-subjection of the requisite solemnity. This goes some way to explaining the association between solemnity and dignity, for solemn leanings or proceedings yield pride in their performance. It seems in keeping for a duchess to perform the

action of "giving her word," but is implausible and even rather uppity in a ditch-delivered drab. Overcome during the service on Yom Kippur, the rabbi sinks to his knees and cries, "Oh Lord, without you, I am nothing!" The cantor is similarly overwhelmed, and echoes, "Oh Lord, without you, I am nothing." When a little man in the back row is heard to cry out in turn, "O Lord, without you, I am nothing," the cantor murmurs to the rabbi, "Who is that nobody to think he is nothing?"

The practice of affirmation was instituted in what is known as the Quakers Act of 1695, An Act That the Solemne Affirmation & Declaration of the People Called Quakers Shall be Accepted Instead of an Oath in the Usual Forme. Affirmation of this kind dispenses with the externality of the force called on to second or underwrite (often literally with the intercession of some kind of sacred writing) the truthfulness of what is being said, relying on the statement itself to provide its own self-confirmation. This self-exteriorizing is sometimes effected through repetition, as in the current form taken by a witness electing to affirm rather than to swear in a British court: "I do solemnly, sincerely and truly declare and affirm that the evidence I shall give to the court in this case shall be the truth, the whole truth and nothing but the truth." If in one sense the repetitions are purely intensive, as though they were equivalent to the child screwing up its face and saying "I really, really, really promise," the repetitions cannot help but direct attention to the attempt of the sequence to take account of different aspects of veridiction, which, to one thus alerted to these shades of difference, cannot avoid kindling a certain curiosity, anxious or obnoxious, as to what loopholes might in fact in the process be being opened up. For the sequence does indeed make it evident that, when you come to think of it (coming to think of it being exactly what such a solemn declaration seems designed to urge one to do), I could say something with all due solemnity without necessarily being sincere about it. And I could also perfectly well say something with due solemnity and in all sincerity that was nevertheless untrue, or not entirely or immiscibly true, because I am mistaken, for example, or have imperfectly remembered. By what warrant in this last case I can promise not to be mistaken or to have forgotten, or do any more than try my best not to be, is unclear. In fact the promise that is made to tell the whole truth about the matter in question, or any matter of any kind, a whole truth that would have therefore to include the complete chain of determinations and entailments extending backward and forward *in saecula saeculorum*, must in all cases be regarded as a well-intentioned white lie, inasmuch as the whole truth about anything at all will necessarily have to

wait until the coming of the Kingdom for its dénouement. As in so many cases, the only way for such a statement to be taken seriously is for it not to be taken completely seriously (wholly seriously and nothing but seriously). And, as in so many other cases, it is hard to be sure whether this overlooking of potentially serious deficiencies in such a statement of intent is to be regarded as a sign of its partial absurdity or a proof that its solemnity makes it proof against just such hairsplitting mischief.

In different kinds of affirmation, solemnizing ritual is progressively deca-thected, first of all into secular theatrics and then into the legalized abstraction of contracts. In such a process, the transcendental invocation evolves into the immanent invocation of the trustworthiness of one's own word, bound in place by legal enforceability. And yet the paradox remains of an action of freely and voluntarily binding yourself by being more serious, even if it is held to occur in the fictive blink-of-an-eye solemnity of clicking the box that accepts the terms and conditions.

A great deal depends in solemn undertakings on a detectable modulation of linguistic register, through the temporary adoption of the special style of utterance proper to the making of oaths. Once again the objections of the Quakers are astute and revealing; as in questions of dress, adornments of speech suggest the suspicious dependence of truth-telling on fictive auxilia-ries. The stylistic means of shoring up the solemnity of the law makes for a complex balancing act, which is precisely equivalent to that involved in the translation of scriptures, as suggested by Heikki Mattila:

> It speaks for itself that the language of a law or judicial decision should not come across as comedy or irony. At the same time, it should not be over-sol-emn or archaic. Clearly, it should not be so complex as to overawe. . . . As a counterbalance, it has to be stressed that the legislator should also avoid an over-relaxed style. In the same way, it should employ everyday words in legal language only with the utmost caution. Legal language always evolves some way behind normal language, without being allowed to lag too far. Laws should create a serious, but not over-solemn, ambience. (Mattila 2013, 53–54)

These ticklish requirements may perhaps speak for themselves, but they mean that neither the law nor the one speaking under its auspices can ever speak entirely for themselves exactly. Indeed, the finicky concern of the law with the maintaining of its own dignity is one of the things that is liable to put it at most risk of discredit.

The possibility of dissimulation (and in sober fact, the necessity for it in some degree) has not in the least prevented those in power from making the taking of solemn oaths compulsory in a way that might seem entirely to vitiate their solemnity, like any confession extorted under duress. Following the passing of the Act of Supremacy of 1534, Thomas Cromwell required the monks of Charterhouse to swear their loyalty to the king over the pope: "I require you to testify by a solemn oath that you believe and firmly hold to be true the very words—my decision is irrevocable—which we propound to you for an honest confession of faith" (Chauncy 1935, 79). It is examples like this one that persuade Jonathan Michael Gray (2013) to the view that "if oaths were a language of the Reformation, then oaths are important not only because they communicated the Reformation but also because they constituted the Reformation" (5).

In solemnization, seriousness is made into a force, through the use of the enforcement that solemnization itself is. Perhaps the best characterization we can give of the sense of solemnity is that it is the apprehension of an unlocatable power, a power that adheres to and suffuses a circumstance without its source, locus, or direction being able to be specified. The self-doubling absoluteness of solemnity insists that it is absolutely itself, without accessory, by means of the very accessory that the performance of its seriousness is.

Solemnity is reverential; it provokes not just seriousness but awed respect. English usage will sometimes seem to draw the object of reverence into the reverencing action—as in the kind of reverential hush that both invites and displays worshipful awe. It seems likely that the "reverential glow" (Montgomery 1855, 172) one may feel in an act of worship, or the feeling of being exhorted to perform the act, the urge one feels to feel urged, is a self-celebrating salute to the solemnizing powers invested onanistically in the very act of worship. For creatures so elaborately instructed in the possibilities of exaltation inwrought in humbling (and most social animals have methods if not concepts of exercising power through symbolic submission), worship will always be invested with "worthship" (Wallis 1664, 120). Latinate humans are wont to believe that they take the earthling name they give themselves from the humus, the damp and lowly clay. The move from *homo* to *humanus* is etymologically puzzling, but has been tentatively explained as a modification of Indo-European *dhéĝh-om*, earth, to *dhgh-m-on*, earth dweller, human (Nussbaum 1986, 187–88).

But the mystery of this enigmatically indwelling-diffusive power without source or fulcrum also marks the dangerous point at which the making through marking of seriousness comes closest to antic craziness, in the suspicion that

this unlocated power is in fact an act of concealment from itself, and a power that comes from the very fact of that concealment. In solemnity, force is farcical, remembering the earliest English meanings of *farce*, from Latin *farcire*, to stuff, cram, or pack, as that which has been unnaturally and unreasonably forced in, as in stuffing or forcemeat or embalming or a comic interlude or even as the liturgical meaning of "farce," as an explanatory or hortatory passage in the vernacular inserted in the chanting of a Latin reading.

This is why solemnity as a kind of mood, atmosphere, or attribute always contains some reference to the act of solemnizing. This undoubtedly involves Agamben's (2017, 354) sacrament of language, but uses it to brace a more general sense of sacralization, or setting apart. That which is solemn is so to the degree to which it seems, even without language, to be giving its word, promising thereby to bear out and make good absolutely and without remainder or excess that which it is, and, this being the most important feature of a promise, guaranteeing its continuance in this mode. All solemnity must reach beyond its moment to promise a setting apart from ordinary things, which are always subject to the decay from seriousness, in the very promise of their continuation. This is why solemnity so often has a historical dimension, in attaching to usages and places that are solemn by dint of having been solemn for quite some time—"if only that so many dead lie round" (Larkin 1988, 98). In the feeling of solemnity, we want to seem to feel the community of the promise of the straight face that others have exerted themselves to keep, both face and promise. The solemnity is perhaps the passage and persistence of the promise rather than its content—or rather, that *is* its content.

But the force of the force of solemnity must surely also be understood in terms of the well-known ambivalence of the notion of the sacred, which is both that which is consecrated and that which is debased or profaned, whether as part of the psychologizing of religion in Durkheim and Freud or the sacralizing of law and political power in Agamben's (2017, 64–68) tireless investigations. Sacred and profane come together surely in exposure of the sacred thing, as a necessity of its constitution, to its possible profanation, the self-scandalizing giggles that must build to eruption at the apprehension of the self-solemnizing vacuity of the solemn. The *sacer*, that which is consecrated or solemnized by being set apart, is made solemn by the clownishness that it sequesters in itself, and as what it is. Solemnity must always be at risk of ridicule, making it possible to borrow from the force of its own defense against profanation to sustain itself.

5 Zeal

Seriousness, and the will to seriousness, are abroad in all human times and climes. But in some circumstances, epidemics of pseudoseriousness can arise, the effects of which can be genuinely grave, in the sense of causing harm or damage. The strange tonality in particular of the kind of violent and vengeful solemnity we know as zealotry, whether religious or political, derives from the mixture it will regularly display of fatuity and violence, if always differently compounded.

Vehemence

Zeal was also commonly used to signify an intense desire or longing, as in Falstaff's remark, just before his meeting with the newly crowned Henry V, that the poor show of his costume "doth infer the zeal I had to see him" (Shakespeare 2011, 425), or Dryden's reference to the longing of bees for pollen, in his translation of Virgil's *Georgics*: "Such Rage of Honey in their Bosom beats: / And such a Zeal they have for flow'ry Sweets [*tantus amor florum et generandi gloria mellis*]" (Dryden 1987, 248; Virgil 1916, 232). In fact, though, zeal has tended over time in English to relate more specifically to a kind of devotion or adherence, rather than simple desire. Falstaff glosses his zeal to see the new king as "earnestness of affection" and "devotion" (Shakespeare 2011, 425). Zeal is characterized by the internal torsion of its desire, which, rather than being freely self-directing, is bent toward a preexisting duty or obligation, or a

duty or obligation made into something held to be preexistent and determining by the very intensification of desire into zeal. In zeal, that is, there is a particular alliance of desire and duty, in which desire, and the duty to desire, and therefore the desire for that duty, are in fraught and frictive intercourse. It is as if, in zeal, desire strives to win out over the demands of duty by going beyond what duty requires, thereby at once fulfilling and defying it. It is this implication of the disciplining force of devotion that makes zeal an inflection of seriousness, which we have seen may be defined as definition, or the closing in of being. Zeal combines expansiveness and narrowness: the zealot concentrates all the diffuse energies, interests, and commitments of ordinary experience into the selective tenacity or reductiveness that seriousness always seems to entail. But zeal is also expansively colonial, endeavoring to occupy social and symbolic space. It therefore aims to go beyond itself in its very self-discipline. One may say that it combines the propagating qualities of a hot gas with the frigor of unswerving resolve.

Zeal is seriousness wound up into vehemence—that is, an intensity that is intent, and therefore embodies effort or the exertion of force. *Vehemence* is derived from Latin *vehere*, to move or carry, and the vehemence of zeal derives from the fact that it is a vehicle or vector. *Vehere* is at work in *convection, conveyance, weighing*, and *inveighing*, and may be related to German *wegen*, to move, and therefore *wagon*; even perhaps to *vexation*. Zeal is characterized as the necessary energy of existence, the striving that must be a feature of all temporal being. It is often described as a kind of physical faculty, as in Matthew Hole's *The True Reformation of Manners*:

> Indeed, what Heat is to the Body, that is Zeal to the Soul; the very *life, health* and *vigour* of it, the source of all its activity and motion: and as the Body without Heat, is but a heavy, lumpish Carcase, so the Soul without Zeal, is sluggish and unactive, and little better than *dead in trespasses and sins*. But the Goodness of Zeal may be best seen in the *good Effects* produc'd by it, and the greatness of the Reward annext to it. (Hole 1699, 19)

Dryden's (1969) *The Hind and the Panther*, a poem "actuated . . . by zeal for Rome," as Samuel Johnson described it, itself repeatedly characterizes Protestant zeal, the "blind conductor of the will" (173), as a violent, desolating madness:

Such warrs, such waste, such fiery tracks of dearth
Their zeal has left, and such a teemless earth.

But as the Poisons of the deadliest kind
Are to their own unhappy coasts confin'd,
As onely *Indian* shades of sight deprive,
And magick plants will but in *Colchos* thrive,
So Presbyt'ry and pestilential zeal
Can onely flourish in a common-weal. (Dryden 1969, 129–30)

Zeal features in Swift's (1958) *Tale of a Tub*, which promises, among the spoof "Treatises wrote by the same Author" listed opposite its title page, *"An Analytical Discourse upon Zeal*, Histori-theo-physilogically *considered"* (2). The imaginary text is invoked in section 6, which gives an account of the joint passions of "Hatred and Spight" that grow in Jack, the Puritan brother of the Anglican Martin:

> For this Meddly of Humor, he made a Shift to find a very plausible Name, honoring it with the Title of *Zeal*; which is, perhaps, the most significant Word that hath been ever yet produced in any Language; As, I think, I have fully proved in my excellent *Analytical* Discourse upon that Subject; wherein I have deduced a *Histori-theo-physilogical* Account of *Zeal*, shewing how it first proceeded from a *Notion* into a *Word*, and from thence in a hot Summer, ripned into a *tangible Substance*. (Swift 1958, 137)

Jack's zeal works him up into a frenzied tearing of his own coat (an image of inherited religious doctrine and ritual):

> *Zeal* is never so highly obliged, as when you set it a *Tearing*: and *Jack*, who doated on that Quality in himself, allowed it at this Time its full Swinge. Thus it happened, that stripping down a Parcel of *Gold Lace*, a little too hastily, he rent the *main Body* of his *Coat* from Top to Bottom. (Swift 1958, 138)

Swift's "Digression on Madness" includes the operations of zeal in the ambitions of philosophers to reduce the world to system:

> Let us next examine the great Introducers of new Schemes in Philosophy, and search till we can find, from what Faculty of the Soul the Disposition arises in mortal Man, of taking it into his Head, to advance new Systems with such an eager Zeal, in things agreed on all hands impossible to be known. (Swift 1958, 166)

Swift's (1958) scornfully comic corporealization of spiritual faculties includes suggestions that zeal, allied with generative capacity, resulted in the

characteristic protuberance of the ears of close-cropped Puritans, such that "the devouter Sisters, who lookt upon all extraordinary Dilatations of that Member, as Protrusions of Zeal, or spiritual Excrescencies, were sure to honor every Head they sat upon, as if they had been *Marks of Grace*" (202).

Zeal was so regularly used to mock adherents of what might now be called "extremist" sects in the mid-seventeenth century that the term was turned against the authorities. In 1654, Richard Hubberthorne published a pamphlet protesting against the arrest and imprisonment of two female Quakers in Oxford titled *A True Testimony of the Zeal of Oxford-Professors and University-men Who for Zeal Persecute the Servants of the Living God.* The text concludes that the *"Scribes and Pharisees"* in authority

> are zealous of the outward Commands, as the Jews was, & yet ye do not believe that Jesus Christ inlightens every one that comes into the world. Here you and your zeal is to be condemned, for it is without the knowledge of God: to it I bear record eternally, and the Commands of Christ you know not, and with the light that cones [*sic*] from Christ Jesus, you and your zeal is to be condemned, which is taken out from the letter in that minde and nature which acteth contrary to the light; so you are in the state of the schisme, whose mouthes must be stopped. (Hubberthorne 1654, 14)

Discussions of religious zeal came to a pitch during the religious struggles of the Reformation, when zeal was often defined as eagerness, intensity, vehemence, ardor, or fervor, which can provoke denunciation that is heated enough itself to approach to the condition of zealotry. The zeal of Puritans and other religious reformers in the sixteenth and seventeenth centuries presents an affective-rhetorical problem for antizealots, namely how to restrain the fervor of overzealous reformers without putting a damper on religious feeling altogether, cooling religion down to empty observance, or how to fight fire with fire without bursting into one's own kind of zealous flame. The many sermons, pamphlets, and books written against Puritans and the other reforming sects during the seventeenth century amply illustrate the comic convolutions of antizealotic zeal. In *The Fire of the Sanctvarie Newly Uncouered*, Cornelius Burges (1625) makes this irony his explicit theme. His dedication explains that

> it speakes of *Fire*: but such as was made onely to warm, not to burne any thing, unles stubble. No man shall neede to call for Buckets to put it out, or Hookes to pull downe any liuing-house on whom it kindleth. (Burges 1625, sig. A3v)

Nevertheless, Burges's own counterardency instantly starts to take fire:

> But here is a Flame that will lick vp all angry Waspes, and inflamed Tongues that presumptuously and without feare, *speake euill of Dignities, and of things they vnderstand not*; rayling on all not so free as themselues to foame at the mouth, and to cast their froth on all that are neere, without difference. (Burges 1625, sig. A4ʳ)

Burges writes that he has prudently "coasted" the "*Terra del Fuego*" (Burges 1625, sig.A6ᵛ) of which he will give his account, allowing him to plead:

> Wonder not to finde me somewhat hot: I work at the *Fire*. To write of Courage like a Coward, and of *Fire* as if one were frozen, deserues the Bastinado and the *Fire* to boote. My spouting of *Fire* among the rude multitude, is but to make way for their betters. (Burges 1625, sigs. A7r–A7v)

Burges therefore asks his reader to use his apologetic preface as "a small skreene to hold betweene you and the fire if you thinke it too bigg, or too neere, and that it would heate you too much," warning against the very warmth he seeks to arouse in his reader, but still signs it off "Valete Calete": farewell, stay warm (Burges 1625, sigs. A10v–A11r).

Although zeal is closely tied to religious behaviors and ambitions, it is certainly not confined to them. The striking oxymoron in zeal of the immoderate and unconstrained desire for discipline and constraint makes for the compounding of austerity and appetite that is characteristic of the zealous devotion to a cause. The importance of the principle of service in military matters makes reference to zeal in military contexts common. A special Medal of Zeal was awarded in Russia under Tsar Nicholas II (Diakov and Khramenkov 2007, 39). Charles O'Hara described the British army ranged under Lord Cornwallis against the rebel forces in South Carolina in 1781 disposing of all their baggage in order to pursue "the most savage, inveterate perfidious cruel Enemy, with zeal and with Bayonets only" (O'Hara 1964, 174), a phrase that is promoted into the title of a military history of the campaign (Spring 2008). Although its primary signification in military contexts is courageous or single-minded dedication to a cause, military zeal lies more than usually close to overzealousness, enabling bloody massacres to be represented as a fierce and loving devotion to duty. One of the most regularly cited exemplars of holy zeal in the Old Testament is Phinehas, who atones for the evil of the Israelites who have been consorting with foreign peoples by slaying an Israelite and the Midianitish woman with whom he has taken up, for which God praises

him to Moses: "Phinehas, the son of Eleazar, the son of Aaron the priest, hath turned my wrath away from the children of Israel, while he was zealous for my sake among them, that I consumed not the children of Israel in my jealousy" (Numbers 25:11). The convergence of the religious and the military is also readily apparent in forms of political zealotry, among leaders prepared to take extreme measures in pursuit of some goal, or among followers of some system of belief—or, one had better say, of faith, since faith is belief that comes short of believing, and so must constantly be subject to affirmation and active probation (Connor 2020).

Extirpation

Zeal provides a telling example of the way in which the earlier signification of a word can seem to be remembered in the patterns of its usages and associations even when that earlier signification may seem to have been left far behind. The history of the word zeal in English is meshed with the history of attitudes toward collective fervor, devotion, or enthusiasm (literally "having the god inside" or "divine infection"), especially in religious matters. Zeal derives from Latin *zelus* and Greek ζῆλος, emulation or jealousy. The word *jealous* is in fact a variant of the word *zealous*, the *j* being an alternative rendering of the Greek ζ in the orthography of Romance languages. The "jealous God" of the first and second commandments is a God who takes being recognized as the only God extremely seriously, to the point of "visiting the iniquity of the fathers upon the children unto the third and fourth generation of them that hate me" (Exodus 20:5) and encouraging a similarly unswerving ferocity in his devotees.

But zeal is not just seriousness or devotion to a cause; it is specifically a competitive form of seriousness, a serious devotion to outdoing others in seriousness, hence the jealousness of the zealous. It reveals something of the aggressive or adversative nature of seriousness, which is always a demand as well as an achieved or admired condition. The phrase *holier-than-thou* arose to characterize the zealot, quoting the denunciation of hypocritical wickedness found in the words of Isaiah:

> [3] A people that provoketh me to anger continually to my face; that sacrificeth in gardens, and burneth incense upon altars of brick; [4] Which remain among the graves, and lodge in the monuments, which eat swine's flesh, and broth of abominable things is in their vessels; [5] Which say, Stand by thyself,

come not near to me; for I am holier than thou. These are a smoke in my nose, a fire that burneth all the day. (Isaiah 65:3–5)

Zeal is the most conspicuous and most stubbornly ineradicable form of meta-seriousness, or seriousness about being serious. Although zeal often advertises itself as the operations of an inner light or individual conviction, it is in fact radically heteronomous. Zeal is a fire that requires a steady source of fuel in those whom the zealot both mimics and seeks to defeat by surpassing. Although other kinds of seriousness of purpose are called zeal, and most zealots will wish to insist on the strongly personal nature of their motivation, insisting that they can do no other, this claim is in fact driven and sustained by the competitive desire for distinction. The aggressive emulation that must be at work in the ways of being serious distinguished as zeal makes it a kind of perversion of seriousness. In this, zeal discloses, rather more obviously than some other manifestations, the psychopathology that must always lurk in the attempt to be entirely serious.

There are two modalities of the emulation involved in zeal. Most obviously, zeal becomes competitive in its efforts to outdo rivals who may have a similar target for their longing. This is the emulation of the suitor seeking to show the superiority of their devotion, which may pass across from amorous desire into the desire to show one's love for the divine in such a way as to attain it first or secure it exclusively. But there is a more subtle internal emulation, in which the drive to demonstrate one's zeal, even to oneself, can begin to strive against the desire for the object. One's devotion to one's devotedness begins to be the rival of the object to which one is devoted. The zeal that animates many zealots is a zeal to live up to the ideal image of their own zeal.

The excess of a gourmand or libertine could not without irony be called zeal because it lacks the sense of the overfulfillment of a requirement. Because zeal is allied to stricture and social demand, it tends to arise and thrive in collectivities, especially those in which questions of social discipline are prominent or emergent. Zeal is a feature of institutional life, whether religious, military, legal, or academic, and indeed may be prominent in the actions that are aimed at inaugurating institutions, an idea of primary impulsion that is preserved in the verb to institute. There is something odd in calling the asceticism of an eremite zeal, because it is deprived of this context of conformity, except as it may perhaps be remembered or alluded to. This accounts for the mimetic side of aemulatio.

Greek ζῆλος could cover a range from eagerness, alacrity, and enthusiasm to fierce resentment, as in the "fiery indignation" condemned by the author of the epistle to the Hebrews (Hebrews 10:27)—πυρὸς ζῆλος, rendered as *ignis aemulatio* by St. Jerome. For unlike mere earnestness or enthusiasm, zeal is also aggressive, asserting principles of constraint in a way that seeks to break through them. This is the effect of aemulatio as envy, the desire for the reputation or social credit that another may have, as well as the defensive jealousy that is fearful of not receiving sufficient recognition for one's own virtues. The social dimension of zeal is also clear in the importance of acts of exhibition. It is not enough to outdo one's neighbors in zeal; one must outdo them in zealous display of it, sometimes through exhibitionist vestimentary conceal- ment, sometimes through the bullying brandishing of nakedness, which are equivalent and even interchangeable forms of exaggeration in the register of ostension. This is perhaps part of the reason for the obsessive libidinization of questions of appearance, exhibition, display, and image-making in the exer- cise of zeal.

The most striking feature of the mixing of cohesion and conflict, confor- mity and nonconformity, in emulative zeal is the fact that the impulse to push toward an always receding extremity and always unsatisfactory excess is itself essentially compulsive. The zealot is addicted to their zeal, meaning that they are also caught in the addict's cycle of competitive self-emulation, needing always to seek to go further in their zealousness.

Although René Girard (1996) has little to say specifically about the opera- tions of zeal, his account of the compoundings of mimesis, desire, and vio- lence seems to provide a valuable context for understanding it. Girard sug- gests that the desire to imitate, which is often a desire to imitate the desire of another, is strongly linked through what he calls "appropriative mimicry" (10) to rivalrous violence:

> If the appropriative gesture of an individual A is in imitation of an individual named B, it means that A and B must reach together for one and the same ob- ject. They become rivals for that object. If the tendency to imitate appropria- tion is present on both sides, imitative rivalry must tend to become reciprocal; it must be subject to the back and forth reinforcement that communications theorists call a positive feedback. In other words, the individual who first acts as a model will experience an increase in his own appropriative urge when he feels himself thwarted by his imitator. And reciprocally. Each becomes the imitator of his own imitator and the model of his own model. Each tries to

push aside the obstacle that the other places in his path. Violence is generated by this process; or rather violence is the process itself when two or more partners try to prevent one another from appropriating the object they all desire through physical or other means. (Girard 1996, 9)

Zealotry is essentially psychopolitical in the fact that the apparently exclusive orientation of the zealot to the future that they aim to bring into being is impelled by the lateral competitiveness with zealotic contemporaries. The effects of imitative zeal are two-sided. On the one side, God aims to encourage emulation of his own jealousy among his adherents, but on the other, as Peter Sloterdijk argues, the most important form of emulation among monotheistic zealots is in fact the will to match or outdo the zeal of God himself:

If they had their way their subservient passion would not simply be their private contribution to the glory of God. It would be the zeal of God himself reaching through them and into the world. This zeal, correctly understood, is an aspect of God's regret at having created the world. In its milder form, it shows his benevolent will to salvage what he still can of a creation that has got out of control. (Sloterdijk 2009, 233–34)

The only way to go far enough in matching the zeal of God is to go too far, and the only way to keep to the straight and narrow is to go off the rails. And what the zealot essentially seeks is not a perfecting of a goal, no matter how emphatic they may be about the coming of the kingdom, of socialism, freedom, feminism, racial justice, or godliness. What characterizes the zealot is extirpatory passion, to drive out every kind of complexity, impurity, or divergence from the original conception of the godhead in creation. This drive to perfection through subtraction is what distinguishes zealotic idealism from other kinds. It is very hard to imagine a zealous capitalist or gourmand, except by imagining their pursuit of more narrowing into an exclusive obsession. A polytheist becomes zealous only when it seems to become necessary for one kind of theism to drive out all the others, as in the commandments issued by the jealous God of Exodus. One can be a zealous lover, but a zealous philanderer seems comically oxymoronic, the figure of Sam in Samuel Beckett's *Watt* perhaps being a rule-proving exception:

Sam, whose amorous disposition was notorious . . . made no secret of his having committed adultery locally on a large scale, moving from place to place in his self-propelling invalid's chair. . . . And when reproached with this Sam

with ready wit replied that paralysed as he was, from the waist up, and from the knees down, he had no purpose, interest or joy in life other than this, to set out after a good dinner of meat and vegetables in his wheel-chair and stay out committing adultery until it was time to go home to his supper, after which he was at his wife's disposal. (Beckett 2009a, 89–90)

Zeal rhymes with radicalism in that it inhabits time in the mode of vicious paradox. Where the zealous may look to and long for a future state purged of imperfections, the zealot also sees these imperfections as perverse departures from a primal condition of simplicity, whether that be the holiness of the Primitive Church or the rapturous indwelling entirety of the godhead prior to the all-hell-breaking-loose of the Creation. Protestant zeal at once borrows from and abhors the doctrine of the *felix culpa*, as expressed in the Exsultet, sung at Easter: "O felix culpa quae talem et tantum meruit habere redemptorem." ("O fortunate fault that merited so great and wonderful a redeemer.") Where the doctrine of the felix culpa sees the long intermission of history as a necessary part of a redemption that will in fact perfect the work of creation and show it to have been providential, the zealot aims to reinstate the state of immaculately null unity that history itself has corrupted. The aim of the zealot is not to redeem the errors of the past but to remove them entirely from history, and even to ensure that history itself will never have occurred.

Salman Rushdie twins zealotry with the passionate desire for historical reversal in his portrait of the exiled Imam in *The Satanic Verses*, compulsively flushing out toxins from his body with glasses of filtered water and broadcasting through his muezzin Bilal his call to undo time:

"We will make a revolution," the Imam proclaims through him, "that is a revolt not only against a tyrant, but against history." For there is an enemy that is beyond Ayesha, and it is History herself. History is the blood-wine that must no longer be drunk. History the intoxicant, the creation and possession of the Devil, of the great Shaitan, the greatest of the lies—progress, science, rights—against which the Imam has set his face. History is a deviation from the Path, knowledge is a delusion, because the sum of knowledge was complete on the day Al-Lah finished his revelation to Mahound. (Rushdie 1988, 217)

The zealot would like to unite himself with the cosmogonic powers of the deity, replaying the creation in order to be sure of inverting and annulling every element of corrupting mutation introduced in and by history. And yet

the zealot must also strive against the intolerable irritation arising from the historical condition of having always to be an after-comer, follower-on, and looker-back. Zeal is often in fact doubly rivalrous: it must reach back to the origin of all things, in order to emulate and outdo its creative powers in the form of curative annulment; but it must, more proximally, surpass a prior generation of reformers, by making the act of reform an ongoing project of reformation, everywhere alert to new corruption, and so gloriously uncompletable. The reformer inaugurates; the zealot intensifies. The reformer strives against opponents; the zealot applies exponents.

Zeal is caught between this abolitionist impulse and the necessity of projecting and prolonging itself. In one sense, zeal will be required to apply itself to an ever diminishing field of unfinished reforms; but in another, a kind of infinite vigilance will be required against the possibility of reactionary reversion and counterreformation. Zeal is therefore what Peter Sloterdijk (2020) calls an "infinite mobilization": it must keep itself in an agitated stasis of suspicious readiness to act in response to dangerous backslidings.

A striking characteristic of zeal is its paradoxical relation to formalism. The iconoclastic assault on images has been treated as one highly characteristic form of zeal. As we will see through this chapter, it has a claim in fact to be thought of as essential to and defining of zeal's workings, in that zeal must always involve a zealous attentiveness to the exhibition and appearance of one's zeal. The form of seriousness we know as zeal makes unmistakable the seriousness of the question of form in seriousness.

The reformist aim of the Puritan is to remove all sinful or superstitious residues of the corruption of Rome. Its emphasis is much more on practice than doctrine, and more on spirit than practice. Organized religions go through regular cycles of eruptive spirit and cramping formalism. The Reverend John Cooper's passionate defense of the principle of self-sacrifice, subtitled *The Lost Power of Zeal Restored to the Christian Church*, goes through the well-established motions of counterposing the life of spirit to the withering death of ritual form:

> All love of worldly vain show, all desire to confirm to its selfish customs, all striving after its power, distinctions, honours, and rewards, in preference to the inner attainments of the Divine, and manifestations of the grace of self-sacrifice, is a resistance of the Spirit, whether it be in the formal of religious life, the emulations of ecclesiastical aims, or the contentions about the doctrines of Christianity. (Cooper 1880, 93)

Cooper finds in the spirit of self-sacrifice the essential requirement and reward of zeal: "Let every believer in Christ realize the power of this doctrine, and the worldliness of the Church is at an end, she will become animated once more with apostolic zeal, and her glorious work will be understood and performed in its true spirit" (116). Zealotry is kept ardent through the constant need to negate, destroy, and deprive, borrowing from the logic of identity performed through abstention and self-inhibition—shaving, circumcision, totemism, food taboo (Connor 2019b, 94–120). The energy that zeal derives from nega- tion very often becomes reflexive, as various kinds of false zeal are denounced as a way of expressing true zeal.

So although the Puritan aims to sweep away vacant or ungodly kinds of formality in order to concentrate attention on the undistorted truth of the Word or, in the more radical sects, the undeflected purity of the speaking of the spirit, their attention must circle down ever more obsessively and micro- scopically on small details of practice. Thus zeal propels antiformalism into ultraformalism. In the Reformation, the proponents of the spirit were sticklers for the letter. Indeed, the word *stickler* itself succumbed to fractious splitting, being used in the early sixteenth century to mean a mediator or arbitrator in a game or contest, but then gradually, perhaps via the idea that a mediator is one who comes between disputants, coming to mean one who advanced a particular cause, or stuck obstinately and contentiously to a particular opin- ion. Puritans were first of all known as "Precisians," and, though this name was superseded by the more common and apparently more embracing "Puri- tans," the tendency even within Puritanism itself was toward the extraordi- nary multiplication of sects and factions, along with carping and carving dis- putes over their very naming, usages reviewed and imitated in an anonymous pamphlet of 1641:

> Every man which is an Antipuritan is not so for the same Reasons, some have more of malice, others are more ignorant, some are pestilent Engineers, and through the sides of Puritans knowingly stab at purity it self, others are but Engines misimployed, or by their owne blind zeal misled, and these perhaps whilst they persecute Gods children, imagine they doe God a gratefull ser- vice therein. . . . And now with the crosse tumults of both factions in extreme choler vented in Pulpits, and Pamphlets, most men grew to be frozen in zeale, and so benummed, that whosoever (as the worthy L. Keep. *Bacon* observed) in those days pretended a little sparke of earnestnesse, seemed red-fire-hot in respect of others. Thus it betided *Protestants,* as those which fare the worse for

ill neighbours, for whilst they curbe *Papists,* or reproove idle drones, they are incontinently branded with the ignominious name of Precisians. (*A Discovrse Concerning Puritans* 1641, 7, 45)

What Theodore Bozeman (2004, 5) calls the "zest for regulation that goes to an extremity" is impelled by a desire to define and reduce that itself proliferates uncontrollably. The comic economy in which formalistic zeal is caught up has provided plenty of opportunity for writers of satire. One should not be surprised to find this precisianist zeal flourishing in universities still at the beginning of the seventeenth century, practicing the arts of logical slicing and dicing, or to see it being reproduced in the delirious tussles over designations emanating from the identitarian zealotry driven by contemporary academics, with the addictive addition of minorities and minimalities of all kinds.

Zeal is in search of a condition of simplicity and self-evidence, in which everything can be simply what it is, without ambiguity or complication. Zeal consists, as Peter Sloterdijk (2009) suggests, of the allergy to the number two, and in "bringing everything down to the number one, which tolerates no one and nothing beside itself" (96). This means an intolerance of numeration altogether, since the oneness without remainder that zeal aims to reinstate could only be subjected to the order of number after the appearance of the twoness that would make it retroactively apprehensible as the serial one, or the one to which one could be added rather than simply the One-and-all encompassing everything without partition and before any fall into division. This is why the allergy to the number two is identified not just with oneness without twoness, or shading of decimal points, in monotheism and the infatuation with various kinds of one-party state, whether political, religious, or philosophical, but also with the adoration of the absolute self-identity of zero, as it seeks to drive out all the calorific randomness that has taken history away from the purified petrifaction of absolute zero. Zealotry is drawn to every kind of "zero tolerance"—of crime, sin, infection, accident, miscegenation, change—having tolerance for nothing except the radiant dream of zero itself, a libidinized nothing that enlarges to become an everything.

The contemporary slogan "cancel culture" is in unrecognized communication with the idea of defacing or undoing in writing. To cancel is literally to cross out, with a mark resembling the lattice on which one might grow a vine. The uses of *cancellare* in Latin tend to emphasize the complexity of its form, as in Pliny's (1983) reference to the "cancellata cutis" of the elephant's creased skin, which he believed the animal used to trap and crush the flies

that tormented it (24–5). The cancellation is the annihilating blot that can never be unblotted, though, of course, to blot in English means both to make a mark and to efface it—for example, with blotting paper. This is why the zealot must always focus anxiously on forms of signification, whether graphic or iconographic, since every icon is a grapheme, and the passing of time and the making of marks are taken as identical (one marks time). So it is the making of marks, as the essential mark of the work of accident, that must be undone or blotted out if time is to be redeemed.

As the force of seriousness—that is to say, as seriousness spilled into force, pure and self-maintaining—zeal is the energy that vigilantly strives for its own exhausted condition of annulment, the slate wiped clean of complexity. Like Freud's death drive, it derives its striving energy from the very thing against which it strives and recoils—namely, time, plurality, existence, contingent emergences. Only the energy of zeal will be able to bear up against the many forms of the number two, in a *sauter pour mieux reculer*, but that energy depends on and derives from twoness itself, which can only be subtracted through additive cancellation.

On the Stump

The particular kind of seriousness exercised in zeal points up an important principle that may be possible to generalize across all forms of seriousness. Zeal is not a condition, or, if it is, it is the condition of aiming for some other condition. Zeal and, even more, zealotry, means aiming to outdo others in zealousness. It is another instance of Larkin's (1988, 98) "hunger . . . to be more serious" and provides an intimation that such a hunger, and such a comparative and competitive orientation, may be a feature of all seriousness. Many kinds of seriousness have the sense of "meaning" things, in the way of intending to do them, and the idea of bending toward or aiming to maintain some purpose is plainly at work in them. We have seen how often philosophers seem to feel the need to proclaim the real seriousness of their own kind of philosophy, or the kind they seek to constitute, as contrasted with more trivial forms of it. Perhaps, in fact, seriousness must always be projective or promissory, and all the ways we have of designating it are in fact signals rather than signs, which are the presumptive—prosumptive, I would fain be able to say—doing of it in its advance designations. Signals are actions, not pictures, or, where they are pictures, as in traffic signals, they are pictures that

themselves do what they urge. This leads to paradoxes when one is intending to signal that one is doing something, or intending to do it, for real, and not just signaling it. Even the phrase *for real* suggests that some kind of performance, or acting out, has been slipped into the idea of "really" acting. There is a minimal shimmer of theater also in words designed to convince bystanders of the reality of one's actions, such as the common contemporary claim to be an "agent"—the word that inconveniently, but tellingly, implies not just someone who acts but also some surrogate hired to perform one's actions—or even more obliquely, to "exercise agency." Those who are zealous for some political cause may well nowadays style themselves "activists," a word unknown before the early twentieth century; it arises originally from the work of the philosopher Rudolf Eucken (1912, 255) as a technical term for thirsting after the spiritual life. It was not until that 1920s that it started to mean one who works actively in support of a political cause, but it still implies a certain infra-thin silhouetting of action by itself—more than simply being active, an activist devotes energy to the action of advertising the activity or condition of being active. The meaning of seriousness is that, to qualify as serious, one must mean to be. One can only "be serious" in the present tense by meaning to be serious, which may often mean or resolving not to dissolve into mere accident or appearance, by intending to behave in such a way as to maximize one's chances of one day being thought to have been serious. All of this may refer us back to Varro's (1951, 1.231–33) seeds planted in a line as the projection of a continuity that itself is continuous with it.

A certain kind of display of approved opinions or actions is sometimes today mocked as "virtue signaling." Seriousness in fact may always be a matter of signals or signalings rather than signs. That is, the projective-promissory nature of seriousness means that it will require various kinds of performance before it can be taken seriously. It is never enough for being serious to remain a simple "being": it must be acted out in certain kinds of ways or, in the useful transitive formulation that Sartre has given us, "existed." One can, I suppose, discover oneself to be serious about certain things, or to "have been" serious about them, as it were "all along." But being serious usually seems to mean forming an intent through the performing of it, or signaling the resolute readiness to perform it, in certain ways—rolling up sleeves, pursing lips, adopting certain kinds of seriousness-signaling inflections (lowered pitch, exaggerated separation of words, etc.), or just saying "Right!" Indeed, recognizing the fact of one's seriousness may constitute no more than the retrospective backdating

of the prospective sort of intent involved in seriousness, often through a reading of the ways in which one may have performed certain actions.

Zeal, like solemnity, of which it is perhaps an agitated version, was twinned with comedy as religious reformers recoiled from the excesses of enthusiasm. The princess in Shakespeare's *Love's Labour's Lost* relishes the ludicrous spectacle of zealots losing themselves in their zeal:

> That sport best pleases that doth least know how—
> Where zeal strives to content, and the contents
> Dies in the zeal of that which it presents:
> Their form confounded makes most form in mirth,
> When great things labouring perish in their birth. (Shakespeare
> 2011, 768)

It was in the work of Ben Jonson that the comic association of zeal with Puritanism was sealed, first of all in *The Alchemist*, in the figures of Ananias and Tribulation Wholesome, the Amsterdam Anabaptists who are among the gulls persuaded to invest in Face's and Subtle's alchemical enterprise. Ananias calls his elder Tribulation to give him reassurance about his suspicions of Subtle and Face: "In pure zeale, / I doe not like the man: he is a *Heathen*, / And speakes the language of *Canaan*, truely" (1937, 340–1). Ananias is made to repeat the etymological error of St. Jerome, who thought that the apostle Simon the Zealot, who is called Kananaios or Kananites, from Hebrew קנאי (*kanai*, a zealot), is so named because he is from the town of Cana or the region of Canaan. Ananias's confusion is taken to be the effect of his own zeal. The common understanding of zeal in terms of heat allows for considerable play with the ideas of diabolism and the "*ignis ardens*" (346) of combustible counterfeit, for example in Tribulation Wholesome's greedy justification of involvement in the profane arts of alchemy:

> It may be so,
> When as the *worke* is done, the *stone* is made,
> This heate of his may turne into a zeale,
> And stand vp for the *beauteous discipline*,
> Against the menstruous cloth, and ragg of *Rome*. (Jonson 1937, 341)

The comedy of the scene in which Subtle leads Tribulation on to thoughts of the power and riches he will gain by means of the philosopher's stone is focused around modulations of the words zeal and zealous. Subtle promises

Tribulation that he will no longer need "your holy vizard, to winne widdowes / To giue you legacies; or make zealous wiues / To rob their husbands, for the *common cause*" (Jonson 1937, 344). Tribulation meantime must restrain the vehemence of Ananias, apologizing to Subtle for him and promising "to humble / Himselfe in spirit, and to aske your patience, / If too much zeale hath carried him, aside, / From the due path" (342), and quelling his pious interjections, with suggestions that he is in fact possessed by zeal as by a diabolical spirit: "Mind him not, sir. / I doe command thee, spirit (of zeale, but trouble) / To peace within him" (345); "it is an ignorant zeale, that haunts him, sir" (346). We owe to Jonson's *Bartholomew Fair*, in the characterization of Zeal-of-the-Land Busy, the first use in print of the word *zeal* as a noun to designate the one displaying or exercising zeal:

> A notable hypocriticall vermine it is; I know him. One that stands vpon his face, more then his faith, at all times; Euer in seditious motion, and re-prouing for vaine-glory: of a most *lunatique* conscience, and splene, and affects the violence of *Singularity* in all he do's: (He has vndone a Grocer here, in Newgate-market, that broke with him, trusted him with Currans, as errant a Zeale as he, that's by the way:) by his profession, hee will euer be i' the state of Innocence, though; and child-hood; derides all *Antiquity*; defies any other *Learning*, then *Inspiration*; and what discretion soeuer, yeeres should afford him, it is all preuented in his *Originall ignorance*; ha' not to doe with him: for hee is a fellow of a most arrogant, and inuincible dulnesse, I assure you (Jonson 1938, 27).

The most arrogant form of dullness possessed by the zealous moralists of the late sixteenth century onward was in the disapproval of popular entertainment. Puritans were particularly zealous—or at least were regularly represented as such in sixteenth- and seventeenth-century drama—in their opposition to the wickedness of theatrical representation. Indeed, the prologue to Ben Jonson's *Bartholomew Fair*, written for the first performance of the play at the court in Whitehall on 26 December 1614, presents the whole play as a metarepresentation of the process of zealously decrying plays and playthings:

> *Your* Maiesty *is welcome to a* Fayre;
> *Such place, such men, such language & such ware,*
> *You must expect: with these, the zealous noyse*
> *Of your lands* Faction, *scandaliz'd at toyes,*
> *As Babies, Hobby-horses, Puppet-playes,*

And such like rage, whereof the petulant wayes
Your selfe haue knowne, and haue bin vext with long. (Jonson 1938, 11)

As has routinely been observed, *Bartholomew Fair* plays, as does *The Alchemist*, with the condition of theatricality. The culminating episode of the play is the dialog between Zeal-of-the-Land Busy and the puppets whom he interrupts performing the story of Hero and Leander, transposed to muddy Bankside.

The action of the episode is framed and programmed by the Old Testament story of Dagon. Busy denounces the puppet play on his entry as the operations of Dagon:

> Bvs. Downe with *Dagon*, downe with *Dagon*; 'tis I, will no longer
> endure your prophanations.
> Lan. What meane you, Sir?
> Bvs. I wil remoue *Dagon* there, I say, that *Idoll*, that heathenish
> *Idoll*. (Jonson 1938, 133)

Dagon was a conventional figure for idolatry—a figure, as it were, for the act of idolatrous figuration. Dagon or Dagan was worshipped among Canaanite peoples, being identified in the Old Testament specifically as the God of the Philistines. The account most frequently alluded to is that given in 1 Samuel 5:2–7. It describes the capture in battle by the Philistines of the ark of the covenant, containing the tables of the law. The ark is set up alongside the image of Dagon in his shrine. Although disappointing the military hopes of the Israelites—"Let us fetch the ark of the covenant of the LORD out of Shiloh unto us, that, when it cometh among us, it may save us out of the hand of our enemies" (1 Samuel 4:3)—the Lord chooses to demonstrate his power symbolically— that is, through the power wielded over symbols themselves:

> [3] And when they of Ashdod arose early on the morrow, behold, Dagon was fallen upon his face to the earth before the ark of the LORD. And they took Dagon, and set him in his place again. [4] And when they arose early on the morrow morning, behold, Dagon was fallen upon his face to the ground before the ark of the LORD; and the head of Dagon and both the palms of his hands were cut off upon the threshold; only the stump of Dagon was left to him. (1 Samuel 5:3–4)

There is a suggestive but unexplicated rhyme here with the undignified demise of the aged Eli in the preceding chapter of Samuel, who is similarly toppled

by being told the news of the routing of Israel: "And it came to pass, when he made mention of the ark of God, that he fell from off the seat backward by the side of the gate, and his neck brake, and he died: for he was an old man, and heavy" (1 Samuel 4:18). Because the ark is not a representation but simply a repository, it can stand as a rebuke against the habit of groveling cravenly to idols. But the very form that its rebuke takes is the violent enforcement in an icon itself, the mutilated statue of Dagon falling on its face, of fetishistic groveling to another icon.

It seems clear that the story of the mutilation of Dagon was seen as a symbolic castration, which images the triumph of the true God over inventions and representations. Like all such forms of iconoclasm, it is a symbolic castration that is also a castration of symbolism as such. Oddly enough, the Hebrew rendered by the English as "only the stump of Dagon was left to him" in the King James version of 1 Samuel 5:4 is itself something of a stump, since the words "the stump of" do not appear—translated literally, they read simply, but puzzlingly, "only Dagon was left to him"—רַק דָּגוֹן נִשְׁאַר—the idea of the stump or, variously, trunk, torso, or body therefore being imported to round out the otherwise amputated sentence.

The zealous erotics of this stump, at once humiliation and triumph, seem to have captivated Puritans and anti-idolaters. The Puritan Henry Barrow (1590) raged against the Book of Common Prayer, as "*a pregnant Idole and full of abhominations, a peice of Svvynes flesh, and abhomination to the Lorde*" (sig. F4ᵛ), saying that it has been "sett vpp as the Idole of Indignation & Dagons stump aboue the worde of God" (sig. G1ʳ). Why, one can wonder, might one "set up" the stump of a statue—or should that be the statue of a stump? There seems to be something stumpy or maimed in an idolatrous statue in the first place, which makes the miraculous mutilation of its thrown-down condition a sort of doubling of its original state.

And indeed some seventeenth-century readers might have had a more particular kind of reason for thinking of the statue of Dagon as essentially maimed or imperfect. Milton's evocation of Dagon among the catalog of pagan gods roused by Satan at the beginning of *Paradise Lost* (1667) reflects a tradition that combines oddly with the story of the mutilation, that Dagon was in fact a hybrid, or half-human:

> Next came one
> Who mournd in earnest, when the Captive Ark
> Maimd his brute Image, head and hands lopt off

In his own Temple, on the grunsel edge,
Where he fell flat, and sham'd his Worshipers:
Dagon his Name, Sea Monster, upward Man
And downward Fish. (Milton 1963a, 17)

Dagon is again described as a "Sea-Idol" four years later in *Samson Agonistes* (Milton 1963b, 65). The 1867 Darby translation of 1 Samuel 5:4 also registers the idea that Dagon was a kind of fish-god or merman: "only the fish-stump was left to him." This conception of Dagon as having the form of a fish from the waist down (or, in one version, from the waist up) appears from the twelfth century in the work of the Jewish commentators on the Bible Rashi and David Kimhi (Macalister 1914, 100). The amphibious conception of Dagon (which might resonate with the word *dragon*, which the name suggests) intensifies the grotesque mingling of condition that is present in the idea of an idol for an iconoclast concerned with purifying the divinity of all carnal admixture.

There is certainly corporeal paradox suggested here, of the kind that is typical of Irish bulls such as the story of the Kilkenny Cats, who fight until they have devoured each other:

There wanst was two cats of Kilkenny,
Each thought there was one cat too many,
So they quarrelled and they fit,
They scratch'd and they bit,
Til, barrin' their nails
And the tips of their tails,
Instead of two cats, there warnt any. (Woods 1942, 682)

The absurdity of the joke is sharpened by the detail of the nails and tails that are left behind (oddly and idly recalling the stories of spontaneous combustion to which only a pair of singed and smoking feet are testimony), slender orts that somehow make the already absurd idea of antagonists who have eaten each other, leaving not a cat behind, even more absurd. It is as though, like cartoon cats, they carried on eating each other until they suddenly realized that, having been eaten themselves, they were no longer physically there and so had nothing to swallow the tail of their adversary with or, as it were, into.

The equivalent absurdity of Dagon's stump is that he is at once the material stump left after his essential features (face and feet) have been excised and yet still sufficiently in existence, somehow and somewhere, for it to be thought

of as "his" stump, which is said to be "left to him" (what "him"?) in the King James translation. The Kilkenny logic of the title of one eighteenth-century tract—*Dagon Fallen upon His Stumps: or the Inventions of Men, Not Able to Stand before the First Commandment of God* (Elwall 1726)—is enacted in the anti-bootstrapping idea that "you" might fall upon the stump that is in fact all that you yourself any more amount to. The ludicrous inbodiment (Connor 2017) involved here is the idea that the body is both a nothing and a something—it is a mere thing that makes it a nothing in contrast to the spirit of which it is the tenement.

The sequel to the miracle of Dagon as recounted in the Old Testament seems to offer an even more absurd and grotesque misconstrual by the Philistines, or even by the text itself. Not only is the Philistines' deity cut down to size, the Lord "smote them with emerods [hemorrhoids] even Ashdod and the coasts thereof" (1 Samuel 5:6). Deciding that the plague-inducing ark is more trouble than it is worth, the inhabitants of Ashdod send it away to the city of Gath, with the predictably uncomfortable sequel: "The hand of the LORD was against the city with a very great destruction: and he smote the men of the city, both small and great, and they had emerods in their secret parts" (1 Samuel 5:9). The inhabitants of Gath in turn pass the ark on to the city of Ekron, whose inhabitants, suspecting what is in store, protest at the transfer, but suffer the same outcome. After seven months of boils, tumors, or hemorrhoids, along with, for good measure, the Septuagint adds, a plague of mice (1 Samuel 6:1), the Philistines decide to send the ark back, with a "trespass offering":

> [4] Then said they, What shall be the trespass offering which we shall return to him? They answered, Five golden emerods, and five golden mice, according to the number of the lords of the Philistines: for one plague was on you all, and on your lords. [5] Wherefore ye shall make images of your emerods, and images of your mice that mar the land; and ye shall give glory unto the God of Israel: peradventure he will lighten his hand from off you, and from off your gods, and from off your land. (1 Samuel 6:4–5)

The idea of sending the ark back to its owners and acknowledging its magical power over all worship of graven images by packing it with what one historian calls "votive models of their twofold plague" (Macalister 1914, 48) is as delicious as it is delirious ("What will please an iconophobic god like Jehovah best of all—surely a set of golden boils to pay homage to his power over representations!"). One senses that the Philistines are struggling badly with the whole

no-graven-images concept—that, surely, being the point. The Philistines are so wedded to their foul habits of idolatry, it seems, that they and their actions must necessarily congeal into a symbolic image of their insuperable fetish for idolization.

Jonson (1938) not only has Zeal-of-the-Land display a kind of absurd confusion in his excited zeal—"Good *Banbury-vapours*" as Knockem remarks (133)—he also draws his zeal into relation to the play of puppets and surrogates. Just as zeal is imaged as a possessing spirit in *The Alchemist*, here Busy invokes the "spirit of zeal" as one might conjure a devil: "Bvs. I will not feare to make my spirit, and gifts knowne! assist me zeale, fill me, fill me, that is, make me full" (134). The obvious self-reduction to the condition of a puppet is pointed up by Win-Wife: "What a desperate, prophane wretch is this! is there any Ignorance, or impudence like his? to call his zeale to fill him against a *Puppet*?" (134). Jonson's aim in having Busy dispute with a puppet (the figure of Dionysius, king of Syracuse, operated by Lantern Leatherhead) is to reduce him to an equivalent condition of quibbling quasi-animation:

> Bvs. First, I say vnto thee, Idoll, thou hast no *Calling*.
>
> Pvp. d. *You lie, I am call'd* Dionisius.
>
> Lan. The *Motion* sayes you lie, he is call'd *Dionisius* i' the matter,
> and to that *calling* he answers.
>
> Bvs. I meane no *vocation, Idoll*, no present lawfull *Calling*.
>
> Pvp. d. *Is yours a lawfull Calling?*
>
> Lan. The *Motion* asketh, if yours be a lawfull *Calling?*
>
> Bvs. Yes, mine is of the Spirit.
>
> Pvp. d. *Then* Idoll *is a lawfull* Calling.
>
> Lan. He saies, then *Idoll* is a lawfull *Calling!* for you call'd him *Idoll*,
> and your *Calling* is of the spirit. (Jonson 1938, 134)

Zeal-of-the-Land is "busy" like the meddling busybodies denounced in the King James version of the New Testament (1 Peter 4:15), but also busy in the sonosemantic sense that his allegedly inspired speech is nothing more than empty "buzzing" or vaporing (Connor 2014a, 163–66): "I haue long opened my mouth wide, and gaped, I haue gaped as the oyster for the tide, after thy destruction: but cannot compasse it by sute, or dispute; so that I looke for a bickering, ere long, and then a battell" (Jonson 1938, 133). He protests to the puppet that "He neygheth and hinneyeth, all is but hinnying Sophistry" (135), but finds himself drawn into a mechanical interchange of assertion and

denial—"It is prophane. *It is not prophane.* It is prophane. *It is not prophane*" (135), prompting Leatherhead to remark that "You cannot beare him downe with your base noyse, Sir" (135).

A wrangle about the vanity of dress lures Busy into the familiar denunciation of the immorality of cross-dressing in the theater, only to precipitate the comic shock of the exhibition of the absence of private parts in the puppets:

> Pvp. *It is your old stale argument against the Players, but it will not hold against the Puppets; for we haue neyther* Male *nor* Female *amongst vs. And that thou may'st see, if thou* [The Puppet takes up his garment.] *wilt, like a malicious purblinde zeale as thou art!* (Jonson 1938, 136)

Disputation is here cut off bizarrely by amputation. This is more than an acceptance of the legitimacy or harmlessness of puppetry; it is a counterassertion of the priority of the puppet over the real boy. The castrated condition of the animated object is proof against the dread of castration.

All the way through *Bartholomew Fair*, the figure of the puppet alternates with that of the hobbyhorse, the head of a horse on a stick sometimes worn by a capering Morris dancer or used as a child's toy. The horse's head whinnying from the loins of the rider is a kind of dildo or codpiece, a stand-in for the phallus that is substitution itself. The head of the puppet animated by the hand is a false tumescence, just as the dancer animates the head of the horse. Everything in all of this is a put-up job:

> Pvp. *Nay, I'le proue, against ere a* Rabbin *of 'hem all, that my standing is as lawfull as his; that I speak by* inspiration, *as well as he; that I haue as little to doe with learning as he; and doe scorne her helps as much as he.*
> Bvs. I am confuted, the *Cause* hath failed me. (Jonson 1938, 136)

The zeal of the zealot cancels down ultimately into the struggle of life, as pure spirit, or I AM, against the corrupting contingency of embodiment. But the phallus, as the prosthesis of the thesis, the stand-in for real "standing," is also a figure for the ultimate and nonannullable substitutability, as the life-and-death matter of identity that cannot be proposed without being exposed to the risk of derisive laughter. The phallus, that is, is the essential figuration of the comic identity of identity with substitution, the symbol of the fact that life and death themselves depend on and so must pass through symbols. The case of a speaking phallus seems in particular to dramatize the absurdity of taking yourself to be yourself, without supplement or residue, and the rage to purify

yourself of surrogacy or substitution. The ultimate aim of the zealot, to effect purifying conversion, is itself converted into a general principle of convertibility, which turns the entire theater of beholders (and the readers who behold those beholders) into players in the *theatrum mundi*:

> Bvs. I am confuted, the *Cause* hath failed me.
> Pvp. *Then be conuerted, be conuerted.*
> Lan. Be conuerted, I pray you, and let the Play goe on!
> Bvs. Let it goe on. For I am changed, and will become a beholder with you!
> Cok. That's braue i' faith, thou hast carryed it away, Hobby-horse, on with the Play! (Jonson 1938, 136)

The revenge of the drama—imagined as a sort of antireligion to which one may be converted, against the Puritan objection to the idolatry of theater—was to turn the denunciation into a kind of idol, what Kirsty Milne (2011, 291) has called the trope of "the Puritan at large in the fair." This is a hardening of the exercise of zeal into the personification known as the "zealot," and of zealousness into zealotry. The word zealot is used in English before the end of the sixteenth century in reference to the apostle Simon, who was known as Simon the Zealot, ζηλωτής, in the belief that he was a member of a sect pledged to absolute resistance to Roman rule that arose shortly before the rebellion in Judaea of AD 66–70. The zealot is so serious about their zeal that they turn it into an inflexible formula, and a formulaic inflexibility. This has a particular absurdity and potency in the case of a zeal pledged to the cause of reform through the sweeping away of empty formalism. Denouncing Dagon makes of the denouncer a "Dagonet," in the Puppet Dionysius's mirror-taunt (Jonson 1938, 135), alluding to a foolish and blundering knight in Arthurian legend. The word zealous becomes a signature of the character of the self-regarding, pleasure-denouncing Puritan, as exemplified in the portrait of the "Zealous Brother" limned in Richard Brathwaite's *Whimzies* (1631). Zeal is identified not with seriousness but with paradox and inconstancy, the purifyingly antitheatrical force of zeal itself nothing more than a catalog of performances and postures:

> He is so possest with *inspiration,* as he holds it a distrusting of the *Spirit* to use *premeditation....* Hee ever takes the Crosse on his left hand, to avoid superstition.... His frequent preaching leaves him no time to pray in: He can *stand*

better than can *kneele*. . . . Hee is seldome or never constant to those *tenets* he holds . . . Though hee seeme all *spirit*, yet during his beeing in this Tabernacle of clay, he holds it fitting to have a little relish of the *flesh*. . . . He holds one probable *Tenet* constantly; "That there are no walking Spirits on earth;" and yet he finds a terrible one at home: which all his *Divinity* cannot conjure. (Brathwaite 1631, 197, 198, 199, 201, 202)

Most conspicuously, the zealous brother has no understanding of the things he is so zealous about.

He holds his Mother tongue to be the Originall tongue; and in that only he is constant, for he has none to change it withall. He wonders how *Babel* should have such a confused variety of *tongues*, and hee understand but one. He never reads any *Author*, lest hee should bee held for an *Apocryphall Pastor*. One would take him for an incessant *Student* by his pale visage and enfeebled body; but the bent of his studies intends more the *practick* than *Theorick*. . . . Hee is holden a great *Rabbi* amongst his *Brethren*, whose weaknesse hee strengthens with perillous paradoxes: which when hee comes to explain, hee as little understands as his amazed *hearers*. (Brathwaite 1631, 198–89, 203–4)

The Puritan is constant only in cleaving to his blind faith, his zeal typified as pure oxymoron. The stage-abhorring Puritan has become a stage Puritan, the jointed puppet dangling from his own histriophobic zeal.

The (disappointingly abrupt) detumescence of Zeal-of-the-Land at the end of the disputation episode in *Bartholomew Fair*, as though Jonson had simply grown weary of the foolery, is a confirmation of what the puppet disputation seems to impute to hypocritical Puritans, namely that their iconoclasm is in fact fevered iconolatry through and through. The "iconoclasts who sought to break the image's spell by dramatically exhibiting its destruction" (Koerner 2004, 105) may be thought of as both exercising and subjecting themselves to an inverted form of fetishism. Where sexual fetishism, on Freud's account, is an attempt to reassert the figure of the phallus against the threat of its ablation, the symbolic castration effected in many forms of iconoclasm is an attempt to phallicize the very absence of the offending organ— hence the throbbing cathexis of the stump, or its equivalent in many churches, the statue not destroyed but left defaced, as a present reminder of its erasure. The logic of the stump, as it may perhaps be denominated, is present in this idea of the self-incriminating residue that is often employed by iconoclasts.

Although in principle icons must be swept away entirely, cleansing the earth of their horror, this can obviously lead to a certain anxiety at the absence of the icon (Where has it gone? What devilish work might it be up to?). Hence the icon must in fact be preserved from the very destruction it is required to suffer. Where the fetishist is said to be insisting that there cannot be anything without a penis, the iconoclast is saying that there cannot be anything but the absence of the penis, which everything must be made to display. As many have recognized, the attack on an image is always in fact a salute to its power, in that what Joseph Koerner (2004, 280) describes as the "broken fetish" cannot but body forth the fetish of the broken, in a grotesque contortion of the very idea of "reformation." Defacement, the attempt to keep the image visible in the state of brokenness and defilement to which one has attempted to reduce it, is a paradoxical (and in the end irresistibly risible) capitulation to the power of the image to arrest and instruct the eye. Most hair-raisingly and hilariously of all, preserving an image in its state of erasure, as the triumphant image of the power of setting the power of images at naught, endlessly resurrected as undead, cannot help but refer to the pathos of the crucifixion itself, as the image of an infinite God willingly permitting himself to be transfixed in the broken finitude of the body. To batter, ablate, and degrade the image of a saint is to Christify it.

But this could happen to Puritans and iconoclasts as well as being effected by them. Zealotry often provokes mocking ridicule in its opponents. But the target of ridicule has a sovereign defense against the charivari that reduces them comically to the condition of a puppet or effigy of their faith. The example of the mocked and persecuted Christ allows for the holy zeal of humiliation, which inverts the inversion involved in the comic diminishment of dignity. Quakers in particular became masters and mistresses in the inversion of public shame. The will to the abolition of fetishes cannot easily avoid becoming a fetish.

Just as antiracism serves to keep thought and discourse suffused with the libido of "race," so the bringing low of the idol, whether Lenin, Saddam, or Edward Colston, serves to perpetuate the puppet-power of the puppet. The extirpatory passion is matched by the need to keep extirpation itself alive and kicking. However radical and uncompromising the desire to eradicate corruption may be, the eradication must in fact be asymptotic or self-limiting, to protect the possibility of the corruption that is its own reason for being. The last devil or Jew or Papist or Nazi or Western imperialist or beneficiary of

slavery will never be wiped out. Like the carefully preserved last vial of small-pox, it must survive in order to be permanently marked for extermination, if only in the land of Nod.

Zeal Media

In contemporary life, zeal has derived new impetus from contemporary forms of immediate communication. This helps to dramatize another important feature of zeal, namely, its sectarian or schismatic character. Peter Sloterdijk (2009) has distinguished in the leading forms of monotheism the mission-ary zeal of an "offensive universalism" (37) and a surprising kind of "defen-sive universalism" (52) that is particularly characteristic of Judaism. But these expansive and contractive forms of universalism in fact cooperate in the zeal-otic outlook, through the "set-theoretical paradox" brought about when "one can only invite everyone if one can be sure that not everyone will come" (130), this restating Freud's (1953–74, 21.114) wry observation that "when once the Apostle Paul had posited universal love between men as the foundation of his Christian community, extreme intolerance on the part of Christendom towards those who remained outside it became the inevitable consequence." The earnest inclusiveness of different kinds of oppressive intersection recalls the rampant sectarianism of earlier forms of radical religiosity.

But this does not get close enough to the thymotic perturbation of zeal, which flourishes not only, and not most intensely, in obvious forms of antago-nism between a community and its outsiders but rather in circumstances in which a coherent social bloc fractures internally along lines that are competi-tive or comparative rather than adversarial. The three-way relations among Catholic, Anglican, and Puritan, as dramatized, for example, in the rela-tions among the three brothers Peter, Martin, and Jack in Swift's *Tale of a Tub*, typify the dynamics. Anglican and Puritan are allied against the Church of Rome, but their very alliance makes disagreement on the degree of the reforms needed to defeat their common antagonist so intense as to render that primary antagonism irrelevant.

This is to be understood partly in terms of the workings of Freud's (1953–74, 21.114; 1991, 14.473) "narcissism of minor differences [*Narzißmus der kleinen Differenzen*]." This phrase is often invoked to point to the strange absurdity of antagonisms between what are seen as similar groups or persons, but the specific role of narcissism in Freud's formula is rarely explored or

even adverted to. Freud himself seems to have used this as a suggestive slogan rather than as something requiring explication. One of the odd things about the formula is that there does not seem to be a canonical point of origin for it in Freud's writing. It is first used in "The Taboo of Virginity" of 1918, in which Freud refers to the argument of Ernest Crawley (1902) in his book *The Mystic Rose* that the taboo on virginity arises from the socioreligious accentuation of the "complementary difference" of sex (57). This prompts from Freud (1953–74, 11.199) the suggestion that "it would be tempting to pursue this idea and to derive from this 'narcissism of minor differences.'" The fact that Freud has just, a line or two earlier, quoted from Crawley (1902) a reference to the "taboo of personal isolation" (399) may make it seem that the "narcissism of minor differences" is also a quotation from Crawley, but the phrase does not in fact appear in his book. Thereafter, Freud refers back indirectly to his own usage, as in the discussion in 1921 in "Group Psychology and the Analysis of the Ego" of the relation between the narcissistic relation to the ego and the "libidinal ties" (1953–74, 18.103) with the group, though Freud confesses himself uncertain as to why "such sensitiveness should have been directed to just these details of differentiation [*Einzelheiten der Differenzierung*]" (1953–74, 18.102; 1991, 13.111). The notion of "narcissism of minor differences" seems to be suggestively in the vicinity here, but without coming to explicitness. When the phrase is used explicitly in *Civilization and Its Discontents* in 1930, it is identified as a quotation from elsewhere, with the acknowledgment that it is "a name which does not do much to explain it" (1953–74, 21.114).

In his 1914 essay "On Narcissism," Freud (1953–74) defined narcissism as a peculiarly rapt form of pleasurable self-absorption: "libidinal complement to the egoism of the instinct of self-preservation" (14.73–74), having analogies to the "megalomania" of children and primitive peoples, in

> an over-estimation of the power of their wishes and mental acts, the "omnipotence of thoughts," a belief in the thaumaturgic force of words, and a technique for dealing with the external world—"magic"—which appears to be a logical application of these grandiose premises. (Freud 1953–74, 14.75)

But why should "minor differences" be helpful, or adapted to the purposes of narcissism? I think we may find a kind of answer in the idea of "libido" or, more precisely, its gerund complement, "cathexis," the process, itself magical in form, of investing energy—magical because the nature or purport of the energy in question cannot be fully specified, nor the nature of the process of

investing it. I pointed at the beginning of this chapter to the essentially tem-poral nature of zeal, which must always maintain itself in a condition of striv-ing, or self-stressing incompleteness. As a kind of metaseriousness, or serious-ness regarding seriousness, zeal may also be characterized as the anxiety of seriousness. This may in turn intimate that the real threat to the libido of zeal, like the threat to libido itself, is not antagonism or obstacle but rather exhaus-tion, whether achieved through ecstatic discharge or slow, entropic diminish-ment. The enemy of desire, the mortal enemy because it is certain in the end to conquer, is the desire for satisfaction.

Viewed in this way, we may begin to see how the zealot may need to make use of a continuing source of irritating stimulus, in the figure of a rival who is reliably close at hand, so close at hand as easily to be confused with them-self (the Judaean People's Front and the People's Front of Judaea). The mim-icry of the rivalry with the almost identical is a mirror of the almost-entire self-mirroring of the narcissist. (The narcissist can only remain so if they refrain from plunging into the pool.) Ovid's (1977, 156) Narcissus is trapped in longing for what he already has, himself, though it is just his self-possession that makes him destitute: "Quod cupio mecum est: inopem me copia fecit." ("What I want I have: my riches make me poor.") Narcissus longs to be other than himself, so he could win the prize of himself: "would that I could with-draw from our own body [*o utinam a nostro secedere corpore possem!*]" (156). Where Narcissus longs to recede from in order to rejoin himself, the zealot turns this upside down, turning the longing for erotic union into a coupling antagonism that keeps itself alive through the secret knowledge of that union. The antagonism with the outsider, or the wholly other, risks encountering both the void of complete, self-annihilating absorption in the life-or-death struggle and the annihilating void of victory. The most important feature of the intimate enmity of the rival is its power of persistence—that is, by always being there, it can ensure the persistence of the possibility of recoil from it. The mimetic rivalry with the intimately almost-same maintains a standing reserve of the libido of seriousness on which zeal depends and that zeal itself exists to ensure.

But, like many accounts of zeal, this may be too focused on the dynam-ics of the individual. For zeal is not psychological but psychopolitical, mean-ing that its effects are always found in a state of multiplication, among the members of a collective that maintains its self-similarity through the stress of internal striving. A striking example of the operations of collective zeal

is furnished by the growth of what during the 1980s and 1990s came to be known as the cult of "political correctness" among academics in the humanities and social sciences. Three decades later (the span of a generation that provides the periodicity of so many social transformations), in a response perhaps to the increasing challenge to liberal thought by the resurgence of political conservatism, political correctness mutated into the rise of what is called "wokeness" or, changing the participial adjective 'awakened' to a noun, just woke, which makes a clear link between secular left-liberal ideologies and religious awakening. The term *woke* seems to have appeared in print as early as 1962, in an article in the *New York Times* titled "If You're Woke You Dig It" (Kelley 1962). The article is in fact about the circulation of "today's Negro idiom" among white people. Here woke means in the know, savvy, fly, largely about use of language. In the teens of the 2000s, the term came to mean "alert to racial or social discrimination and injustice." The substitution of the perfect tense (broke, woke) for the passive past participle (broken, awoken) combines African American oralism with a memory of the deliberately quirky Anglo-Saxon archaism characteristic of and often mocked in Puritan and Dissenting speech. The fact that woke, as an off-the-shelf insult employed by conservative objectors, has come to mean wide-eyed in the sense of somnolently conformist rather than spryly alert has added to the degradation of the term.

The term woke is given a zealotic cast in its temporal associations, as expressed especially in the injunction to "stay woke," which was in use in the 1960s but gained new impetus following the 2008 song "Master Teacher" by Erykah Badu, with its refrain "What if it were no niggas / Only master teachers? / I stay woke." Although "consciousness-raising" was an important part of the lexicon of feminist and civil rights activism in the 1960s, the new stress on maintaining rather than awakening such awareness indicates an awareness of a second awakening, and the danger thereafter of nodding off about such issues. This structure of recurrence, or reawakening to awakening, is the relation of aemulatio that characterizes the contemporary zealotic temper. Indeed, zealots are frequently second-generation converts, seeking to reverse the backsliding of the first generation of revolutionaries. The long and turbulent prehistory of orthodox Christianity up to the Council of Nicaea in 325 gave many doctrinal opportunities for later groups to proclaim themselves preservers and revivers of the original faith. The rewritings of biblical doctrine by the twelfth-century Cathars, whose beliefs centered on the achievement of perfection in earthly life, seemed to many to be extravagant and

infantile distortion. But the Cathar perfecti (*Cathar* from the Greek "pure") "honestly thought they were the only true Christians, that the clergy were servants of Satan's Church; and that Cathar teaching presented a stream of pure underground Christianity, often persecuted, but always surviving and reaching back to the days of the apostles" (Lambert 2002, 131). According to Thomas Fuller's (1837, 2.474) *The Church History of England*, "the odious name of PURITANS" was not known until 1564, some thirty years after the first break with Rome in Britain. The insurrections of zeal, which may derive their force from the doctrine of resurrection, are frequently themselves a literalization of that doctrine.

Contemporary forms of zeal receive impetus from a strain of critical and cultural critique embedded in academic culture, especially in Anglophone cultures. This is not any eruption of theoretical discourses to match that of the 1960s and 1970s, but rather the long-term sedimentation of oppositional cultures originally nourished by those discourses—which have often been seen as a deflection into "culture" and the culture of "cultural theory" of the defeated political hopes of 1968. Over half a century, academics raised in this familiar and rather nestling culture of critique have grown into authority in their universities, slowly, and through the irresistible argument of supersession, sedimenting their position, as they took their places on hiring, funding, and governance committees. I must look very much like one of them. Like many zealotic groupings, this generation, who now impart their enthusiasm to their grandchildren, are both hegemonic within the universities in which they have their base, along with large sections of the press, media, and liberal professions, and ironically but bracingly convinced of their romantic marginality. The rage of the discovery that liberals of this persuasion were actually in a slight electoral minority, following the vote to leave the European Union in Britain and the victory of Donald Trump in the US, seems to have encouraged a move from what had previously been antiauthoritarian liberalism to ever more obviously antiliberal authoritarianism.

There were certainly people in the 1960s and 1970s who lived out philosophical theories as a kind of praxis, another magic word for the doing of things that was encouraged by Marxist theory, but this proved ever more difficult during the 1970s and 1980s, given the extraordinary diversity and fiendish abstractness of the varieties of theory that became the intellectual engines of work in the humanities. Such discourses seemed well adapted to the work of binding academic institutions together, while also giving opportunities for

internal differentiation, through the well-tried process of elaborating esoteric concepts. Surprisingly, however, some of the principles of cultural theory were able to take root outside the university. For this to happen, these perspectives needed to be reduced to skeletal formulae and stripped of all the toiling agonies of objection and counterargument that characterized the 1970s seminar, in which, to resuscitate the old joke, the presence of four participants implied five warring opinions. No concept was more lacerated by critique and hairsplitting than the idea of identity, even and especially among feminists. And yet the ringing rejection of all that academic if-and-buttery made the increasing religious force—the archaically impassioned fantasy, many an old codger may still wearily wish to insist—of identity unassailable in the decades of thymotic self-assertion. The transformation of bones of contention into articles of faith required lethal injections of seriousness into previously super-sophisticated arguments about, say, the performativity of identity, in order to precipitate innocently self-dispatching Escherisms like the designation "nonbinary" (as I heard one philosophy professor mutter during a University of Cambridge meeting, career-immolating had it been more audible, "Well, let's face it, you're either nonbinary or you're not"). It was as though physics had wearied of the fiendish complexities of neutrinos, quantum entanglement, and charmed quarks and decided to revert for restful simplicity to the principles of Democritus: "εἶναι τῶν ὅλων ἀτόμους καὶ κενόν, τὰ δ᾽ ἄλλα πάντα νενομίσθαι: there are atoms and the spaces between them; surmise makes up the rest" (Diogenes Laertius 1931, 452).

And yet it could not easily be said that this was a simple case of complex ideas becoming cruder and simplified as they migrated out of the university, for "academic discourse" propagated hugely outside the university and began to feed back into it, via the modes of social media that increasingly have become the organs of academic publication, this then forming a self-augmenting feedback loop. Other institutions adopted the modes of religious zealotry that had previously been contained within academic institutions. In the UK, such venerable institutions as Tate, the British Library, and even the metropolitan police began purgative reviews of their own tainted histories. Academic life had thereby achieved one part of its immemorial dream, to be regarded as much more than merely academic, making it for the time being the most evident form of the zealotic style.

What all these have in common is the principle of the omnipotence of thought, or what became its substitute, the secondary omnipotence of the

forms of discourse that embodied it. Academics who were unwilling to put their career prospects at risk by political activism of a traditional kind turned inward to a sort of politics of style in which to live out their austere fantasy of striving against the very ingrained systems of privilege and exclusion they epitomized. Indeed, the magical theory of the political efficacy of styles of life became a leading principle in academic theory, especially in subjects in which the study of form had been traditional. As themselves technicians of the symbolic order, academics in the humanities can be more or less guaranteed to believe that forming new and more just economic systems and social relations need consist of nothing more, and must never be anything less, than a matter of strategic variations in symbol choice and style of life. The particular style of seriousness that diffused from universities from the 1980s onward was an affirmation of the seriousness of style, a dandiacal maxim stripped of all its glitter as the war of discursive styles became a hard-nosed technique of social advancement.

There is, of course, a long tradition of universities fomenting radical forms of political theory by acting as spaces apart in which improbable ideas can be cultivated and experimented with, even to the point of living them out in practice. Most students discover the performance arts of the committee for the first time in university. Up until the 1960s, political audacities were usually imported from outside academic life, sometimes as reverential reenactment, in Maoist communes set up by overall-wearing independent schoolboys in North Oxford, and so on. But a complex and far-reaching series of economic and political changes over the last half century have inverted the usual order of things. What this means is that the university is no longer a camera obscura (the imaginary realm of Academia on the model of Utopia or Ruritania) in which the realities of politics can be played out, or played with, but rather a template for social relations, programming a collective pantomime of wish fulfillment and magical motivation.

Britain has a particularly long tradition of conceiving of educational institutions as models for society—an idea that a film such as Lindsay Anderson's *If . . .* both parodied and promoted. But during the 1980s, the parodic gap closed. Rather than the seminar providing a fragile, temporary enactment of tolerant collective deliberation, social relations were actively and systematically remodeled as seminars in action. This bizarre process was assisted by two strongly interlinked phenomena: the expansion of higher education, as part of the engineered shift away from traditional kinds of labor and

employment, and, running in parallel, the revolutionary expansion and diversification of information technologies, manifesting in particular as the prodigious growth in communications media. The expansion of higher education, ill-aligned with career outcomes of appropriate levels of social esteem, has produced across many countries a very large class of disappointed graduates, especially in the humanities, irritated to discover that there were so few opportunities in the world beyond the university to continue living out the utopian theatrics and less-than-utopian squabbling schismatics of student life. But the growth and diversification of media forms nowadays allow for a kind of lifelong affiliation with the academic world, in a sort of self-certifying mass emeritus status.

There are parallels here with the invisible colleges established by the hosts of nonconformist and dissenting groups from the late seventeenth century onward. Denied access to the universities, there being only two, nonconformists quietly brought about a transformation in British education through the dissenting academies they set up, through the development in particular of the medical education that was so laughably absent from Oxford and Cambridge. But there the parallel ends, for the invisible colleges of the eighteenth and nineteenth centuries were indeed alternative forms of higher education, not alternative forms of social arrangement modeled on the collective fantasy of social life embodied by the university.

Finding academic careers closed to them, graduate students, especially ones who actually found it relatively easy to find employment, albeit of an insultingly degrading kind, have sought to continue their sabbatical sojourn with adversary theory, albeit in the drastically cut-down forms produced by the trench-whisper transmissions of social media. The move away from traditional forms of employment, at least for humanities graduates, enabled graduates to continue to live out the fantasy social relations of the seminar in their professional lives, as museum curators, advertising executives, website designers, or local authority workers. Denied livings in the ivory tower, evicted graduates set about remaking the world as an imaginary ivory people's republic. Perhaps the most telling example of this magical generalization and actualization of student politics is the setting up of Facebook, designed, we have been repeatedly assured, simply to allow the rapid formation of "communities," and the increase in the possibilities of "communication" and "coming together," the absence of which was piously supposed to be the cause of so many social agonies and impediments. A couple of decades later, Facebook,

and equivalent transmitters and amplifiers of self-important squabble such as Twitter and whatever will irresistibly succeed them in the way of social media and mediatized sociality, represent the perfect conjuncture of unworldly dormitory idealism and world-dominating power, or at least the power to monopolize attention.

The most important aspect of the collective phantasmal politics diffused beyond the universities into social life has been the serenely taken-for-granted conviction that almost all social arrangements were governed by and the expression of a corrupt and oppressive system, universally inclusive and yet in some strange way depending systematically on cruel exclusions of every kind of minority and even some very considerable majorities. This system has various interchangeable names, of which the most catholically comprehensive has for some time been "capitalism." The majoritarian conviction of marginality is extended as a kind of moral indemnity, equivalent to the old religious assurance of the salvation of the faithful, to every group. Company directors, sportspeople, professors, television presenters, and advertising executives earning prodigious salaries could represent themselves as victims of systematic discrimination by pointing to semi-identical people alleged to be from other, more advantaged kinds of social groups with even more prodigious salaries. Everybody was urged and allowed to dwell within the charmed, immunologically sealed circle of their imaginary marginality. The universality of exclusion provided the grounds for the systems of "total membership" ascribed by Peter Sloterdijk (2016a) to the legacy of religious monotheism, but in fact just as likely to be the product of the contagious monomania of media systems.

In all this, the zealotic style, and the characteristic formalism of zealotry, have come conspicuously to the fore. The principle of jealous and competitive aemulatio has been energized by the huge mimetic temptations and powers represented by media systems that prize impulsive and compulsive immediacy. The vast engine of emulation that media systems have become have created optimal conditions for the operations of zeal, always provoked by the conforming desire to be the same and the convulsive desire to be more aggressively and excessively the same. In 2020, a pandemic occurred, largely identical in its physical forms and consequences with many other pandemics that have come and gone largely unobserved, not least by their victims, but subject now to the coercive epiphenomenal inflammations of real-time bills of mortality, in the reporting of news as statistics that, because they were bound

always to represent some change in some direction or other, would always seem to provoke some more or less urgent response, thus guaranteeing spasmodic insurgences of excitement. The doom-hugging admonitions enabled by media systems who themselves depended on them seemed to promote zealotic striving to the universal style of seriousness, in the watchful mode of alertness to opportunities for the seriousness-stoking work of simulacral rage. The continuing role of admonition in the formation of seriousness will be the subject of this book's final chapter.

Yet we must also acknowledge the irrepressible force and certain victory in the end of the long-term antagonist of zeal, namely victory itself, which is to say fatigue, since fatigue always carries away the bay. The fervor of zeal feeds on the local irritations provided by groups knit together by their urge to outdo each other in furthering the common cause, but it will tend quickly to burn through the available fuel of collective-competitive vehemence. Typically, and banally, zealotic anti-institutionalism cannot avoid generating institutional forms, since all systems of communication tend toward redundancy and reflexivity, and every fission thereby decays into fusion. These systems of communication begin as shared forms of recognition and acknowledgment, as suggested by Seamus Heaney (1998, 124) in evoking the "land of password, handgrip, wink and nod, / Of open minds as open as a trap," (but then cool into routine and black-boxing formulae that provide affective economizing. If zeal is the oxygen of excitement, it cannot avoid also bringing about oxidation, and so catching, with every passing second of success, surcease. Where there is death, assuredly, there is hope.

6 Rue

One is serious about things to which one feels an attachment, or with which one wishes to have, obtain, or retain a relation. The serious man for Aristotle is one who seeks to live his life intrinsically, as something willed in the way that an agent or author wills, rather than as a series of extrinsic accidents. Most forms of seriousness seem to attach to some notion or other of attachment, if to nothing external then at least to oneself. This is true even of those things to which we have no attachment, or where an existing attachment has been lost, as in the case of grieving and mourning, which have been the subject of prolonged attention in psychological and anthropological literature. A leading theme of this literature has been the effort expended in processes of mourning to preserve, repair, or re-create what has been lost, as though mourning were a process of retying the thread that has been snapped by the death or disappearance of the loved object. The comportments of mourning "link us to our losses," in Philip Larkin's (1988, 106) phrase. Solemn occasions are often associated with acts of remembering or commemoration, often described, with flagrant and insolent inanity, as the building and sustaining of "collective memory," as though to force into continuity acts of personal remembering with the mnemonic acts of knot-in-handkerchief reminding that must necessarily substitute for memory. You set the alarm clock precisely in order to force yourself to remember that you must wake up because you know you will be in a condition (unconsciousness) in which you are unlikely to be able to remember. The remembrance, remembrance being remembering

pimped up as ceremony, that is audaciously and unabashedly called "cultural memory" is really amnesia in its Sunday best, meaning not only that nobody actually even pretends to remember the things in question but that nobody needs to.

But there is another mode of being serious about loss or dissociation, very familiar through being repeatedly invoked and referred to, but which has rarely been subject to the same kind of attention. I am going to call it rue, enlisting this stiff, bitter little bruise of a word to stand for the range of relations of negative wishing we may have to past actions, which specially encompass regret and remorse. Where the Aristotelian spoudaios is serious in an anterior or forward-facing way, we can think of rue as a kind of backward or posterior seriousness. As will become apparent, nobody can be said to feel, or even know what it is like exactly to feel, rue nowadays, let alone practice it. But this is an advantage for my purpose, which is to make out the implicit understanding that seems to be distributed across the repertoire of attachments involved in the ritualization of painful feelings relating to lost objects.

Nowadays rue is now much closer to regret than in earlier times, in which rue could encompass sympathetic sorrow, distress, or concern, without any suggestion of personal responsibility or regret. Robert Fabyan's (1533) chronicle of English history laments, "The iij.Edwarde. The deth of whome maye rue / All Englysshmen" (fol. cxvir). Rue in this sense survives spectrally in the kind of sorrow expressed when one says, "I was sorry to hear of your diagnosis" without any danger of seeming to offer an apology for it. Similarly, A. E. Housman's (somewhat archaic) "With rue my heart is laden / For golden friends I had" (1959, 80) does not imply any responsibility for the loss of his companions.

Rue resembles mourning, in that it is a comportment, meaning that it hovers, or perhaps rather sways, between a condition and an action. One has not in English been able to refer naturally to being in a state of rue for quite a long time, with A. E. Housman's antique usage again making the creaky point:

Dead clay that did me kindness,
I can do none to you,
But only wear for breastknot
The flower of sinner's rue. (Housman 1959, 133)

Rueing (or ruing) is much more commonly something you are thought to do nowadays, most commonly in the sort of thing evoked by "rueing the day"

on which one performed some injurious or ill-advised action. Yet it is not exactly clear what rueing, as opposed to having a feeling of rue, involves. One may bless the day one was born with a recognizable act of blessing, or similarly curse it, but there is no accredited verbal or gestural action by which one might be said to perform rue. In this, rueing perhaps lags a little behind mourning, which began as a verb meaning to feel sorrow, loss, anxiety, and even romantic yearning, as in the words of Chaucer's Miller:

> I moorne as dooth a lamb after the tete.
> Ywis, lemman, I have swich love-longynge,
> That lik a turtel trewe is my moornynge (Chaucer 2008, 75)

But, unlike rue, mourning began from the end of the fourteenth century to become sedimented in various ceremonial actions, public and private. The 1611 King James Bible tells us that after the death of Jacob, Joseph "made a mourning for his father seven days" (Genesis 50:10). The externalization of the condition of mourning, meaning that one can be "in" it in a way that one cannot be said to be "in rue," is crystallized in the use of the word *mourning* from the mid-fifteenth century to mean mourning costume.

A similar transition has been undergone by grief, which has been progressively externalized into actions of what is called "grieving," to the point where grief now seems to name the process of grieving whereby one deals with, dispels, or "works through" one's otherwise corrosive state of grief, in a kind of recognized and even strongly mandated psychometabolic process. For Freud (1953–74), this process was intended to ensure that "all libido shall be withdrawn from its attachments to that object" (14.244). As that task is too demanding to be accomplished all at once, Freud thought, it is "carried out bit by bit, at great expense of time and cathectic energy, and in the meantime the existence of the lost object is psychically prolonged" (14.245). Why Freud thinks that it might be any easier to decathect the memories of the loved one piecemeal rather than all at once, like looking through a photograph album prior to throwing it away (or, as so often in fact, deciding to keep it just in case), is mysterious, but is probably due to Freud's habit of thinking about feeling economically, in terms of divisible quantities. Denise Riley frames a deliciously dissident misprision, Shakespearian in its perversity, of the purpose of the approved work of grief, as a protocol leading to a desiderated outcome, in her memoir of her mourning for her dead son:

> This so-called "work of grief" is turning out to be a shatteringly exhausting

apprehension of the needed work of *living*. . . . The notes and emails of con-dolence have stopped arriving and I've acknowledged each of them. Yet after all this ritual and effort, he *still* hasn't come home. What more does he want? (Riley 2020, 76)

There seems by contrast to be no equivalent narrative of passage through or out of rue, no accepted or approved kinds of rue routine, which therefore makes rue seem closer to the melancholically uncompleted mourning charac-terized by Freud (1953–74, 14.257), in which "by taking flight into the ego love escapes extinction." And yet rue is still strongly inflected by a moral sense of duty, and of a task to be performed or ordeal ordained.

One may certainly, however, link some of the feelings attached to rue to the development of an imperative force in mourning, the feeling that mourn-ing is something one has a kind of responsibility to undertake as well as to undergo, a responsibility to oneself, but to others too, insofar as duties to self are nowadays so strongly urged. It is telling that Freud's influential account of mourning should focus on grieving as a kind of labor. This work is a private enterprise for Freud, undertaken with the ultimate desire, or perhaps sim-ply an instinctual impulse, to work oneself free from a burden of grief that would ultimately leave one unable to live. But one may see in his account an internalization of the pressure to externalize mourning processes that are so very widespread in human places and times. Such externalization is, we may assume, more than the work of social sedimenting. The rituals of grief indicate not only a process but a proceduralization: the procedure is made laborious in order to make a procedure of elaboration, confirming that some work is being done, and therefore some duty performed or some debt cleared. The work of mourning may be related to the feeling that Freud thought widespread among many groups of humans, that death is never to be seen as a mere accident. Just as many groups of humans assume that every death must be the result of some determinate cause or other, and, for preference, some human-type agent, so the work of mourning may be seen as a kind of belated causation machine. Just as the thought that death could not simply happen without being done by something or somebody, so a death cannot be allowed to happen without something being done *about* it. To be mourned is to be done to death, with that special kind of doing, as the sacralization of otherwise empty effort by projected purpose, which for humans bears the name of work. What matters, more often than we allow ourselves to see, is not what the work performs but what is performed by the idea that some manner of work is being done.

Rue is among the flowers Ophelia distributes in her late madness in *Hamlet*, along with "rosemary, that's for remembrance"; pansies, "that's for thoughts"; fennel and columbine, "There's rue for you. And here's some for me. We may call it herb of grace a Sundays. You must wear your rue with a difference" (Shakespeare 2011, 322). Rue is often twinned with rosemary as an image of preservation in and of memory: the exiled Perdita in *The Winter's Tale* greets Polixenes and Camillo in Bohemia with these two emblematic herbs:

> Give me those flowers there, Dorcas. Reverend sirs,
> For you there's rosemary and rue; these keep
> Seeming and savour all the winter long:
> Grace and remembrance be to you both (Shakespeare 2011, 1298)

Rue was known as "herb of grace," and the coupling of sorrow and grace appears in the departing words of the Gardener in *Richard II*, following his conversation with Isabel, Richard's queen:

> Here did she fall a tear; here in this place
> I'll set a bank of rue, sour herb of grace.
> Rue, even for ruth, here shortly shall be seen,
> In the remembrance of a weeping queen. (Shakespeare 2011, 691)

It is not quite clear what Ophelia means by her allusion to wearing the herb "with a difference." The term derives from the heraldic principle of cadency, which requires that heirs of coats of arms should differentiate their arms in ways that indicate their degree of direct or indirect succession. Ophelia's words seem to indicate the joining of difference and continuity that is a feature of rue. In rueing a fault or a loss, one repents, wishing away some action performed by or on oneself. But rueing also involves acknowledgment of one's continuity with what one rues. One wears rue in order to assert one's difference from what one rues, even as one asserts one's lineage from and so continuity with that difference. In rue, one must rue one's actions, asserting one's difference from them, as unmeant or unconsidered or simply reprovable. In so doing, one puts what one rues at a distance from oneself. But this is not to purge it or clear one's life of it, for rue is not absolution. For one rues the necessity of having to continue to be the person who performed the rued action, or neglect of action, even as rue asserts a determination to continue to be that person. Beckett (2010, 60) plays with this ambivalence: "I regret

nothing. All I regret is having been born." In this kind of encompassing ur-regret, one would logically end up having to regret being in any condition to regret, though of course regret is only possible for the one who is still sufficiently subsistent to regret their existence. Rue is in this sense indeed sour grace.

Rue, which resembles mourning (the proximate cause of Ophelia's madness is her grief at the death of her father, Polonius), is really something like its opposite. Mourning concentrates attention around the object that has been lost, in order ultimately to effect some acceptance of that loss. Rue enacts a disavowal, or a painful putting aside of some part of oneself in order precisely to enable it to take up residence in oneself, in a kind of intimate negativity, a loss or partition of self that is given an apartment in it. One thereby makes of what one disavows a kind of object of devotion. Rue can become, and perhaps must always involve, a kind of brooding, a pathological failure, as we cheerfully say, to "let go," even though brooding, from a Germanic verb-root *bro-*, to warm, is a productive sharing of one's body heat with that to which one has given birth. To be broody is as it were to lament the absent child that one has not yet conceived, as though it were in fact already a loss. Perhaps this is why, when the loss is real, the brooding of grief can seem to mold some imaginary rebirth out of loss, as in Constance's reply in *King John* to the charge of King Philip that "You are as fond of grief as of your child":

> Grief fills the room up of my absent child,
> Lies in his bed, walks up and down with me,
> Puts on his pretty looks, repeats his words,
> Remembers me of all his gracious parts,
> Stuffs out his vacant garments with his form;
> Then, have I reason to be fond of grief? (Shakespeare 2011, 619)

The mocking imposture contained in Constance's words effects that drawing near of performance to philosophy that seems so regularly to occur at moments of intense understanding in Shakespeare, as Constance tries to literalize the daft mummery she has fondly imagined for herself a moment earlier: "Preach some philosophy to make me mad. . . . If I were mad, I should forget my son, / Or madly think a babe of clouts were he" (Shakespeare 2011, 618). But now imposture mocks the charge of mockery, since the reality of all action is to be found in acting, the shadow part played by the poor player, or Denise Riley's "glum mum" for whom "each word overhears itself" (2020, 8, 61). In

the conditions of extremity to which rue holds, seriousness can only consist in abandoning the pantomime of simple self-identity, or continuity of being.

Our age believes itself to be much more concerned with the transformative emancipation of the individual from ties and trappings, and less concerned with the assumption of duties and commitments, or less inclined to regard them as formative. As such, we have less inwardness with the range of feelings associated with the function of acknowledgment, and interiorization of what is nevertheless felt to be inimical or alien to the self. Heroism is believed to lie less in the undergoing of regret than in the mass-mediated aristocratic disdain for it, as articulated by the "Je ne regrette rien" of Edith Piaf, or the regrets "too few to mention" of Frank Sinatra. Rue may be associated with acts of repentance, but it stubbornly disdains acquittal, or the possibility of clearing a debt that is promised in repentance: penitence derives from Greek ποινή, penalty, blood-money, redemption, or vengeance. Rue does not allow for this kind of new beginning, boundingly unencumbered, but rather embodies an unwillingness to relinquish a continuing responsibility for one's acts and omissions, the responsibility that derives from a serious attitude toward one's life in time, serious in the sense that it cannot allow for radical discontinuity or casual interruption of series. Rue is like shame, in that it does not rely on outward measures and frames of reference; one can be declared or found guilty, and indeed one perhaps always must. But shame is what secretly finds you out when you have apparently gotten off scot-free. This may be why states such as rue and shame, which seem to have the force of actions without their outward and visible form, seem to escape any sense of due process. One rues, but there is no prescribed way in which to rue, no order of service. As is made clear in Eleanor's speech to Gloucester in *Henry VI Part 2*, after she has been led in shame through the streets, rue is a closet affect, which is the opposite of public spectacle:

> Come you, my lord, to see my open shame?
> Now thou dost penance too. Look how they gaze!
> See how the giddy multitude do point,
> And nod their heads, and throw their eyes on thee!
> Ah, Gloucester, hide thee from their hateful looks,
> And, in thy closet pent up, rue my shame,
> And ban thine enemies, both mine and thine! (Shakespeare 2011, 509)

But the privacy of rueing may also explain why rue might be twinned with grace, which does not depend on one's actions, penitent or reparative as they may be, but on the loathing acceptance of the lurid *so-it-was* of what one nevertheless regrets and the gratuitous necessity of what may or may not come by chance.

The archaic strangeness of rue may also explain some of its staying power: to be archaic does not mean to be superseded but rather to be unnoticed. Like the Wardour Street actions of vowing and slaying, rue is much more likely to be encountered in poetry (or, oddly, newspaper headlines) than in psychotherapy or the pedagogic calendar of the human resources department. So, even though there is no accepted process of rueing, rue is nevertheless, like shame, highly stylized. There has been a growing tendency for rue to be the subject of menaces and admonitions, few of them as ferociously particularized as Henry VI's words to Richard shortly before his death at the end of *Henry VI Part 3*:

> And thus I prophesy, that many a thousand,
> Which now mistrust no parcel of my fear,
> And many an old man's sigh and many a widow's,
> And many an orphan's water-standing eye—
> Men for their sons, wives for their husbands,
> And orphans for their parents' timeless death—
> Shall rue the hour that ever thou wast born. (Shakespeare 2011, 564)

Indeed, almost all the appearances of the word *rue* in the work of Shakespeare involve warnings or threats. Minatory rue is somewhat like shame, in that it cannot really be imposed by others, even though, as with shame, huge efforts are made to do just that. This is why people who it is believed should be forced to feel and show their shame are typically subject to ceremonies that draw on the kinds of things that can be relied on to cause it, such as pillorying, tarring, shaving, stripping, and so forth. Such actions infallibly succeed in their purpose, because anybody subject to them would be bound to feel ashamed. But this means that the actions must fail, too, since shame can only truly exist where there is self-reproach, of which the outward assault of others can only ever be a frustrated imposture. In an exactly equivalent way, the torturer can extract the confession they want only if they abandon the desire to extract the truth. Shaming consists in making mock of its object, even as that public shaming is itself no more than a mock-up of real shame that must always

belong to a more finely private place. This is a standing rebuke and stinging irritation to remorse-mongers, and gives extra ferocity to the efforts to ensure that people are shamed, in always unsatisfactory lieu of being really, meaning spontaneously, ashamed. The fact that we so often say that people should be ashamed ("of themselves," as we may needlessly and yet tellingly add, as though they should be ashamed of themselves for not feeling the shame for themselves) is a sign of how annoyingly rarely they can be relied on to be. The difference between the transitive action of shaming someone and the reflexive state of being ashamed is reinforced in English by the vanishing of *ashame* used as a transitive verb, as when John Knox (1558) writes of God having made Deborah virtuous and victorious in battle "to confound and ashame all man of that age, because they had for the moste part declined frome his true obedience" (fol. 42ᵛ), or when Ezekias Woodward (1643) declares, "There is not a Creature in the World, which doth so mightily convince, reprove, ashame mans ingratitude, as the dog doth" (6). This usage seems largely to have died away by the end of the seventeenth century, meaning that, in the absence of the one who might cause one to be ashamed, being ashamed has to become an action self-performed.

Regret

The drive to make people regret their actions, and to govern or direct them by making them anticipate that regret, is one of the strongest impulses among social yet aggressive, and therefore socially aggressive, primates, who tend to devote much more attention to ordering the lives of others than ordering their own, and is especially marked in the arrangements made by the most subtly and systematically aggressive primate of all. The puppet-pedagogy of minatory rue is expressed in all the grim promises and prospects that abound in social life, and perhaps indeed constitute the earliest lessons in socializing seriousness. No wonder that children, richly intimating the game that is afoot with all this talk of things they will be made to feel sorry for, learn early on the potency of the counterfantasy that "they'll be sorry when I'm dead," and perhaps as adults never learn completely to do without the armament of threatened regret.

What does it mean to make people rue things, or to want to? In very large part, it must surely involve forcing people to take one seriously, by forcing them to take their own lives seriously. Just as the Aristotelian spoudaios

strives to will his life, rather than merely being alive, so the one threatened with future regret is a don't-care who must be made to care, through the negative forms of will (not being unwilling, but willing that something not have been) that rue, regret, and remorse are. So powerful and sustained is this minatory pedagogy that seriousness can come to be identified entirely with precautions against regret. The more that precautions are made available by the sharing of different kinds of risk, the more being serious comes to mean performing actions designed to head off the condition of future regret. Taking your life seriously involves taking into ever more exacting account the need to anticipate and avoid occasions for regret: regret for your casual promiscuity, your blind and merely habitual fidelity, not keeping up your pension payments, failing to live sufficiently in the moment, that extra double scotch, the hasty word, the overcautious silence.

As I have been trying to show in this book, seriousness depends on a stylistics, on ways of programming, proving, and performing seriousness. The varieties of self-distancing gathered together, diffusely as they may be, in what I am calling rue are unlike many other ways of being serious in being resistant to being formalized. It may be that this is shifting, with the growing potency of acts of apology (Connor 2019b, 121–47) being a sign of nascent rue-formalization.

It is a different matter with regret, which has steadily been narrowed and become formalized in its usage. To regret is an intensification of Old English *greten*, to weep, or transitively to weep for. (The word survives in Scottish English.) The *re-* prefix was probably attached on the model of other words that indicate, not so much repetition as reflexivity, or inward process. In its earlier uses, from 1400 or so onward, regretting encompassed a rather wide range of sorrowful feelings or actions toward different sorts of events or conditions. To regret was commonly used to mean to grieve for, or lament the loss of. The author of *Pearl* (1906), from around 1380, addresses the vision of his lost love with the words, "Art þou my perle þat I haf playned / Regretted by myn one, on ny3te?" (11). One can easily imagine how sorrow at a loss might be twinned with wishing it had never happened, and then slowly turn inward to encompass responsibility or self-recrimination. The development of the word *regret* parallels that of the word *sorry*, which, from Old English onward, could mean both feeling sorrow or pain and reflexively feeling penitence or remorse: the poem *Judgement Day I* refers to "þam þe his synna nu sare geþenceþ . . . sarig fore his synnum [those who think sorrowfully about

their sins . . . [and] are sorry for their sins]"—though W. S. Mackie holds back from a modern implication of remorse in his rendering "him who now sadly reflects upon his sins . . . sorrowful because of his sins" (*The Exeter Book* 1958, 160, 161). The development of regret away from lament and in the direction of deprecation can produce strange collisions of sense, as for example in an epitaph or funeral announcement that may still occasionally today declare the deceased to have been "deeply regretted" where presumably no disapproval need be implied of the actions they have performed in their lives, or of their having existed at all.

The word regret could still have a sense of recoiling from something unpleasant in a sermon preached in 1610: "I present my selfe here this day, as a spectacle vnto the world, and to Angels, and to men; though with some regret, and reluctation of the flesh, yet with great comfort, and exultation of the spirit" (Higgons 1611, 40–41). Helkiah Crooke (1615) reports similarly a few years later that "as bitter things are hardly swallowed, so rotten or stinking smels are not receiued into the Sense without a kind of regret and loathing" (710). It seems that it was during the ensuing century that penitence or remorse began to predominate in uses of the word regret, and this coincided with a marked increase in the frequency of its use. Remorse seems to be present, for example, in the observation that "all spirituall adulteresses, cast quite away, all rememberance and care of God. For alasse, what would this doe, but breed a regret in their consciences, and make them they could not follow, their disloyall courses so delightfully" (Bayne 1618, 258–59).

When one hears or says, "I regret to inform you," with the gloomy sequel for which the formula prepares—failure in an examination, rejection of an application, news of a demise—the words execute a metaperformative or microritual of ritualization. Anyone who utters the performative "I regret" is indicating that they are insulating themselves from any actual regret they may feel by the very act of giving utterance to it: I fear you are going to regret hearing what I am about to say much more than I am going to regret saying it. The function performed by the formula need have nothing to do with what they might actually be feeling. In many cases, they may be indicating that they are not themselves responsible for the bad news they have to impart, meaning that their regret may seem to encompass wishing they had not been landed, as, say, a junior doctor, with the responsibility their words discharge. In such a formula, the expression of regret has become a way of transmitting somebody else's regret (or nobody's in particular, as some general sense of

abstract regrettability, as in the floating adverb "regrettably") as it were under sealed cover. This regret at having to execute the office of transmitting regret is sometimes half acknowledged by the small dilation provided in the phrase "I regret to *have to* inform you." (I wouldn't give you the hurt or disappointment my news is bound to bring unless I had to.)

Although one can no doubt sincerely feel and honestly express regret of various kinds, the word itself has moved away from a personal to a more impersonal, even official register. This is perhaps why adverbial reinforcement can often seem necessary, as when one says that one "deeply regrets" something. Because regret is ever more recognizably one of the pseudo- or zombie-feelings to which institutions or public officials speaking on their behalf give expression (Connor 2013), the use of the word regret in a personal circumstance will increasingly be liable to suggest evasion or retreat into the realm of hedging formula. Thus regret has become the word one uses when one is performing the display of apology ("dispology," perhaps) for offense that has been taken at one's words or actions, where one wishes to keep open the possibility that the taking of offense is actually unreasonable: "I regret any hurt my words may unintentionally have caused." Indeed, regret is the partner to offense, offense and regret therefore being a Pinky and Perky pair of puppets in the rhetorical paso doble of sally and parry.

Remorse

The term that carries most of the reflexivity associated with rue is *remorse*, a reflexivity literalized in Tennyson's voluptuous evocation of the self-tormenting pains of the self-reproacher in his poem "Remorse":

> Lest ought of solace I should see,
> Or lose the thoughts of what I do,
> Remorse, with soul-felt agony,
> Holds up the mirror to my view. (Tennyson 1963)

The intensity with which one is reputed or supposed to feel remorse sits oddly with the fact that there is no longer an active verb associated with that feeling, the verb *remord*, meaning to recall with regret or to afflict with remorse, and its parallel *to remorse*, surviving in only a handful of instances beyond the end of the sixteenth century. The pain of remorse is regularly represented as the biting signaled in the Latin *remordere*, to bite again or bite back. There is

no etymological link with *murder*, unless it is involved in the collective noun a *murder of crows*, the origin of which is unclear, but may perhaps have to do with the fierce operation of their beaks (crows being eaters of carrion rather than predators who might be suspected of killing). The biting of remorse is expressed sharply in the fourteenth-century Middle English devotional *Ayenbite of Inwit* (Dan Michel 1866), which translates precisely the phrase *remorse of conscience*. Its precision is of a piece with the book itself, as it was acidly characterized by W. P. Ker:

> The *Ayenbite of Inwit* is well known by name, and passes for a book; it is really a collection of words in the Kentish dialect, useful for philologists, especially for those who, like the author of the book, only care for one word at a time. The *Ayenbite of Inwit* was translated from the French by Dan Michel of Northgate, one of the monks of St. Augustine's at Canterbury, in 1340; it is extant in his own handwriting; there is no evidence that it was ever read by any one else. The method of the author is to take each French word and give the English for it; if he cannot read the French word, or mistakes it, he puts down the English for what he thinks it means, keeping his eye firmly fixed on the object, and refusing to be distracted by the other words in the sentence. This remarkable thing has been recorded in histories as a specimen of English prose. (Ker 1948, 150–51)

Like rue, remorse belongs to a class of feelings that one has to learn to feel, or at least to name. In neither case does it seem very profitable to speculate about whether, or in what form, such feelings might exist before or apart from being so named. Remorse is less exotic than rue, but certainly very far from the ordinariness of regret, which may be familiar not only from all kinds of official correspondence but in many everyday expressions of negative wishing—"I really regret not going to the doctor earlier about this"—or precautionary prudence—"You are going to regret that second bottle of wine in the morning"—or the negation of negative wishing—"I don't regret for a second breaking up with her." Where rue has a primarily poetic cast—for example, in the faint wisps of grandiloquence that hang around an expression like "rueing the day" even when it is used in ordinary circumstances—remorse belongs to a religious or juridical register, or tugs discourse upward into it. That is, one feels remorse, if one does, for the kind of thing that might once have been thought of as a sin or honorific failure, rather than for a mere lapse or infraction. Remorse is focused, in fact, not on the nature of the reprovable act, but

on the degree or quality of self-reproach it stimulates. This puts remorse in the neighborhood of shame feelings rather than guilt conditions.

It must be understood that, whenever one uses the word "belongs" of a word or phrase in relation to a register, one must mean mostly "seems to belong," or is usually supposed to. A very large proportion of the work of discourse involves divergences or migrations from such supposed belongings. A phrase like *buyers' remorse* retains whatever minor chuckle capacity it does precisely because of the tickling friction of registers it imparts, and the absurdity (for the time being) of the suggestion it conveys that the impetuous purchase of a battery-powered rather than electric drill might amount to a spiritual flaw or failing. Indeed, the phrase buyers' remorse is one of the clearest illustrations one could imagine for demonstrating the usual difference between regret and remorse, precisely because it seems to blur it.

The value of remorse, like the value of shame, as the sign of "authentic" (from Greek αὐθέντης, murderer or perpetrator) rather than externally imposed moral feeling, is precisely what gives value to the signs of its production, or rather, the production of its signs. Children learn very quickly the lesson that punishment may be abated or averted altogether through the quality of their expressions of remorse. (It is not really that this is a childish way of thinking; rather it is that children, who are so very much at the mercy of their will to survive, are programmed to pick up very quickly the prominence and potency of expressions of remorse in human discourse.)

A distinctive instance of the potency of the idea of remorse is in legal circumstances, and in particular in criminal law. Indeed, by far the most common appearance of the word remorse in contemporary public discourse is in circumstances that concern the question of whether somebody convicted, or in danger of being convicted, of a misdemeanor has shown remorse. Courtrooms and the associated apparatus of deliberation and judgment are not set up, as churches or monasteries are, for the formalized expression of penitence. And yet what might seem to be the moral embarrassment of remorse and the expectation of it is made surprisingly explicit in judicial operations. Convicted persons can expect more severe punishment if they do not express remorse or, if they do not believe themselves to be guilty of their crimes, agree to body it forth in some acceptable measure. There is evidence that a defendant's remorse or failure to demonstrate it is of particular importance in the sentencing decisions made by juries in capital cases (Simons 2004, 322–23). Converting to Christianity seems to be a good way of eliciting leniency from

juries, perhaps because this is taken as a token of sincere remorse, and recent converts do better than lifelong adherents to Christianity, perhaps because it is thought that the latter should have known better (Miller and Bornstein 2006, 681–82). Judges passing sentence do not say, nanny-like, "You will go to prison for five years, or until you are sorry, whichever is the sooner," yet the expression of remorse is an important expectation in granting parole to convicted prisoners.

There are many reasons why people convicted of crimes may not feel or express remorse: they may not have committed them, they don't believe that what they did should be regarded as criminal, they have forgotten committing their crime, they may feel remorse but are too outraged that other people get away with what they have done or at the excessive nature of their sentence, or they are too numbed with misery and terror at what awaits them or untutored in the conventions of how guilty people are believed to feel and behave to give their remorse convincing utterance or embodiment. All of these make the likelihood of anyone being able reliably to appraise the degree of the inward and spiritual intensity of a culprit's remorse from their outward and visible demeanor very remote indeed, even aided by investigations designed to allow for distinguishing of "genuine" from "falsified" remorse (Brinke et al. 2016). The fact that so much of the law depends on this principle of remorse puts it at risk of making very poor decisions—for example, sentencing innocent people to harsher punishment than people genuinely guilty of their crimes.

Justification, or at least excuse, for this sapless practice is provided by claims that failure to show remorse, like sullenness or shiftiness, is probably in any case a reliable indicator of a propensity to commit crime, since the faculty of remorse is thought to be an indwelling moral faculty not possessed by certain kinds of "psychopathic" personalities. In their article "Callous-Unemotional Traits Robustly Predict Future Criminal Offending in Young Men," Kahn, Byrd, and Pardini (2013) draw on the evidence from psychology that "the affective features of psychopathy, often referred to as callous-unemotional traits (e.g. shallow affect, callousness and lack of empathy/remorse) constitute a core component of this disorder)" and point to "the clinical utility of CU traits for predicting future antisocial behavior across the life span" (87). The authors also draw on Hervey Cleckley's *The Mask of Sanity*, first published in 1941 and frequently reissued, which makes the absence of the capacity for remorse the central feature of a personality without the affective depth or inwardness that ordinary moral subjects may be assumed to possess:

The psychopath . . . shows almost no sense of shame. His career is always full of exploits, any one of which would wither even a rather callous specimen of the ordinary man. Yet he does not, despite his able protestations, show the slightest evidence of major humiliation or regret. This is true of matters pertaining to his personal and selfish pride and to esthetic standards that he avows as well as to moral or humanitarian matters. If Santayana is correct in saying that "perhaps the true dignity of man is his ability to despise himself," the psychopath is without a means to acquire true dignity. (Cleckley 1964, 372)

Cleckley fingers the psychopath as a kind of mimic personality, who is therefore lacking in a special quality of seriousness, as "a man who is sane by the standards of psychiatry, aware of all the facts that we ourselves recognize, and free from delusions but who conducts himself in a way quite as absurd as the psychotic" (403–4). The idea that the behavior of psychopaths and psychotics is "absurd" rather than monstrous is arresting, but also suggestive. The existence of psychopaths is a serious matter, it seems, in part because they molest the very idea of seriousness. The word *psychopath*, as a name for somebody who is not subject to a pathology but rather *is* that pathology in embodied, emblematic form, only appeared in English in 1885 (Connor 2019a, 12), but it seems to have moved into the place that might have been occupied by similarly mimic personalities, such as those possessed by devils, devils being characterized as counterfeiters of being. (According to much medieval opinion, the power of the devil himself, permitted by God, consisted only of the power to counterfeit power, though this power turned out to be considerable.) The ritual of the demand for remorse enacted in courtrooms, parole hearings, and media theatricalizations of these theatrical occasions is really a probative ordeal of soul testing, designed to establish whether its subject can be taken seriously as a human. If they cannot, the danger of doing them wrong is presumably much reduced.

But even worse than this, from the viewpoint of criminal law, is the potential for absence of remorse to mock or maim the law's self-image as a system not only for enforcing certain kinds of behavior through penalty but also for the cultivation of moral sentiments and the reformation of character—even, as with the extortion of confessions by ecclesiastical courts, for the salvation of souls, no less. In some legal systems, the production of remorse has a central role in courtroom procedure: Yanrong Chang (2004, 705) maintains that

"questioning in Chinese criminal courtrooms is not to obtain information; rather, it is to persuade. Patterns of questioning are used to extract confessions or remorse from defendants." All of this makes the failure to feel remorse, or at least give a makeshift performance of it, in essence a kind of contempt of court, and the fulsome expression of it by contrast a warming tribute to the power and goodness of the law.

In other words, the reason for the centrality of remorse in legal systems, in which, unlike religious systems, it has in fact no formal place at all, is that without it the application of the law might not be taken sufficiently seriously—that law might fail to be regarded as equivalent to justice, and be reduced to a soulless mechanism for controlling behavior through threat of punishment. It is certainly true that there are those who see remorse as central, not to the workings of law, but rather to the way law should work. Stephanos Bibas and Richard A. Bierschbach (2004, 87) argue at length that "people value remorse and apology because they heal psychic wounds, teach lessons, and reconcile damaged relationships," and that therefore "remorse and apology should also loom large in the criminal arena, where victims' wounds are the greatest and need the most healing." In their view, criminal law is too focused on questions of crime and punishment as they relate specifically to the perpetrators of crime, and would benefit from what they call a "relational" approach that "teaches moral lessons, brings catharsis, and reconciles and heals offenders, victims, and society" (89). The authors go on to complain that "criminal procedure has come to focus on serving procedural values such as fairness, efficiency, and accuracy to the exclusion of incorporating substantive goals into the structure of procedural mechanisms" (96). Although these "substantive goals" are repeatedly invoked through their long article, we are not told what they are, when they were decided and by whom, where they are recorded, and how they might if necessary be revisited and modified.

Perhaps a clue is offered by the suggestion casually thrown out in what I have just quoted, that a relational approach "brings catharsis." Catharsis? Here is not the place, you will be relieved to read, for a lengthy excursus on the history of catharsis, from its beginnings as a medical term signifying the discharge of morbid humors, principally through evacuation of the bowels and then, by agricultural extension, the actions of pruning or ground clearance, and, in religious application, the fanatical emphasis on purification thought to be characteristic of heretical sects like the Cathars, as met with briefly in my earlier discussion of zeal. The purgative model of things, which

suggests the preferability of purity over pollution, has a lot going for it, of course—for example, in terms of hygiene, table manners, and environmental ethics. But it is also queasily true that the madhouses and penitentiaries of the world have always been thickly populated with adherents of extreme forms of purity, moral, racial, and otherwise (and how can there be any other kind, for somebody who takes purity seriously, and for whom moderate purity is just another name for pollution). But the most important feature of the word *catharsis*, of course, is that it is the term of ritual practice central to many primitive cults that Aristotle deploys to characterize the alleged emotional effects of tragedy. To suggest that law might have cathartic effects is to let the hissing, scratching cat of the histrionic out of the bag. It is to suggest that the law is as polluted as everything else in human life by the deadly plague of literature in performance.

This is surely to mistake justice for the therapy of theater or the theater of therapy, or, putting it even more starkly, to mistake law for "justice." The application of the law may well bring about "closure" and "healing," along with other "substantial social, psychological, and moral benefits" (Bibas and Bierschbach 2004, 100), and well done to it if that happens, but that is not what it is for. It would be horrifying if it were. Criminal law has struggled for centuries to attain the condition of abstraction from the emotional needs and demands, and moral lusts and luxuries, of those who apply it or apply to it. "Relational" sounds gentle, meek, and mild, but almost always becomes arbitrary and authoritarian when it means that law starts to have to operate relative to local demands and assumptions. This may easily be verified by reference to the legal systems that operate, not autonomously, but relative to the interests of those who employ them, whether they are the inquisition, Stalin's show trials, or the rituals of shaming that tend to be part of authoritarian legal systems everywhere. Remorse and apology may well do good, just as forms of punishment and incarceration may too, sometimes, though probably of a different kind. But it is not law's business to do good, and it is reckless and grotesque to require it. Bizarrely, Bibas and Bierschbach lament that "criminal procedure does little to encourage or even allow meaningful apologies and expressions from offenders to their victims and the community" [the "community"!!] (92) and yet provide extensive examples of how the question of remorse is in fact invoked in very substantial ways to inflect deliberative judgment and sentencing, examples that go a very long way to demonstrating the kind of nonsense and cruelty that can ensue—the uncomfortable fact,

for example, that "seemingly remorseless acts by children or adolescents can affect whether they are tried as juveniles or as adults" (94).

It is not, of course, that remorse and apology are themselves wicked and absurd, but it is wicked and absurd to imagine that the fact that they are good things means that they should be incorporated into criminal procedures. Just because something is a good idea does not mean you should do it, as my colleague Tim Crane wisely used to say. Bibas and Bierschbach (2004, 101) acknowledge the evidence that "remorse-based sentencing in practice often correlates poorly with the offender's actual remorse or blameworthiness," but seem to feel that this is because there is not enough of it. The fact that "judges, sentencing juries, the news media [!!] and the public [!!!!] overwhelmingly weigh remorse heavily in disposing of criminal cases and assessing offenders as persons" (92) should ring jangling alarm bells rather than reassure us that it would be right to amplify the role played by "reconciliation rituals" (118). No doubt there are many other things that weigh heavily with such persons, which we nevertheless encourage them to set aside in matters of law; it is one of the compelling reasons that courts do not apply to news desks or assemble large crowds in public squares for guidance in making their decisions.

As with the long history of forcing persons to make solemn attestations of their honest and unforced loyalty to certain principles, there is a principle of doubled seriousness at work in the tacit requirement to feel or show remorse. One forces the convicted to take seriously their continuity of being with the crimes they have committed (I am the one who committed the crime, yet am also the one who now regrets it, and not just because I was caught), counter-signing their guilt, that is, with shame, in order to confirm the seriousness of the law and its application. If it is an embarrassment to the law that the demand for remorse is such that it is almost impossible to perform it with complete seriousness (the only way to do remorse being in some degree to overdo it), this may be got over by the principle that the expression of remorse has a general utility in providing examples of how genuine moral feeling ought to appear in public. In all of this, the ceremonial consort of remorse-exhorting and consent makes the legal system a Keatsian vale of soul-making (1958, 2.102), in which the system and its subjects must commit to confirming the seriousness of each other's existence and enterprise.

This is an effect of the by now hopelessly inextricable entanglement of law with morality. And yet law and morality have the powerful relationship they do precisely because they are, and must be, distinct. The principle "You should

obey the law" is a moral principle, not a legal one, in the way that an edict such as "You must obey the law on pain of penalty" is legal. The difference between law and morality is that the law can force you to obey; indeed the law just is this force. Morality exercises force too, of course, but of a more obscure and so strangely more forceful kind, because the force of morality depends on its being unenforceable and so forced to shrivel into the triviality of violence as soon as it is enforced. This means you can submit to the force of morality, but cannot be forced to, without morality turning into law. Remorse commutes between these two commingled opposites.

The most important point about remorse in legal circumstances is that it is ostensive and therefore ritualized. To have remorse is to assure people you have it by showing it in some way, almost always in the form of saying you feel it. Indeed, showing and saying adhere so closely in this matter that feeling remorse is hard to peel apart from saying you do or feeling the impulse to say it. It does not seem to me to be plausible to regard people as being subject to some vague gnawing to which they struggle to fit a name, until with a sudden sense of recognition they realize that it must be remorse. You cannot really feel remorse unless and until you can knowledgeably name it. Remorse is among the many feelings in which we must be schooled, not in any crude or outside-in imposition, but in a slow, back-and-forth adjustment between feeling and expression. Remorse and pedagogy are bound together in intricate ways: one learns to feel remorse, but in order to do so must also learn *how* to feel remorse.

Impossible for the Stage

It is not surprising to find that, given the necessity for schooling and styling in the modes of remorseful exposition, prodigies or world-champion exponents of remorse should arise. Nowhere is this more the case than with the figures of Romantic remorse.

Contemporary writers seem to be agreed in the view that remorse and repentance were not recognized or especially regarded in the classical world (Kaster 2005, 80–81; Konstan 2008, 246–47). But remorse is to be distinguished from repentance, since repentance depends on the existence and acceptance by the penitent of some recognized economy of acquittal or redemption, while remorse is more intensely a matter of self-arraignment than the desire to make amends. Joseph O'Mara (1948) notes that there is

something strongly egotistical in remorse, which may arise in or lead to "a will soaked in selfishness" (28). The escape from remorse offered by repentance requires, but also offers the relief of, a certain uncentering of self, or dissipation of the seriousness with which one "takes oneself." In turning to the conventionalized modes of repentance or reparation, "The vital current of my will no longer nourishes my sin with a morbid and proud self-preoccupation; it turns instead to gather up and vivify all the forces of reparation" (29).

The problem for many is precisely that remorse is the means whereby the self takes over the work of reproach that, in many tribal societies and during religious ages, takes exteriorized forms. This is why remorse is the means by which the self both spurns and asserts its pride, as dramatized in Satan's great speech in book IV of *Paradise Lost*. Satan asks himself, "Is there no place / Left for Repentance, none for Pardon left?" and answers immediately, "None left but by submission" (Milton 1963, 75). For Satan literally takes himself seriously—that is, assumes that he has been created as a freely self-determining being, rather than as a kind of clockwork toy made for docile magnification of a God whose very narcissism makes it impossible to take him seriously. If he is not a clockwork toy, his disdain for divine authority must be as fully divine as his temptation to bend the knee:

> But say I could repent and could obtaine
> By Act of Grace my former state; how soon
> Would highth recall high thoughts, how soon unsay
> What feignd submission swore: ease would recant
> Vows made in pain, as violent and void.
> For never can true reconcilement grow
> Where wounds of deadly hate have peirc't so deep:
> Which would but lead me to a worse relapse,
> And heavier fall: so should I purchase deare
> Short intermission bought with double smart.
> This knows my punisher; therefore as farr
> From granting hee, as I from begging peace. (Milton 1963, 75–76)

Satan's passion ends in his resolution, "So farwel Hope, and with Hope farwel Fear, / Farwel Remorse: all Good to me is lost; / Evil be thou my Good." Milton is quick to instruct us that this resolution derives from the ungoverned play of passion, "Which marrd his borrowd visage, and betraid / Him counterfet, if any eye beheld: / For heav'nly mindes from such distempers foule /

Are ever cleer" (76), but the doxical stage direction comes too late to damp down its dangerous intensity. Indeed, in the case of Romantic remorse, the possibility of penance seems often to be specifically refused, to allow for the persistence of a will to remorse that itself seems remorseless.

The dramatic problem faced by both Coleridge and Byron, both of whom wrote poetic dramas centered on remorse, is that remorse refuses the temporality and therefore the possibility of actionable plot that penitence allows. Coleridge's play *Remorse* solves this problem by twinning remorse with revenge. The play, which Coleridge rewrote in 1813 from its original 1797 form as *Osorio*, centers on the rivalry of two brothers, one of whom plots to have the other murdered in order to take his beloved for himself. But the brother escapes and returns to win back his beloved and execute revenge on his brother by forcing remorse upon him. Making the instilling of remorse the object of desire allows for the workings of plot—impediment, striving, concealment, ruses, and goal-directed action—that the shapeless gnawings of remorse alone would not. In *Osorio*, Albert recounts that in his exile,

> I bared my head to the storm,
> And with loud voice and clamorous agony
> Kneeling I pray'd to the great Spirit that made me,
> Pray'd that Remorse might fasten on their hearts,
> And cling, with poisonous tooth, inextricable
> As the gored lion's bite! (Coleridge 1912, 2.532)

Osorio responds with conventional fiendish gnashings: "Remorse! remorse! / Where gott'st thou that fool's word? Curse on remorse!" (Coleridge 1912, 2.591). Alvar's closing doggerel after his wicked brother has been stabbed articulates the childish but consolingly minatory lesson of *Remorse*:

> In these strange dread events
> Just Heaven instructs us with an awful voice,
> That Conscience rules us e'en against our choice.
> Our inward Monitress to guide or warn,
> If listened to; but if repelled with scorn,
> At length as dire Remorse, she reappears,
> Works in our guilty hopes, and selfish fears!
> Still bids, Remember! and still cries, Too late!
> And while she scares us, goads us to our fate. (Coleridge 1912,
> 2.881)

It is in the works of Byron that remorse achieves its extreme autonomy from the consolations and reparative mechanisms of plot. In *The Giaour*, Byron (1981) elaborates the traditional association between the pangs of remorse and the scorpion reputed to sting itself when surrounded by fire. But where the scorpion's self-stinging "Gives but one pang, and cures all pain" (53), Byron prefers the prolongation of the torment of the one caught in the suffering of insufferable alternation:

> So writhes the mind Remorse hath riven,
> Unfit for earth, undoom'd for heaven,
> Darkness above, despair beneath,
> Around it flame, within it death! (Byron 1981, 53–54)

The Corsair returns to the evocation of this vehement self-torment:

> There is a war, a chaos of the mind,
> When all its elements convulsed—combined—
> Lie dark and jarring with perturbed force,
> And gnashing with impenitent Remorse;
> That juggling fiend—who never spake before –
> But cries, "I warned thee!" when the deed is o'er. (Byron 1981, 182)

Byron finds the rhyme of force and remorse irresistible, and it does not seem to make a substantial difference whether he is evoking the force of remorse, or the force that comes from the refusal of remorse, as in "The Lament of Tasso":

> For I have anguish yet to bear—and how?
> I know not that—but in the innate force
> Of my own spirit shall be found resource
> I have not sunk, for I had no remorse
> Nor cause for such. (Byron 1986, 117)

Unlike Coleridge, who splits revenge and remorse in order to twin them, Byron in his *Manfred* attempts to compress revenge and remorse together into the same subject. In the process, he fulfills the ambition, which is more common than one might suppose, of producing a wholly unactable drama, writing to John Murray in 1817 that "I have no great opinion of this piece of phantasy: but I have at least rendered it *quite impossible* for the stage, for which my intercourse with D[rury] Lane has given me the greatest contempt" (Byron 1904, 55). It is no accident that Byron should have this untheatrical

or, rather, antitheatrical ambition, since it is in the nature of remorse to resist actability. At the same time, what action there is in *Manfred* is the action of trying to resist acting. Byron's Manfred is in dialog with the many Gothic villains tortured by various kinds of thrilling guilt who appeared on the stage in the late eighteenth century. As Bertrand Evans (1947, 757) observes, "Villain after villain exhibited this special agony with a violence that mounted through the decades; their crimes were crimes of magnitude—robbery, arson, murder, incest: it mattered little what they were, so long as they were sufficiently appalling to motivate the paroxysms of remorse which became the *raison d'être* of the Gothic play." Manfred spurns the heteronomous subjection of pardon and penitence in favor of the remorse that he can make his own, asserting the sovereignty of his own self-subjected suffering, which "all in all sufficient to itself / Would make a hell of heaven . . . there is no future pang / Can deal that justice on the self-condemn'd / He deals on his own soul" (Byron 1986, 90).

One may see in this the contrary of the psychopath's incapacity to be serious, in a remorse that itself becomes a pathological principle, refusing to countenance the farcical dissolution of self into theater that repentance might involve. For the subject of remorse, remorse is the principle that keeps them alive in the same way as malady underwrites the watchful will to life of the hypochondriac. The soul sustained in the grandeur of remorse clings monomaniacally to its bitter self-division. "This is convulsion, and no healthful life," says the Chamois Hunter, who has rescued Manfred from his suicidal plunge into the rocky abyss, and Manfred's reply is an enlargement of that directionless convulsion:

> Think'st thou existence doth depend on time?
> It doth; but actions are our epochs: mine
> Have made my days and nights imperishable,
> Endless, and all alike, as sands on the shore,
> Innumerable atoms; and one desart,
> Barren and cold, on which the wild waves break
> But nothing rests (Byron 1986, 68–69)

Where Byron's contemporaries and later readers have permitted themselves puzzled reflection on what can possibly be the cause of remorse so grandiose, contemporary critics find in the poem's very sense of an excess that is resistant to representation a cozily familiar formula, fueled by the vortex of

trauma. The failure or blaring futility of the drama becomes its motive prin-
ciple, introducing "a new sense of the sublime as a uniquely disruptive experi-
ence that threatens to collapse the distinction between aesthetics and moral-
ity" (Melaney 2005, 463). You can say that again, and Melaney assuredly does:
disruption and unrepresentability are made the terms of "a verse drama that
bears a relation to theater but challenges the very terms on which theater is
conventionally conceived" (470). The unspeakable and thus nameless sin at
which Manfred so exorbitantly hints becomes the idea of trauma that has fur-
nished so unstinting a principle of grace abounding for our current genera-
tion. As a nameless grief turned into a grievance that one need never finish
naming, the principle of trauma maps tidily onto Manfred's diffusely cosmic
remorse.

Remorse is a rational emotion, in the sense that it is supposed to enforce a
moral ratio, a principle of self-limit and an economy of debt recovery. Man-
fred's remorse is joyously irrational, in that it has no cause and, because it has
no cause, need have no possibility of end, so need never be given up. Byron
(1986) tiptoes toward the revelation that Manfred's sin is that of incest com-
mitted with Astarte. As she first appears, he cries, "I will clasp thee, / And we
again will be—[*The figure vanishes*]" (59). Later, Manfred cries to her, "Thou
lovedst me / Too much, as I loved thee: we were not made / To torture thus
each other, though it were / The deadliest sin to love as we have loved" (85).
His servant, Manuel, comes coyly close to filling in the details: "her, whom
of all earthly things / That lived, the only thing he seem'd to love,— / As he,
indeed, by blood was bound to do, / The lady Astarte, his—Hush! who comes
here?" (96).

In fact, however, this sin must not be named, not because it is so awful that
it dare not speak its name, but because it is so banally ubiquitous (as Freud
wryly observed, why the universal ban on incest unless everybody was inter-
ested in having a go at it?), and to name it would allow a slip back into the con-
ventional rationality of penalty and repentance. Incest must remain unnamed
in order to stand in for remorse without or beyond reason or measure. Byron
(1904) seemed to enjoy the speculations as to the cause or nature of Manfred's
remorse, writing to the publisher John Murray in 1817 that Manfred is "kind
of magician, who is tormented by a species of remorse, the cause of which is
left half unexplained" (55). But this lack of explanation is not mere negligence
or bafflement. In its attempt to harness the power of remorse for itself, without
any allowance being made for regulative and reformatory principles outside

the self, in a kind of supremacism of self-exalting abasement, Manfred's remorse is a kind of pure resistance to representation and conception that is both deadly serious and comical. It anticipates the theatrical antitheatricality that is concentrated in plays such as Jean-Paul Sartre's *The Flies* and Steven Berkoff's *Greek*, which represent, not so much retellings of the myths of guilt and atonement as attempts at untelling, intimating a life lived in something other than tragic plot and the arthritis of crime and punishment.

The return of zeal to contemporary intellectual and mass emotional life, the former exchanging more and more energies with the latter, has been accompanied by a recathecting of remorse. But, like every other major emotional comportment, this remorse is no longer concentrated into satanically aristocratic figures like Manfred. Rather its incitements and gratifications are diffused in small doses over a very large scale, allowing for collective participation and the maintenance of emotional intensity through attributed and vicarious feeling. As Pascal Bruckner has argued:

> Remorse has ceased to be connected with precise historical circumstances; it has become a dogma, a spiritual commodity, almost a form of currency. A whole intellectual intercourse is established: clerks are appointed to maintain it like the ancient guardians of the sacred flame and issue permits to think and speak. At the slightest deviation, these athletes of contrition protest, enforce proper order in language, accord their imprimatur or refuse it. In the great factory of the mind, it is they who open doors for you or slam them in your face. This repeated use of the scalpel against ourselves we call the duty of repentance. (Bruckner 2010, 2–3)

Where Manfred concentrated the energies of remorse in himself, the contemporary mass mediations of remorse are in every sense broadcast. Where Manfred's is a psychodrama, a writhing protest against the necessity of being constrained in theater, the workings of remorse in contemporary life are a generalized psychopolitical operatics. What needs to be understood in considering the particular kind of seriousness embodied in collective remorse is the subjunctive will it embodies. Remorse is not something that one ever simply feels, for remorse is supposed to push naturally toward the repentance that allows the future to be reconciled with the past, in the mode of reparation that pays off a debt. Rather, remorse-repentance comportment is an example of the class of feelings we might call "exhortatives." Remorse-repentance is closely twinned with admonition and the urgent warning that time is running out,

as articulated by John the Baptist: "Repent [Μετανοεῖτε], for the kingdom of God is at hand" (Matthew 3:2). Repentance does the work of bringing time under tension that is always evident in seriousness. For Kierkegaard, remorse is the principle that allows the interruption of the constant state of interruption, distraction, and impediment that is temporal life, and that Kierkegaard (1948) identifies with sin itself, the sin, that is, of the failure of seriousness: "Each day, and day after day something is being placed in between: delay, blockage, interruption, delusion, corruption. So in this time of repentance may Thou give the courage once again to will one thing" (31). Remorse is the "concerned guide, a knowing one" (39) that prevents the constant distraction from seriousness. Kierkegaard concludes, "This is indeed an interruption. But it is an interruption that searches back into its very beginnings that it might bind up anew that which sin has separated, that in its grief it might atone for lost time" (31–32).

Repentance, as the sandwich board calmly reminds us, is always late, and yet stirringly and agonizingly still early enough not to be entirely too late. As John Cleese, playing the headmaster struggling in the film *Clockwise* to get to a speaking engagement, says, "It's not the despair . . . I can take the despair. It's the hope I can't stand." The temporality of remorse is similarly pressurized for Kierkegaard:

> When remorse calls to a man it is always late. The call to find the way again by seeking out God in the confession of sins is always at the eleventh hour. Whether you are young or old, whether you have sinned much or little, whether you have offended much or neglected much, the guilt makes this call come at the eleventh hour. The inner agitation of the heart understands what remorse insists upon, that the eleventh hour has come. (Kierkegaard 1948, 40)

Yet remorse also seems to be out of time, and never to have its definitive date or absolute hour:

> There is, then, something which should at all times be done. There is something which in no temporal sense shall have its time. Alas, and when this is not done, when it is omitted, or when just the opposite is done, then once again, there is something (or more correctly it is the same thing, that reappears, changed, but not changed in its essence) which should at all times be done. There is something which in no temporal sense shall have its time. There must be repentance and remorse. (Kierkegaard 1948, 38)

For Kierkegaard, remorse and repentance are part of the making-serious of the individual soul, which embraces the divine by taking its remorse upon itself. And yet, of course, this is exactly the urge, admonition, and promise that has been held out collectively through religious and prophetic discourse, operating as a stabilizing drone or ground bass and allowing simultaneously for urgency and deferral. Rather than exhortation to purifying action, there is the diffusion of exhortation itself across the field of religious and twilight-religious communication, which is nothing other than this exhortation, renewed early and late. So remorse is not just characterized by a complex temporality; it is this complexity itself. It is the complexity embodied in the ludicrous monstrosity of the doctrine of original sin, of a sin with which one is born, the sin that all along, one was already going to have committed, and that it is from the very moment of birth impossible to avert, leaving the rest of one's life as the work of repentance.

Of course, the genius of the idea of original sin is that it also makes full repentance impossible, precisely because the sin and the repentance are transferential. For there is a danger in the idea of repentance, the danger precisely that it will absolve or dissolve sin, and since sin is interruptedness itself, the interruption of sin must be kept eternal. If we find the strange combination of the "rhetoric of recrimination" (Bruckner 2010, 13) and the "atmosphere of renunciation" (4) characteristic of modern global politics strangely familiar as well as just strange, it is because it has subsisted for centuries in organized religion—most systematically, but by no means uniquely, in Christianity.

It approaches petulance for Pascal Bruckner (2010, 45) to complain that "it is always from Christianity and from it alone that repentance is expected because it invented repentance in its modern forms," even as he sharply characterizes the pride that goes with the exercise of European humility and that is even magnified by the self-denunciation:

> We Euro-Americans are supposed to have only one obligation: endlessly atoning for what we have inflicted on other parts of humanity. How can we fail to see that this leads us to live off self-denunciation while taking a strange pride in being the worst? Self-denigration is all too clearly a form of indirect self-glorification. Evil can come only from us; other people are motivated by sympathy, good will, candor. This is the paternalism of the guilty conscience: seeing ourselves as the kings of infamy is still a way of staying on the crest of history. . . . Megalomania without borders: by attributing all the misfortunes

of the world to man, a certain kind of ecology shows an unbridled anthropocentrism that confirms our status as the "master and destroyer" of the planet. (Bruckner 2010, 34, 35)

Having diagnosed this megalomania, Bruckner (2010) himself is not beyond glorification of it: the West "is detested not for its actual faults but for its attempt to amend them, because it was one of the first to tear itself away from its own bestiality and invited the rest of the world to follow its example" (37). No doubt: for this narcissistic moral profiteering too, repentance is due.

The cult of sin and the affective comportments that multiply in response to and in order to maintain that cult are familiar from religion, but have no eternal need of religious faith. Indeed, it seems that religion is breaking free of organized faith, into the distributed apparatus of faith-operations mediated through mediation itself. At a certain level of organization, organized religion can do without the mise-en-scène of religion. In the past, media systems, scriptures, tablets of the law, the gospels, the Gutenberg Bible served to spread the afterglow of the ecstatically here-and-now "collective effervescence" from which Durkheim derived religious feeling. Now, mediation moves fast enough to boil up that effervescence itself. Instead of the dense concentration of the crowd there is the instantaneous diffusion of variable faith-operations, of faith without credentials or credenda, in which data can fulfill the function of conscience (Connor 2020; Humphreys 2015).

In a sense, this represents the triumph of remorse over repentance, the preference for the yield from the symbolic economy of remorse over the real gains that might come from actions of repentance, that might be so effective they could lead to the forgetting of the sin altogether. One can be sure that not many of the forty million (the equivalent of an entire country) estimated to be living and working under conditions of modern slavery will be freed as a result of the operations of remorse in relation to selected forms of historical slavery. Like Manfred, the world has found a way of living in the pure remorse, itself become mesmerically tragic, that turns its face away from the work of remedy that might diminish its emotional gratifications. The figure of Faust, Satan, or Manfred is a subject sustained in and by pure remorse; the collective remorse mediated in our world has no need of this concentration, having produced an immense machinery of mediated remorse, enacted through exhortative vicariance, in displays and exhibitions of denunciation and renunciation in the name of others, none of whom need anymore be

there, or anywhere. A subject formed and sustained in remorse gives way to a free-floating remorse in search of subjects to be its bearers.

Pascal Bruckner (2013) has pointed to the eschatological enlargement of the cult of ecological remorse: "Just as Third Worldism was the shame of colonial history, and repentance was contrition with regard to the present, catastrophism constitutes the anticipated remorse of the future" (3). The radical ecologism of our time "*is the latest avatar of Prometheus, even if it is a penitent Prometheus*" (88). In ecologism and climate change activism we see the convergence of technologized reverie with religious notions of the End of Days. There is the possibility of paralyzing terror in the thought that it is all our fault, where the vague nonce-entity "it" summoned in phrases like "It is hot today" or "It is late" has expanded to become truly the "it-all." But there is also the temptation to tarry in the grandeur of our crime, elevated into awe by the sheer scale of the damage that we seem to have been able to achieve. The intoxication of remorseful self-accusation—no better if it is "Look what we have done" than if it is "Look what you have done to me"—follows a primitive logic of sacrifice, in which one strikes a pretend bargain with a divine judge who we imagine will mitigate our sentence if we own up to the crime and proffer our suffering as recompense. There is a kind of rapture in paralyzed despair, but we would do better to sacrifice the rapture of the imaginary sacrifice we make with our suffering. For we are not on trial or on stage or only in our own phantasmal jurisdiction, and there is nothing to which we can make recompense or with which we can negotiate a plea bargain. What we have to do is to get to work—not the magical work of remorse or even of repentance: in place of the pseudoserious work of despair, and forgoing the luxuriations of rue, there is available to us, as always, the work of simple, difficult repair.

7 Monition

Where the idioms and accents of rue live out a relation of seriousness to the past, the stylized practices clustering around the act of warning dramatize the will to be serious about our relation to the future. Things that we call serious, in the sense of dangerous or harmful, call on us to *be* or *become* serious, in the sense of asserting or concerting our attention about them. It is hard, though perhaps not entirely impossible, to imagine someone who agreed that some matter or other was serious but who nevertheless felt no pressure to take it seriously. A World War I joke summarizing the different outlooks of Germans and Austrians in times of crisis encapsulates this incongruity: "In Berlin, the situation is serious, but not desperate; in Vienna, it is desperate, but not serious." In the case of a person who agreed that something was serious but failed themselves to take it seriously, we would be likely to think that they could not in fact be taken seriously in saying that they regarded the apparently serious matter—the prospect of unemployment, the risk of personal injury, the imminence of a volcanic eruption—as in fact serious. They would have instead to be taken merely to be conceding that the serious matter is the kind of thing that others would probably regard as serious, thereby protecting the principle that a serious matter just is one that should be taken seriously.

The seriousness of such situations often lies in the fact that they warn seriously of consequences that may be more serious still. A warning is a suggestion, rising sometimes to a threat, of negative consequences, which seems to require some action to avert those consequences. One might inform someone

that their weekly paycheck will be paid on Thursday as usual, but one could scarcely warn them of this contingency unless for some reason it had come to seem threatening or undesirable. I might be informed of the likelihood of thunderstorms in Manaus in the second half of the week, but this could not reasonably be construed as a warning unless there was a reason why these weather conditions mattered to me more than those of any other particular location in the world—because I was planning to fly into or over it, for example. These conditions, of mattering to the addressee and mattering enough to seem to require of them some focused response (or, of course, deliberate ignoring of the warning, which, because it is not merely careless, is done seriously), underlie the action of warning. Warning is the articulation of the implicit address contained in the idea that things are "urgent." It is an acting out of the idea that urgent situations themselves urge a response from us.

Another way of saying this, of course, is that the act or warning assumes or produces the assumptions that such conditions exist. The particular kind of urging that warning or monitory address conducts is in large part what makes certain matters urgent. These conditions and the social-discursive relations they establish make the action of warning one of the most powerful performative styles of the serious. This may be why the action of warning is so often demonstratively framed as the performing of the action that it is, in the issuing of what in disciplinary employment circumstances are known as "formal warnings," for example, or in phrases such as "I am warning you," "Let that be a warning to you," "I give you fair warning," "I strongly advise you," or even just "Now look" or "Listen here."

Nevertheless, there is often a gap or delay between serious matters and taking them seriously. We worry that there may be more of a Viennese than a Berliner outlook. The way in which the gap is closed, and in which a serious thing conjures or is made to enjoin a serious outlook, is often through the range of actions that I will describe as monition, the use of this unfamiliar word for prospective seriousness being intended to parallel my use of rue in the last chapter to cover the forms of retrospective seriousness. If the most familiar variety of rue is regret, then the most familiar variety of monition is the act of warning. This action is too commonplace to seem either very interesting or difficult to construe, though the commonness of warnings may in fact end up seeming more singular than it at first appears to be. We issue and encounter warnings constantly, in notices encouraging us to be aware of all kinds of possible harms in our vicinity or arising from our behavior, and in all

kinds of everyday idiom: watch your step, look out, mind the gap, heads up, beware. Advertisers urge us to purchasable pleasures via more or less covert warnings—"Don't miss this unrepeatable offer!"—while government agencies frequently sharpen or sweeten imperatives with warnings: "Don't die of ignorance." Even quotidian civilities like taking one's leave will often infiltrate a recommendation to cautious foresight, as in the common valediction "Take care."

In the field of communication studies, studies of warning, where they exist at all, tend to focus on the effectiveness of different kinds of warning, rather than on the question of the kind of communicative or performative action warning might be: on how to warn, then, rather than what warning is. It is as though a study of the linguistic phenomenology of promises, of which warnings might be thought to be a negative form, were to concern itself exclusively with how to tell how often they will be kept or broken. The authors of one such study, though they see some utility in explaining to their readers that a warning "is a functional message or system of messages informing an audience, most often a large public audience, of some likely threat or danger" (Sellnow and Seeger 2013, 51), see no reason to go recklessly beyond the technical questions of how and how well warnings work (they can be too vague, it turns out, too mild, too often repeated, too restricted in reach, too late), into the question of the work that warnings do, presumably because it is assumed that we are so thoroughly familiar with that work. Other commentators focus on the legal and commercial aspects of warnings, to provide, as it were, advance warning as to the kind of warnings that need to be supplied by manufacturers of goods, and how to make them effective: "Warnings must possess characteristics that make them prominent and salient so that they stand out from background clutter and noise" (Wogalter, DeJoy, and Laughery 1999, 114). Understandably enough, perhaps, studies of this kind assume that warnings will only be requisite in cases where serious attention is understood to be necessary. The focus of this chapter, by contrast, is on the work that warning does specifically in forming, formalizing, and maintaining seriousness, in the form of this precautionary attention.

Most social creatures have evolved symbolic systems for warning adversaries off or warning conspecifics to take evasive action. We may suppose accordingly that one of the primary functions of any symbolic system, considered as the aggregation and coordination of separate states of awareness, must be to raise the alarm or, alternatively, to assuage it. If gossip is a kind

of grooming, as Robin Dunbar (1996) persuasively argues, then it might be possible to see the vast array of soothing, smoothing, and socially reinforcing actions and utterances as negative alarms, or all-clear assurances. And, whether the warning is serious or simulated ("If you go down to the woods today"), its rationality seems self-evident and in no need of explanation. A warning offers its addressee information or urges emotional preparedness that will help that addressee avoid or avert negative consequences. Seen in this way, warnings seem like an entirely understandable form of practical and prudential reasoning. Why would you not warn? Why would you not want warning, or want to heed it?

Yet, on closer inspection, the utility of warning may come to seem less obvious and straightforward. This is not to say that warnings do not serve the purposes they are supposed to (though they may not always), but rather to say that warnings may have kinds of subsidiary or surrogate utility, some of them rather unexpected. Observed in more detail, the variety of the forms and functions of the rhetoric of warning seems rather to mark out a Wittgensteinian language game, or a complex stressory system in which the creation, sustaining, and melodic management of stress are at least as important as defense against or diffusion of it. We may gloss the stimulation, continuance, and alleviation of stress as the pressure to take things more seriously. The significance of monitory pragmatics in the making out and maintaining of importance, and the living out of seriousness, should seem more worth our attention than it typically has been.

Like the experience of rue, but in the opposite direction, the act of warning, and the secondary reflex of paying heed to it, bring time under tension, literally connecting us in series, an unbroken line, with the future tense. Warning urges us to pay attention to what time will unfold and alerts us to the fact of the unfoldingness, in German the *Vielfältigkeit*, the manifolding news, of time. Warning has its place in an account of the styles of seriousness not only because it focuses us on self-preservation but also because it involves an ethics of consequence and, as a consequence of that, of responsibility. One should live not carelessly and at random, like the Aristotelian φαύλῳ, the empty or immoral man who takes life as it comes, or is taken by it, living without even thinking of living a "life," without desire or surprise and without even the self-approving existential project of making the choice of chance, τυχόν (Aristotle 1926, 142–43). One must be warned, or beware, not just to avoid danger, but to live seriously, in ongoing answerable awareness,

and thereby to live one's life as something willed and known, willed as knowable. The watchword for this kind of life, or attitude toward living, might be Ariel's song: "If of life you keep a care, / Shake off slumber, and beware. / Awake, awake!" (Shakespeare 2011, 1082). The one who is aware is ready for alarms, primed for calls to arms, and alert—that is, lifted up to a height, *alla + erta*, the place that is erected, from Latin *erigere*, and so living in two places, at once above and ahead of themselves and the life they mean to have lived. Seriousness is just this imaginative-imaginary eminence that taking things seriously promises and imposes.

Warning aims to impart the freedom of choice that can come from awareness, but must always itself be coercive, in some kind or degree, if only because every kind of freedom *to*, as opposed to freedom *from*, must impose a compulsion, the choice—impossible not to make—of whether or not to exercise it. Warning is threatening in that it aims to induce responsibility for events and effects while seeming to offer to increase opportunity. Even as it seems to offer the wherewithal to act responsibly in one's own interests, warning aims to make it difficult to disclaim that responsibility. The mock reassurance often given for some imposed ordeal or exaction is that it is "for your own good," as though one's own good were not any kind of benefit but rather the imperative requirement of attending to one's good, to which one is held to be subject rather than being the subject of it. Warning warns that one must be concerned with one's good, and that one's good should be an ongoing concern. In seeming to offer the avoidance of negative consequences, warning is a form of conditional incrimination, or potential holding to account, in the threat it opens up of having to take the responsibility for not having taken responsibility. This may be why the words *admonition* and *admonishment* have come to mean both warning and reprimand, as though to anticipate in the warning the reproof for having ignored it.

This is nowhere more the case than in the intimidating warning involved in the action known as "reading you your rights," expected of arresting police officers in many legislatures, in which I am informed that I do not have to speak, but that anything I do say, or omit to say, may harm my defense. Most people know already, or it is certainly thought they should know, that they do not have to speak in such circumstances, in the absence of any kind of instruction to do so. But the seeming permission given in this statement, or the formal affirmation of the right to silence that has been a principle of common law in England since the seventeenth century, is a warning of a

compulsion, the compulsion in fact that the warning is. For in it I am warned that if I do not speak, it can be taken as an instance of deliberately, and so possibly suspiciously, keeping silent, even if it is said to be the case that no adverse judgments may be made on the basis of my silence. So I may very well still be able to not speak, in the form of an impotential indifferently open to me at every moment and in every conceivable circumstance, but what I cannot do any more is *just* not speak, in such a way as to have my not speaking treated as neutral or inconsequent, or not treated at all as anything. I cannot any more simply and neutrally not speak, once my not speaking may be taken as evidence of some telling silence in response to the circumstance of being taken into custody. The warning in this instance functions as a question to which I am forced to give some answer. The warning forces me into the condition of deliberate choice, of seriously and purposively intending my silence, which leaves it open to being considered strategic. It is a neat example of the Fregeian distinction between sense and reference. The pikestaff-plain reference of the statement is "You do not have to speak," but the sense of it is, "What have you got to say to that, now that you know everyone will know what you now decide to say, or not?"

This reveals a general principle of the warning, that it forces things into significance, removing the choice of making no choice, and making it impossible for anything to be unmeant. Shakespeare provides a neat diagram of the force insinuated in the offering of opportunity in the opening scene of *King Lear*, in which the old king offers his daughters, who have no doubt benefited from long rehearsals of the glib and oily art, the opportunity of profiting from his irascible narcissism by participating in an affection auction, each one pretending to love him more than the other:

> LEAR . . . what can you say to draw
> A third more opulent than your sisters? Speak.
> CORDELIA Nothing, my lord.
> LEAR Nothing?
> CORDELIA Nothing.
> LEAR Nothing will come of nothing. Speak again. (Shakespeare
> 2011, 635)

Lear's "nothing will come of nothing" is proverbial, though he seems to vary it slightly from the usual form "nothing can come of nothing"—that is, nothing is self-originating (Dent 1981, 184). The change from "can" to "will" shifts

the emphasis menacingly from antecedents to consequences. Cordelia is paralyzed, or stripped of any possibility of the precious commodity we currently call "agency," precisely through the manner of being given it in the malice of Lear's admonition. Shakespeare also allows the words to function as an unheeded warning to Lear himself, that the violence of the nothing that is, according to René Girard (1991), mimetic rivalry will be unleashed by this empty display of Lear's "mimetic desire for the mimetic desire of his daughters" (183). What will unfold in the course of the play, this scene announces, is indeed the bloody nothing of violence. It is uncertain what response this warning allows or enjoins for its audience or readership, although this being a play, the warning is compromised by the promise of story it holds out.

To warn is to enforce intention or deliberateness, enlarging awareness and the possibility of freely choosing action, but closing down any possibility of acting completely freely, in the sense of being free of awareness of possible negative consequences requiring preparatory or cautionary action. The coercive responsibility given by a warning means that not only is one given the ability to respond to the warning—by taking evasive or aversive action—one is by the same token deprived of the ability to be unresponsive to it, since ignoring the warning will itself constitute a response to it, which may in different senses "harm our defense." The offer made by a warning or by any kind of advice that implies a negative consequence that I must, as a result of the advice, be regarded as accountable for, frames a question to which it is impossible not to return some kind of response. I can by all means refuse the offer made by a warning, but I cannot refuse the fact of its having been made, and so therefore cannot refuse my refusal of it. In the salty stanza from Bob Dylan's "Highway 61 Revisited":

> God said to Abraham, "Kill me a son."
> Abe said "Man, you must be putting me on."
> God said "No." Abe said "What?"
> God said "You can do what you want Abe, but
> The next time you see me coming you'd better run."

Warning and the state of alert awareness it is designed to arouse begin as heterophoric, a "heads-up" conveying of attention away from oneself and on to what lies ahead and beyond one's own constrained being and interests. But monitory objects, occasions, and methods grow in variety and intensity as part of the apparatus of settled civilizations—a civilization being regarded as

a way of spreading risk by sharing it—even as the likelihood of actual dangers recedes, partly because of the protective fabric formed by such warnings, and the knowledge that there are others to whom we have delegated the job of paying alert attention to them. Although warnings may thereby be successful in minimizing risk, they nevertheless form a libidinizing incorporation of the play of warning, the complement of which may slowly come to be not intermittently focused alertness, like that produced by the mobbing call required to drive off a predator, but a sizzling hum of generalized and objectless apprehension. Nobody thinks they enjoy anxiety, but the quality of anxiety allows for a kind of erotic addiction to a fear that does not quite have an object, which the anxiety itself gives the half satisfaction of seeming to hold at bay. In the words of Patroclus in *Troilus and Cressida*, "danger, like an ague, subtly taints / Even then when we sit idly in the sun" (Shakespeare 2011, 1174). *Danger* derives from Latin *dominarium*, lordship, mastery, and in its early uses indicated sovereignty, or the extent of a subject's power. Portia says to Antonio, of his bond to Shylock, "You stand within his danger, do you not?" (852). We all stand within the danger of dangers held for the time being at bay—of illness, crime, unemployment, poverty, violence, defeat of hopes— and the ever-present danger that those dangers may in fact become present. But the fabric of mediated warning makes up the feeling of safety from enclosure within modulated danger. "At bay" seems to derive from the convergence of two ideas, that of the state of suspense indicated by the open mouth, from medieval Latin *badare*, to gape, itself symbolizing the yawning of possibility, and the cornering of the hunted animal by baying dogs. To be in an abstract state of being able to become aware of danger seems safer than being entirely inattentive to that possibility.

In issuing a warning, one becomes in part the subject of what might otherwise make one an object. For, twinned with their coercion and the forcing of open fields of possibility into pathways of significance and choice, warnings also give pleasure, to the warner, the warned, or both, along with whatever witnesses to the warning there may be. The presence of warnings in narrative— for example, in the story of Oedipus and other classical tragedies—should also suggest that warnings tend to initiate narrative sequences. It is striking that the action of warning, which aims to concentrate seriousness, should give rise to so many narrative instances of warnings that are themselves not taken seriously, presumably because that is much more interesting than good advice duly followed. The figure of Cassandra, who was given the gift of prophecy by

Apollo, but then punished by him for refusing his advances by being doomed never to be believed, provides an instance of a metamonitory warning against ignoring warnings, even as this ignoring is a necessary part of the unfolding of tragic narrative. "The Boy Who Cried Wolf" provides a contrary warning against issuing warnings that are insufficiently serious, since they will similarly encourage mistaken disbelief. "I told you so" suggests the importance of the action of telling, in the sense of conveying a story as well as information. Melanie Klein suggests that the figure of Cassandra embodies the internalized monitor known in psychoanalysis as the superego, along with an internal dialog of belief and disbelief that its urgings can provoke, as dramatized in the vacillation of the Elders in the play in response to Cassandra's prophecies:

> Their refusal to believe what at the same time they know expresses the universal tendency towards denial. Denial is a potent defence against the persecutory anxiety and guilt which result from destructive impulses never being completely controlled. Denial, which is always bound up with persecutory anxiety, may stifle feelings of love and guilt, undermine sympathy and consideration both with the internal and external objects, and disturb the capacity for judgement and the sense of reality. (Klein 1975, 293)

Florence Nightingale's (1992) bitter essay "Cassandra" of 1852, in which she protests against the enclosure of women in domesticated lives, comes to a climax with an explicit identification, not with Cassandra, but with the "female Christ." As though instantly disavowing this identification, Nightingale appends a peculiarly aggressive footnote acknowledging that "insanity, sensuality and monstrous fraud have constantly assumed to be 'the Christ,'" and attacking the impostures as she sees them of Mormon revelation (231). No matter how powerful the warning may be, the power of the gratification offered by inhabiting the person of Cassandra can produce this kind of recoil into anxious ambivalence.

The one who warns opens up the prospect of a story that may come to be told in the future, even as their warning also allows for an avoidance of the narrative or an alternative narrative of avoidance. In Don DeLillo's *White Noise*, the moral pleasures embedded in disaster have become a staple of family entertainment:

> "Japan is pretty good for disaster footage," Alfonse said. "India remains largely untapped. They have tremendous potential with their famines, monsoons, religious strife, train wrecks, boat sinkings, et cetera. But their disasters tend

to go unrecorded. Three lines in the newspaper. No film footage, no satellite hookup. This is why California is so important. We not only enjoy seeing them punished for their relaxed life-style and progressive social ideas, but we know we're not missing anything. The cameras are right there. They're standing by. Nothing terrible escapes their scrutiny." (DeLillo 1986, 66)

The pleasures of monitory utterance sometimes involve impostures of warning, or warnings against things that gain their force from allowing no defense. Neil Kinnock (1983) employed this trope in a speech of 7 June 1983, two days before Margaret Thatcher's election victory, in a series of mock warnings: "If Margaret Thatcher wins on Thursday, I warn you not to be ordinary. I warn you not to be young. I warn you not to fall ill. I warn you not to get old." The seeming cruelty or absurdity of warning against the inevitable is of course intended to intensify the urgency of taking action to avoid being exposed to its worst consequences. But it borrows from the sense of destiny, or rather the sense of destiny mastered in foreknowledge (I *knew* it) that comes from the acknowledgment of it.

In taking the broadest view of the affective work done by monitory pragmatics, we must take into account the force of this kind of warning, which in fact allows for no meaningful response. In a number of countries across the world, there is a road sign that warns motorists of the risk of falling rocks, usually with an image showing rocks tumbling down a steep escarpment. There certainly seems to be some point in warning motorists that on the road ahead they may encounter rocks around which they may need to swerve. But this is not what the illustration shows, but rather rocks tumbling down a steep incline from left or right on to the road. It is not at all clear what kind of evasive action is expected to be taken in the case of such sudden or unexpected landslides. Should I drive slowly, scanning the steep sides of the road as well as the road itself for signs of subsidence, and therefore lengthen the amount of exposure I have to the possible cascade? Or should I drive faster, in order to get through the danger zone more quickly, in the process perhaps increasing my risk of driving into a rockfall that might otherwise have occurred safely some yards in front of me? One might well conclude that such a sign is designed as a "Don't tell us you weren't warned" performative to head off the objection that motorists were left ignorantly exposed to the danger, and to indemnify the authorities against legal action rather than to offer genuinely helpful advice.

There will always be something minatory in a monitory utterance, an implied threat of some more or less undesirable consequence of not heeding

the warning. Cotton Mather concludes his letter of remonstrance against those who supplied native peoples with alcohol with words that threaten the more than fatal consequence of not attending to his admonition:

> These are some of the Faithful *Admonitions*, which in the *Name* and *Fear* of God, were to be set before you. And for the Conclusion of them, I Admonish you to meditate on that awful Word of God, in [*Hab.* 2:15.] Wo to him, that gives his Neighbour Drink that puttest thy Bottle to him, and make him Drunken. Being then at length terrified, by the terrible *Wo*, which you have incurred, by *Selling the Indians Drink*, and *putting your Bottle unto them*, to *make them Drunk*. (Mather 1700, 15–16)

This may be why monition, and more particularly the aggressive intensification of it implied in the term admonition, so easily mutates into the rebuke known as admonishment. It is as though, in admonishment, admonition were anticipating the sullen or thoughtless nonresponse to it. This is particularly the case with religious admonitions, which warn of consequences that are literally worse than death; in threatening the punishments of hell or the posthumous privations of purgatory, they do not so much offer an escape from death as rule out the possibility of any escape in it, than which nothing could more fiendish. Indeed, warnings in general seem to take their occult tonality from the long history of religious exhortings to have a care for one's soul, or one's condition in the afterlife, exhortings that simultaneously open the sinner up to awareness of their jeopardy while offering the possibility of canceling it through the narcissistic self-congratulation and minor omnipotence of thought or prophetic fantasy involved in foreknowledge. Although the admonishment of sinners is one of the spiritual acts of mercy emphasized in Catholicism, the passion for admonishment is conspicuously strong in forms of Protestant religion, and Calvinism in particular, which emphasize predestination. John Calvin tackles the objection to predestination head-on, and in fact with discernible relish, in the chapter of his *Institutes of the Christian Religion* that deals with free will. What is the point of the exhortations to amend one's life and obey commandments if the mind of an omniscient God cannot without blasphemous presumption be regarded as able to be changed?

> But it will be asked, why are they now admonished of their duty, and not rather left to the guidance of the Spirit? Why are they urged with exhortations when they cannot hasten any faster than the Spirit impels them? and why are they chastised, if at any time they go astray, seeing that this is caused by the

necessary infirmity of the flesh? "O, man! who art thou that replies against God?" (Calvin 1989, 1.277)

The absence of an instrumental justification for exhortation just is the justification, since the Lord God does not do payoffs and plea bargaining, and never could without ceasing to be all-powerful. One may therefore need to distinguish the purpose from the function of admonition. One cannot read or listen to admonitions for any length of time (and the issuing of admonition usually occupies considerable lengths of time) without the suspicion stirring that if the open and announced purpose of warning is to give advance notice of some likely outcome, its function is not always, and perhaps not even usually, to provide the opportunity for evasive action but rather to intensify the sense of seriousness—to induce one's audience, and retroactively oneself, to take seriously things they otherwise might otherwise neglect to, or weary of. Calvin's form of seriousness is the chastening awareness that, if there really were a God, and not just a pantomime devil tricked up in radiance, it would have to be the proof of one's absolute helplessness and negligibility:

> I answer, just the same as if God were to say, Since nothing is gained by admonishing, exhorting, rebuking this stubborn people, I will withdraw for a little, and silently leave them to be afflicted; I shall see whether, after long calamity, any remembrance of me will return, and induce them to seek my face. . . . when the Lord, offended and, as it were, fatigued with our obstinate perverseness, leaves us for a while (by withdrawing his word, in which he is wont in some degree to manifest his presence), and makes trial of what we will do in his absence, from this it is erroneously inferred, that there is some power of free will, the extent of which is to be considered and tried, whereas the only end which he has in view is to bring us to an acknowledgment of our utter nothingness. (Calvin 1989, 1.286)

It seems odd for the absence of free will to be regarded as intensifying the sense of the serious, but that effect derives not from the sense of being responsible for one's fate, in this world or the next, but from the strangely aggrandizing knowledge of one's littleness.

Omens

The monitory relationship involves tense and ambivalent relations between addresser and addressee. The monitor may be a mentor and a friend in need,

guiding and supporting. But they may also be an admonisher, one to whom one must bend the knee. "Friendly advice" is rarely entirely amicable, either in the giving or the receiving.

But although the relations of admonition may seem all too human, not all warnings issue from actual acts of human address. Monitory relations may derive impetus from the strong predisposition of human beings to look for and respond to warnings in their environments. One of the most significant of these in human history has been the force of what is known as omens, or premonitions, which might be seen as agentless warnings, warnings issued not with regard to a possible future but as it were from that future itself, as "coming events cast their shadows before," in Thomas Campbell's (1907, 159) "Lochiel's Warning."

Systems of interpretation for omens and portents abounded in the ancient world, along with complex techniques for making the natural world speak through divination. Divination typically coordinates chance and order, the surrender of human choice in throwing dice or bones at random, drawing lots, or turning at random to a passage from a sacred text, which is designed to disclose the patterns that exist latently in nature. The practice therefore employs randomness against itself, to demonstrate the fundamental serious-ness, in the sense of its divinely ordained connectedness, of all things, and the impossibility of irrelation or the purely chance event—except as the kind of portent that an out-of-the-blue occurrence may often seem to be. The icily fervid overcoherence of the paranoiac is an intensification of the divinatory faith in universal earnestness, or intolerance of absurdity, in the principle enunciated by Emerson (1875, 9) that "the universe does not jest with us." The suspicion that this technique simply discloses the inescapable indolence of the human desire for coherence, conspiring constantly against surprise and to reduce the world to known and familiar proportions, can itself furnish a confirmation of the principle of the interconnection of mind and world. Divi-nation allows for a reassuring interpenetration of the given and the made, force and spontaneity, the quasi-arduous toil of interpretation being bound to unfold the truths that nature in any case already proclaims on its own account. Jakob Böhme systematizes the principle of what has become known as the doctrine of signatures in his twinning of the idea of outward and visible form, or the self-writing of phenomena, and the idea of spontaneous self-proc-lamation: "Every thing hath its mouth to manifestation [*hat seinen Mund zur offenbarung*]; and this is the language of Nature, whence every thing speaketh

out of its property, and doth continually manifest, declare, and set forth it self to what it is good or profitable" (1651, 4; 1635, 15).

The impulse to give a "mouth to manifestation," or make an utterance of every inscription, is animist, in that the centrality of significant sound making in humans predisposes us to think of sounds as intentional in a way we do not extend to the merely contingent making of marks, the dent in the cushion, or the smear on the glass. Intent is twinned to portent, the straining in to the stretching forth. The principle of panophonia (Connor 2012) assimilates sound to voice and in doing so seems to turn vocal acts into monitory ones, which seem not only to speak but also to call for attention to their quasi-address (an address, from Anglo-Norman *dreser* and medieval Latin *directiare*, being literally that which draws us into uprightness or makes us stand to attention).

A striking example of sounds that seem to call for formalized audience is found in the texts known as *brontologia*, which dealt exclusively with the interpretation of the sounds of thunder. One of the earliest of these is an Etruscan calendar of thunder signs, from around the early seventh century BCE, which shows familiarity with the divination traditions of the Near East. It does not survive in its original Etruscan, but was published in a Latin version by Publius Nigidius Figulus and, translated into Greek as a brontoscopic calendar (Εφήμερος Βροντοσκοπία), forms part of a treatise by Johannes Lydus titled *De ostentis* (*On Portents*) (Turfa 2012, 3). Bede was thought to be the author of one such guidebook, the *De tonitruis libellus* (Juste and Chiu 2013). Many of these divinatory systems depend not on the auditory quality of the thunder but more abstractly on a reading of the significance of its circumstances, such as the fact of its being heard in the four points of the compass or at certain times, whether days of the week or hours of the day (Liuzza 2004, 7–20). Nearly always, however, the thunder is a warning of danger—to men, trees, crops, or fish, though the portent may sometimes be propitious: according to the text attributed to Bede, thunder in December "promises prosperity and the best of health to all" (quoted in Liuzza 2004, 11).

The animation of the voice of the thunder, or perhaps one might as well say its animalization, is assisted by its pseudovocal nature, or capacity to be heard as growling, groaning, or grumbling. But the speech in which the thunder conveys its meanings is ventriloquial, in that it is a speech projected into its putative utterer by its audient—it is, in a literal sense, hearsay, something heard as being said. One of the most well-known representations of thunder

speech is that alluded to in the fifth section of T. S. Eliot's *The Waste Land*, titled "What the Thunder Said." The allusion is to a parable that forms part of the *Brihadaranyaka Upanishad*, in which the procreative god Prajapati speaks in a voice made of thunder to an audience of his descendants, gods, men, and demons (*asuri*):

> Having lived the life of a student of sacred knowledge, the gods said: "Speak to us, Sir." To them then he spoke this syllable, "*Da.*" "Did you understand?" "We did understand," said they. "You said to us, 'Restrain yourselves [*damyata*].' " "Yes [*Om*]!" said he. "You did understand."
>
> 2. So then the men said to him: "Speak to us, Sir." To them then he spoke this syllable, "*Da.*" "Did you understand?" "We did understand," said they. "You said to us, 'Give [*datta*].' " "Yes [*Om*]!" said he. "You did understand."
>
> 3. So then the devils said to him: To them then he spoke this syllable, "*Da.*" "Did you understand?" "We did understand," said they. "You said to us, 'Be compassionate [*dayadhvam*].' " "Yes [*Om*]!" said he. "You did understand."
>
> This same thing does the divine voice here, thunder, repeat: *Da! Da! Da!* that is, restrain yourselves, give, be compassionate. (*The Thirteen Principal Upanishads* 1921, 150)

This making out of meaning in noise is in fact a dominant interpretative principle of the Upanishads, which consist of repeated exercises in the splitting and reassembly of syllables to articulate the various bits of mystical intimation contained in them. The Sanskrit word *satyam*, truth, is subjected to this analysis:

> That is trisyllabic: *sa-ti-yam*—*sa* is one syllable, *ti* is one syllable, *yam* is one syllable. The first and last syllables are truth (*satyam*). In the middle is falsehood (*anrtam*). This falsehood is embraced on both sides by truth; it partakes of the nature of truth itself. Falsehood does not injure him who knows this. (*The Thirteen Principal Upanishads* 1921, 151)

The process acted out in this pretty little rigmarole is at work in many forms of auditory hallucination, in which the meanings projected into what might otherwise be regarded as pure noise, in an auditory version of the inkblot test devised by Hermann Rorschach (1951) in 1921, seem to be given the force of revelation, a force that probably derives transferentially from the force of the

analytic attention paid to them. The whole episode is a parable of confabulatory coinstruction, or autosolemnifying hallucination. In essence, Rorschach's psychodiagnostic procedure follows the practices of divination, equally relying on making sense out of the chaotically senseless, even if other interpretative intermediaries must be called to the scene to make sense in their turn of the allegedly spontaneous sense made by the subject (Galison 2004).

The doctrine of articulatory signatures belongs to the view that the world of appearances is bound together by relations of resemblance. In principle, such a view of the world finitizes it, insisting that nothing can emerge out of nothing or nowhere, meaning that, properly read, signs and appearances simply echo and reverberate between each other in perpetuity. Where the modern world strains to make out relations of cause and consequence, an earlier dispensation, which can by no means, however, be regarded as simply having been dispensed with, sees relations of signification and significance, which may come to be more deeply understood, but are not susceptible of development. Such a view might give the temporary calm that comes from a wholly providential belief that being foreseen means having been provided for, a view that empties and flattens time into mere resonance.

What restores futurity, and the possibilities of hope and dread it gives, is the principle of obscurity, which requires the labor of interpretation, a word that etymologically seems identical with prophecy, since both mean speaking for, or on behalf of. Everything in the universe of signatures is meaningful, but in the mode of the meant-to-mean, or what is known as the portentous. Importance resides in this portentousness or, more strictly, derives from the interpretative labor of reading the signs of things. The reading out of utterance may seem peculiarly potent in that it occurs in time, and so may seem to mimic the sense of meaningful temporal unfolding that it embodies.

Prophecy

Floating between the realms of the timeless and the temporal is the act of prophecy. Prophecy compounds two distinct ideas. First there is the idea of speaking for, or in the place of. God's prophets speak the words of God unto men. In Ezekiel, the word *prophesy* is often used to mean a kind of magic speech—the use of utterance to bring about miraculous effects. In the valley of dry bones, God commands Ezekiel to "prophesy upon these bones, and say unto them, O ye dry bones, hear the word of the LORD. Thus saith the Lord

GOD unto these bones; Behold, I will cause breath to enter into you, and ye shall live" (Ezekiel 37:3–4). Ezekiel duly utters on God's behalf the executive words that God has commanded him to utter, and as he says them, "there was a noise, and behold a shaking, and the bones came together, bone to his bone" (Ezekiel 37:7). The point is that here the "I will" of "I will cause breath to enter into you" is not used to express some future intention or intention for the future but rather to make something occur in the present. A chain of discursive command is instituted, in which God commands Ezekiel to command the bones, which duly reassemble themselves. But then, more familiarly, and in contrast to this idea of transferred speech or speaking-for, there is the idea of prophecy as foretelling, the adumbration in advance of events that are yet to come. How are these two functions, of here-and-now commanding and long-distance foreseeing, associated?

Prophecy is not prediction. I may predict a 5 percent increase in the rate of inflation, but I prophesy famine, fire, and flood. Similarly, I can predict a win for Hurricane Fly in the 2:30 race at Haydock Park, but I prophesy the End of Days and universal lamentation. It is plain, therefore, that prediction concerns precise and particular events that may be verified or falsified. This means that prediction consists of predication, the making of statements, in the future tense. This is why you can lay odds on prediction and occasionally even collect your winnings. Prophecy, by contrast, is the kind of utterance that is known as a performative, like the statement "I name this ship the *Enterprise*" or "I now declare you man and wife," in that it aims as much to induce a particular effect or condition of its utterance as to issue a statement about a state of affairs in the world.

This means that prophecy, which is often accompanied by or accomplished through various kinds of ventriloquism, also resembles it. First, as in Ezekiel, prophecy borrows or mimics the function of a god, notably Apollo, the god of prophecy who overtook the priestesses of the Delphic oracle. But, as a performative, prophecy is also like ventriloquism in that it is a sort of conjuring, which arouses in the one who hears or receives the prophecy the desire or the temptation to see it made good. It is not the ventriloquist who throws his voice into the dummy; it is his audience that throws the idea of voice from one place to another. Similarly, it is not the act of prophecy that draws the present tense of utterance into conformity with future events but rather the desire of the reader or receiver of the prophecy (along with the dread mixed into that desire) for it to be proved as a prediction. Prophecy aims to magnetize the

unmade future, to tempt or seduce it into conformity with a past in which it might come to seem to have been foreknown.

This is why prophecy is so rarely tied to specified times and places, or, if it is tied to a date, as in affirmations of the end of the world, that date can and must always be revisable. Predictions are exhaustible, but prophecy, though it must always concern the future, is anachronistic, floating between the present tense of its utterance and the open and prospective time of its putative fulfillment, a fulfillment that must never in fact definitively or once-and-for-all arrive. The prophecies of the sixteenth-century apothecary Nostradamus in fact seem to jumble up past, present, and future, since quite a few of the events that he claimed to foresee had in fact already taken place. One example is the discovery of the tomb of Augustus, which had occurred in 1521, and which Nostradamus seems to predict on three separate occasions in his prophetic writings. Meanwhile, as history unfolds, readers of Nostradamus continue to find new assignments and applications for the events that he predicted, indifferent to how they may previously have been interpreted.

Prophecies are often inaugural, a word that advertises its links with augury, from divination through the flight of birds (Latin *avis*, bird, and *garrire*, to talk). The visible speech of birds' flight patterns attended to by augury has no interiority, no intent, other than to signify the making of signs itself. Cassandra is said to have gained the gift of prophecy after her ears were licked clean by snakes in the temple of Apollo, which suggests a similar link between prophecy and the activity of animals. Prophecy often occurs in conditions of trance or fever, which ensures that the utterances of prophets are riddling, delirious, or garbled—unless it is the necessity for obscurity that enjoins the heightened conditions in which it is delivered. Such obscurity is appropriate for a mode of discourse that relies on meaning being read in from the outside rather than expressed from the inside.

Prophets are typically ignored. Indeed, we may say that the point of prophecy is that it should be ignored in its own time, the only time in which it might seem to be of any use. The purpose of prophecy is always to allow the revelation, too late, that the prophecy should at the time have been heeded, though there is usually no practical way in which the knowledge could have been put to use even if it could have been discerned. Like the sign that warns of falling rocks, it is not entirely clear what one is supposed to do with a prophecy of the coming of the Lord in wrath. Perhaps, although prophecy often seems to concern itself with catastrophe and apocalypse, the function of its temporal

uncertainty, far from collapsing past and future together, is ultimately to keep history open, unconcluded, and revisable, while also ensuring that past, present, and future remain looped together by anticipation and retrospection.

Prophecy consists, therefore, of the reflexive performance or provocation: "Make prophecy out of this if you can." And this is another form of ventriloquial imposture. Prophecy, in which a mortal seems to impersonate the powers of divinity so as to order the things of this world through the power of utterance alone, in fact turns out to be able to do just what it wagers. For prophecy is the performance of just this power of performance, which means that all prophecies are prophetic of the same thing—that, rather than commanding history, they will in fact be taken up by it. Prophecies prophesy no more, and no less, than that they will, in the end, be taken to have been prophetic.

Although the era of omens and oracles may seem to have gone, more and more of the warnings that modern humans encounter take the form of interpretable signs rather than warnings articulated by other human subjects. Earlier usages tend to represent these monitions, not as warnings in the present of a future, but as reminders from a past as to its current posterity. Varro influentially associated monition with monumentality, as *monere*, to instruct, + *mentum*, mind, since monuments remind:

> From the same [*memoria*] is monere "to remind," because he who *monet* "reminds," is just like a memory. So also the *monimenta* "memorials" which are on tombs, and in fact alongside the highway, that they may *admonere* "admonish" the passers-by that they themselves were mortal and that the readers are too. From this, the other things that are written and done to preserve their *memoria* "memory" are called *monimenta* "monuments." (Varro 1951, 217)

Quoting Varro, Walter Charleton associates Stonehenge with

> the most durable Memorials of worthy Men and Actions, by which generous spirits are animated to tread in the rough and craggy wayes of Virtue, upon expectation the Gratitude of posterity will endeavour to vindicate their names and deserts from the devouring jaws of Oblivion; the first place belongs to those, which the Grecians call κενοτάφια, the Romans *Monumenta,* and we in imitation of them *Monuments:* because they serve to instruct the present and future ages, in things done in ages past; and remain to succeeding generations, as certain Memorials of the famous performances of their Ancestors. . . . So that a Monument, in propriety of signification, is an *Admonition by putting in remembrance.* (Charleton 1663, 4)

The "inanimate Remembrancers" (Charleton 1663, 5) evoked by Varro and Charleton need not necessarily constitute a warning to take heed of eternity. But they seem progressively to have been taken not as a sign of enduring majesty but as a *memento mori*, to give the present reader tremulous pause, in the style of the anonymous inscription, probably from the sixteenth century, to be found in the north aisle of St. Mary the Virgin Church in East Bergholt, Suffolk, the village in which John Constable was the miller's son:

WHAT ERE THOV ART HERE READER SEE
IN THIS PALE GLASS WHAT THOV SHALT BE
DESPISED WORMES AND PUTRID SLIME
THEN DVST FORGOT & LOST IN TIME
BIRTH BEVTY WELTH MAY GILD THY EAST
BVT YE BLACK GRAVE SHADOWES THY WEST
THER EARTHLY GLORYS SHORTELIVD LIGHT
SETS IN A LONG & VNKNOWN NIGHT
HERE TILL THE SVN OF GLORY RISE
MY DEAREST DARKE AND DVSTY LYES
BVT CLOTHED WITH HIS MORNING RAYE
HER POLISHD DVST SHALL SHINE FOR AYE
READER FIRST PAY TO THIS BEDEWED STON
THE TRIBVTE OF THY TEAR & THEN BEGON

The address of the epitaph is characteristically transferential. It is only the attentive presence of the reader in front of the tablet that activates the address to them, like an automatic recording triggered by their approach, and that serves to wind the addressee into its gears, as they read themselves reading. The inscription-address is literally a program, a pre-scription or writing through in advance, of their act of reading. The address is personal, even as it is dismissively generic ("what ere thou art") and presents the reader with the deliciously grisly prospect of their personal dissolution into post-personal dust. The verse draws together the punctual moment of the reading "here" and the "what ere" constituted by the indefinite repetitions, past and present, that serve both to capture and conscript in advance every future occasion of reading, and yet also to advance every future reader into the ghostly condition that lies in their future. The epitaph contrasts the reflective hardness of the stone, the "pale glass" that holds the address upright and intact (if also inevitably eroded over four centuries or so), and the anonymous slime and dust it

covers over, bringing them together in the witty-grotesque oxymoron of the "polishd dust" of the radiant resurrection in which it trusts, or its words do. The final "begon" is a familiar *nunc dimittis* for all readers of such epitaphs, as well as a designation of the entire process of "being gone" the inscription is designed to anticipate and, for the suspended space of the reading, enact. To be the reader of this epitaph is to become aware of one's condition of being gone from it and the scene of reading it programs. The admonition both calls the reader bracingly to attention and decomposes the reader and its reading both. The epitaph is pure seriousness, without even a flicker of instrumentality: nothing the reader could do could mitigate a whit the inevitability of the putrid process against which it pretends to warn.

The solemnity of poetic epitaphs is often effected through the tension under which time may be brought through such pseudowarning. In Shelley's (1975) "Ozymandias," all that remains of the "colossal wreck" of the statue of Ozymandias, its head half sunk in the sand, are two legs and a pedestal, on which is inscribed "Look on my works, ye Mighty, and despair!" (320). The meaning of these words has changed, or has rather been solemnized into a joke: the admonition to coming generations to despair of ever being able to match the magnificence of Ozymandias is turned into the admonition that the end of all such admonitions is despair—or rather the cancellation of every conditional if-and-but in the "lone and level sands" that stretch uniformly away in all directions.

When signs seem to point to dangerous or undesirable events, they take the intensified form of omens rather than mere indications. Threats are sometimes, we have noted, thought of as curdled rather than candied promises. The parallel is confirmed by the possibility of a statement like "If you carry on your philandering, I promise you will regret it." But, perhaps because of an evolutionary history in which survival depended more on the recognition and avoidance of environmental threats than on the exploiting of environmental advantages (since failure in the former risks losing everything, while failure in the latter only risks forgoing marginal advantage), we tend to think of omens as warnings rather than promises, or pay more attention to those warnings of danger than we do to more silvery intimations. Omens, after all, are ominous, and premonitions usually forewarn of bale rather than bliss. "Boding," it is true, from Old English *bodian*, to announce, proclaim, or presage, can be for good or ill, but not "foreboding." Edmund Bolton wrote in 1619 that the Roman general Marcus Crassus took the sneering remark of the Mysians' leader that the legions might justly call themselves lords of the world if they

prevailed as "a faire forebodeing" (Florus 1619, 478), but from this point onward, foreboding is ever more exclusively of fearful rather than fair outcomes. The pragmatics of impersonal warnings are governed by the hermeneutics of care, a word that, in its semantic shift from burden to valued object, or from negative to positive concern, suggests some of the self-securing value of monitory awareness. We care about the things for which we have a care, or which urge us to have a care (Connor 2019b, 174–203). There are many symbols of good luck, but most of them are deployed defensively against bad luck and so may be thought of as anti-omens rather than in themselves positive omens. The other reason that omens seem more serious than signs of good luck is that they are imperative rather than indicative, demanding a response rather than merely pointing to a likely state of affairs. An omen is a sign of a future that it may be possible to avert; a good or propitious sign is a promise that nothing serious—that is, nothing requiring a serious response—is afoot. The red sky at night means that the shepherd can take peacefully to his bed.

A common form of omen is the prodigy, some extraordinary event that foretells ruin or disaster. Caska enthusiastically evokes a series of such prodigies at the beginning of *Julius Caesar*:

> Against the Capitol I met a lion,
> Who glazed upon me and went surly by
> Without annoying me. And there were drawn
> Upon a heap a hundred ghastly women
> Transformed with their fear, who swore they saw
> Men all in fire walk up and down the streets.
> And yesterday the bird of night did sit
> Even at noonday upon the market-place,
> Hooting and shrieking. When these prodigies
> Do so conjointly meet, let not men say,
> "These are their reasons; they are natural":
> For I believe they are portentous things
> Unto the climate that they point upon. (Shakespeare 2011, 339)

Caska goes on to provide a neat explication of the double logic of the prodigy, in which discontinuity is governed by a principle of continuity:

> Why all these things change from their ordinance
> Their natures and preformed faculties

To monstrous quality, why, you shall find
That heaven hath infused them with these spirits
To make them instruments of fear and warning
Unto some monstrous state. (Shakespeare 2011, 339)

The prodigy is an anomaly or interruption of nature—an excess that may be hinted at in the link between *prodigious* and *prodigal*, the latter from Latin *prodigere*, to drive forth or get rid of—that can only be redeemed or made whole by being put into series with another anomaly or interruption yet to come. "Monstrous quality" is therefore taken to be in accord with "monstrous state." The fact that monsters are etymologically demonstrations or showings is a confirmation of the magical principle of the prodigious, that it breaks with what is customary in order to assert its paradoxical continuity with some matching break of continuity to come. In this sense, a portent or premonition is a kind of reassurance that no real anomaly or permanent suspension of law is possible in nature. Omens are the proof that in nature, there is nothing that is nonserious, in the sense of being wholly random and without consequence or significance. This extends to coincidences and puns, which the logic of the omen insists on literalizing. In his collection of omen stories, Valerius Maximus (2000) tells of the death of the Consul Petillius, besieging a mountain named Letum (Death) in Liguria: "In an exhortation to his troops he said: 'Today I shall take Letum without fail.' Then, fighting recklessly, he confirmed the chance utterance by his own death (letum) [*fortuitum iactum vocis leto suo confirmavit*]" (62–63).

Although they may seem to press upon us or powerfully elicit our attention, omens belong to a magical logic that operates blindly and without purpose, rather than a logic of motive or intent—that is why they can arise through accidental actions, though these can never be accidental according to a magical view of the world as governed by impersonal and universal webs of connection. This impersonality is retained in the ways in which the giving of warning has been automated, from the use of apotropaic image-machines such as the gorgoneion and the varieties of scarecrow, through to many forms of alarm and monitoring devices in the modern world. Not only are many kinds of machinery equipped with ways of signaling potential dangers or problems with their own functioning, through gauges and valves of various kinds; there are also many modern machines and social apparatus whose primary function is to furnish warning. The result is beginning to be a delegation of attention to devices, apparatuses, and applications. Christian Licoppe

(2010) has observed the ways in which the need to manage the constant interruptions of warning has produced a "pragmatics of notification devices" arising from the "tension between the need for them to be perceptually salient (to be noticed), while proving less intrusive, causing less of an imposition on their recipient, and allowing her/him more leeway in their acknowledgment and treatment" (300). Hence the menacing mutedness of alarms in obstetric wards and airport cockpits, whose soft and mock-soothing tones are designed both to urge themselves on their audiences and to inhibit impulsive overreaction, partially warning against the warning they are imparting. But the pressure to pay proper attention to our attention proxies becomes ever more difficult as they both multiply and become more sensitive to potentially sinister variations.

Standby

The result in turn may be the replacement of the jagged variation in forms and intensities of attention, as demanded by ordinary discontinuous responses to events as they arise, by a general condition of alertness, a condition of perpetual standing by or being in readiness to pay attention. Italians answer the phone by saying "Pronto," ready, prompt, in Cleopatra's sense when she sends to Caesar to say, "I am prompt / To lay my crown at's feet" (Shakespeare 2011, 145). Latin *promptus* is from the past participle of *promere*, to bring out, produce, or make manifest, formed from *pro* + *emere*, to take or buy. The one who responds promptly to what prompts them can do so because they are in a permanent state of preemption. They are all ready, or already ready to act readily. In Middle English, "Al redi" was what a servant would say to signal immediate compliance, corresponding to the sailor's "Aye sir," as when we read in Genesis 17:3 in the Wycliffite Bible, "The Lord aperide to hym, and seide to hym, I God Almyȝti . . . And Abram felle down al redi in to the face" (Wycliffe 1850, 1.107). Such immediate responsiveness corresponds to the being-ready or, as it were, "ready, already," signified in Hebrew *hineni* [הנני], "Here I am."

This alreadiness, or being-already in readiness to be, is shadowed by, and alternates with, the other traditional accompaniment to the overload of stress stimulation, the act of putting aside, in numbly defensive indifference. Media systems alternate between being means of bringing serious matters to public attention and means of insulating viewers against the very stabs of seriousness

that those media are intended, at least at times, to communicate. The suspension of the development of television during World War II allowed for the extension of the technology into systems of defense and early warning, through what Paul Virilio (2009) calls a "total visibility" of networks of radar installations, designed to see not only beyond the visible horizon but also into the near future: "This total visibility, cutting through darkness, distance and natural obstacles, made the space of war translucent and its military commanders clairvoyant, since response time was continually being cut by the technological processes of foresight and anticipation" (97). When the development of television for entertainment resumed following the war, the paths of monitoring and broadcasting seemed to have diverged. But the vast growth in "news" from the 1980s onward slowly reintegrated entertainment with early warning functions, given increased intensity by every new crisis or disaster that allowed for minute-by-minute updates on the "developing situation."

The adjectival term *standby* seems to have derived from military and especially naval usage, to "stand by" meaning to enter or adopt a state of attention, or readiness to obey a further instruction. The mixture of steadying reassurance and menacing intent in such usages was activated chillingly in the instruction given by outgoing president Donald Trump to the Proud Boys quasi-militia to "stand back and stand by," which was scarcely improved by his subsequent remark that they should "stand down" (BBC News 2020). As a noun, a standby is something held in reserve, in early nineteenth-century usage, often in the sense of something on which one can always rely (echoed in Tammy Wynette's "Stand by your man"), but then slowly fading down to the idea of a temporary substitute, stand-in, or understudy. The standby, and the condition of standing by, are characteristic of, and increasingly essential to, the growth of forms of security, precaution, and insurance that are almost coextensive with the growth of complex societies. During the twentieth century, standing by, or being held in reserve, has become identified more and more with mechanisms, and therefore with people made equivalent to mechanisms. Standby has become identified in particular with electrical and electronic devices, which are kept running at very low power levels in order to ensure prompt or immediate responsiveness when required. When I was growing up in the 1950s and 1960s, most electrical mechanisms required a process, at once irritating and yet sometimes oddly soothing, known as "warming up," matched by the very considerable booting-up period required for early computers. The device of standby operation, in which more and more

things exist in a condition between being on and off, allows for the reduction of transitional states and the removal of the sense of any absolute gap between the on and the off.

It is a pleasing coincidence that Heidegger's reflections on the being at hand (*vorhanden*) and being to hand (*zuhanden*) of equipment should have been developed in the very years in which "standby" started to be referred to as a mode of operation of electrical equipment such as radios, TVs, and, especially, computers. In "The Question Concerning Technology," Heidegger introduces the idea that technology turns the world into an array of objects that are on standby, waiting to be put to use: "Everywhere everything is ordered to stand by [*zur Stelle zu stehen*], to be immediately at hand, indeed to stand there just so that it may be on call for a further ordering. Whatever is ordered about in this way has its own standing. We call it the standing-reserve [*Bestand*]" (1977, 19; 1967, 16). And yet for Heidegger this gathering together in readiness is not something freely and voluntarily performed on a purely passive and objectified nature. There is something, which Heidegger calls "technology," but really means something like the force that technology effects, or the set of relations it urges, that orders man into this way of ordering the world:

> Modern technology as an ordering revealing is, then, no merely human doing. Therefore we must take that challenging that sets upon man to order the real as standing-reserve in accordance with the way in which it shows itself. That challenging gathers man into ordering. This gathering concentrates man upon ordering the real as standing-reserve. (Heidegger 1977, 19)

A favorite metaphor of Heidegger's is that of "calling"; the relation that characterizes the *Bestand* is one of being on call, and it applies to those who order and operate things as well as the things themselves. The making over of objects into modes of standing by puts humans into a standby condition too, ready to be called to attention. Cryogenics dreams of being able to keep human beings in standby mode for centuries, while the practice of induced coma literalizes the relation of being put "on hold."

The era of what Peter Sloterdijk (2004, 87) has called *Explizierung*, explicitation—the spelling out or making manifest of processes that previously had been merely implicit or contingent, along with the growth, both consolatory and anxiogenic, of command-and-control processes dependent above all on systems of prediction, monitoring, and early warning—might be thought of as characterized by contingency bought at the cost of a huge expansion

of the realm of latency. The pressure to make the latent patent (Latin *latere*, to lurk, or lie concealed, and *patere*, to lie open, spread out, or exposed to view) through explicitation puts one in a position of having to be in readiness through the process, to which such considerable resources are devoted, of "risk assessment" for every kind of possibility. This brings about the solemn folly of circumstances in which one puts oneself at risk through the very mania for attentiveness to negative possibility, or precaution that has become incautiously exorbitant—for example, the "reckless prudence" of the application of austerity measures to national economies or the securing of pension funds at unacceptable cost to their members.

Such externalized monitory systems often employ the display apparatus that has become known as a "monitor," as though it existed not in order to watch but rather to "keep watch" on things, so that we do not pay attention so much as remain on the alert for things that may require our attention. A monitor in schools is a pupil promoted to the status of observer and guide. *Monition* has long been in use to name the act of formal notification, often with the exercise of requirement. A "moneo" was university slang for a formal summons or injunction.

Monitoring belongs to the huge growth in the need for maintenance of the many different kinds of devices, apparatus, and system that had entered into familiar use by the end of the nineteenth century. Rather than standing apart from whatever object or process needed to be guided and overseen, and acting through intermittent interventions—the periodic cleaning of a rifle or sewer, the weekly check on the tire pressure, the repair of roads and brickwork at intervals—monitoring began to take more reflexive and self-regulating forms. As the control of mechanisms began to be mediated ever more through secondary instruments set out on various kinds of control panel, so the mechanism's own self-relation formed ever tighter feedback loops. Rather than providing information about the progress of the operations they were designed to perform, machines were designed to furnish ever more detailed and immediate information about their own operational states.

The architecture of fortifications, from the castle to the pillbox, is designed not only to provide security but to ensure a monitory differential over potential aggressors. The panoramic viewpoint offered by elevation means that space is turned into the time needed to retreat or defend oneself; to be above is to be ahead. Early warning systems became a routine part of warfare only during World War II, especially following the development of radar, which

substituted information for elevation. From canaries in coal mines onward, large numbers of animals have been used as "sentinel species" to provide warnings of industrial or environmental threats. The giant lizards known as monitor lizards derive their name from their occasional habit of standing on their rear legs as though surveying for danger.

The model for this is the signaling capacity of the human body in the fluctuations of its vital signs. The signals provided by the visible condition of the skin, which is still called complexion, were the visible expression of the humoral system that governed physiology for centuries among many human civilizations. The most common experience of medical monitoring has come to be the experience of pregnancy, which has been comprehensively medicalized, not exactly by being turned into an illness, as is sometimes claimed, but by being turned into a condition with the potential to become an illness or emergency, which must be subject to checks to maintain it in the condition of normality. For many, though emphatically not all, women in the world, pregnancy is less dangerous than ever before in history, but that safety has been bought at the cost of a condition of anxiously extended exposure to monitoring. A discontinuous field of calm interrupted by sudden terror and trauma has become a continuous condition of pretraumatic precaution, the latter word aptly suggesting the condition of being on guard against the need to take guard.

Machines not only provided the means of monitoring symptoms and bodily states—for example, through the polygraph, which began life as a mechanism for automatically making a copy of handwriting as it was inscribed (Thomas Jefferson owned one and spent years trying to perfect it), but which by the 1870s started to be used to record different bodily functions (Bedini 1984; Connor 2014b). The name "polygraph" proved adaptable to these new systems not because it produced multiple copies of the same message but because it allowed for the graphing and collation of several different streams of bodily information simultaneously—pulse, respiration, blood pressure, skin conductivity. The lie-detecting polygraph was developed for forensic use by John August Larson in 1921, though names like the "emotograph" and "respondograph" were tried out by rivals (Alder 2007, 80). Larson (1922) himself proposed to call his machine the "cardio-pneumo-psychogram."

Not only were machineries of various kinds deployed for the purposes of monitoring bodily states, but machineries themselves operated and were operated through symptomatologies. Not only power stations but also items

of personal and domestic use regularly report on their own internal states, giving warnings of low pressure, failing batteries, and the like. The domestic smoke alarm is designed not just to warn of the presence of smoke but also to give an alarming warning that it is approaching a condition in which it will be unable to raise the alarm. In Don DeLillo's (1986) *White Noise*, the narrator records impassively: "The smoke alarm went off in the hallway upstairs, either to let us know that the battery had just died or because the house was on fire. We finished our lunch in silence" (8). By the beginning of the twenty-first century, the monitoring of the body's condition and performance had moved out of the obstetric unit and the operating theater to the auto-assaying of the quantified self through the step-counting mobile phone and the data stream of the Fitbit. These self-monitoring devices could start to operate in arrays that could be used to give warning of things beyond individual physiology. Human beings have joined snakes and elephants, the sentinel species who reputedly give warnings of earthquakes, allowing for tremors and aftershocks to be precisely mapped by means of data derived from Fitbits and other monitoring devices. You do not read email: you "check" it, as everything is checked—weight, body mass index, blood pressure, bone density, and mood. Because you monitor the input of email and social media streams, they themselves become monitory systems, which allow their users to become monitors of the stream of monitions.

Numbers and Nightmares

Monitoring is often identical with operations of surveillance, though there are clear differences in the linguistic phenomenology of the two terms. As its name suggests, *surveillance* operates a kind of supervision, which is active and inquisitory. *Monitoring*, by contrast, more often seems to suggest listening in, or listening out for (despite the ubiquity of visual devices known as monitors). Surveillance is markedly more hostile, secretive, and suspicious than monitoring: we might keep a patient "under observation" if we were monitoring their condition, but we could not naturally say that we keep them "under monitoring" (we would have instead to speak of keeping them "under a regime of monitoring" or some such idiom), since monitoring in fact keeps the monitor themselves under a certain kind of obligation to careful attentiveness. Perhaps preserving a memory of its origin in the Comité de Surveillance set up in 1792 during the French Terror, surveillance is also more official and

institutional than monitoring; indeed, while it seems intelligible to monitor oneself—for signs of illness or moral laxity, say—to keep oneself under surveillance would seem to evoke a rather pathological kind of self-relation. To monitor a patient's condition can often be benign and protective of the patient in a way that surveillance rarely can. Surveillance is used in conditions that suggest a sort of deferred arrest; monitoring suggests a relation of careful readiness to intervene for the purposes of support. Surveillance protects the interests of the agent performing the surveillance, while monitoring aims to protect the interests of the one being monitored. One might readily monitor pollution levels, air quality, or rates of deforestation in the natural environment, but it would sound oddly aggressive to call this surveillance. The awareness among adopters of the word in English of the suspiciously asymmetrical relations established by surveillance underlies the need for the transitive word *surveil*, sometimes awkwardly distinguished from the comparative softness of "survey" by the sounding of the terminal *l*, to rhyme with "prevail." In contrast to the subject who conducts surveillance, the monitor is a subject-object, one who subjects themselves to something, as they put themselves in a condition to receive and respond to a warning sign.

The function of a monitor in an election or in an education institution is usually to ensure the maintenance of certain modes of behavior. But the monitoring function of devices is usually quantitative rather than qualitative. What monitoring systems, as opposed to persons acting as monitors, are designed to detect is almost always different kinds of "level"—blood pressure, parts per million of carbon dioxide, or numbers of infections during an epidemic. Where the embodied monitor has the authority to determine behavior, the monitoring system induces responsibility in the one who reads or ignores it.

The emphasis on levels, using uniform and continuous series typically numerical in function and form, engenders a strange kind of discontinuity of attention, focused around threshold states and rates of transition. Examination systems in academic settings exemplify this liminal clustering of intensity very clearly. Most students in the UK examination system are given some kind of mark that signifies adequate performance, typically in a range from 60 to 68, in which 4 or 5 marks can be casually traded among examiners without much concern. But as soon as a student approaches 69, which is just below the mark of 70 that might "trigger," as the term often is, a first-class mark, everything becomes subject to much closer scrutiny, as though the magnification

of an image has been turned up several times. The gap, that is, between 69 and 70 is thereby functionally made much larger than that between other numbers. Once a student has got through the zone of special attention and is being awarded marks of 72 or 73, examiners are apt to become light-headed at the prospect of the unused reservoir of 27 marks that lies in front of them, and can easily be persuaded to award dividends of 5, 10, or 15 marks without protest. This variability in the unit is not usually thought to be a feature of numerical series, especially ones subject to aggregation, in which the marks for different papers are added up as though every mark were exactly one mark away from that below and that above it, and indeed can only be added up on that basis. The hugely distorting effect of this fitfully fevering phenomenology of number, which goes far beyond that of any of the forms of systematic or unconscious bias to which examiners are supposed to be alert, probably derives from the imaginary perspective of the number line, which encourages us to think that the difference between small numbers, which feel close to us on the number line that recedes away from us, is much greater than the difference between large numbers, which seem too far away for significant differences to be discernible. Hence most people tend to feel that a billion is only a bit bigger, the difference between the murmur of an *m* and the plosive puff of a *b* perhaps, than a million, as compared to the difference between one and a thousand. Perhaps the variable quality of quantity also has something to do with the life course, in which the amount of change that occurs between the ages of, say, three and four is much greater than the negligible changes that are likely to occur between seventy-three and seventy-four.

This helps to account for the strange disproportion in responses to monitoring systems. We are much more concerned about very small variations in systems that seem closer and more concerning precisely because they are so small and require a sharpening of resolution to get them in focus. Thus a small increase in risk of some condition among a large population taking a vaccine seems much more compelling and prompts much more alarm than the much larger risk of the disease against which the vaccine protects, especially in a media system that can only survive through the huge inflation of attention to rare and singular events, and the simultaneous battle to create salience (literally, that which leaps out) from homogeneous habit. Similarly, the prominence in our systems of risk perception of recent changes of state, and the looming disasters about which they seem sinisterly to whisper—the capacity of the new to monopolize attention that might otherwise be concerned with the merely

bad—encourages us to take small new numbers (a dozen blood clots per million) much more seriously than huge old numbers (1.2 million TB deaths per annum). The fact that we are programmed to pay attention to what alarms us (plane crashes) means that we find it hard to be alarmed by familiar things, however simultaneously terrible and probable they may be (car crashes).

A highly mediated society such as has emerged across the world in the last century has equipped itself with all the means required to function as a reflexive stress machine. This prosthetic self-consciousness may be said to be authentically existential, in that it keeps itself in existence through the pyretic attention it maintains to the threats to its existence and, more important, the possibility of such threats, now made calculable and therefore a matter of general responsibility, as indicated by Peter Sloterdijk:

> Certainly, every social system needs a foundation of institutions, organizations, and transport means; it must ensure the exchange of goods and services. The maintenance of the feeling of social cohesion among the shareholders, however, can only follow through chronic, symbolically produced stress. The larger the collective, the stronger the stress forces need to be that counteract the disintegration of the uncollectible collective into a patchwork of introverted clans and enclaves. As long as a collective can work itself up into a rage over the notion of doing away with itself, it has passed its vitality test. (Sloterdijk 2016b, 8)

In a stress collective, whether a nest of ants, a troop of gibbons, a football team, or a society undergoing a crisis (and it should be universally acknowledged that a society not in a state of crisis must be anxiously in want of one), everything has the capacity to be regarded as news, an advance warning of a change of state that threatens the collapse of equilibrium altogether. Although there are heroic narrations of the transmission of good or hopeful news, such as the twenty-six miles run by Pheidippides to bring to Athens the news of the defeat of the Persians at Marathon, or Browning's (1996) "How They Brought the Good News from Ghent to Aix," the principle that bad news travels fast and in fact has much more impetus to travel and be transmitted than good news is well established. Although we never discover what the good news is that is being conveyed so urgently by Browning's horsemen, we do hear that it is "the news which alone could save Aix from her fate" (22)—surrendering unnecessarily when help is on its way, perhaps—implying that it does in fact have some tonic element of warning in it. The hunger for news seems often to

be a hunger for the seriousness that bad or ominous news seems to bring with it, since such news seems to mandate continuing attention, whereas in the case of good news there is no particular reason to stay tuned. Good news has no cohering force, since what is good about it is that it requires nothing of us, after the first few outbreaks of bell ringing and firework displays. The stress of bad news, and the warning it may contain of worse, may in fact be regarded as a form of large-scale social tuning, charging the otherwise empty present with omen and imminence, urging attention to the danger, but, more important, remaining attentive to the need for attention. The monitory-minatory updating of fatality figures during an earthquake or epidemic provides an ideal way both of inciting and maintaining states of collective seriousness, in a sort of scansion that keeps serious concern focused in the interval between the thresholds of indifference and panic. In W. H. Auden's (1991) *The Age of Anxiety*, one of the listeners to the radio news in a bar, "suddenly breaking in with its banal noises upon their separate senses of themselves, by compelling them to pay attention to a common world of great slaughter and great sorrow" (454), opens the group's colloquy with the words "Numbers and nightmares have news value" (459). T. S. Eliot's *The Family Reunion* counterposes the different kinds of news, the ancient and the contemporary, the numbed pulsing of its verse balancing the news of international catastrophes with the announcement that there is nothing to be done about them:

> And whether in Argos or in England
> There are certain inflexible laws
> Unalterable, in the nature of music.
> There is nothing at all to be done about it,
> There is nothing to do about anything,
> And now it is nearly time for the news
> We must listen to the weather report
> And the international catastrophes. (Eliot 1969, 329)

It might once have been the case that news bulletins perforated the distractions of entertainment provided by radio and TV, just like the arrival of the morning or evening editions of the newspaper. But the saturation of social space by mediated communications creates the historically unprecedented phenomenon of twenty-four-hour rolling news, with entire channels devoted to the broadcast of what is known in France as *actualités*, a situation that both creates and is cradled by the need for news, whether or not there is any actual

news in need of report. The effect is to maintain the condition of constant vigilance to danger, kept alive in a rhythmic time signature of rapid response and postponement.

The earliest continuous monitoring devices, which were typically rotating spools of paper on which a series of traces could be inscribed or, as the device for tracing sound named by Alexander Graham Bell the "phonautograph" implies, might seem to be able to inscribe themselves, gave the monitoring of levels a temporal axis and, more important, gave a linear shape to futural projection. Whether they imaged the movements of stock markets, heart rates, voting patterns, or rainfall, graphs became powerful tools of prediction and forethought. There can be no doubt at all of the explanatory power that graphs can have, or the insights they can sometimes offer into likely patterns of development. The language of waves, blips, dips, spikes, nosedives, and cliff edges, of being ahead of or behind "the curve" or "off the scale," is our collective prosody of monitored process, which convinces us that we are doing something more serious than monitoring our own monitoring, because putting things in a line, or being serial, is what being serious amounts to. But graphs also have an addictive, mesmerizing quality, which perhaps comes from the combination in them of the idea that graphs are an image of nature's own autography and the fantasy that all one has to do is to extrapolate the line to be able to forecast or forfend the future. The graph is verily and literally one of the leading styles of seriousness. Being able to see the line is like having the power to draw it, the very word *draw* meaning to draw out. The future that we can see by extrapolation (the word itself a sort of autological extension of the meaning of *interpolate*, to improve or polish up by adding material internally) is the equivalent of the past we hallucinate by filling in the missing portions of a ruin. It is hard not to see in this the grip of the idea expressed in the Latin *serere*, to sow in a row, a word that means literally to plant, but is used metaphorically also to mean beget, give rise to, found, inaugurate, or establish what we call a lineage. Graphs are the oracular output of monitoring systems, the way in which those systems are made to give utterance, through the processes of making out that are designed to make the utterance seem spontaneously self-made, bringing secret patterns to light in the past and seeming to show the unfolding of the future.

Warnings in mass-mediated communications allow for the huge amplification of the reflexivity involved in giving warning to oneself. Because one can read easily for oneself the signs set out in graphs, seeing what the figures

set out as writing must prefigure, one is in the position of the monitor or admonisher. At the same time, one is also in the position of the one called to react, to take seriously the matters signified by the graph. There is a kind of omnipotence fantasy at work in this, though it takes the form not of the swelling sense of infinite power but of the huge if also ennobling weight of infinite responsibility, meaning the pressure to respond responsibly to warnings. The affect that is generated by such a coupling of omnipotence fantasy with help-less, attentive waiting is typically not the sense of seriously focused purpose—Something Must Be Done—but rather, since something must always nowadays need urgently to be done about so many, many things, the peculiarly sedulous form of passivity known as dread.

Dread is one of a number of words used not just to designate states of fear but more particularly to sacralize it. From the very beginning of its uses in English, to dread signifies a mixture of terror and reverential awe, of the terrifying and the precious (dreadful things are also awe-full). W. R. Bion (1967) introduced the term "nameless dread" for a feeling of terror in the infant that the mother fails to reflect back to it, after what is supposed to be its "sojourn in the breast," in a coher-ent and thus manageable form: "If the projection is not accepted by the mother the infant feels that its feeling that it is dying is stripped of such meaning as it has. It therefore reintrojects, not a fear of dying made tolerable, but a nameless dread" (116). But "nameless dread" is really a tautology, since dread contains the idea of the formless. Dread is not a fear of some fearful form, nor even precisely the fear of fear itself, but the fear, itself formless, of a formless fear.

Richard Rolle's (1884) *Psalter* renders the Vulgate's Psalm 13:5, "trepidav-erunt timore, ubi non erat timor," as "thai quoke for dred whare dred was noght" (49). The King James version prefers the pallid "There were they in great fear" (Psalms 14:5). Rolle offers the explication that the wicked are con-centrating their fear on the wrong thing altogether: "*thai* qvoke for drede whare na dred was: *that* is in losynge & harm of erthly goeds, *the* whilke is noght to dred. Bot *thai* sould haf dred of *the* fire of hell, *that tha*i fall in. for *tha*i dred it noght" (49). The wicked are wrong to dread what they dread; instead, they should dread damnation, incurred precisely by their failure to dread it. Unless you dread, you run the risk of something truly dreadful. Only dread, we strongly feel, can keep that dread of insufficiently dreading at bay. Dread is helplessness, but a helplessness intensified by the dread that one gives oneself, and comes to depend on, in that it is the abstract form of that which has no concrete object. One's dread takes the reverential form of awe

(comparable with Swedish *aga* and Old Danish *aughae*, discipline) because of the obsessive-compulsive circuit of needing to dread for fear of failing sufficiently to dread. Infused with an aura of sanctity, the dread is itself the containing breast that for Bion fails to contain the dread, returning it as nameless.

Poetry provides abundant evidence of the poeticization of dread by religion. For Coleridge, for example, evoking the power of his own poetic vision in "Kubla Khan," the dread becomes seductive allure:

Weave a circle round him thrice,
And close your eyes with holy dread,
For he on honey-dew hath fed,
And drunk the milk of Paradise. (Coleridge 1912, 1.298)

Whether it is the dread of nuclear destruction, environmental disaster, financial collapse, revolution, or pandemic, all amply intimated by warning signs and omens, dread is kept at a low level, but in a standby condition, and so able to be reactivated quickly when things become serious or, rather, in order to make them so. One does not keep one's dread in reserve: dread is this condition of virtuality.

"I dread to think what will happen," we may say, and expect to hear said. This means that one does not dare think about something so dreadful as that which one dreads. But dreading to think, and the thought of dread, are in fact the kinds of thinking characteristic of dread, by which one means, perhaps, the terrifying deterrence of thinking (and the thought of it). One shrinks from thinking of the thing one dreads, even as dread just is this shrinking from thinking, which is at the same time a shrinking of thinking. The feeling of dread is in part a feeling that something is impending that will require a huge expense of spirit and effort of feeling to meet it. The namelessness of the dread is the amplifier of the feeling of the impending need for feeling, which is prepared for in the anxious and exhausting readiness for dreading, which yet holds itself back in preparation for the dread, so as not to waste one's resources and be left with the cupboard bare of capacity for terror when the time comes. Dread is in fact the superlative state of worry, which is in itself the feint of concern. Worrying about the adequacy of one's dread, worrying that one may not be worrying enough or directing one's worry to the most threatening object is in fact the condition of dread. Dread is the proof of seriousness, the feeling of seriousness itself, abstracted from the particular things that one might be required to be serious about.

And this is also what makes it the pathological imposture of seriousness. Plutarch relates that, on the night before the battle of Philippi, Marcus Brutus was visited by a terrifying demon:

> As he was meditating and reflecting, he thought he heard some one coming into the tent. He turned his eyes towards the entrance and beheld a strange and dreadful apparition, a monstrous and fearful shape standing silently by his side. Plucking up courage to question it, "Who art thou," said he, "of gods or men, and what is thine errand with me?" Then the phantom answered: "I am thy evil genius, Brutus, and thou shalt see me at Philippi." And Brutus, undisturbed, said: "I shall see thee." [ὄψομαι]. (Plutarch 1918, 207)

To be able to look through dread to see its object steadily is rare indeed. It is the quality of evil, or at least of the seriousness the evil seems to command, never to be sufficient unto its day.

Conclusion

I suppose I have not succeeded completely in this book in avoiding writing about serious things—love, death, pain, duty, truth, and so on—though I have wanted to focus, not on what is serious about serious things, but on what makes for seriousness, on the ways of taking things seriously and so on that seriousness itself consists in, the ways in which it may be mandated, manifested, and made to count as seriousness. I think I have found repeatedly that seriousness is not, despite what we tend to think about it, self-sufficing, meaning that, in order to take things seriously, one must do more than simply devote exclusive attention to them. Certainly, that exclusiveness of attention is part of the way in which seriousness is thought about, but seriousness often seems to require more, in the form of various kinds of regulating and confirming ritual. Repeatedly it has seemed that, in order for something to be serious, it has to be susceptible to and productive of ceremonies of different kinds. Ceremonies themselves, religious and otherwise, should therefore be regarded as serious in a specially complex way, given the centrality of what might be called ceremonics in all the ways of taking things seriously, for which the intrinsic seriousness of things, in all the different meanings of that word, is seemingly never enough.

So, rather than being, as we tend to think it should be, self-sufficing, seriousness turns out usually to need to be self-supplementing. I have had occasion a few times to quote Philip Larkin's (1988, 98) reference to the "hunger . . . to be more serious," and it may be that this hungering is in fact intrinsic to

seriousness, along with the ways of being serious about seriousness that I have frequently come upon in this book. To be serious turns out often to mean the serious attempt to find a way of being more, or even more, serious than one feels oneself to be, or hopes to be taken to be. One of the approved ways for doing this is through anger, which can be the result of arguing yourself into feeling so unarguably in the right that you have the right to be overtaken by an elemental and exterior force that leaves you no choice but to lose all self-possession. Since anger requires you to surrender your composure, allowing your features to take on the contortion of an attacking animal, it is very literally a "mug's game," or game of mugging. And because anger, as the mere minatory sign of violent intent, may itself not be enough, many thousands and perhaps millions of human beings have been assaulted or murdered in the proof of the seriousness of your anger known as violence.

A reader may perhaps concede that the chapters of this book have covered a lot of ground without the book having arrived anywhere very conclusive, or able to command a view at altitude of the territory traversed. And I would have myself to acknowledge that I have not evolved or, it may be regretted, even sought to evolve, anything as grand or decisive as a philosophy of seriousness, or general account of what seriousness is or the work it does. It may be frustrating for many to find at the end of a book like this that the answer to the question "What is seriousness?" should turn out to be "many different kinds of thing." The fact that seriousness means many different things means that there will be many styles of seriousness that will have been left unconsidered by this book. But then, perhaps a book that claimed to have given a complete account of any subject would be bound to have trivialized it.

There is perhaps one cohering principle to which this book will be seen reliably to cleave, if that is any consolation—namely, that for humans the question of the kind of existence one will have, or turn out to have had, will always be at work, by which, as we should know, we mean in play. That is, the styles of seriousness matter so much because style, as the question of the way in which things are to be done or said or thought, is itself so irreducibly serious a matter for human beings. It matters how one does things, and one's way of being serious is always a particularly serious matter. One cannot not take the style of one's existence seriously and live out one's days anyhow, not least because that kind of Diogenean embrace of the dog's life is in fact one of the most ancient and much-elaborated styles of seriousness. To be is to be concerned with one's way of being.

Indeed, the word *way* seems to embody all the ambivalence of seriousness. *Way* derives (here we go again) from the same Germanic root as *weigh*, with the idea of the way being developed from the idea of carrying goods along a certain route, deriving from PIE *wegh-, lying behind Sanskrit *vah* and Latin *vehere*, to carry. In making ways, one enacts the way in which weight makes ways for itself, and ways have weight. Seriousness just is this process of seeking to refuse what would otherwise be the absurdity or inertia of just being, meaning that there could be no simple way of being serious. Seriousness must be styled, because seriousness amounts to a stylistics of existence. It has to be that we do not have to be in any particular way, but it is certain that we must have, or finally must have had, our being in certain kinds of way rather than others. To "have your being," in the phrase used by Paul in Acts 17:28 (or, more precisely, quoted by him from the poem "Cretica" by Epimenedes), as opposed it seems, to simply being, is to be-have or, as we say, to "behave oneself," that particular mode of having one's self, or the modulation of that having in general, that is involved in forms of behavior. That is why it is so important (literally, carries so much weight) that we find ways of acting out the necessity of particular ways of being.

If one wonders what kind of person might be regarded as qualified to consider the question of what seriousness is and does for humans, the answer in my case is that I have been a scholar of literature for a long time. Scholars of literature are inclined, like members of every academic discipline worth its salt—physics, philosophy, biology, even and maybe most of all theology—to harbor the secret and immodest conviction that their specific field of operations in fact includes everything. I certainly have come to feel, grandiosely enough, that the particular way of not exactly doing things, as J. L. Austin (1979, 271) so suggestively described it, that literary writing seems to exemplify, is in fact at work almost wherever human beings say anything to each other or themselves in words, or do anything describable in words. Every form of symbolic deportment can therefore be made to look as if it belongs to my department. Literature means what is written, which essentially therefore means what has been written, since the condition of writing is that it opens up the future perfect, the survivability and recallability of what will have been. But this writability does not need to wait for actual writing to exist, for it comes into view as soon as a word can be repeated, and recognized as the same as (which must always mean no more than almost the same as) some other occurrence of the event of that word. Literature comes into being just as

writing does, well in advance of its literal appearance, wherever that is taken to be, in the epic of Gilgamesh or in the framing of the inaugural joke, which would probably have been about some form of the incongruity between somebody's body and their words.

Literature, then, is on the scene as soon as, and for just as long as, it is impossible for human beings simply to do things, simply to act, without acting out their actions in some way or other. Literature, in this imperial conception, means formality, doing things by means of repeatable and variable forms, which means not exactly doing them: not merely doing them, or not quite doing them. It means, not just being able to play, as probably even walruses and chaffinches can a bit, but also being able to joke, to form playful representations of one's play with representation. Living in the kinds of intricately languaged arrangements that human beings have to means that the only way for them to do things is through not exactly doing them. This means doing them in some way or other, in modulation or polytropic doing, turnings away from an elementary doing of things that will always be in prospect but in fact never available. This book, like the last three or four I have committed, is concerned much less with literary artifice than with worldly actions, of word and deed, always subject to the qualification (more enlargement, alas, than restriction) that in the social field, action is never possible except through acting out, and that really doing things is in fact an exotic subset of the almost universal field of not exactly doing things. But I offer this account of the self-understanding of literary criticism less as a methodological trump card or bid for final authority than as a characterization (possibly an overfriendly one) of the way in which people like me are inclined to see the seriousness of what they do.

There is another feature of literary criticism that may give at least an opening advantage in the business of understanding the nature and force of seriousness. For, whatever else they may be, scholars and students of literature are who they are in the way they are because they are supposed (assumed, required) to be people, and in point of fact *the* people, who take literature seriously. Strangely, though, this often involves a systematic inattention on their part to what for most nonprofessionals is the most obvious and unarguable thing about literature, namely that people write it for fun and for other people to read, hear, or watch, equally for fun. The fun that might be had from being helped to imagine people in the most extreme states of agony and rapture (though, for preference, agony) is, to put it mildly, an intriguing kind of thing.

But it is assuredly our kind of thing. The essential feature of watching *Oedipus Rex*—only imperfectly concealed by making it part of a curriculum, warning students that it might make them sad or afraid, and setting examinations on it—remains the fact that you do not have to do it in the first place. To say that literature is governed, proximately as well as ultimately, by the pleasure principle, a stern phrase that itself seems emblematically to yoke gratification and *gravitas*, is to suggest that literature may be seen in part as a laboratory in which the pleasure principle is subjected to the most devilishly denaturing kinds of pressure. The resulting blends of enjoyment and urgency, delight and demand, are what I have often meant to convey with the use of the psychoanalytic word *libido*, if rarely in anything like a strict psychoanalytic sense, in this book. Seen as this kind of laboratory apparatus, literary forms can at least provide a head start into the question, as venerable as it is variable, of what kind of pleasure, such pleasure that pleasure is not the word, in Beckett's (2009b, 4) formulation, there always seems to be in taking things seriously.

The field of social phenomena is deeply rent (painfully, pleasantly) by different forms of the tension between doing and not exactly doing, between real life and the inflected life of literature—that is, between serious and unserious or incompletely serious things. This is so much the case that desperate persons often turn to literature in the official or honorific sense to pursue the arduous search for antidotes to the fevers of fable and infections of inflection in the folk forms of literariness that are wildly epidemic in human life. When Henry James (1934, 5, 6) writes, "Really, universally, relations stop nowhere . . . while the fascination of following resides . . . in the presumability *somewhere* of a convenient, of a visibly-appointed stopping-place," he is pretending to apologize for succumbing to the temptation to suggest that things might ever in fact begin and end, a temptation made irresistible by the power of narrative over human imagining. Although people of my persuasion have spent what might be presumed to be a useful amount of time thinking about the workings of different kinds of style, this book sadly but deliberately drops short of the claim that literary studies must thereby have the drop on every other form of understanding, when it comes to making out how things are made to seem, remain, or cease to be serious. For there is either much, much more literature than one tends to think, extending as far as the eye can see, or, since there is little to distinguish literature from everything else, much, much less.

Works Cited

Agamben, Giorgio. 2017. *The Omnibus Homo Sacer*. Translated by Daniel Heller-Roazen et al. Stanford, CA: Stanford University Press.

Alder, Ken. 2007. *The Lie Detectors: The History of an American Obsession*. New York: Free Press.

Ardley, Gavin. 1967. "The Role of Play in the Philosophy of Plato." *Philosophy* 42:226–244.

Aristotle. 1898. *The Poetics of Aristotle*. 2nd ed. Translated by S. H. Butcher. London: Macmillan.

———. 1911. *The Poetics of Aristotle*. Translated by D. S. Margoliouth. London: Hodder and Stoughton.

———. 1926. *Nicomachean Ethics*. Translated by H. Rackham. Cambridge, MA: Harvard University Press.

———. 1953. *Aristotle, The Poetics; Longinus on the Sublime; Demetrius, On Style*. Translated by W. Hamilton Fyfe. Cambridge, MA: Harvard University Press/London: William Heinemann.

———. 1995. *Aristotle, Poetics*, edited and translated by Stephen Halliwell; *Longinus on the Sublime*, translated by W. H. Fyfe; *Demetrius, On Style*, edited and translated by Doreen C. Innes. Cambridge, MA: Harvard University Press.

Arnold, Matthew. 1921. *Essays in Criticism: Second Series*. London: Macmillan.

Auden, W. H. 1945. *Collected Poetry*. New York: Random House.

———. 1991. *Collected Poems*. Edited by Edward Mendelson. London: Faber and Faber.

———. 1996. *Prose and Travel Books in Prose and Verse*. 4 vols. Edited by Edward Mendelson. London: Faber and Faber.

———. 2002. *Complete Works. Prose*. Vol. 2, *1939–48*. Edited by Edward Mendelson. Princeton, NJ: Princeton University Press.

———. 2008. *Complete Works. Prose.* Vol. 3, *1949–1955*. Edited by Edward Mendelson. Princeton, NJ: Princeton University Press.

Austin, J. L. 1962. *How to Do Things with Words.* Oxford: Clarendon.

———. 1979. *Philosophical Papers.* 3rd ed. Edited by J. O. Urmson and G. J. Warnock. Oxford: Clarendon Press.

Bachelard, Gaston. 1948. *La Terre et les rêveries de la volonté.* Paris: José Corti.

Barrow, Henry. 1590. *A Collection of Certaine Sclaunderous Articles Gyuen Out by the Bisshops against Such Faithfull Christians as They Now Vniustly Deteyne in Their Prisons Togeather with the Answeare of the Saide Prisoners Therunto.* Dordrecht: s.n.

Baudrillard, Jean. 2007. *Forget Foucault.* Translated by Phil Beitchman, Lee Hildreth, and Mark Polizzotti. Los Angeles: Semiotext(e).

Bayne, Paul. 1618. *A Helpe to True Happinesse. Or A Briefe and Learned Exposition of the Maine and Fundamentall Points of Christian Religion.* London: E. Griffin for W. Bladen.

BBC News. 2020. "Trump Now Tells Far Right to 'Stand Down' amid White Supremacy Row." https://www.bbc.co.uk/news/election-us-2020-54359993.

Beckett, Samuel. 1973. *Molloy. Malone Dies. The Unnamable.* London: Calder and Boyars.

———. 1977. *Collected Poems in English and French.* London: Calder and Boyars.

———. 2009a. *Watt.* Edited by C. J. Ackerley. London: Faber and Faber.

———. 2009b. *Murphy.* Edited by J.C.C. Mays. London: Faber and Faber.

———. 2010. *Texts for Nothing and Other Shorter Prose 1950–1976.* Edited by Mark Nixon. London: Faber and Faber.

Bedini, Silvio A. 1984. *Thomas Jefferson and His Copying Machines.* Charlottesville: University of Virginia Press.

Beisecker, David. 1999. "The Importance of Being Erroneous: Prospects for Animal Intentionality." *Philosophical Topics* 27:281–308.

Bibas, Stephanos, and Richard A. Bierschbach. 2004. "Integrating Remorse and Apology into Criminal Procedure." *Yale Law Review* 114:85–148.

Bion, W. R. 1967. *Second Thoughts: Selected Papers on Psycho-Analysis.* London: William Heinemann.

Biran, Pierre Maine de. 1841. *Oeuvres philosophiques.* Vol. 2. Paris: Librairie de Ladrange.

Böhme, Jakob. 1635. *De signatura rerum: Das ist Bezeichnung aller dingen wie das Innere vom Eusseren bezeichnet wird.* Amsterdam?: s.n.

———. 1651. *Signatura rerum: or The Signatvre of All Things.* Translated by John Ellistone. London: John Macock for Gyles Calvert.

Bourdieu, Pierre. 1984. *Distinction: A Social Critique of the Judgement of Taste.* Translated by Richard Nice. Cambridge, MA: Harvard University Press.

Bozeman, Theodore Dwight. 2004. *The Precisianist Strain: Disciplinary Religion and Antinomian Backlash in Puritanism to 1638.* Chapel Hill: University of North Carolina Press.

Braithwaite, Richard. 1631. *Whimzies: or, A New Cast of Characters*. London: for Ambrose Rithirdon.

Brinke, Leanne ten, Sarah MacDonald, Stephen Porter, and Brian O'Connor. 2016. "Crocodile Tears: Facial, Verbal and Body Language Behaviours Associated with Genuine and Fabricated Remorse." *Law and Human Behavior* 36: 51–59.

Browning, Robert. 1996. *Poetical Works*. Vol. 4, *Bells and Pomegranates VII–VIII (Dramatic Romances and Lyrics, Luria, A Soul's Tragedy) and Christmas-Eve and Easter-Day*. Edited by Ian Jack, Rowena Fowler, and Margaret Smith. Oxford: Oxford University Press.

Bruckner, Pascal. 2010. *The Tyranny of Guilt: An Essay on Masochism*. Translated by Stephen Rendall. Princeton, NJ: Princeton University Press.

———. 2013. *The Fanaticism of the Apocalypse: Save the Earth, Punish Human Beings*. Translated by Stephen Rendall. Cambridge, MA: Polity.

Burges, Cornelius. 1625. *The Fire of the Sanctvarie Newly Uncouered, or a Compleat Tract of Zeale*. London: George Miller and Richard Badger.

Byron, George Gordon, Lord. 1904. *The Works of Lord Byron: Letters and Journals: Volume IV*. Edited by Rowland E. Prothero. London: John Murray/New York: Charles Scribner's Sons.

———. 1981. *Complete Poetical Works, Volume 3*. Edited by Jerome J. McGann. Oxford: Clarendon Press.

———. 1986. *Complete Poetical Works, Volume 4*. Edited by Jerome J. McGann. Oxford: Clarendon Press.

Calvin, John. 1989. *Institutes of the Christian Religion*. Translated by Henry Beveridge. 2 vols. in one. Grand Rapids, MI: Wm. B. Eerdmans.

Campbell, Thomas. 1907. *Complete Poetical Works*. Edited by J. Logie Robertson. London: Henry Frowde/Oxford University Press.

Care, Henry. 1687. *Animadversions on a Late Paper Entituled, A Letter to a Dissenter upon Occasion of His Majesties Late Gracious Declaration of Indulgence*. London: John Harris.

Carroll, John. 2012. "Beauty Contra God: Has Aesthetics Replaced Religion in Modernity?" *Journal of Sociology* 48:206–33.

Carroll, Lewis. 1998. *Alice's Adventures in Wonderland* and *Through the Looking-Glass and What Alice Found There*. Edited by Hugh Haughton. London: Penguin.

Cervantes, Miguel de. 1986. *The Adventures of Don Quixote de la Mancha*. Translated by Tobias Smollett. New York: Farrar, Straus, and Giroux.

Chang, Yanrong. 2004. "Courtroom Questioning as a Culturally Situated Genre of Talk." *Discourse and Society* 15:705–22.

Charleton, Walter. 1663. *Chorea Gigantum. Or, The Most Famous Antiquity of Great-Britain, Vulgarly Called Stone-Heng, Standing on Salisbury Plain, Restored to the Danes*. London: for Henry Herringman.

Chaucer, Geoffrey. 2008. *The Riverside Chaucer*. 3rd ed. Edited by F. N. Robinson and Larry D. Benson. Oxford: Oxford University Press.

Chauncy, Maurice. 1935. *The Passion and Martyrdom of the Holy English Carthusian*

Fathers: The Short Narration (1570). Edited by G.W.S. Curtis. Translated by A. F. Radcliffe. London: Society for Promoting Christian Knowledge.

Cleckley, Hervey. 1964. *The Mask of Sanity: An Attempt to Clarify Some Issues about the So-Called Psychopathic Personality*. St. Louis, MO: C. V. Mersby.

Cohen, Leonard. 2006. *Book of Longing*. New York: Ecco Press.

Coleridge, Samuel Taylor. 1912. *Complete Poetical Works*. 2 vols. Edited by Ernest Hartley Coleridge. Oxford: Clarendon.

Connor, Steven. 2012. "Panophonia." http://stevenconnor.com/panophonia.html.

———. 2013. "Collective Emotions: Reasons to Feel Doubtful." http://stevenconnor.com/collective.html.

———. 2014a. *Beyond Words: Sobs, Hums, Stutters and Other Vocalizations*. London: Reaktion.

———. 2014b. "Modes of Manifold Writing." http://stevenconnor.com/polygraph.html.

———. 2016. "The Crisis Work." http://stevenconnor.com/crisiswork.html.

———. 2017. "Ludicrous Inbodiment." http://stevenconnor.com/inbodiment.html.

———. 2019a. *The Madness of Knowledge: On Wisdom, Ignorance and Fantasies of Knowing*. London: Reaktion.

———. 2019b. *Giving Way: Thoughts on Unappreciated Dispositions*. Stanford, CA: Stanford University Press.

———. 2019c. "How to Give Way: An Interview with CRASSH, 15th October 2019." http://stevenconnor.com/givingway.html.

———. 2020. "Religion beyond Belief." http://stevenconnor.com/religion-beyond-belief.html.

Cooper, Rev. John. 1880. *Self-Sacrifice: The Grandest Manifestation of the Divine, and the True Principle of Christian Life; or, The Lost Power of Christian Zeal Restored to the Church*. London: Hodder and Stoughton.

Corney, Bolton Glanvill, ed. and trans. 1908. *The Voyage of Captain Don Felipe Gonzalez in the Ship of the Line San Lorenzo, with the Frigate Santa Rosalia in Company, to Easter Island in 1770–1*. Cambridge: Hakluyt Society.

Cowper, William. 1995. *The Poems of William Cowper*. Vol. 2, *1782–1785*. Edited by John D. Baird and Charles Ryskamp. Oxford: Oxford University Press.

Crawley, Ernest. 1902. *The Mystic Rose: A Study of Primitive Marriage*. London: Macmillan.

Crooke, Helkiah. 1615. *Mikrokosmographia: or, A Description of the Body of Man*. London: William Iaggard.

d'Argens, Jean-Baptiste de Boyer, Marquis. 1757. *Philosophical Visions*. London: for R. Griffiths and T. Field.

Dan Michel of Northgate. 1866. *Dan Michel's Ayenbite of Inwyt, or Remorse of Conscience in the Kentish Dialect 1340 AD*. Edited by Richard Morris. London: Trübner and Co./Early English Text Society.

Davies, Paul. 2014. "Remarks on an Unknowing and Unforgiving Seriousness: A Re-

ply to Alexander García Düttmann." *World Picture 9*. http://www.worldpicture-journal.com/WP_9/Davies.html.

de Vaan, Michiel. 2008. *Etymological Dictionary of Latin and Other Italic Languages*. Leiden and Boston: Brill.

DeLillo, Don. 1986. *White Noise*. New York: Penguin.

Dent, R. W. 1981. *Shakespeare's Proverbial Language: An Index*. Berkeley: University of California Press.

Derrida, Jacques. 1988. *Limited Inc*. Edited by Gerald Graff. Translated by Jeffrey Mehlman and Samuel Weber. Evanston, IL: Northwestern University Press.

———. 1995. *Points . . . Interviews 1974–1994*. Edited by Elisabeth Weber. Translated by Peggy Kamuf, Christie V. McDonald, Verena Andermatt Conley, John P. Leavey Jr., Michael Israel, Peter Connor, Avital Ronell, Marian Hobson, and Christopher Johnson. Stanford, CA: Stanford University Press.

Diakov, M. E., and A. Khramenkov, eds. 2007. *Medals of the Russian Empire: Part 7, 1894–1917*. Moscow: Volf.

Diamond, Cora. 1991. "The Importance of Being Human." *Royal Institute of Philosophy Supplement* 29:35–62.

Dickinson, Emily. 1975. *Complete Poems*. Edited by Thomas H. Johnson. London: Faber and Faber.

Diogenes Laertius. 1931. *Lives of Eminent Philosophers*. Vol. 2, *Books 6–10*. Translated by R. D. Hicks. Cambridge, MA: Harvard University Press.

A Discovrse Concerning Puritans Tending to a Vindication of Those, Who Unjustly Suffer by the Mistake, Abuse, and Misapplication of That Name. 1641. London: for Robert Bostock.

Dryden, John. 1969. *The Works of John Dryden*. Vol. 3, *Poems, 1685–1692*. Edited by Earl Roy Miner and Vinto A. Dearing. Berkeley: University of California Press.

———. 1987. *The Works of John Dryden*. Vol. 5, *Poems; The Works of Virgil in English; 1697*. Edited by William Frost and Vinton A. Dearing. Berkeley: University of California Press.

———. 2000. *The Works of John Dryden*. Vol. 7, *Poems, 1697–1699*. Edited by Vinton A. Dearing. Berkeley: University of California Press.

Dunbar, Robin. 1996. *Grooming, Gossip and the Evolution of Language*. Cambridge, MA: Harvard University Press.

Durkheim, Emile. 2008. *The Elementary Forms of Religious Life*. Translated by Carol Cosman. Oxford: Oxford University Press.

Düttmann, Alexander García. 2014. "Against Self-Preservation, or Can SCUM Be Serious?" *World Picture 9*. http://www.worldpicturejournal.com/WP_9/Duttmann.html.

Eliot, T. S. 1969. *Complete Poems and Plays*. London: Faber and Faber.

Elwall, Edward. 1726. *Dagon Fallen upon His Stumps: or The Inventions of Men, Not Able to Stand before the First Commandment of God, Thou Shalt Have No Other Gods But Me*. Wolverhampton: s.n.

Emerson, Ralph Waldo. 1875. *Letters and Social Aims*. Boston: Houghton Mifflin.

Emmet, Dorothy M. 1946. "On the Idea of Importance." *Philosophy* 21:234–44.

Ernout, Alfred, and Alfred Meillet. 2001. *Dictionnaire étymologique de la langue latine: Histoire des mots*. Paris: Klincksieck.

Eucken, Rudolf. 1912. *Life's Basis and Life's Ideal: The Fundamentals of a New Philosophy of Life*. Translated by Alban G. Widgery. London: Adam and Charles Black.

Evans, Bertrand. 1947. "Manfred's Remorse and Dramatic Tradition." *PMLA* 62:752–73.

An Exact Account of the Trials of the Several Persons Arraigned at the Sessions-house in the Old-Bailey for London & Middlesex Beginning on Wednesday, Decemb. 11, 1678 and Ending the 12th of the Same Month. 1678. London: G. Hills.

The Exeter Book: Poems IX–XXXII. 1958. Edited by W. S. Mackie. London: Early English Text Society/Oxford University Press.

Ezzy, Douglas. 2016. "Religion, Aesthetics and Moral Ontology." *Journal of Sociology* 52:266–79.

Fabyan, Robert. 1533. *Fabyans Cronycle Newly Prynted wyth the Cronycle, Actes, and Dedes Done in the Tyme of the Reygne of the Moste Excellent Prynce Kynge Henry the Vii. Father vnto Our Most Drad Souerayne Lord Kynge Henry the Viii*. London: Wyllyam Rastell.

Fava, Giovanni A., and Per Bech. 2016. "The Concept of Euthymia." *Psychotherapy and Psychosomatics* 85:1–5.

Feynman, Richard P., Robert B. Leighton, and Matthew Sands. 1963. *The Feynman Lectures on Physics: Mainly Mechanics, Radiation, and Heat*. Reading MA: Addison-Wesley.

Florus, Lucius Annaeus. 1619. *The Roman Histories of Lucius Iulius Florus*. Translated by Edmund Bolton. London: William Stansby.

Foucault, Michel. 2010. *The Birth of Biopolitics: Lectures at the Collège de France, 1978–1979*. Edited by Michael Senellart. Translated by Graham Burchell. New York: Palgrave Macmillan.

Frankfurt, Harry G. 1998. *The Importance of What We Care About: Philosophical Essays*. Cambridge: Cambridge University Press.

———. 2006. *Taking Ourselves Seriously* and *Getting It Right*. Edited by Debra Satz. Stanford, CA: Stanford University Press.

Frege, Gottlob. 1980. *Translations from the Philosophical Writings of Gottlob Frege*. 3rd ed. Edited and translated by Peter Geach and Max Black. Oxford: Blackwell.

Freud, Sigmund. 1953–74. *The Standard Edition of the Complete Psychological Works of Sigmund Freud*. 24 vols. Edited and translated by James Strachey et al. London: Hogarth Press.

———. 1991. *Gesammelte Werke*. 18 vols. London: Imago.

Fuller, Thomas. 1837. *The Church History of Britain: From the Birth of Jesus Christ to the Year MDCXLVIII*. 3 vols. London: Thomas Tegg; Glasgow: R. Griffin; Dublin: Tegg and Co.

Galison, Peter. 2004. "Image of Self." In *Things That Talk: Object Lessons from Art and Science*, edited by Lorraine Daston, 275–94. New York: Zone Books.

Girard, René. 1991. *A Theater of Envy: William Shakespeare*. New York: Oxford University Press.

———. 1996. "Mimesis and Violence." In *The Girard Reader*, edited by James G. Williams, 9–19. New York: Crossroad Publishing.

Gorelik, Gregory. 2016. "The Evolution of Transcendence." *Evolutionary Psychological Science* 2:287–307.

Gould, Stephen J. 1995. *Dinosaur in a Haystack: Reflections in Natural History*. New York: Harmony Books.

Gray, Jonathan Michael. 2013. *Oaths and the English Reformation*. Cambridge: Cambridge University Press.

Gregory, Daniel. 2018. "The Feeling of Sincerity: Inner Speech and the Phenomenology of Assertion." *Thought* 7:225–36.

Haack, Susan. 2016. "Serious Philosophy." *Spazio Filosofico* 18:395–407.

Hamilton, William. 1760. *Poems on Several Occasions*. Edinburgh: W. Gordon.

Hardy, G. H. 1940. *A Mathematician's Apology*. Cambridge: Cambridge University Press.

Harrison, Jonathan. 1978. "The Importance of Being Important." *Midwest Studies in Philosophy* 3:221–39.

Heaney, Seamus. 1998. *Opened Ground: Selected Poems 1966–1996*. New York: Farrar, Straus, and Giroux.

Hegel, G.W.F. 1884. *Lectures on the Philosophy of History*. Translated by J. Sibree. London: George Bell and Sons.

———. 1949. *The Phenomenology of Mind*. 2nd ed. Translated by J. B. Baillie. London: Allen and Unwin.

———. 2018. *The Phenomenology of Spirit*. Edited and translated by Terry Pinkard. Cambridge: Cambridge University Press.

Heidegger, Martin. 1967. *Vorträge und Aufsätze: Teil 1*. Pfullingen, Germany: Verlag Günther Neske.

———. 1977. *The Question Concerning Technology and Other Essays*. Translated by William Lovitt. New York: Garland.

Higgons, Theophilus. 1611. *A Sermon Preached at Pauls Crosse the Third of March,1610. In Testimony of His Heartie Reunion with the Church of England, and Humble Submission Thereunto*. London: William Hall for William Aspley.

Hixon, Sean W., Carl P. Lipo, Ben McMorran, and Terry L. Hunt. 2018. "The Colossal Hats (*Pukao*) of Monumental Statues on Rapa Nui (Easter Island, Chile): Analyses of *Pukao* Variability, Transport, and Emplacement." *Journal of Archaeological Science* 100:148–57.

Hobbes, Thomas. 2008. *The Elements of Law Natural and Politic*. Edited by J.C.A. Gaskin. Oxford: Oxford University Press.

Hole, Matthew. 1699. *The True Reformation of Manners, or, The Nature and Qualifications of True Zeal*. Oxford: for Henry Clements.

Housman, A. E. 1959. *Complete Poems*. New York: Henry Holt.

Hubberthorne, Richard. 1654. *A True Testimony of the Zeal of Oxford-Professors and University-men Who for Zeal Persecute the Servants of the Living God, Following the Example of Their Brethren of Cambridge*. London: for Giles Calvert.

Humphreys, Stephen. 2015. "Conscience in the Datasphere." *Humanity* 6:361–86.

Hutcheson, Francis. 1738. *An Inquiry into the Original of Our Ideas of Beauty and Virtue*. London: D. Midwonter et al.

James, Henry. 1934. *The Art of the Novel: Critical Prefaces*. Edited by Richard P. Blackmur. New York: Charles Scribner's Sons.

———. 2009. *The Bostonians*. Edited by R. D. Gooder. Oxford: Oxford University Press.

James, William. 1985. *The Varieties of Religious Experience*. Edited by Martin E. Marty. New York: Penguin.

Jonson, Ben. 1937. *Ben Jonson Volume V: Volpone; Epicoene; The Alchemist; Catiline*. Edited by C. H. Hertford and Percy Simpson. Oxford: Clarendon.

———. 1938. *Ben Jonson Volume VI: Bartholomew Fair; The Devil Is an Ass; The Staple of News; The New Inn; The Magnetic Lady*. Edited by C. H. Hertford, Percy Simpson, and Evelyn Simpson. Oxford: Clarendon.

Juste, David, and Hilbert Chiu. 2013. "The *De tonitruis libellus* Attributed to Bede: An Early Medieval Treatise on Divination by Thunder Translated from Irish." *Traditio* 68:97–124.

Kahn, Charles. 1985. "Democritus and the Origins of Moral Philosophy." *American Journal of Philology* 106:1–31.

Kahn, Rachel E., Amy L. Byrd, and Dustin A. Pardini. 2013. "Callous-Unemotional Traits Robustly Predict Future Criminal Offending in Young Men." *Law and Human Behavior* 37:87–97.

Kandiyali, Jan. 2020. "The Importance of Others: Marx on Unalienated Production." *Ethics* 130:555–87.

Kant, Immanuel. 1915. *Sämtliche Werke*. Vol.2, *Kritik der praktischen Vernunft*. Edited by Karl Vorländer. Leipzig: Felix Meiner.

———. 1997. *Critique of Practical Reason*. Translated by Mary Gregor. Cambridge: Cambridge University Press.

Kassner, Rudolf. 1919. *Zahl und Gesicht: Nebst einer Einleitung: Der Umriss einer Universalen Physiognomik*. Leipzig: Insel.

Kaster, R. 2005. *Emotion, Restraint, and Community in Ancient Rome*. Oxford: Oxford University Press.

Keats, John. 1958. *The Letters of John Keats*. 2 vols. Edited by Hyder Edward Rollins. Cambridge, MA: Harvard University Press.

Kelley, William Melvin. 1962. "If You're Woke You Dig It." *New York Times*, 20 May 1962, section SM, 45.

Ker, W. P. 1948. *Medieval English Literature*. London: Oxford University Press.

Kierkegaard, Søren. 1948. *Purity of Heart Is to Will One Thing: Spiritual Preparation*

for the Office of Confession. Translated by Douglas V. Steere. New York: Harper and Row.

Kinnock, Neil. 1983. "Election Speech." (7 June, Bridgend). https://www.youtube.com/watch?v=-QPhMVbleU0.

Klein, Melanie. 1975. *Envy and Gratitude and Other Works 1946–1963*. New York: Delta.

Knox, John. 1558. *The First Blast of the Trumpet against the Monstruous Regiment of Women*. Geneva: J. Poullain and A. Rebul.

Koerner, Joseph Leo. 2004. *The Reformation of the Image*. London: Reaktion.

Konstan, David. 2008. "Assuaging Rage: Remorse, Repentance, and Forgiveness in the Classical World." *Phoenix* 62:243–53.

Lambert, Malcolm. 2002. *Medieval Heresy: Popular Movements from the Gregorian Reform to the Reformation*. 3rd ed. Oxford and Malden MA: Blackwell.

Larkin, Philip. 1988. *Collected Poems*. Edited by Anthony Thwaite. London: Marvell Press/Faber and Faber.

Larson, John A. 1922. "The Cardio-Pneumo-Psychogram and Its Use in the Study of the Emotions, with Practical Application." *Journal of Experimental Psychology* 5:323–28.

Lawrence, D. H. 1998. *The Rainbow*. Edited by Kate Flint. Oxford: Oxford University Press.

Licoppe, Christian. 2010. "The 'Crisis of the Summons': A Transformation in the Pragmatics of 'Notifications,' from Phone Rings to Instant Messaging." *Information Society* 26:288–302.

Liuzza, R. M. 2004. "What the Thunder Said: Anglo-Saxon Brontologies and the Problem of Sources." *Review of English Studies* 55:1–23.

Lockyer, Nicholas. 1640. *A Divine Discovery of Sincerity According to Its Proper and Peculiar Nature*. London: E. Griffin for Iohn Rothwell.

Loeb, Paul S. 2010. *The Death of Nietzsche's Zarathustra*. Cambridge: Cambridge University Press.

Lord, Errol. 2018. *The Importance of Being Rational*. Oxford: Oxford University Press.

Macalister, R. A. Stewart. 1914. *The Philistines: Their History and Civilization*. London: Humphrey Milford/Oxford University Press.

MacKenzie, Compton. 1933. *Water on the Brain*. London: Cassell and Co.

Mansfield, Harvey C. 2007. "How to Understand Politics: What the Humanities Can Say to Science." *First Things*, August–September 2007, 41–47. https://www.firstthings.com/article/2007/08/004-how-to-understand-politics.

Marvell, Andrew. 1971. *The Poems and Letters of Andrew Marvell*. Vol. 1, *Poems*. 3rd ed. Edited by H. M. Margoliouth and Pierre Legouis. Oxford: Oxford University Press.

Mather, Cotton. 1700. *A Monitory, and Hortatory Letter, to Those English Who Debauch the Indians, by Selling Strong Drink unto Them*. Boston: s.n.

Mattila, Heike E. S. 2013. *Comparative Legal Linguistics: Language of Law, Latin and Modern Lingua Francas*. Translated by Christopher Goddard. London: Routledge.

McAleer, Graham. 2019. "Contracts and Solemnities in Adam Smith's Sacred Anthropology." https://lawliberty.org/contracts-and-solemnities-in-adam-smiths-sacred-anthropology/.

Medawar, Peter B. 1961. "VI. Critical Notice. *The Phenomenon of Man* by Pierre Teilhard de Chardin." *Mind* 70:99–106.

Melaney, William D. 2005. "Ambiguous Difference: Ethical Concern in Byron's *Manfred.*" *New Literary History* 36:461–75.

Mercier, Hugo. 2020. "The Cultural Evolution of Oaths, Ordeals, and Lie Detectors." *Journal of Cognition and Culture* 20:159–187.

Miller, Monica K., and Brian H. Bornstein. 2006. "The Use of Religion in Death Penalty Sentencing Trials." *Law and Human Behavior* 30:675–84.

Milne, Kirsty. 2011. "Reforming Bartholomew Fair: Bunyan, Jonson, and the Puritan Point of View." *Huntington Library Quarterly* 74:289–308.

Milton, John. 1963a. *The Poetical Works of John Milton.* Vol. 1, *Paradise Lost.* Edited by Helen Darbishire. Oxford: Clarendon.

———. 1963b. *The Poetical Works of John Milton.* Vol. 2, *Paradise Regain'd; Samson Agonistes; Poems upon Several Occasions, both English and Latin.* Edited by Helen Darbishire. Oxford: Clarendon.

———. 2012. *The Complete Works of John Milton.* Vol. 3, *The Shorter Poems.* Edited by Barbara Kiefer Lewalski and Estelle Haan. Oxford: Oxford University Press.

Montgomery, Robert. 1855. *The Sanctuary, a Companion in Verse for the English Prayer Book.* London: Chapman and Hall.

Nealon, Jeffrey T. 2017. "Jokes and the Performative in Austin and Derrida; or, The Truth Is a Joke?" *Cultural Critique* 95:1–24.

Nietzsche, Friedrich. 1922. *Gesammelte Werke: Sechster Band.* Munich: Musarion Verlag.

———. 1969. *Thus Spoke Zarathustra.* Translated by R. J. Hollingdale. London: Penguin.

———. 2006. "On Truth and Lies in a Nonmoral Sense." Translated by Daniel Breazeale. In *The Nietzsche Reader,* edited by Keith Ansell Pearson and Duncan Large, 114–23. Oxford: Blackwell.

———. 2017. *The Will to Power: Selections from the Notebooks of the 1880s.* Edited by R. Kevin Hill. Translated by R. Kevin Hill and Michael A. Scarpitti. London: Penguin.

Nightingale, Florence. 1992. *Cassandra and Other Selections from* Suggestions for Thought. Edited by Mary Poovey. New York: New York University Press.

Nussbaum, Alan J. 1986. *Head and Horn in Indo-European.* Berlin: De Gruyter.

O'Hara, Charles. 1964. "Letters of Charles O'Hara to the Duke of Grafton." Edited by George C. Rogers Jr. *South Carolina Historical Magazine* 65:158–80.

O'Mara, Joseph. 1948. "Remorse and Repentance." *Irish Monthly* 76:25–30.

O'Toole, Garson. 2019. "The Curate's Egg: Parts of It Are Excellent." *Quote Investigator.* https://quoteinvestigator.com/2019/04/04/egg/.

Orwell. George. 1954. *Nineteen Eighty-Four.* Harmondsworth: Penguin.

———. 1968. *The Collected Essays, Journalism and Letters of George Orwell: My Country Right or Left 1940–1943.* Edited by Sonia Orwell and Ian Angus. London: Secker and Warburg.

Ovid (Publius Ovidius Naso). 1929. *The Art of Love and Other Poems.* Translated by J. H. Mozley and G. P. Goold. Cambridge, MA: Harvard University Press.

———. 1977. *Metamorphoses: Books 1–8.* Translated by Frank Justus Miller and G. P. Goold. Cambridge, MA: Harvard University Press.

The Pearl: A Middle English Poem. 1906. Edited by Charles G. Osgood. Boston: D. C. Heath.

Peryn, William. 1546. *Thre Godly and Notable Sermons, of the Moost Honorable and Blessed Sacrament of the Aulter.* London: Nycolas Hyll for Robert Toye.

Plato. 1926a. *Laws Books I–VI.* Translated by R. G. Bury. Cambridge, MA: Harvard University Press.

———. 1926b. *Laws Books VII–XII.* Translated by R. G. Bury. Cambridge, MA: Harvard University Press.

———. 2013. *Republic.* Vol. 2, *Books 6–10.* Edited and translated by Christopher Emlyn-Jones and William Preddy. Cambridge, MA: Harvard University Press, 2013.

Pliny the Elder (Gaius Plinius Secundus). 1983. *Natural History: Books 8–11.* 2nd ed. Translated by H. Rackham. Cambridge, MA, and London: Harvard University Press.

Plutarch. 1918. *Lives. Dion and Brutus. Timoleon and Aemilius Paulus.* Translated by Bernadette Perrin. Cambridge, MA: Harvard University Press.

Redfern, Walter. 2008. *French Laughter: Literary Humour from Diderot to Tournier.* Oxford: Oxford University Press.

Reid, Charles. 1967. "On Seriousness." *Southern Journal of Philosophy* 5:228–37.

Renan, Ernest. 1892. *Feuilles détachés.* Paris: Calman Lévy.

Riley, Denise. 2020. *Say Something Back* and *Time Lived without Its Flow.* New York: New York Review Books.

Robinson, Arthur. 1914–15. "The Philosophy of Maine de Biran: The Way out of Sensationalism." *Proceedings of the Aristotelian Society,* n.s., 15:252–70.

Rolle, Richard. 1884. *The Psalter, or Psalms of David and Certain Canticles: With a Translation and Exposition in English.* Edited by H. R. Bramley. Oxford: Clarendon.

Rorschach, Hermann. 1951. *Psychodiagnostics: A Diagnostic Test Based upon Perception.* Translated by Paul Lemkau and Bernard Kronenberg. Bern: Hans Huber Verlag.

Rushdie, Salman. 1988. *The Satanic Verses.* New York: Picador.

Sartre, Jean-Paul. 1943. *L'Être et le néant. Essai d'ontologie phénoménologique.* Paris: Gallimard.

———. 1983. *Carnets de la drôle de guerre.* Paris: Gallimard.

———. 1984. *Being and Nothingness: An Essay on Phenomenological Interiority.* Translated by Hazel E. Barnes. London: Methuen.

Sawyer, Sarah. 2018. "The Importance of Concepts." *Proceedings of the Aristotelian Society* 118:127–47.

Sellnow, Timothy L., and. Matthew W. Seeger. 2013. "Theories of Communication and Warning." In *Theorizing Crisis Communication*, 49–75. Chichester, UK: Wiley.

Shakespeare, William. 2011. *Complete Works*. Edited by Richard Proudfoot, Ann Thompson, and David Scott Kastan. London: Bloomsbury Arden Shakespeare.

Shelley, Percy Bysshe. 1975. *Complete Poetical Works*. Vol. 2, *1814–1817*. Edited by Neville Rogers. Oxford: Clarendon.

Simons, Michael A. 2004. "Born Again on Death Row: Retribution, Remorse, and Religion." *Catholic Lawyer* 43:311–38.

Sloterdijk, Peter. 2004. *Sphären 3: Schäume*. Frankfurt: Suhrkamp.

———.. 2009. *God's Zeal: The Battle of the Three Monotheisms*. Translated by Wieland Hoban. Cambridge, MA: Polity.

———. 2010. *Rage and Time: A Psychopolitical Investigation*. Translated by Mario Wenning. New York: Columbia University Press.

———. 2013. *You Must Change Your Life: Anthropotechnics*. Translated by Wieland Hoban. Cambridge, MA: Polity.

———. 2016a. *In the Shadow of Mount Sinai: A Footnote on the Origins and Changing Forms of Total Membership*. Translated by Wieland Hoban. Cambridge, MA: Polity.

———. 2016b. *Stress and Freedom*. Translated by Wieland Hoban. Cambridge, MA: Polity.

———. 2020. *Infinite Mobilization: Towards a Critique of Political Kinetics*. Translated by Sandra Berjan. Cambridge, MA: Polity.

Smollett, Tobias. 2009. *The Expedition of Humphrey Clinker*. Edited by Lewis M. Knapp and Paul-Gabriel Boucé. Oxford: Oxford University Press.

Spring, Matthew H. 2008. *With Zeal and with Bayonets Only: The British Army on Campaign in North America, 1775–1783*. Norman: University of Oklahoma Press.

Swift, Jonathan. 1958. *A Tale of a Tub: To Which Is Added the Battle of the Books and the Mechanical Operation of the Spirit*. 2nd ed. Edited by A. C. Guthkelch and David Nichol Smith. Oxford: Oxford University Press.

Tennyson, Alfred Lord. 1963. *Poetical Works*. London: Oxford University Press.

Tertullian (Quintus Septimius Florens Tertullianus). 2016. *Tertullian's Treatise on the Incarnation*. Edited and translated by Ernest Evans. Eugene, OR: Wipf and Stock.

The Thirteen Principal Upanishads. 1921. Translated by Robert Ernest Hume. London: Humphrey Milford/Oxford University Press.

Tönnies, Ferdinand. 1963. *Community and Society*. Edited and translated by Charles P. Loomis. New York: Harper and Row.

Trilling, Lionel. 1972. *Sincerity and Authenticity*. Cambridge, MA: Harvard University Press.

Tuomela, Raimo. 1995. *The Importance of Us: A Philosophical Study of Basic Social Notions*. Stanford, CA: Stanford University Press.

Turfa, Jean MacIntosh. 2012. *Divining the Etruscan World: The* Brontoscopic Calendar *and Religious Practice*. Cambridge: Cambridge University Press.

Usener, Hermann. 1896. *Götternamen: Versuch einer Lehre von der Religiösen Begriffs-bildung*. Bonn: Friedrich Cohen.

Varro, Marcus Terentius. 1951. *On the Latin Language*. 2 vols. Translated by Roland G. Kent. Cambridge, MA: Harvard University Press.

Valerius Maximus. 2000. *Memorable Sayings and Doings: Books 1–5*. Edited and translated by D. R. Shackleton Bailey. Cambridge, MA: Harvard University Press.

Véliz, Carissa. 2020. *Privacy Is Power: Why and How You Should Take Back Control of Your Data*. London: Penguin Random House.

Virgil (Publius Vergilius Maro). 1916. *Eclogues. Georgics. Aeneid: Books 1–6*. Translated by H. Rushton Fairclough and G. P. Goold. Cambridge, MA: Harvard University Press.

Virilio, Paul. 2009. *War and Cinema: The Logistics of Perception*. Translated by Patrick Cammiller. London: Verso.

Wallis, John. 1664. *Grammatica lingua anglicanae*. 2nd ed. Oxford: Typis Lichfield-ianis.

Whitehead, A. N. 1920. *The Concept of Nature*. Cambridge: Cambridge University Press.

Wilde, Oscar. 1980. *The Importance of Being Earnest: A Trivial Comedy for Serious People*. Edited by Russell Jackson. London: Methuen.

Wogalter, Michael S., Dave DeJoy, and Kenneth R. Laughery, eds. 1999. *Warnings and Risk Communication*. London: Taylor and Francis.

Woodcock, Thomas. 2003. *Legal Habits: A Brief Sartorial History of Wig, Robe and Gown*. London: Ede and Ravenscroft.

Woods, Ralph L., ed. 1942. *A Treasury of the Familiar*. New York: Macmillan.

Woodward, Ezekias. 1643. *A Sons Patrimony and Daughters Portion*. 2 vols. London: for T. Vnderhill.

Wycliffe, John. 1850. *The Holy Bible, Containing the Old and New Testaments, with the Apocryphal Books, in the Earliest English Versions Made from the Latin Vulgate by John Wycliffe and His Followers*. 4 vols. Edited by Rev. Josiah Forshall and Sir Frederic Madden. Oxford: Oxford University Press.

Yeats, W. B. 1951. *Collected Poems*. New York: Macmillan.

Young, Edward. 1678. *A Sermon Preached before the Right Honourable the Lord Mayor and Aldermen of the City of London*. London: for William Birch and William Leach.

Yurchenko, Sergey B. 2021. "The Importance of Randomness in the Universe: Super-determinism and Free Will." *Axiomathes* 31:453–78.

Zimmerman, H. E. 1922. "Insects to Fight Pests." *St. Nicholas: A Monthly Magazine for Boys and Girls* 49:993–94.

Index